A HISTORY OF
BRITISH
ART

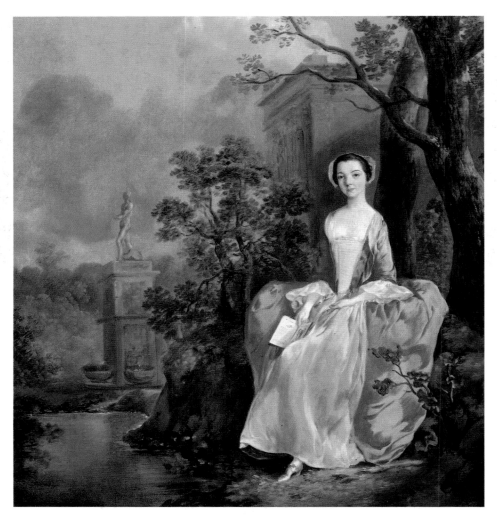

THOMAS GAINSBOROUGH *Girl with a Book Seated in a Park,* c.1750.

Andrew Graham-Dixon

A HISTORY OF BRITISH ART

University of California Press

Berkeley Los Angeles

This book was first published to accompany the BBC television series
A History of British Art, broadcast in 1996.
Series Producer: Gillian Greenwood.

University of California Press
Berkeley and Los Angeles, California
Published by arrangement with BBC Worldwide Ltd.

First California Paperback Printing 1999
© Andrew Graham-Dixon 1996, 1999
The moral right of the author has been asserted.

ISBN 0 520 22376 4

Special photography by Eileen Tweedy, Nicholas Tilly
and Nicholas Turpin.

'Out of the Chaos of my Doubt' (page 6) from *Selected Poems*
by Mervyn Peake, and 'A, a, a, Domine Deus' (page 161) from
The Sleeping Lord and Other Fragments by David Jones
are reproduced courtesy of Faber & Faber Ltd.

Commissioning editor: Heather Holden-Brown
Project editor: Anna Ottewill
Designer: Linda Blakemore
Picture researcher: Deirdre O'Day

Set in Stone Serif by BBC Books.
Printed and bound in Spain by Gráficas Estella, S.A.
Colour reproduction by Radstock Reproductions Ltd,
Midsomer Norton

9 8 7 6 5 4 3 2 1

CONTENTS

For Sabine

Out of the chaos of my doubt
And the chaos of my art
I turn to you inevitably
As the needle to the pole
Turns … as the cold brain to the soul
Turns in its uncertainty;

So I turn and long for you;
So I long for you, and turn
To the love that through my chaos
Burns a truth,
And lights my path.

MERVYN PEAKE 'Out of the Chaos of my Doubt'.

ACKNOWLEDGEMENTS

The blame for any weaknesses in this book's argument lies entirely with me, but during the course of formulating that argument I have incurred many, many debts, first and foremost to my colleagues at BBC Television. This book would have taken a very different form and, I suspect, it would have taken me much longer (yes, even longer) to write had it not been for Michael Jackson and Alan Yentob. They commissioned the television series *A History of British Art*, the scripts for which evolved at the same time as the chapters in this book. Their persistent confidence in the whole project has been a constant encouragement.

I have hugely enjoyed working with the directors and producers of the individual television programmes in the series and their dedication and intelligence has been a tremendous source of pleasure and a considerable challenge to me throughout the last three years. The Jesuitically correct Paul Tickell, the emotionally driven Tanya Seghatchian, the endlessly energetic Martin Davidson, the restlessly Blakean Rik Lander and the retentively inventive Jamie Muir have given enormous amounts of time, energy and perceptiveness to *A History of British Art*. The many, many (many) discussions which I have had with them have played a great part in shaping this book.

Emma Laybourne, the series's chief researcher, has been a pillar of strength and persistence. Susannah Walker contributed a great deal on the Middle Ages, Adam Levy added more, and Maxine Levy provided much material on the art of the eighteenth and twentieth centuries. Kim Evans, Head of Music and Arts, and Roly Keating, Executive Producer, have given helpful advice and provided a sometimes much needed sense of perspective from on high. Luke Cardiff, cameraman-in-chief to the series, has shown a patient, quiet, intelligent affection for the art and architecture of Britain, which has taught me many subtle lessons in looking. Many thanks also to Richard Hill, Eric Wisby, Mike Sarah, Lorraine Silberstein and Beth Millward.

Last but most, Gillian Greenwood, Series Producer, has been endlessly constructive, indefatigably stubborn and unfailingly humane.

I would also like to thank all those at BBC Books who have worked so hard and diligently on *A History of British Art*. Heather Holden-Brown has been almost perversely confident in my ability to complete the manuscript on time and without her confidence I certainly never would have done so. Anna Ottewill has been constantly supportive under stress. Deirdre O'Day has researched the pictures admirably and Linda Blakemore has designed what I think is both an elegant and friendly book. Emma Shackleton has been an exemplary editor, and she has heroically weeded out many of the inaccuracies and distortions (though not all of them I hope) with which my original manuscripts presented her.

8

I owe a great debt of gratitude to Andreas Whittam Smith and Tristan Davies for granting me a sabbatical from *The Independent* to write this book. Thanks also to *The Independent* for giving me the chance to develop so many of my ideas about British art within its pages. Some of those ideas (particularly those about Holbein and Rachel Whiteread) appear almost verbatim here.

During the course of research I have visited many places and spoken usefully to very many people: art historians, museum directors and curators, painters, art collectors, art dealers, librarians, historians, architects, philosophers, gardeners, zoologists, journalists, buskers, snooker players, *joueurs de pétanque*, taxi drivers and too many others to specify. I would particularly like to single out for thanks the historians Margaret Aston, Diarmaid MacCulloch and Patrick Collinson; the art historians David Freedberg and Susan Foister; the directors of the National Gallery and Tate Gallery, Neil MacGregor and Nicholas Serota, as well as Andrew Wilton and David Brown of the Tate Gallery; Simon Thurley, Curator, Historic Royal Palaces, and Christopher Lloyd, Surveyor of The Queen's Pictures.

The above have been exceptionally tolerant and forbearing in response to my many requests and queries. I would also like to thank Jean Kay and Sheila Marshall of the BBC Research Library, who have worked tirelessly and invaluably on behalf of *A History of British Art*. More generally, I would like to thank all those who have shared their time and opinions so freely. What follows is a list (sadly partial) of some of those who have been most helpful and stimulating: Mike Abrams, Tony Adams, Brian Allen, Maria Arnold, Wendy Baron, Susan Bennett, David Bindman, David Bowie, Anita Brookner, Kate Burvill, Patrick Caulfield, Constance Clements, Linda Colley, Peter Conrad, Michael Craig-Martin, Dennis Creffield, Eamon Duffy, Mark Girouard, Anthony Graham-Dixon, Elizabeth Graham-Dixon, Suzanne Graham-Dixon, Christopher Haigh, Richard Hamilton, Robin Hamlyn, Adrian Hardwicke, Francis Haskell, Françoise Hawkins, Martin Hawkins, Karen Hern, Mary Hersov, Christopher Hill, Damien Hirst, Howard Hodgkin, Robert Hughes, Ronald Hutton, Michael Landy, John Larson, John Leighton, Philip Lindley, Oliver Millar, John Newman, Diana Owen, Ronald Paulson, Marcia Pointon, Roy Porter, Stuart Proffitt, John Richardson, Michael Rosenthal, John Rowlands, Charles Saumarez Smith, Kevin Sharpe, Robin Simon, Edie Sinclair, David Solkin, David Starkey, Roy Strong, David Sylvester, Tim Tatton-Brown, Christopher Tilly, Nicholas Tilly, Rodney Turner, Leslie Waddington, Paul Williamson, Rachel Whiteread, Sebastian Wormell and Giles Worsley.

Finally, I must thank my family for putting up with so much (and so little) for so long.

INTRODUCTION

Not long after starting this book I was browsing in a second-hand bookshop when I came across a slim and somewhat worse-for-wear Pelican paperback called *Art in England*. Published on the eve of the Second World War, 'with 32 photogravure plates', it was a rather depressing, grey little anthology of essays which seemed to me to sum up the spirit in which the British have historically treated British art. It contained, among other things, a brisk eight-page account of painting in England from the Middle Ages to the end of the nineteenth century, written by Kenneth Clark, in which the then Director of the National Gallery justified his brevity by asserting that 'we are, after all, a literary people'. A few pages later, Douglas Lord concluded a yet briefer piece with the remark that 'There is no tradition of English art, no continuity: but occasionally a meteor blazes its trail across the sky.' Lord was I think, referring, to Turner.

An air of abjectness and a consciousness of failure has for centuries hung over the discussion of art not just in England but in Britain as a whole. Perhaps this partly explains the curious fact that no-one, to my knowledge has, until now, attemped a general history of the subject in one book. I remember a friend of mine (a painter) looking at me lugubriously when I told him that I had been commissioned to write a book and present a television series about British art: 'What will you say? It is a very overrated subject, you know. After Turner, after all, who has there been? Who? And there aren't many before him, either.'

Anyone comparing the title of this book with its relatively modest size will realize that it can by no means offer a comprehensive account of its subject. It is not meant to do so. I have not attempted to write a textbook, but rather to construct an argument, and to address certain damaging preconceptions about both the history and the quality of art in Britain. It is often said that the British are a tribe of writers, not painters, and that while there are honourable exceptions to the rule (Turner is most often cited although sometimes it is Constable, sometimes Gainsborough) there is little historical evidence that we have ever been truly possessed of a native *visual* imagination. This has always struck me as a peculiar and eccentric piece of self-directed racism. Besides, it is simply not true.

This history begins by exploring two extraordinary and largely forgotten legacies. The first is the tradition of Catholic religious art which thrived in the British Isles before the Reformation. For far too long, discussion of British religious art (and by implication the British medieval imagination) has been based on the extremely partial evidence of surviving medieval manuscript illuminations. To give just two instances of this, almost everything that Kenneth Clark had to say on the matter of British art in the Middle Ages was based on analogy with manuscripts; the same is true of Nikolaus

Pevsner in his rather disappointing book, *The Englishness of English Art*. Almost no serious consideration has been given to the brilliant traditions of large-scale figurative carving and sculpture that the Reformation snuffed out. Recent research has rescued some extraordinary objects from centuries of neglect – objects which prove that the British once lived lives as visually rich and profound as those of any other people in Europe. One of the chief aims behind this book is to broaden appreciation of the beauty and the emotional power of such little known but astonishing works of art as the Abergavenny Jesse and the Mercer's Hall Christ.

The second forgotten legacy of the past which lies at the centre of this history is that tradition of anti-art which dominated Britain for more than a century after the start of the Reformation. During the sixteenth and seventeenth centuries Britain was convulsed (as no other culture in Christendom has ever been, to quite the same extent) by iconoclasm. I have tried to analyze the complex passions and terrors that lay behind the Protestant need to smash and blind and deface (literally strip the faces off or remove the heads from) figurative works of art. I have been greatly helped by the pioneering historical work that has been done in recent years on the Reformation by Eamon Duffy (in *The Stripping of the Altars*) and by Margaret Aston, whose *England's Iconoclasts* is in my view one of the most brilliant and dedicated pieces of research ever undertaken by a British historian. The smashing of images, the destruction of all figurative art ('papal trash' in the eyes of Protestant reformers) has generally been considered by art historians as an improper subject for the study of art history, an episode in our past best treated with discreet silence. I have taken the different view that unless we can understand what fuelled this desire to destroy we can never hope to understand the curious, devious course taken by art in Britain ever afterwards.

The main body of this book is an attempt to anatomize the nation's love-hate relationship with art and to understand the huge struggles that lie behind the development of later indigenous traditions. In the immediate aftermath of Reformation, the native British artist became temporarily paralysed. The initiative was passed to foreign artists, and to two in particular, Hans Holbein and Anthony Van Dyck, whose unbroken influence may be traced from the sixteenth and seventeenth centuries onwards.

The extent to which the British art tradition has been moulded by foreign artists should never be underestimated. Jingoistic types have seen this as a weakness. I personally think it one of the great strengths of British art, that it should be so difficult to define in strict relation to a people of one geographical origin. The Britishness of British art – the Britishness of the British nation, indeed – lies in its essentially patchwork quality. There is a nice paradox here. What makes British art so quintessentially British is the fact that it has been created by people of so many different origins: not only Welsh, Scottish, Irish and English but also French, German, Flemish and Dutch (I could go on).

The heterogeneity of British art has been a constant for many centuries. Religion has in my view been the chief determining factor in shaping the course of the visual

imagination in this country. The wholesale destruction of art during the Reformation severed the British decisively from the European Catholic art traditions and took the British visual imagination down a different route. As I have pursued the British art tradition along its idiosyncratic path, I hope I have done some justice to the greatest British artists. I have tried to place figures such as Stubbs and Turner where they belong, which is at the centre of the history of art in the West. I have also tried to shed light on some of the less frequented byways of the British art tradition. Above all, I have tried to demonstrate not only that there has been a great, vital and continuing tradition of visual thought in Britain, but also that the truest route to a broad and profound understanding of British culture itself – in its religious, political, philosophical and historical dimensions – lies in an understanding of that tradition. The history of art in Britain has too often been told as if it were a marginal one. I believe that it is one of the most revealing of all our cultural stories and I hope the strength of that conviction will be apparent in the following pages. The ambition behind this book is simple: to help myself and others to understand and to love British art a little bit more.

Andrew Graham-Dixon, February 1996.

Note Due to the inevitable restrictions of space in any book of this kind, it has not been possible to illustrate all of the works I mention. Although, of course, reproductions can never be more than shrunken ghosts of original works of art, their absence can be frustrating to the reader. To compensate for this, the *Notes on Works* at the end of the book indicates the location of every object discussed and cites, where possible, other books in which a reproduction of each work can be found.

DREAMS AND HAMMERS

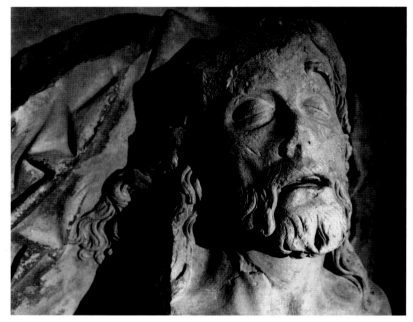

SCULPTOR UNKNOWN figure of Christ (detail), The Mercer's Hall, London, c.1500–20.

What are the roots that clutch, what branches grow
Out of this stony rubbish? Son of man,
You cannot say, or guess, for you know only
A heap of broken images, where the sun beats,
And the dead tree gives no shelter …

T. S. ELIOT *The Waste Land,* 1922.

'At Clare … we brake down 1000 pictures superstitious;
I brake down 200; 3 of God the Father, and 3 of Christ,
and the Holy Lamb, and 3 of the Holy Ghost
like a dove with wings …

WILLIAM DOWSING record of reforms at the parish of Clare, January 1643.

The End of Art

John Ruskin declared that 'Great nations write their autobiographies in three manu-
scripts: the book of their deeds, the book of their words and the book of their art'. That
eminently Victorian art critic believed that, of those three books, 'the only quite trust-
worthy one is the last'. But, in the case of his own nation, he was only half right.

Art in Britain through the centuries may be said to amount to an autobiography of
the British nation. But like most autobiographies it is less than entirely trustworthy. The
story is full of lacunae, pages have been burned or lost and many chapters in the long
vexed life that it imperfectly records have been almost entirely written out. The work of
a divided personality, it is a composite of self-invention, self-deception, willed amnesia
and involuntary forgetting.

Nevertheless, although it is an unreliable tale, it is revealingly unreliable. Nothing
tells us more about British culture than the gaping holes punched into the fabric of its
past by those radical, muscular acts of censorship and abolition which lie at the heart of
the history of British art. That history begins with the most consequential of all those
acts and therefore it begins with an ending: the destruction by force of what had been
for centuries the native traditions of painting and sculpture.

The Lady Chapel in Ely Cathedral [1] is now a bare and grey place, starkly daylit,
although it was not always so. In his guide to the architecture of Cambridgeshire,
Nikolaus Pevsner notes with studied understatement that the effect of the building as it
exists now is more than slightly misleading. Originally, he points out, 'there was not the
clarity of today, but a rather hotter and more exciting effect'. Designed in the fourteenth
century by someone whose name remains unknown, the Lady Chapel was once
adorned by more than a hundred carved and painted figures, which enacted the life and
miracles of the Virgin Mary. The windows, now plain, once glowed with holy stories
told in coloured glass: blues, greens and reds as thick and dark as the red of blood. Every
one of the bare niches set into its walls once contained a freestanding statue. Two hun-
dred years after the chapel was completed a group of men armed with hammers and
chisels came into the building, destroyed every image and smashed every window. Its
scarred walls still resound with the rage of English iconoclasts.

The Lady Chapel was turned into an empty parallelogram of limestone by vast
forces of schism. But although it may be empty its emptiness is full of significance. The
beliefs that drove men to destroy what it once contained were plainly meant never to be
forgotten. The building's wounded interior could have been made good, but instead
many of its damaged statues were kept as they were. It mattered deeply to those wield-
ing their weapons of iconoclastic correction that the mutilated bodies of art should be
left in open view, ruined and disgraced for ever. The headless and limbless torsos still to
be seen in the Lady Chapel today were deliberately and aggressively left in place, like
corpses exhibited after an execution. This is the repudiation of religious art made visible
and made permanent. A Chinese academic who had fled from the Maoist regime in

1 The Lady Chapel, Ely Cathedral, 1348.

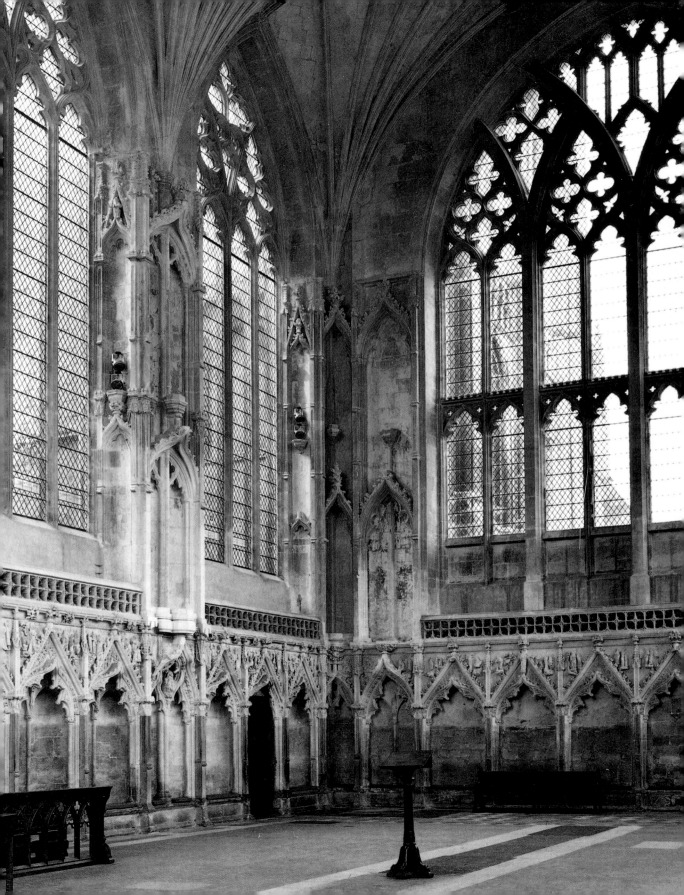

his native country visited Ely in the 1960s and remarked, simply, 'Ah, you too have experienced a cultural revolution'. He was right. The Lady Chapel is a monument to the purge of minds, as well as buildings, that took place in Britain in the sixteenth and seventeenth centuries. To visit it is to begin to understand the enormity of what happened, the sheer scale and violence of the iconoclasm involved as the British, in the throes of a crisis of faith, wrought havoc on their indigenous traditions of art.

Most British schoolchildren are taught at least a little about the Reformation. They are taught that it began in 1534 when Henry VIII, determined to divorce Catherine of Aragon despite the pope's disapproval, repudiated papal authority and rejected the Roman Catholic faith. They are taught that he dissolved the monasteries and founded the Church of England. This at least is common knowledge. But the extent of destruction involved as the British converted from one faith to another is much less widely known.

Henry's dissolution of the monasteries in 1536 was no more than the officially sanctioned starting point for more than a century of drastic and violent iconoclasm throughout Britain. The radical leaders of the new Protestant church were vigorous and determined opponents of all Roman Catholic rituals and imagery. Under their direction thousands upon thousands of works of religious art were burned and smashed. Throughout Scotland, Wales and England cathedrals and churches were emptied of sculptures, paintings and stained glass. Grimly festive bonfires of art were lit, and the common people were encouraged to warm themselves as their religious past went up in flames. Nowadays, the English church in the peaceful English landscape is widely and fondly regarded as a symbol of cultural continuity – a sign that some things, at least, never change. This is a misconception. Few places have changed as much as English churches. Britain's distant past is not peaceful, it is violent, and its churches and cathedrals are the battlefields on which the most vigorous war for the soul of the culture was once waged.

The Lady Chapel at Ely contains not one but two histories, both of which the British in recent centuries have chosen, or have simply found it convenient, to forget. Britain's ruined choirs tell us about one form of extremism lurking within the historical soul of the nation: the extremism of the Protestant movement, rooted in a distrust of art, ceremonies, display, theatre, sensuality and visual exuberance of most kinds. The world of images that survives piecemeal within those choirs tells us about another and quite opposite form of extremism, lurking even more deeply and anciently within the historical soul of the nation: an extremism rooted in a passionate and heady attachment to images.

The British have hated and they have loved art as deeply as any of the peoples of the West. However, the extremes between which they have so violently swung, in their attitudes to the image, are precisely what make the British art tradition unique. Before we can anatomize the hatred we must try, though the attempt may be in vain, to piece together the love.

Dreams

The Middle Ages in Britain have become the Missing Ages, and British churches and cathedrals have become the graveyards or excavation sites of the art produced during the long centuries of Roman Catholic belief. Lawrence Stone once compared the task of the historian of medieval art in Britain to that of 'the palaeontologist, who from a jaw-bone, two vertebrae, a rib and a femur contrives to reconstruct the skeleton of some long extinct creature and endow it with flesh'. But there are certainly enough remains to refute the eccentric and still often repeated notion that the British have never proved themselves to be an especially exuberant or self-expressive nation. The British were once a zealous, convulsive, rowdy, colourful and superstitious people, possessed by consoling dreams of other, brighter worlds and by nightmares of death and damnation, living their painful and devoted lives in a world of smoke and incense and music and hot, hot colour.

No journey through their broken images can hope to amount to much more than a partial tour of a long dead civilization, a quest for what can never be fully recaptured: a Fragmentiad. But it is worth undertaking, because what is left is not only extremely moving, extremely powerful and too little known, it is also the folk memory, preserved in object form, of a time when the British were unimaginably different from the people they have become.

Too crude to be a masterpiece, but crude enough to be unforgettable, *The Last Judgement* [2] on the wall of the parish church of Wenhaston in Suffolk is a potent and transporting relic of English dread: a powerful image of the terrors of Doomsday that were once ritually imprinted on the imaginations of the faithful by the nation's large workforce of religious artists. The Wenhaston Doom, as it has been christened, was designed to be a cautionary object of daily contemplation by ordinary men and women. Painted in the late fifteenth century by an anonymous monk, it once formed the tympanum, or painted backdrop, to the carved wooden statue of Christ on the cross that once dominated the church from on high in the chancel arch. That statue is long lost, but the silhouette of the missing crucifixion is clearly visible in the painting. The Wenhaston Doom itself only survives by chance. Whitewashed over in 1548, it was taken out of the church as junk to be burned three and a half centuries later. But before it was destroyed a sudden rainfall washed off the white paint of Reform to reveal an authentically English vision of heaven and hell.

The painting makes no concessions to artfulness, has no interest in flaunting its own virtuosity, and its message comes across all the more directly for that. The naivety and crudeness of the anonymous monk's journey-work draughtsmanship, and its execution on boards joined by evidently makeshift carpentry, only accentuate the authenticity of the image and the simplicity with which it phrases a simple command-ment: Thou shalt be afraid. Hell, as hell often does, seems rather more vivid than heaven. The artist has painted the most horrid of horrid places as a large fish. The pains

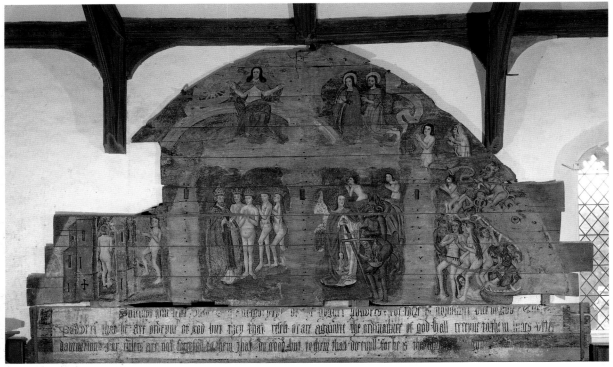

2 ARTIST UNKNOWN *The Last Judgement* (detail, right), St Peter's Church, Wenhaston, c.1490.

felt by those crowded into its gaping maw are more evident than the pleasures of those walking through the gate of heaven.

Part of the picture's appeal lies in its very mundanity. St Michael, weighing the souls of the saved and the damned, has the slightly weary, uninterested air of a clerk going through another day in the office. Some of the demons look like people you may know distorted as in a bad dream, while the blessed could be your next-door neighbours, off to heaven and feeling pretty smug about it.

The artfulness of art, in an age when images were regarded as natural auxiliaries of belief, was less important than its directness: the simplicity with which it conveyed its message or the transparency with which it conjured up the picture of a saint or the Madonna or the Saviour. The viewer's relationship to art was not primarily aesthetic, but visceral. Art then was not art as it is understood today. Art was the most important form of instruction in a society where hardly anyone could read. Art was an aid to prayer, and to meditation, a way of helping people to envisage heaven and hell, and of helping them to understand the right way to salvation through faith and good works. Images were signposts to the next world, placed in this one.

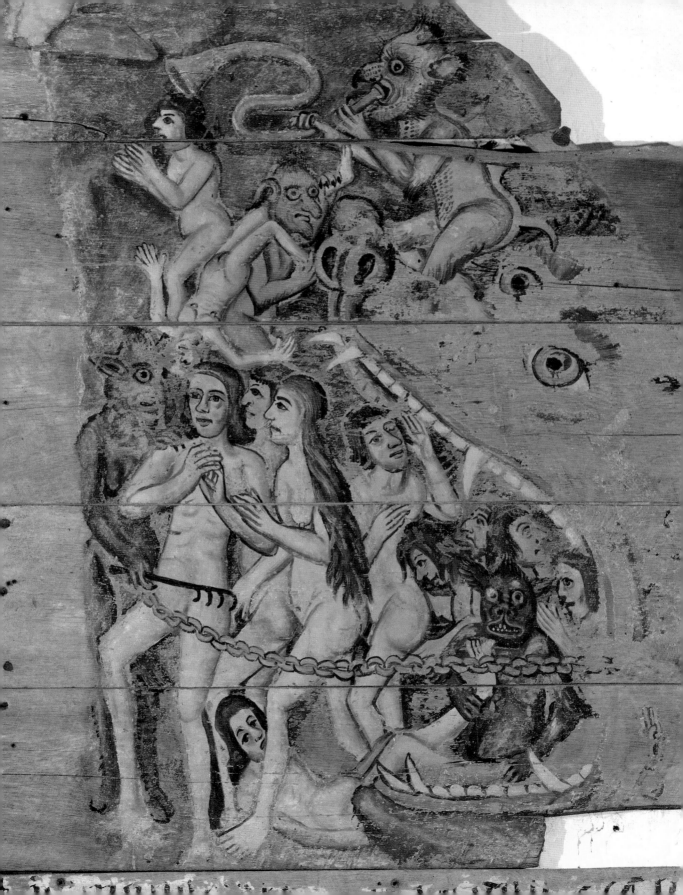

The intimacy of the relationship which once existed between the British and the works of art in their lives is equally palpable at Ranworth, a small but well-endowed fourteenth-century church on the Norfolk Broads, built and decorated on the profits of the East Anglian wool industry. The tiny paintings in its antiphoner, one of the most beautiful of East Anglian illuminated manuscripts, are masterpieces of straightforward religious conviction and visual imagining, confident in their picturing of the greatest mysteries of the Christian faith as events that could have taken place just around the corner. In the miniature devoted to the Ascension we see Jesus Christ levitating into heaven. Only his feet are visible, but his footprints are left on the ground, two dark patches on light green grass glossed by the dew. Elsewhere in the same book we find Jonah being disgorged by a whale that resembles a great white shark, but which may also have been shaped by memories of a very large pike seen by the artist somewhere on the Norfolk Broads, perhaps not too far from Ranworth [3]. These images are brilliant hybrids of faith and imagination. They exist to persuade people of the feasibility of

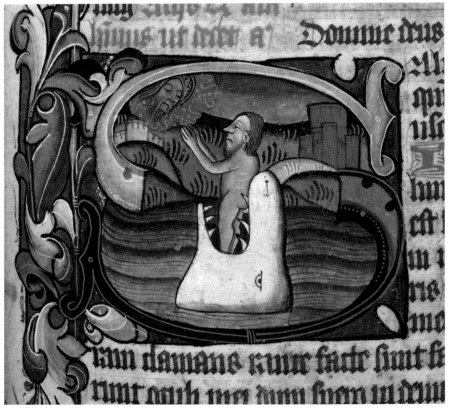

3 ARTIST UNKNOWN *Jonah and the Whale*, from the Ranworth antiphoner, St Helen's Church, Ranworth, c.1460.

miracles. 'Yes', they say, 'these events really happened, and they happened to people as real as you in places as real as your places'.

The parishioners of Ranworth preserved their art carefully from the iconoclasts of the Reformation (no small feat) and the screen in the church has retained many of its painted figures of saints and angels. The work is much more sophisticated than the direct painting at Wenhaston. The figures are painted in richer colours: bright blues and greens and golds ground from semi-precious stones, rather than the ochres and browns which the more rustic painter of the Wenhaston Doom obtained from the soil. They are drawn more elegantly by an artist with a strong sense of design and colour, and they pose with a sinuous, serpentine grace, like heavenly courtiers. Their author remains anonymous: artists of the time did not sign their work, because they did not consider art as self-expression but as cooperation with God's purposes.

Although the saints on the Ranworth screen are images of beings purer and holier than any alive in the real world, they are not intimidatingly perfect and they wear kind, encouraging expressions on their faces. They are genteel household gods appropriate to what was probably a rather genteel, prosperous parish. The painted saints in the church were as much a part of everyday life as the blacksmith or the baker. Approach them, look upon them, and pray to them and you may be heard and helped. Images like these were the focal objects of a pragmatic form of superstition, and each saint had his or her own special talent. The images on the right-hand side of the rood screen at Ranworth form what was known as a Lady Altar. Prominent among the saints painted there is St Margaret of Antioch who, according to her legend, had been miraculously preserved within the belly of a dragon before bursting forth triumphant to the great discomfort of the said creature. She was considered one of the chief patron saints of childbirth. The pregnant women of Ranworth would light candles to her image and pray to her for the safe delivery of their children.

The historian Eamon Duffy has written of 'the intimate interweaving of this world and the next' in Catholic England. Images were the stitching that joined these two fabrics. Images carried the cries of this world to the next and translated what was holy into visions that seemed so real that you could touch them. They served a huge, yearning need among a people for many of whom heaven offered the only prospect of release from short lives of great pain and hardship.

Art was the sympathetic handmaiden of a faith rooted in sympathy for the sick and the dying, whose God had Himself experienced human pain and an excruciating death through the person of Jesus Christ. There is no more moving mediation on this theme than the Mercer's Hall Christ [4]. The fact that its existence has been known to only a handful of people until now makes it one of the most compelling instances of the black hole of amnesia and ignorance into which so much of the medieval art of Britain has been allowed to fall. It was discovered entirely by chance in the 1950s by builders digging beneath the building's foundations. It should be on public view but is to be found, instead, lying on the floor of the Mercer's Hall boardroom. Time has lent the

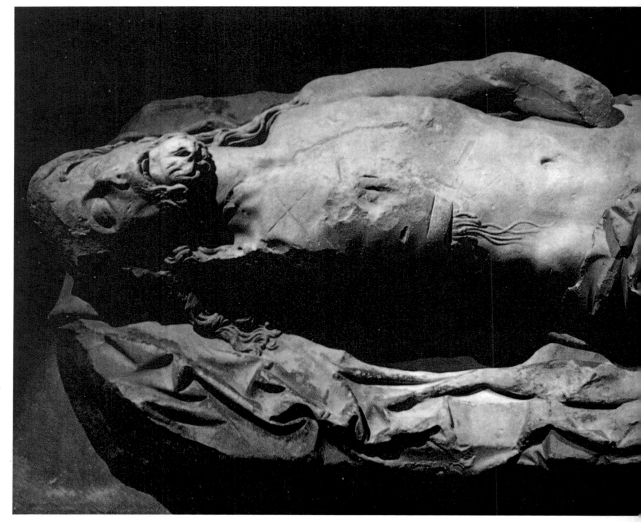

4 SCULPTOR UNKNOWN figure of Christ, The Mercer's Hall, London, c.1500–20.

work additional pathos and now this marble corpse of Christ proclaims two deaths, the death of God and the death of an entire tradition of British art.

The sculpture is a masterpiece of early sixteenth-century European art, an image that captures the terror and beauty, the strangeness and pathos of the central narrative of the Christian story. It is British art's equivalent to Mantegna's *Dead Christ* in the Brera Gallery in Milan, or Michelangelo's *Pietà* in St Peter's Basilica in Rome. Here one of the oldest myths is told yet again, but so freshly and passionately that it is as if for the first

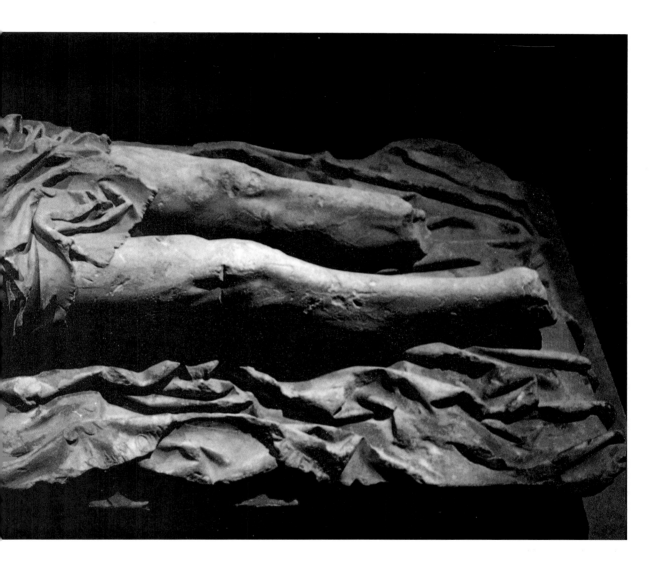

time. A god made himself into a man and died a foul death to save all humanity. The tale is told in a scarred, bleeding corpse of stone. The muscles and the tendons in the legs have been spasmed by the cramps and pains of crucifixion. The face of the dead man-god is twisted in a grimace of pain [detail, page 12]. The realism of the carving is disturbing; this is a work created on the cusp of an English Renaissance that was never to be and it exhibits the new, confident grasp of the human anatomy which had spread through Italy, France and into the Low Countries by the 1510s and 1520s. But it must

have been yet more disturbing in its own time when it was painted. There are tiny traces of rust-coloured pigment in the hair of the figure. The lips were once painted, the teeth once white and the tongue, pushed up to the roof of the mouth, picked out in a soft and subtle red. Even without the paint the figure is startlingly real and the body a body to believe in. Christ has just breathed his last breath before the miracle of his Resurrection, and the light of the world has gone out.

The subtlety and the sophisticated anatomical knowledge that went into the creation of this image of Christ do not make it a sophisticated or even a particularly civilized sculpture. Its power is the ancient power of art to arouse love and sympathy. This skinny stone deity, who has lived a hard life and died a harder death, is an object of pathos which offers consolation and hope. 'Your god suffered, as you suffer', the statue says. 'He felt pain, as you feel pain. Love him and you will be saved.'

The image of Christ was, of all representations, that which most directly called forth all those immediate and involuntary responses to the image on which the Catholic Church depended to instil and incite faith. Because this was the central image of the church, it has survived in only a very few cases. The crude dying Christ whom we see being speared by an improbably long spear in *The Crucifixion* altarpiece [6] in Foulis Easter Church, near Dundee, is almost the only Scottish painting of the Saviour to survive the destruction of religious imagery. But the greatest losses probably occurred in wooden sculpture. Once every church and every cathedral in Britain was dominated by a larger than life-size carved and painted figure of Christ on the cross. Suspended from the roof or inserted into the top of the rood screen of the church, this was the climactic image of the faith, one that was designed to crown all the other images – the painted saints and prophets, the angels and archangels – and give them their meaning.

One of the very few surviving relics of these great carved Christs is to be found at the back of the pews in the church of Cullompton in Devon. Only the base remains of what was once a large sculpture of Christ and the two Marys, originally made to be placed over the rood screen. It consists of three large pieces of carved wood which were intended, in a rather narrow, foreshortened perspective, to conjure up the stony and skull-littered ground of Golgotha. The carving of these stark, astonishing fragments of the Catholic past is muscular and rudimentary but also tremendously assured [5]. They are death's heads in a desert land, created simply with hard, straight blows of the chisel and they have a power and a simplicity never to be seen again in English sculpture. There is something of the Aztec or Toltec about the rood base. It goes straight to the heart of the most primitive and eternal of all human feelings: the terror of death.

Only one unarguably great wooden figure survives intact from the wreckage of the British cultural revolution. It is the figure of a prophet [7] which occupies one of the side chapels of St Mary's, a priory church in Abergavenny. This is the most impressive wood carving to have escaped the bonfires of the Reformation in Wales, and it is a work of stirring strangeness. A figure of Jesse, father of David and ancestor of Jesus Christ, it was carved out of the trunk of an oak tree sometime in the late fifteenth century.

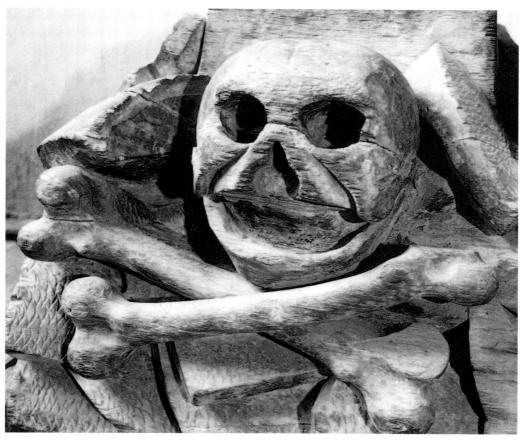

5 SCULPTOR UNKNOWN Golgotha, remains of a rood base (detail), St Andrew's Church, Cullompton.

In the theology of medieval Catholicism Jesse was thought of as the root from which Christ will grow. The severed stump that projects upwards from the Abergavenny Jesse's groin was once a tree of other carvings – other figures and tales – twisting and growing up the wall to reach its climax in a carving of Christ's life, death and Resurrection. The Tree of Jesse was one of the commonest of late medieval symbols, an image which linked the prophecies of the Old Testament to their fulfilment in the New Testament, and which also poetically figured one of the central metaphors of the Christian story by envisaging Christ's Resurrection as a divine version of the diurnal miracle by which green shoots sprout, every spring, from the bare trees of winter.

The Abergavenny Jesse is an image with roots that clutch. The tree was an ancient focus of fertility cults stretching from Athens to Snowdonia, and the Christian Tree of Jesse was an attempt to appropriate one of the oldest and most powerful pagan symbols

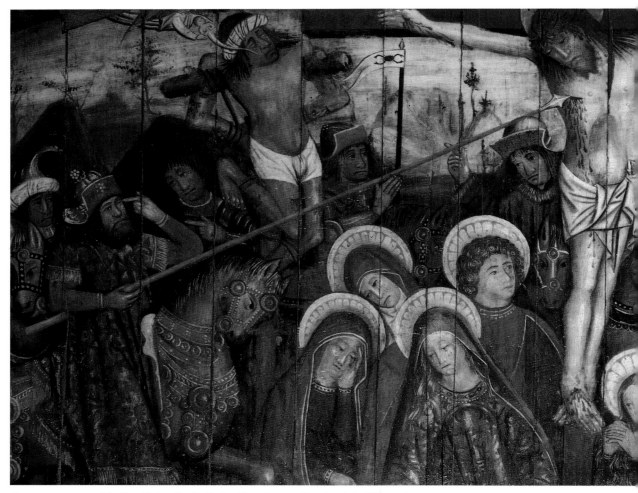

6 ARTIST UNKNOWN *The Crucifixion,* Foulis Easter Church, near Dundee, late 15th century.

and turn it into an agent of the Catholic Church. The memory of that appropriation is strong in Abergavenny, where the power of the image that survives has been enhanced by the lopping off of all the exfoliating branches of Christian story and allegory. There is something mysterious and pagan about this great wooden image of a prophet from the East. The huge stiff wooden folds of his clothing give him bulk and power, while his face is carved in a startlingly different register of brilliantly achieved naturalism. Lined and slightly wizened, this Jesse is the master of occult secrets, but he is keeping them to himself. He is strong and inscrutable and he may have magic powers. The realism achieved by the woodcarver is daunting, but looking at his work we find ourselves worlds away

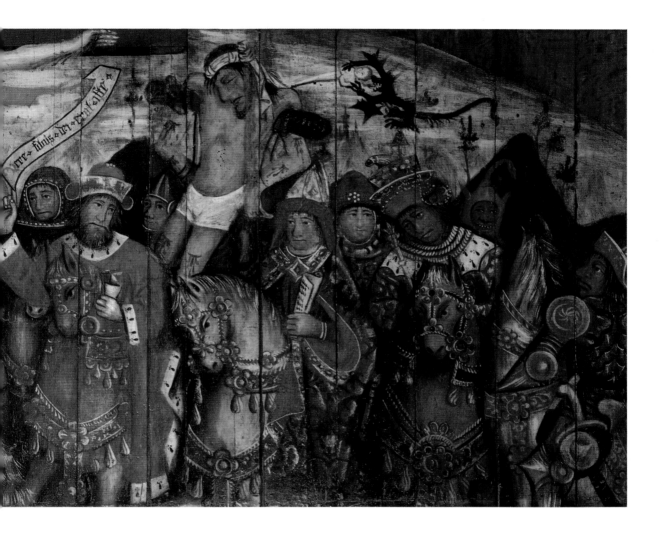

from anything as cool as observation. This sculpture belongs still to a landscape of belief where ancient rites and sacrifices, propitiatory gestures to the gods of fertility, the spirits of the forest and the field and the river, may still, in certain corners, be taking place. The Abergavenny Jesse knows the power of the old myths and fears and hopes. Once Britain had its totems and its fetishes too.

Despite the diversity of the evidence and the fact that only fragments survive, there is some consensus on at least one distinct characteristic of British art, namely its tendency to a certain excessiveness, a habit of breaking the rules, overstepping the mark and inventing curious proliferations of image irrelevant or somehow superfluous to

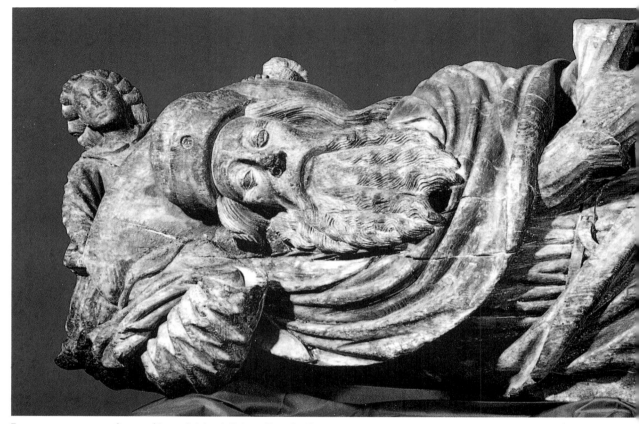

7 SCULPTOR UNKNOWN figure of Jesse, St Mary's Priory Church, Abergavenny, late 15th century.

theological doctrine. Evidence for this is to be found in the grinning gargoyles, the weird creatures that we find carved in stone capitals and in the seats of misericords. Many medieval churches still boast the odd gurning imp, or melancholy monkey with padlocked testicles. But the most conspicuous example of the tendency is to be found in East Anglian manuscript illumination, where this delight in marginalia, in art that over-spills the boundaries of decorum with its own irrepressible energy, becomes so powerful that it almost takes over the books in which it is found. The Gorleston Psalter, an early fourteenth-century illuminated book which crawls with such irreverent irrelevancies, or 'babooneries', as they came to be known, is the classic example of the genre. This inventiveness is omnipresent in British art of the Middle Ages.

The baboonery appears to have been invented in Britain, and baboonerism is indeed one of the most powerful characteristics of the British temperament. There is an uncontainability, an irrepressible, vigorous eccentricity at the heart of the national

imagination. Nikolaus Pevsner noticed it in the *Englishness of English Art,* and suggested that it explains the English fascination for genre subjects (Hogarth and Frith being his chief examples). But baboonerism is more profoundly a part of the British inheritance than that. The unruliness of the great British imaginative creations, the unwillingness of the native genius to conform to genres or conventions, is a large contribution to the culture of the West. It makes of British art and literature a series of proudly irregular, anti-academic counterblasts to the more rule-bound traditions of the classically minded cultures of the Mediterranean South.

Chaucer's *Canterbury Tales* and the plays of Shakespeare are the most powerful literary instances of the tendency, being works of art so lively, so filled with the vitality and the freedom of the untethered artistic imagination, that they overflow their own structures, unmaking the poetry of pilgrimage and the conventional dramaturgy of tragedy and comedy as they make themselves. This dangerous capacity of the British

imagination may also, at least in part, have been responsible for the vigour of the backlash against it during the Reformation.

The most stunning and extraordinary spaces made by the medieval visual imagination were the cathedrals, and they are also the places that have been most distorted and denatured by the triumph of Protestantism. Today, the cathedral towns of England tend to be rather genteel, stifling places ruled by the ethos of the tea shop. Signs inside the cathedrals themselves generally request visitors to keep their voices down. But these were once the vivid, fascinating theatres of a convulsive religion, wreathed with the smoke of incense and filled with noise and colour.

The great cathedral was a prefiguration of the City of God. It was a transcendental realm, a bridge between this world and the next, the closest thing on earth to a vision of heaven itself. Hope and joy turned into stone, it was a structure made to be visible from miles away: a ship of salvation with its steeple like a mast rising high above the thatched roofs of the town. The cathedral front with all its carvings was not the dim, faded congregation of bleached stone ghosts that we see today. Conservators have found and analysed hundreds of minute paint samples found on the stone saints, prophets, martyrs, confessors and doctors of the church on the West Front of Exeter Cathedral [8]. Once, these figures would have been decorated into subtle lifelikeness. Through a microscope it is possible to see that some of them had been painted and repainted as many as eight times during the course of the Middle Ages.

The cathedral proclaimed the message of God through almost magical enticement and consolation. Entering its doors you were meant to feel not only metaphorically but literally closer to God, in a place almost, if not quite, as grand and uplifting as the eternal jewelled city itself. On walking into the cathedral at Exeter in the fifteenth century the visitor would have been immediately struck by one of the wonders of medieval England: an enormous carved and painted wooden Christ on a huge cross, which was, we know from an entry in the cathedral's ledger book, covered in gold and silver foils. On feast and procession days choirs would have sung from concealed positions, often directly behind the images in the cathedral, so the entire building would have seemed almost literally alive. The carved and painted figures in the Minstrels' Gallery at Exeter have holes in their waists designed to be sung through, so, with their pink cheeks and living painted eyes, they would have appeared to be hymning the promise of the heavenly city. Smoke from the incense burners would have mixed with the sound of polyphonic singing. Intoxication by spectacle and music was the purpose of the cathedral. It was a place of swooning, impassioned belief, an opera or an orgy of faith encouraged by bright living images and lively sounds and smells. It was this world, full of light and colour and sound that the Reformers set out to stifle, to silence, to bleach, to smash and to whitewash.

8 The West Front, Exeter Cathedral, 1349.

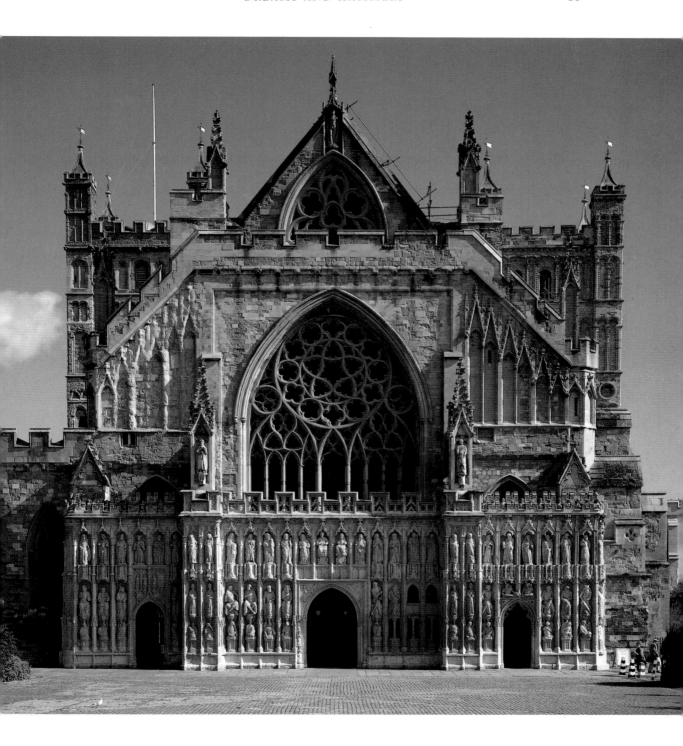

Hammers

To leave the old England of the cathedrals behind and to enter the small church of the village of Withersdale Street in Suffolk is to cross the largest ideological divide in British history. This is one of the very few places in the country where it is possible to experience the texture of the brave new world envisaged by the Reformers of British culture as they completed their tasks of destruction. There are no shrines, no lights, no altarpieces, no great carved gods of stone or wood in here. The church takes the form of an almost completely empty white cube [9].

Withersdale Street is not far from the church at Wenhaston, with its quaint painted Doom, but here we see a different kind of doom enacted: the doom of the whole world of Catholicism in Britain, after last judgement has been passed on it by the reforming Protestants of the sixteenth and seventeenth centuries. It is a place that has been purged and purified, denuded of image and relic and every last vestige of superstition. It has been stripped of everything, in fact, except the Word. To an Englishman or an Englishwoman used to the customs and appearances of the old faith, it would have once seemed almost unimaginably revolutionary: a church constructed out of the absence of all that Roman Catholic convention demanded a church contain.

The ornate space of the Catholic Church, seething with imagery, the stage-set of a theatre devised to inspire hope and terror, has been swept clear. Instead of the bright dreams of art, there are bare walls and clear windows. Instead of colour there is whiteness. Instead of the altarpiece, there is a diptych made of words and words alone, the Ten Commandments inscribed in careful cursive script on two panels of wood and placed above the simple altar in the simple, barn-like church. There is no screen covered with painted saints in here. Instead, there is that most Protestant of Protestant additions to the furniture of the church, a symbol of the new faith's emphasis on inward reflection not outward glory, and on the importance of salvation through the Word and the Word alone: a plain but bulky pulpit.

'Thou shalt not make unto thee any graven image or any likeness of any thing that is in heaven above or that is in the earth beneath, or that is in the water under the earth.' The theology that lay behind the Reformation was ancient, as old as (almost certainly even older than) Mosaic law itself. The Jews had been taught by the Old Testament to beware of veering into idolatry in the practice of their own religion, as well as to beware of whoring after the strange gods of neighbouring tribes. Art and the Judaeo-Christian religions have never had an entirely easy relationship with one another, and throughout the history of Western civilization there have always been men with hammers zealous to purify the temple, to sweep it clear of false idols.

There are many graphic descriptions of image-smashing in the Old Testament. Both Moses, the destroyer of the Golden Calf, and Josiah, the iconoclastic king of Judah, provided generations of future iconoclasts with ancient sanction for their own activities. The British iconoclasm of the sixteenth and seventeenth centuries was not a new

9 Church of St Mary Magdalene, Withersdale Street.

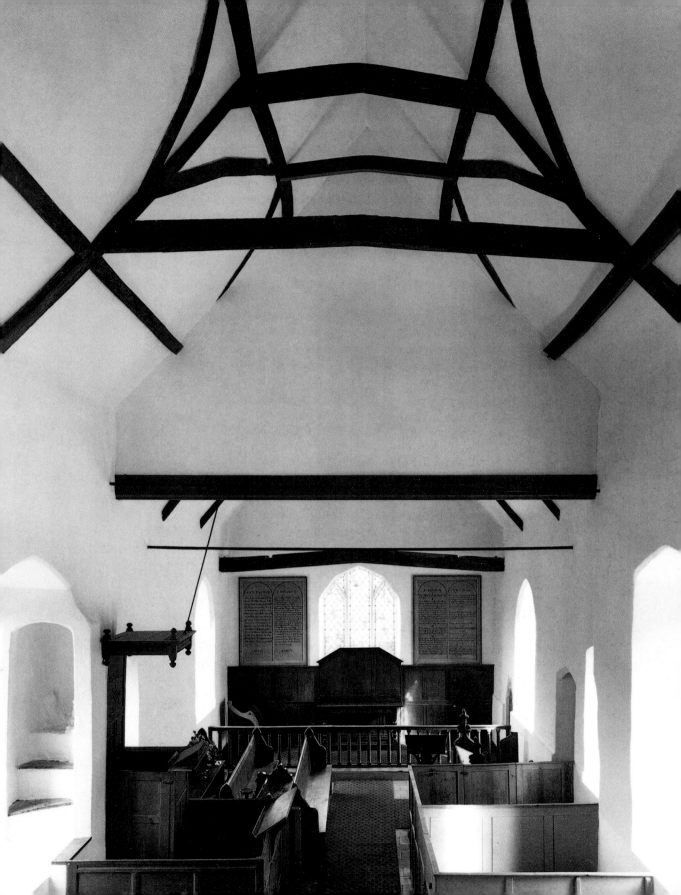

phenomenon. Iconoclasm had been widespread throughout the Byzantine Empire in the ninth century, while in England during the late fourteenth and throughout the fifteenth centuries there had been the sporadic destruction of the nonconformist Lollards. In the sixteenth century the teachings of John Calvin and Martin Luther inspired iconoclasm throughout Northern Europe, including Britain, but the fact remains that in Britain the ruination was greater than anywhere else. The blanket efficiency with which it was carried out from Land's End to John O'Groats is a tribute to the extraordinary reach of centralized church authority at the time. The end result of the destruction was as devastating as it was meant to be. Virtually all medieval art in Britain was destroyed between 1536, when Henry VIII dissolved the monasteries, and 1658, when Oliver Cromwell died, effectively bringing the long process of Reformation to a close.

In Britain, uniquely, iconoclasm was not a phenomenon restricted to the odd outburst of destruction. Iconoclasm was a tool of revolution. The smashing of images was conceived as the smashing of old, corrupt ideas about the world and about the right way to salvation. The whitewashing of paintings was thought of as a whitewashing of men's and women's minds.

It is a peculiar fact that this great project has been popularly remembered as a series of drunken interludes in the history of the nation. One-hundred-and-twenty years of zealous destruction have been written off as an embarrassing mistake, a regrettable incident. In fact, the Reformation of Britain was carried out, with great care and meticulous attention to detail, by the leaders of the Church of England and of the Church of Scotland.

Because the Church of England in particular has wanted for more than a century to disown its radical, destructive history, existing guides to its historic buildings very rarely emphasize the central role played by its most earnest and serious bishops in engineering the English cultural revolution. Oliver Cromwell's drunken revolutionary soldiers, the officially favoured scapegoats despite the tiny part which they played in the destruction of images and windows, are often blamed for the damage. 'I'm one of the ruins that Cromwell knocked about a bit', sang the popular artiste Marie Lloyd in the 1920s – equating the acts of smashing up and getting smashed, and turning the huge upheaval of the Reformation into a music-hall turn.

The Reformation was no laughing matter to those who lived through it and to those who enforced it. For Henry VIII the rejection of papal authority had merely been an act of expediency and personal calculation, a way of furthering political and dynastic ambitions. But to a new, fervent generation of radical and freethinking clerics, inspired by the teachings of John Wycliffe, Calvin and Luther, it opened a door of opportunity. It was a chance to reform and redeem what they saw as a corrupt faith and a corrupt world.

The institutionalized and systematic nature of the whole process cannot be overstressed. Under the guidance of men such as the first Archbishop of Canterbury, Thomas

Cranmer, and the bishops Hugh Latimer and Nicholas Ridley, the destruction of the Catholic faith commenced. Though instigated by Henry VIII, the process of Reform truly accelerated after the succession of his son, the young and sickly Edward VI, in 1547. Mary I briefly reintroduced Catholicism to Britain after she ascended the throne in 1553, but Elizabeth I re-established Protestantism as the state religion when she became queen in 1558, and another great wave of iconoclasm swept across the nation. In Scotland John Knox and other ringleaders of the new Protestant avant-garde ensured that the process was at least as swift, if not swifter. There was one last further iconoclastic convulsion in the seventeenth century. In the 1640s, during the English Civil War, those energetic men in dark suits, the Puritans, finished off what Henry VIII had inadvertently begun.

The idealism, the passionate desire for truth that lay behind the actions of the Reformers have been obscured – as obscured, indeed, as the passions and the ideals that lay behind the art which they so effectively destroyed. The essence of the first English Protestants' objections to images in churches was that reverence due to God and God alone was being paid to inanimate objects. Their argument with the old religion, the Roman Catholic faith, was that it confused the things of this world with the things of the next, and that it allowed too free a flow of exchange between the mundane and heavenly realms. They were disturbed by what they saw as a haemorrhaging of holiness from its proper place, heaven, so that, dispersed among the images and cult statues and shrines and relics of the Catholic world, it had become fatally diluted. For them, the image-infested groves of the Catholic Church were no better than the pagan groves of antiquity, thickly populated with heathen idols. To the Reformer, the image was quite simply a false idol, the symbol of a dark and demon-haunted pagan past which was soon to be left behind. Only the Bible, the authentic word of God, read and preached and inwardly meditated upon, could lead people to salvation.

The determination to sweep in a new world underpins the violence of the Reformers. Their vandalism was evangelism. Conviction, not stupidity, hacked away the statues in the Lady Chapel in Ely. Conviction dismembered the twelfth-century Christ that once stood in All Hallows Church, Gloucestershire and left a dismembered foot and a decapitated head, tanned with age, eyes shut and uneasy. Conviction put buckshot in the faces of the carved angels in the tie-beam roof in the church of Blythburgh in Suffolk.

In its earliest years, the Reformation was accomplished through a series of increasingly stringent statutes against images. First it was forbidden to light candles to images. Then certain images would have to be taken down. Then others. Then all. The process was gradual but inexorable and it was also, on many occasions, spectacular. The earliest church leaders of the iconoclastic movement favoured mass incinerations, public bonfires of suspect images which were the forerunners of the much later public book-burnings of the Nazis in the early 1930s. The horror of twentieth-century Britons at such activities was touched by amnesia: burnings of far greater efficiency had been carried out in Britain almost four centuries earlier.

In Smithfield in London during the late 1530s Latimer staged several 'jolly musters', as he called them, having his agents gather hundreds of wooden figures of Christ, the Virgin Mary, the saints and the prophets from all over the country, then piling them high and torching them. These were, importantly, visual demonstrations. The Reformers were visually astute men with distinct if extreme aesthetic preferences. They hated the corrupt, sensual, vividly animate beauty of the image, and they loved the impersonal, purifying beauty of fire. But still, you sense when reading even the most dispassionate eyewitness accounts of the time, each of the first great acts of destruction was followed by a pause, a tiny silence, as the hammer blows echoed away and the flames died down to embers. There must have been a little hesitation, a moment of uncertainty, as those assembled waited to see if God would show his displeasure. Each time he did not, the Protestants grew in confidence.

The fear that lay behind much Reformation activity was fear of one of the primal powers of art: the ability of the image to seem as real as a real person, to come to life, and not only become an object of worship in its own right, but perhaps do evil to those who oppose it. This fear of the dangerous, potentially animate qualities of art may be detected in the methods of the destroyers. Defaced images often had their eyes scratched away, as though, by breaking visual contact between image and viewer, the suspect power of the image might be defused. The potent realism and the beguiling presence of the most affecting art of the pre-Reformation period may partly explain the violence of the reaction against it. Destruction can be seen as a kind of back-handed compliment. To deface or smash an image is to acknowledge its power.

The idealistic Protestants saw their destruction as a means of disproving the power of images and loosening the chains of superstitious belief which they felt had tightened around the minds of the laity. During the most extreme phase of the Reformation, the Puritan moment of the 1640s, the abolition of Christmas and the destruction of Stonehenge were temporarily discussed as ways of furthering the cause. The pagan festival and the pagan stone circle were to be done away with because, just like the images of the Catholic faith, they were part of the dangerous, misleading, ancient superstitious history of the nation, a history that needed to be unwritten.

But there was, also, much resistance to the Reformation throughout the long century of destructions. There are many stories of doors locked against the destroyers, of bands of devout Catholic women barring the entrances to their churches, of treasured images being hidden or buried against the day when the Catholic faith might, just might, return. The imagery that does survive, in the churches and museums of Britain and elsewhere, was almost invariably saved by such acts of conscientious objection to the iconoclasts. Among the most remarkable is a stone Tree of Jesse, carved sometime in the 1470s, which was hacked to pieces by the Reformers in the 1560s [10]. The pieces were swept up by an anonymous sympathizer in the hope that, one day, someone might attempt the jigsaw puzzle which would restore them to their former glory. Their original colouring is remarkably intact, and it enhances the pathos of these vibrantly alive heads

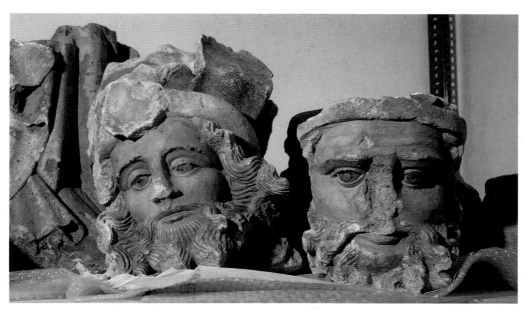

10 SCULPTOR UNKNOWN remains of a Tree of Jesse, St Cuthbert's Church, Wells, 1470s.

of stone. They still await restoration and are still almost unknown, these English prophets with their faces of Hellenistic dignity. The unexhibited and apparently unwanted property of the Church of England, they have long been kept in several old wooden vegetable crates marked, inaptly, 'They're fresh, they're British'.

In other paradoxical cases it seems that Catholic recusants ensured the survival of images by defacing them, but just a little. The half-hearted act of iconoclasm, the act of going through the motions of Reform by tamely scratching out part of the figure but leaving the rest intact and reparable, proved among the most effective methods of resistance. In many cases it is impossible to distinguish between failed iconoclasm and deliberate partial defacement.

Even the annals of the final, Puritan phase of Reform, the last mopping up operation of English iconoclasm, are full of stories of local resistance to the visitations of the destroyers. A high window or a carving out of reach often survives because, when the Reformers came to visit, all the ladders in the parish suddenly and mysteriously went missing. The parishioners of Ufford in Suffolk saved the great wooden font-cover in their church by the simple expedient of pretending to lose the key to the church door when the Church's agent charged with its destruction arrived in the village. He left, cursing, vowing to return, but somehow never got around to it. But although the process of Reform was resisted, the logic and the vigour that lay behind it proved ultimately irresistible and the man locked out at Ufford was to have the last laugh.

His name was William Dowsing and he was one of the most vigorous of the last English iconoclasts. A man with a pickaxe in one hand and a pen in the other, he kept a tally of his destructions as he went along. Dowsing's record of his image-smashing activities in Suffolk in the early 1640s is the baldest and also the most haunting account of the progress of the iconoclastic movement. His diary is the record of a vanishing, a curt tale in which, behind the proud officious enumeration of tasks accomplished, we can hear tearing and smashing and can see the fabric of medieval culture going, going, gone under the hammer of a new faith.

Dowsing, rapacious devourer of art and enumerator of his own conquests, was both the Don Giovanni and the Leporello of the English Reformation. He was particularly active in January 1643. He wrote:

Suffolk, at Haver ... We broke down about an hundred superstitious pictures; and seven fryars hugging a nunn; and the picture of God and Christ; and diverse others very superstitious; and 200 had been broke down before I came.

Sudbury, Suffolk. Peter's Parish ... We brake down a picture of God the Father, 2 crucifixes, and pictures of Christ, about an hundred in all; and gave order to take down a cross off the steeple; and diverse angels, 20 at least, on the roof of the church.

At Clare ... we brake down 1000 pictures superstitious; I brake down 200; 3 of God the Father, and 3 of Christ, and the Holy Lamb, and 3 of the Holy Ghost like a dove with wings; and the 12 Apostles were carved in wood, on the top of the roof, which we gave order to take down; and 20 cherubins to be taken down; and the sun and the moon in the east window, by the King's arms, to be taken down.

The Protestant protests against the old and he announces the new, and a vital part of that protest is physical. The hammer is the tool that the Protestant uses to shake the Catholic out of his long, bad dream of false images, and make him see the light. The artificial sun and moon, images created by men, must go. Once the stained glass has been removed, the real sun streams in through pure, clear glass.

The white cube of the church at Withersdale Street was a long and painful time in the making. To visit it is to see and to feel the complete triumph of the Reformation and perhaps to begin to grasp its significance, often misunderstood, in the story of art. It is often said that the Reformation marked the moment when the British ceased to be visually aware, when they became a nation of vandals and visual philistines. But the church at Withersdale Street exposes that assertion as a lie or at least a profound mistake. Withersdale Street may be a place built on the rejection of imagery. It may be a place from which painting and carving have been studiously excluded. It may be a place

where the Word, shining and naked in the bright light of truth, rules undisputed. But it is also beautiful, the conscious and vital expression of an aesthetic sensibility. Though it represents the purgation and the shattering of the old Catholic dream, it is itself a profound instance of visual dreaming.

Withersdale Street is the most radical dream of the Reforming temperament turned into a building. It is the dream of a brave new world, swept clear of what John Milton called Catholicism's 'deluge of ceremonies' and as virgin as the world which Noah contemplated after the flood had receded. White, the colour of the whitewash with which the Reformers had obliterated the brightly coloured images of the Catholic past, is also the colour of snow which, falling on the world, whitens it to a state of primal purity and makes of it a *tabula rasa*. At Withersdale Street, for the first time, it becomes possible to talk of an aesthetics of anti-art, a prescient aesthetics of abstract suggestion.

In retrospect, it is possible to read many forms of idealism into the whiteness of Withersdale Street and to see how the whiteness of Protestant Reform and the fresh start which it symbolized was not only a religious fresh start, but also a secular one, full of secular possibilities. The Protestant faith was a faith which encouraged and empowered ordinary people, which taught them to read and to think for themselves. The whiteness of Withersdale Street is a democratic whiteness. The Protestant faith was a faith which enjoined reflection and introspection. The whiteness of Withersdale Street is a reflective whiteness, the whiteness of inward thought. The Protestant faith was a rational faith, a faith built on the killing of old superstitions and on the death of magic. The whiteness of Withersdale Street is a rational whiteness which would eventually become the whiteness of scientific enquiry, of the hospital and the anatomy theatre. The Protestant faith was a questioning faith, an avant-garde faith. The whiteness of Withersdale Street is questioning and avant-garde. It is a dangerous, unpredictable whiteness, meant to praise God but one which may end by prompting questions about his very existence. The interior of the simple Protestant church is the most adventurous space ever made in Britain.

The Future that Never Was

British culture was formed from the violent collision of two extremes: a superstitious faith and its radical rational rebuttal. But after the long battle of the Reformation had subsided, the British became extremely suspicious of extremes. As a consequence they refused to push either of the two aspects of the national temper to its logical conclusion. The history of art in post-Reformation Britain is a model of that process. In some respects it is best understood as a history of two things that never happened.

The Reformation decisively severed Britain's links with Continental Europe. Before the Reformation, the British were vigorous participants in a pan-European Catholic culture which stretched from Dunfermline to Beirut. After the Reformation, the British

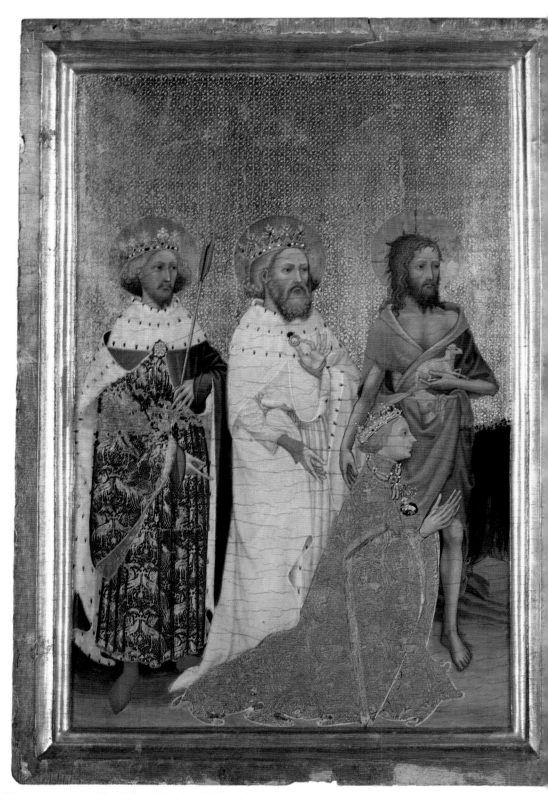

11 ARTIST UNKNOWN The *Wilton Diptych,* c.1395−9.

were the embattled inhabitants of a Protestant nation, cut off from and at perpetual
odds with the Catholic peoples of mainland Europe. Britain had become an island
mentally and emotionally as well as geographically. What this meant in art was that
British painting and sculpture were suddenly cut off from the Catholic traditions of
figurative art which had nourished them for centuries.

In the Renaissance wing of the National Gallery in London there hangs a beautiful
devotional painting called the *Wilton Diptych* [11] and it contains the most beautiful
dream of heaven to survive in all British art: a paradise garden thick with fat, bright
blossoms, occupied by a lethargic, almond-eyed Virgin and crowded round with long-
necked, sleepy angels with flowers in their golden hair. The *Wilton Diptych* hangs among
Sienese paintings of the fourteenth and fifteenth centuries and it is the only British
painting in this section. Walking through the rest of the museum, the visitor passes all
that never took place in British art. There was to be no British Titian, no Tintoretto, no
Raphael, no Michelangelo, no Caravaggio, no Velázquez.

But, having cut themselves off from their past and from mainland Europe, and
having invented a bright and radical alternative to the West's traditions of religious
painting and sculpture, the British proceeded to turn their backs, also, on their own
dangerous radicalism (at least in art). The avant-gardism and purity of Withersdale
Street's aesthetics, the aesthetics of the white cube, would be shunned in Britain. But
they would be developed and pushed into a national style of art in another place and in
another time by another English-speaking people

The United States was the nation eventually produced by the failure of the Puritan
moment in England. The Puritan dream of a fresh start, of a new society free from the
corruptions of the past, emigrated from Britain with the Pilgrim Fathers when they
crossed the Atlantic to build their Brave New World. More than three centuries later, the
United States' extreme, radical origins were rediscovered and celebrated by American
artists. In the art of the New York School and their followers, between the end of the
Second World War and the early 1970s, we see the final destination of an aesthetic first
pioneered by radical clerics working in sixteenth- and seventeenth-century England.

The pattern is not hard to detect. In Britain during the Reformation Catholic art,
vividly animate, figurative art, was challenged by the beliefs of purifying Reforming
zealots. They argued that the supernatural can never be made manifest in the likeness
of a figure and that to do so is to set up dangerous false idols in the temple of the true
faith. They smashed and destroyed figurative images. They developed a new aesthetic of
purified whiteness, of spiritually charged blank surfaces and vacuums redolent with
meaning. They created a white cube. They then embellished that empty space with words.

In post-war New York a group of American artists turned their back on figurative art
and produced paintings which depict large, spreading voids: glimmering emptinesses
for which the highest transcendental claims were made. There was a recognition of the
link between their aesthetic radicalism and a much older religious radicalism – albeit
perhaps only a semi-conscious one – in the titles given to the paintings by artists such as

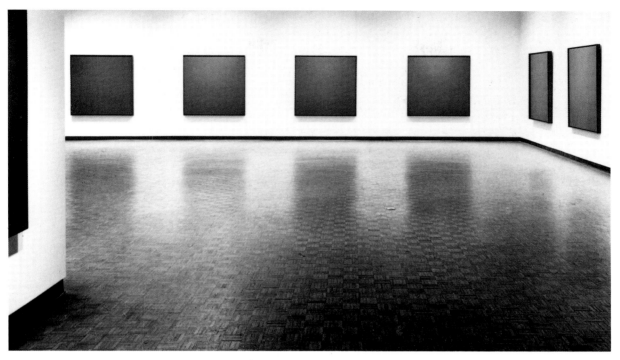

12 Ad Reinhardt room, Jewish Museum, New York, 1967.

Barnett Newman: *Onement, Abraham, Genesis.* It seems eccentric to think of paintings like Newman's, or those of his contemporaries, Mark Rothko, or Ad Reinhardt [12] as modern art, because they are so deeply nostalgic for the seventeenth century and for the fiercely anti-image Mosaic law which had so inspired the early Protestants. Perhaps it is no accident that many of these painters were Americans of Jewish descent: men who would, as Jews, have been very aware of the links between this aspect of aniconic Judaic culture and a Protestant aesthetic of significant blankness.

Their works were to be followed by still more purged and empty canvases: pure black canvases, pure white canvases, fields of visionary emptiness. These objects were exhibited almost invariably inside a pure white cube. Then, finally, American artists invented Conceptual Art, Word Art . The pure white cube was embellished with text.

American artists have a greater sense of history than they are generally credited with. When Lawrence Weiner began to show his simple texts stencilled on to gallery walls in the early 1970s his work was hailed as the last word in late modernism. In fact it is nothing of the kind. It is really just the Ten Commandments, up on the church wall, all over again; the return of an old, old simplicity. Carl Andre, the Minimal sculptor, was almost the only American artist to acknowledge explicitly the links between American

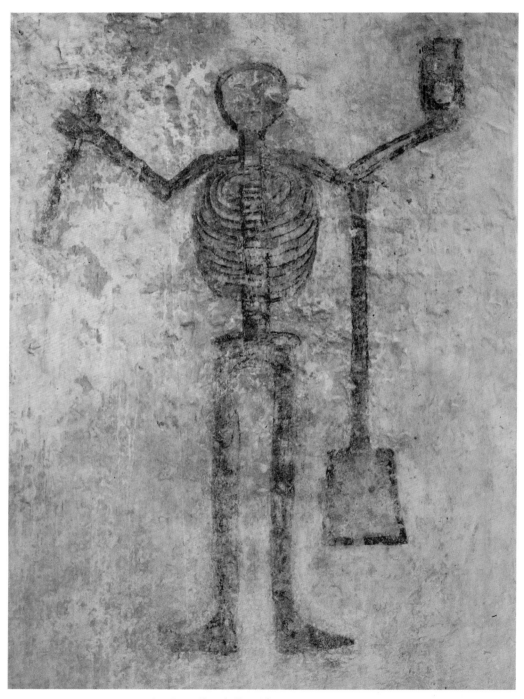

13 ARTIST UNKNOWN *Time,* Merthyr Issui Church, Partrishow.

art and the aesthetics of the British Reformation. His mute rows of bricks, laid out on the gallery floor, were inspired, he once said, by the empty plinths he had seen in English churches on his holidays. In the American art gallery of the 1960s and 1970s, as Andre recognized, we may see an almost uncannily perfect image of the Reformed church. This was the radical space of Protestant theology remade in secular art of the twentieth century, the culmination of a British aesthetic, abandoned by the British themselves, achieved in a pure space where whiteness and the Word ruled triumphant.

The history of British art was not to follow the European nor the American course. Its route would be more troubled, more circuitous, more devious. Its route would lie between extremes, not in the exploration of them. Its route would lie between Scylla and Charybdis, between the dream and the hammer, between a desire for the future and an inability to forget the past. The model for its difficult future, after the Reformation, is to be found in another place.

Partrishow

The church of Merthyr Issui at Partrishow lies to the south of the Black Mountains in south-east Wales. It is a very quiet place. Standing in the churchyard, the visitor looks right across one of the greenest valleys in the world and feels miles from anywhere. A hundred yards below, where a narrow road twists one last time before beginning its ascent to the church, there is the well where a local hermit and martyr, St Issui, once preached. It is said that a wealthy man who drank from the waters of St Issui sometime in the eleventh century was cured from leprosy here and that it was he who paid for the building of the church as a gesture of superstitious gratitude.

Inside, the hermit's church has been Reformed, gently and not entirely successfully. The simple carpentry of its round-vaulted ceiling, unadorned by the paintings that once were to be seen there, is a beautiful sight. The church retains its rood screen, which has been elaborately carved with nuts and berries and leaves: a hymn to the fertility of the world in Irish oak. The images that once stood on top of it have gone, the walls have been whitewashed and the church has been decorated with religious texts written in a careful, looping hand.

The new world of the Reformation has almost pushed the old world of the Middle Ages aside here, but only almost. Behind the pews, at the backs of the congregation, there is an ancient figure painted in ox blood which has rotted through the whitewash of Reformation [13]. It is a figure of Time, a skeleton armed with a scythe, hourglass and spade. It has the arresting quality of a cave-painting or a picture of the worst fear painted by a small child. Once seen, this ghoul from the past is not easily forgotten.

Some conflicts are never resolved and the Reformation is one of them. No matter how many layers of white paint are applied, the image always finds a way of coming back to haunt the British imagination.

TWO

NORTH
AND SOUTH

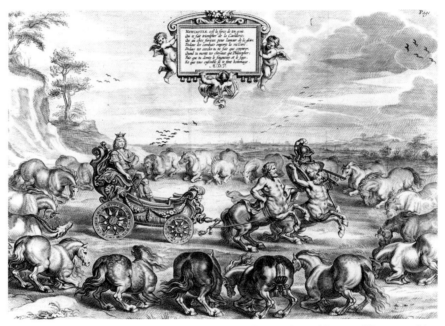

14 ARTIST UNKNOWN seventeenth-century engraving from *A General System of Horsemanship* by William, Duke of Newcastle.

... the King's majesty and the rest of the masquers were
discovered sitting in the Throne of Honour, his majesty
highest in a seat of gold and the rest of the lords about him ...
The habit of his majesty and the masquers was of watchet,
richly embroidered set up of white; their caps silver
with scrolls of gold and plumes of white feathers.

Description of Charles I and his entourage playing
their parts in the Court masque, *Salmacida Spolia,*
designed by Inigo Jones and performed on 21 January 1640.

... paint my picture truly like me and not flatter me
at all but remark all these ruffness, pimples, warts
and everything ...

Oliver Cromwell's directions to his painter,
about 1650.

The Safe Havens of the Imagination

What happens to the imagination in a society that distrusts images? What do artists do when their work has been outlawed? In the immediate aftermath of the Reformation painters and sculptors became refugees. Their main employer, the Church, had dispensed with their services and their visions of dread and consolation had been exorcized. Now they would have to put the imagination to other uses and find other places in which to express it. They would have to adapt to new circumstances and find new opportunities if their skills and their capacity for dreaming were to persist. Looking at British art of this period is like watching a house at night. Lights go out in some rooms and come on in others, sometimes where you least expect them.

Although artistic opportunities were limited, there were some, above all in England, where the secular spaces of the Elizabethan world became the safe havens of the visual imagination. The result was a brief but extraordinary blooming of fantasy in the second half of the sixteenth century.

The most haunting architectural relics of the time are the great houses built by Elizabeth's courtiers. They built them to proclaim their own everlasting glory and also, with politic caution, to receive and honour the hard-faced queen who ruled over them, should she happen to pay a visit on one of her annual tours of the nation. They have been called prodigy houses and the name is apt. Among the most prodigious places in England, they are unique, creations in stone and glass entirely unlike buildings made in any other time and place.

A kind of wildness has crystallized into architecture at Burghley House, Hardwick Hall, Longleat and Wollaton Hall. These are houses that do not feel designed by an architect so much as conjured up, in a puff of smoke, by a genie in a bottle. They seem extravagant partly because of their proliferation of decorative detail, which lends them a powerful quality of excessiveness, combined with stony restraint. They are chilly and decadent. Their combination of large scale and filigree intricacy is also partly responsible for their overwhelming strangeness, the way they disorient the senses and haunt the mind. They are huge, but also so finely worked that they have the character of very small, precious possessions: ornate boxes, like jewel caskets which miraculously have been made large enough to inhabit. They are not houses so much as objects of art.

On the rooftop at Burghley House in Cambridgeshire, designed and built by the queen's principal adviser, Sir William Cecil, tall chimneys sprout in superabundance [15]. Here, architecture has exquisitely metamorphosed into sculpture. A universe of besetting strangeness has been carved from stone with a jewel-cutter's delicacy. Some parts of the roof have been embellished with miniature pyramids, others with balls of fire made from stone spheres, spiked with curling flames of metal that have been polished to catch the sun's rays. The chimneys are capped by many tiny carved stone castles in the air, which symbolize the imaginary nature of the whole enterprise. This is one of the world's masterpieces of unfunctional building. Seen close to, the chimneys at

Burghley are like chess pieces arranged in an obscure but purposeful configuration. Seen from a distance, they rise like the minarets and towers of the East. To look up at the roof from the deer park that now surrounds the house is to see its true strangeness most clearly. A vision of Cairo, miracled in yellow stone, rises out of a verdant English landscape of smooth lawns and spreading oaks.

The most haunting of all the Elizabethan prodigy houses, perched on the very top of the windiest hill in Derbyshire, is Hardwick Hall. Built for the Countess of Shrewsbury by the architect Robert Smythson, its splendour is genuinely awe-inspiring. It is a place where supernatural events suddenly become easier to believe in. The house itself has the character of a hallucination, especially at twilight or night-time when the great uneven leaded-glass windows reflect the fading light of sunset, or the rising moon, with a twinkling, mirage-like quality.

There have understandably been many sightings of ghosts at Hardwick and the house itself feels as though it may be a spectre too. It has about it the atmosphere of a place that could dematerialize on one particularly haunted night. Even the trees in the garden, bent double by the wind that sweeps in relentlessly from the cold north, are disconcerted by their proximity to it, sighing and moaning continually. In winter wind-blown rain hits the windows at an almost horizontal angle and finds its way in through interstices in the leading, producing sudden fizzing, impish showers inside the house. There may be castles in the air on the roof at Burghley, but Hardwick is itself a castle in the air, sitting in eccentric dominion over the freezing heights of the valley which it commands. Only in a culture with something obsessive and maniacal at its heart could such a strange, intimidating folly have been built.

The Elizabethan house often seems overburdened by a powerful sense of the imaginary which it cannot quite contain, but its very excessiveness is one of the keys to its significance. The prodigy house was one of the very few places where the British visual imagination could express itself after the abolition of art in churches. Its fullness, its wildness, its haunting, haunted, magical character was made possible by a great transmigration of energies and skills. The Reformation had produced a huge unemployed workforce of carvers, painters, glaziers and illuminators, and it had turned a world full of colour and incantatory vision into a void. At Hardwick, the most complete of all surviving Elizabethan prodigy houses, it is as if an entire culture possessed by images and the imagination has been squeezed into the compass of a domestic dwelling.

Inside, the house has some of the qualities of a medieval church. The artists and craftsmen who worked here were so used to thinking in religious terms that the influence was bound to show in their secular work. The massy stone steps leading up to the Great High Chamber have the venerable heaviness of cathedral stairs. The Long Gallery, filled with portraits of ancestors and culminating at the far end in a grand state portrait of the queen, takes such reminiscence to the point of mild sacrilege. It is a processional space, like the nave of a church, but substituting images of ancestors for those of the saints in side chapels, and the image of the queen for that of the Saviour.

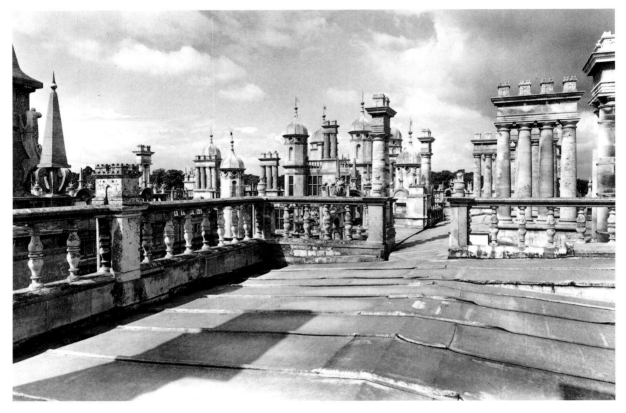

15 SIR WILLIAM CECIL Burghley House, rooftop and chimneys, 1587.

The Elizabethan moment has not been valued very highly by historians of art. This is largely because of the strength of the received idea that the Italian High Renaissance is the standard against which all sixteenth-century painting, sculpture and architecture should be measured. But a large part of the strangeness and enchantment of the visions produced in Elizabethan England derives from the fact that such standards simply cannot be applied to them.

The Elizabethans were uninterested in naturalism and indifferent to the illusionistic device of perspective. Their art was incomparably harder and more angular than the art of Florence or Rome or Venice, and it deliberately looked backwards in time in its resolutely, stiff, intricately coded character. But it was a style that could lead to abandon as well as constraint. English art's view of space remained ignorant of the potential but also free of the limitations of one-eyed, vanishing-point Renaissance perspective. The art of the Elizabethan period is often irrationally thronged with image and incident, inconceivable in the more deliberately constructed spaces of High Renaissance art.

The carved and painted frieze that runs around the upper level of the High Chamber at Hardwick is a beautiful demonstration of this [16]. Made by the little-known artist Abraham Smith, its subject is Diana the huntress. It is an allegory. The hunt is a symbol of the true heart's search for virtue, and the goddess of the hunt, the virginal Diana, is here a flattering allusion to Elizabeth I, the Virgin Queen of England. But the symbolism of the work is less memorable than its easy imagining of a world suspended between reality and myth. This painted forest is the forest of Edmund Spenser's fantastical and recalcitrant Elizabethan allegorical romance, *The Faerie Queene,* made visible. Spenser's allegory branched out so far beyond his original purpose, the praise of Elizabeth I, that he was eventually forced to abandon it and leave it as a wondrous curiosity, vivid and alive but ambiguous in its meanings.

The Hardwick frieze, likewise, was planned as an allegory in praise of the queen but has turned, in the process of its making, into something altogether stranger and more beguiling than that. It is a vision of the cornucopian wonder of the world, containing exotic monkeys probably drawn from life, and miniature elephants almost certainly not, as well as thoroughly English deer and a few carefree examples of that purely mythological creature, the unicorn. This is the wilder strain of Elizabethan imagining made manifest in a work of painted sculpture. The Hardwick frieze was based on a series of engravings after the Flemish artist Martin de Vos, but it departs far from its original source. It has the same romantic quality of a dream made real as the rooftop of Burghley and, like Burghley, it feels strongly touched by the spirit of the East. The figure of Diana is not at all a Greek or Roman goddess but part Buddha, part Shiva.

A series of tapestries made by the Sheldon workshop, in the early seventeenth century, is a later but still vivid example of the survival of medieval picturing practices in England. Entitled the *Four Seasons,* the tapestries exhibit an old and blatant form of English anarchy in their filled-to-bursting compositions. The unruly spirit of babooneries, those lively incidental details in English illuminated manuscripts, has here migrated into secular tapestry. A pig is stuck while a village burns down while crops are gathered in while a fox chases a hen while a pair of lovers lie together under a hedge. Their richness is the old richness of an art that dares to fill its imagined worlds with hordes of irrelevant detail. These woven images might not represent the world with the sophistication of Italian Renaissance art, but their disorderliness contains a kind of truth, aspiring to match the plenitude of creation. They are not progressive works of art but they are matchless.

The greatest example of this migration of skills took place in literature. It is often said that this was the time when the English finally showed that they were happier with words than images. But that assertion is only partly true. After the Reformation words did not replace images, they *incorporated* them in a different way. Language was used to summon up all the pictures that had been destroyed. This can be seen in the rich imagistic prose of the English translations of the Bible from this period, but above all in the poetry of William Shakespeare. Shakespeare, the giant of English literature, also has a

16 ABRAHAM SMITH *Diana the Huntress* (detail), late 16th century.

place in the history of British art because for him language was, fundamentally, a visual medium.

His first instinct was to show, rather than to tell, and he treated words as if they were lines and colours to shape the visions that crowded in on him. Leonardo da Vinci advised artists to study the shapes made by clouds. Shakespeare may have been acting on his advice when he wrote the tremendous speech in *Antony and Cleopatra* in which the hero sees his own changeable character in the boiling skies of Egypt:

> Sometime we see a cloud that's dragonish;
> A vapour sometime like a bear, or lion,
> A tower'd citadel, a pendent rock,
> A forked mountain, or blue promontory
> With trees upon't that nod unto the world
> And mock our eyes with air.

Having compared his life to the fickle pictures painted by a cloud, Antony then sees his imminent death as a whitewashing of them. To die is to become a blank canvas, a white sky, completely empty. This is a powerful and poignant way to describe the death of a man, but it can also be read as a metaphor for the whitewashing of England. The speech is dense with picture and Shakespeare has stretched conventional grammar to the point where connective speech has become as summary and fluid as the skein of brushstrokes in an oil sketch. He often twisted language, distorting it to his own purposes. He did so almost always in order to cram more images together and thereby bring a world more vividly before the mind's eye. This is why reading or listening to his words can so easily feel like undergoing a form of possession.

The fact that Shakespeare was born into a post-Reformation world may partly explain the intensity and the beauty of the images he created in the free space of a secular theatre. He was writing for an audience with a great hunger for the visual, a people who had lost almost all other images in their lives. But if Shakespeare at the Globe could count himself king of infinite space, conventional painters were bound within the nutshell of the English Court. They were obliged to work to the demands of a nervous and self-conscious elite.

The most gifted of Elizabethan painters, Nicholas Hilliard and Isaac Oliver, specialized in painting pictures on pieces of vellum as small as a baby's hand. The Elizabethan miniature epitomizes the small and guarded world of English painting in the aftermath of Reformation. Hilliard and Oliver painted Elizabeth's courtiers circling their Virgin Queen in all their peacock finery, every last detail traced with the finest of squirrel-hair brushes. The dress, pose and setting of the pictures were devised to pay the Virgin Queen allegorical homage. The lances and shields that the courtiers sometimes carry and the symbols with which their costumes are emblazoned are the chivalric emblems of their fealty. They appear as valiant knights in armour, as proud suitors, their necks encircled

by huge ruffs, or as fantastically garbed languishing lovers. There is something tense and nervous about them too, however, and behind the overdressed facade there lurks perhaps the consciousness that they are playing an elaborate courtly game on which their lives may depend.

The most memorable of these images are the most deceptive: Hilliard's *Young Man Amongst Roses* and Oliver's *A Man Against a Background of Flames* [17]. It is easy to romanticize these painted lovers, to see them as yearning, impassioned men of feeling, but they are actually men engaged in very formal, inscrutable displays of affection. Court etiquette demanded that all male courtiers be infatuated, officially at least, with Queen Elizabeth herself. These miniatures, like the cool Elizabethan love sonnets of Sir Philip Sidney, exhibit not the unleashing of love but its disciplining and subordination: love's control for political ends. The sonnet confines a feeling within the unalterable shape of a fourteen-line poem written in iambic pentameters, and releases that feeling back into the world governed and formalized. So, in their own way, do Elizabethan miniatures by projecting the image of a feeling controlled totally by convention and directed to the ideal lover. In Hilliard's miniature, a young man is twined about with the five-petalled eglantine roses that were one of Elizabeth I's many symbols of virginity. Oliver's young man is, likewise, dutifully exhibiting his love for his Queen. 'How I burn, my lady', says the lover consumed by the flames of passion. But look into his eyes and you see a cold, unyielding pragmatism.

Elizabethan painting is made of codes and puzzles and its gleam is the unfriendly light of calculation. Its inscrutable spirit is the spirit of Elizabeth herself, and her canniness and cold-blooded political flair are perfectly reflected in the hard, enamelled surfaces of Elizabethan state portraits. These works of art are unique and exotic fabrications that have no counterpart elsewhere in European painting: portraits so densely packed with symbolic attributes and so removed from reality that they are not really portraits in the conventional sense at all.

Apply the standards of naturalism to the *Ditchley Portrait,* in which we see Elizabeth's feet firmly planted on a map of England, and the painting is an absurdity. The nation is looking up her dress. But she is immune to literal-minded irreverence of that kind: a poised and reserved giantess, she is literally on top of her world. She even controls the weather, dispelling storms and bringing sunshine.

The *Armada Portrait* celebrates Elizabeth's most famous victory with a fine disregard for the conventions of time and space. The painting memorializes the defeat of the Spanish Armada which was sent against England by Philip II of Spain in 1588. We find Elizabeth standing in the centre of the painting with her right hand resting on a globe. In the background two events are impossibly taking place at the same time: to the left of the queen the Spanish Armada advances on a clear and golden sea; to the right the Armada founders in defeat in the English Channel. Elizabeth is seen as the great Protestant monarch of an endangered Protestant nation. Embattled but victorious, she has held the forces of the Catholic antichrist at bay.

17 ISAAC OLIVER *A Man Against a Background of Flames,* 16th century.

The Rainbow Portrait [**18**] is the most brilliant portrait of England's most intimidating queen and the masterpiece of Elizabethan painting. Elizabeth has had herself painted as the Sun, the unmoved mover and centre of her universe. She is a cold, cold star, athough not unalluring because she combines frigidity with eros. Behind the glittering image of Elizabeth there always lurks the hard knowledge of hard realities and the sense of great forces held at bay. Elizabeth was Henry VIII's daughter and she inherited the Reformation that he had begun. The rainbow that she holds symbolizes the fact that she has brought peace to schismatic England. The emblems on her sleeve may be the most apt of all her attributes, however. The snake, wisdom, with a heart dangling from its mouth, announces that the queen's head rules her feelings.

In all her portraits Elizabeth's face is like a cosmetic mask. She rigorously controlled her own image and no paintings or drawings of her could be circulated without her prior permission. This censorship explains why in so many images she appears frozen at the same age. In paintings made late in her reign she seems as brittle as a china doll and almost as artificial. These pictures were stilled and stifled by the requirements of *Realpolitik* and the Elizabethan cult of sovereignty. Elizabeth had ascended the throne in the middle of a tumultuous period in English history, and she was the unmarried queen

18 ISAAC OLIVER *Elizabeth I: The Rainbow Portrait,* c.1600–1603.

SINE SOLE
RIS.

of a country that was isolated from a predominantly Catholic Europe. The unique difficulties of her reign partly account for the ingenious strangeness of the art it produced.

There is almost no room in Elizabethan state portraits for the play of imagination. The last, ossified productions of a certain kind of painting in England, they have much in common with medieval art. They are bright in colour and crawl with intricate codes and symbols, consciously recalling the images of the saints that had once filled the churches of England. They are pictures of a virgin queen that appropriate both the appearance and the iconography of a far older tradition of paintings of the Virgin Mary. But they were to lead nowhere. They were a last gasp in an airless room.

Elizabethan England was as uniquely and self-consciously English as any of the Englands that there have ever been. But it left little impact on the visual arts, other than to haunt the minds of those who came after with the oddity of a brilliant cul-de-sac. This makes it something of a paradox, although a very English one: a false start, a potential centre that became a margin instead. Certain visual skills and energies may have survived during this time, by migrating to the new and unfamiliar territories afforded by the secular world. But they did not survive beyond this moment. The Elizabethan age was a curious, rich, confusing, limbo-like interlude. There would be no more houses like Hardwick or Burghley. There would be no more portraits like the ornate, arcane, weird portraits of Elizabeth. A civilization that arrived as suddenly as a puff of smoke, the movements of which were as fast and puzzling as those of a cloud, also disappeared with the speed of one scudding across the sky.

In the case of painting and sculpture this is perhaps not so hard to understand. The whole of Britain was in the throes of the Reformation throughout the Elizabethan period, and this would continue for more than half a century after Elizabeth's death. Artists continued to be regarded as no more than craftsmen. The structure of the many and various local communities which constituted Britain at the time did not allow for the formation of artists' academies and workshops of the kind which, most notably in the Italian states, raised the social standing of the painter and sculptor.

Throughout Elizabeth's reign images were still being taken out of churches, were being burnt and smashed. For more than 120 years, stretching from the reign of Henry VIII to that of Charles I and into the Protectorate of Oliver Cromwell, the very calling of the visual artist was being continually challenged and undermined. So, although some painters might have survived as refugees they were embattled and, eventually, completely demoralized. The miniature and the state portraiture of Elizabeth's time demonstrate that their skills at least were intact. But their morale was fading fast. This explains why native British artists, during the long and critical years of the Reformation, had so little influence on the destiny of British art.

It took two foreigners to repair the wreckage of the British visual tradition and to lay the foundations of a recognizably British way of making and thinking about painting. They both worked for the English Court, but they were separated by nearly 100 years and by huge differences in temperament and approach.

The Foreignness of British Art

One day in 1527, in a quiet, well lit room in a house in London, a lady in a white fur hat sat for her portrait. Contact between painter and sitter was probably restricted to the exchange of glances. He may have occasionally asked her to move her head or her hands, but the main sound in the room was probably that of his physical activity: the scratch of chalk or the whisper of his fingers rubbing the surface of the image to establish tone.

The drawing made that day has not survived but the painting for which it was the essential preparatory work has and it now hangs in the National Gallery in London. Certain details were added by the painter after the initial sitting: a blue background on which has been inscribed a delicate, almost abstract tracery of vine leaves and tendrils; the squirrel which the lady holds; the starling perched on a branch next to her. The animals and vegetation in the picture may once have had some heraldic or other symbolic meaning. But this has been forgotten and we know nothing about this woman except that she was a lady living in London at the time of Henry VIII. She has become simply Hans Holbein's *Lady with a Squirrel and a Starling* [19]. It is one of the ironies of history that the painter's aristocratic subject should have become anonymous, her distinction subsumed within the fame of her former employee.

The picture's strength lies in its dedication to a particular ideal of truthfulness. It is not one of those paintings of a person which encourage you to admire the artist's inventiveness, his flattering transformation of his subject. A young woman, neither particularly beautiful, nor particularly ugly, gazes away to her left. She seems withdrawn and a touch melancholic. The immediacy of Holbein's image is startling. He has perfectly noted the degree of wetness of her eyes and he has followed the line of her slightly protuberant nose, her unpronounced mouth and small chin with complete, absorbed attentiveness. His painting is a masterpiece of observation.

To spend some time in a room full of Holbein's portraits can be a disturbingly intense experience. His people are present in a way that men and women painted by other painters somehow are not. It is as if, walled in behind the surfaces of his paintings, Holbein's sitters still live. They look slightly apprehensive, as if holding their breath. It has often been said that Holbein was the painter who showed the English what they looked like. He did more than that. He showed them the difference between the self seen in the mirror and the self seen by another. He gave permanence to that revelation. But he also registered, in their aloof and slightly tense expressions, the uneasiness of a generation to whom the sensation of having a likeness taken was new and unfamiliar. Perhaps they thought he might steal their souls. Perhaps he did.

Holbein's persuasiveness is inseparable from his technique and his technique has never been surpassed. It fluctuates with extreme subtlety between methods often reckoned incompatible with one another, so that in his paintings a hard minuteness often coexists with soft but perfectly evocative generalizations. His brushstrokes are so

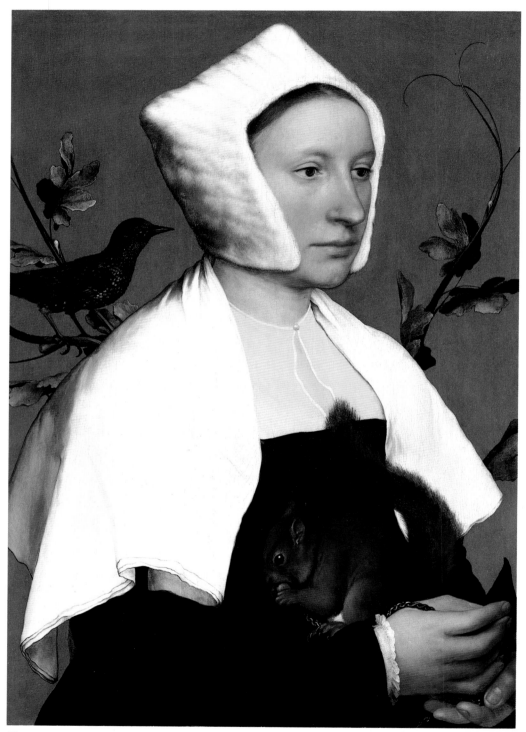

19 HANS HOLBEIN THE YOUNGER *Lady with a Squirrel and a Starling*, c.1526–8.

20 HANS HOLBEIN THE YOUNGER *Thomas Elyot* (detail), c.1532–4.

cleverly adapted to what they depict that you can get extremely close to his paintings and still read them totally coherently as description.

The best way to understand this is by comparison. To get closer to a portrait by Holbein's great Italian contemporary, Titian, is to begin to read it as a painting. A painting by Titian seen close to discloses the visual mechanics – the brushstrokes – that make it so convincing from a distance. As you get closer to the picture there is a sense in which you retreat from its subject. But Holbein virtually abolishes this double aspect of art, which means that to get closer to a painting by Holbein is very like getting closer to a real person. To approach his portrait of *Thomas More* (or any of his more highly

21 HANS HOLBEIN THE YOUNGER *Henry VIII*, 1536.

realized portraits) is, extraordinarily, to receive more rather than less information about the sitter. It is to notice truly minute details, such as the exactness with which Holbein has painted More's skin, with its slightly greasy moistness, and the care which he has taken over every last hair in his beard. One or two have gone silvery grey.

As Court Painter to Henry VIII Holbein was required not merely to realize but also to idealize his patrons. The largest and most resoundingly convincing propagandistic picture that he painted for Henry, the grand state portrait of the king and his family that was created for the walls of Whitehall Palace in London, was destroyed by fire in the seventeenth century. But it survives, if sadly faded, in the form of Holbein's highly finished full-size study for it painted on paper.

It is a tremendously eloquent image, one which contains all of Henry's pride and huge ambition. The most charismatic king in British history stands before us with one hand on his hip and the other on the dagger at his waist. He is almost as broad as he is tall: a man transformed into a superman or a kind of God on earth, strong enough to bear the weight of his dynastic responsibilities and reshape the nation. Henry VII stands close by but he looks like a spectre next to his great, meaty son: the ghost of a past that has been shouldered aside.

When Holbein painted the picture Henry VIII was already overweight and it would not be long before he would be carted around his various palaces in a contraption on wheels. But Holbein has transformed Henry's deformities into strengths. The king's vast bulk has been remade into an image of redoubtable, formidable solidarity, sheer weight made to convey weightiness. He is both immovable object and irresistible force.

Yet Holbein's realism also, in other ways, ran against the grain of state propaganda, contradicting its messages implicitly and subversively. This cannot have been intentional, but technique is also attitude and Holbein's technique contained within it the germ of what was to become in Britain a powerful and morally charged view of the portrait, according to which it would be regarded as foolish if not actually wicked to assume too much self-importance. Holbein's realism was so intense that he could not play the flatterer easily. The honesty of his vision did not allow him to do so and this is graphically clear in the smallest and most highly finished portrait of Henry to survive by his hand [21]. The eye may linger on the splendour of the king's jewels and the richness of the fabrics in which he is clothed. But such surface minutiae, however brilliantly painted, cannot distract the attention for long from the image of ruthlessness that is Henry's face, with its fat, heavy jowls and stare of authority. It is a painting that captures too much of Henry's cruelty to be merely flattering. It is the portrait of a king as a thug.

Nowhere is Holbein more powerfully himself than in his drawings. Here the special quality of clear-eyed and almost scarily neutral observation that he brought to British art is at its most intense. These pictures of English faces are small miracles, like stills snipped from a lost film of the past. Although they seem to speak in a whisper they are revolutionary. They teach a new and radical way of seeing.

22 SIR ANTHONY VAN DYCK *Thomas Killigrew and William, Lord Crofts,* 1638.

The drawings are the most direct embodiments of Holbein's poised and sure empiricism, and in them the nature of his achievement is crystal clear. When Holbein drew the knight and diplomat Sir Thomas Elyot [20] he caught the faint flush of his cheek, his greenish-blue eyes and his five o'clock shadow. Every element of his face has been precisely observed, including immature side-burns and a few strands of hair that have truantly separated themselves from the lank, combed mass of the rest. This sophisticated brand of Northern European realism is both essentially humane and also self-effacing before the facts of existence which it records. It is not naturally adapted to the glorification of human beings and this makes it a great leveller. There is no sense of social, religious or any other kind of hierarchy in his drawings of people so that what emerges from them is a sense of common mortality and humanity. This was his most important legacy. In Holbein's drawings of those people who witnessed at first hand the beginnings of the Protestant conversion of the British we may discern the first picturing

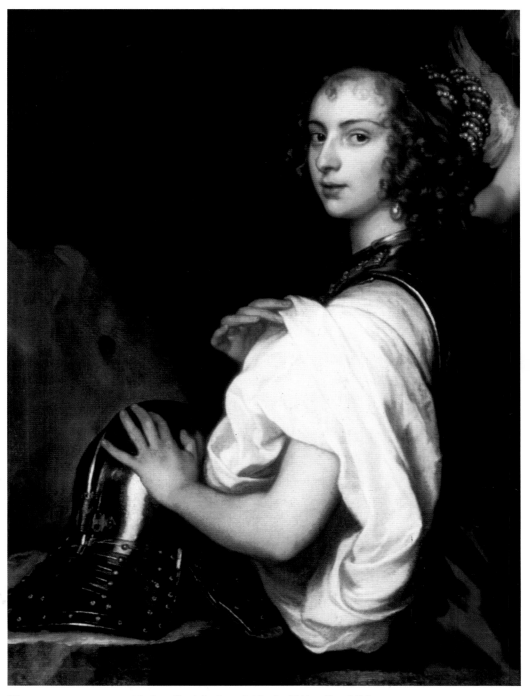

23 SIR ANTHONY VAN DYCK *A Lady as Erminia, Attended by Cupid* (detail), c.1638.

of a new Protestant sense of identity. This is an art focused with intimidating clarity, like the Protestant faith itself, on the individual; and with such unmannered neutrality on *all* the individuals to have come within its orbit that its realism indicates a new and incipiently democratic view of life. This is an art which to Protestant eyes came to signal a deep and commendable suspicion of hubris and vainglory, a disregard for outward pomp and circumstance, and a new emphasis on the individual conscience. Holbein made the human face seem more naked than it had ever done previously. In doing so he sowed the seeds of what eventually became a distinctively British attitude to picturing the self.

Almost 100 years later, in 1632, Anthony van Dyck arrived in London from Antwerp. Holbein's quiet northern realism and the stiff, reserved, ornate portraits of Elizabeth were worlds away from his triumphantly sensual style. Van Dyck did not paint people as they were, but as they wanted to be. He was a painter of myths, dreams and aspirations; of sitters beautifully and seductively transformed.

Van Dyck became Principal Painter to Charles I and his Court, and over the next decade devoted himself to the portrayal of the mannered, fragile society in which he found himself. In his art we see England's most aloof king and Court preserved forever in all their splendid, doomed, isolated arrogance. The work which Van Dyck created in London in the 1630s is the composite image of a society, but it is also the epitome in painting of an extraordinary moment in the cultural history of a nation: a moment when it seemed, briefly, as though the swelling tide of the Reformation might be reversed; a moment when it seemed as though the great breach between Protestant Britain and Catholic Europe might once more be healed.

The roots of Van Dyck's style lay in Baroque art and reached back to the High Renaissance of the early sixteenth century in Italy. Van Dyck had been taught in the studio of the Flemish painter Peter Paul Rubens. The dim rich splendour and the loose flickering touch of Venetian painting had also much impressed him, and the ghosts of Titian and Veronese can often be sensed in his pictures. He brought a new openness and freedom, a new opulence, a new brightness of colour, a new sensuality and a new sense of drama to British painting, qualities that had become both literally and metaphorically alien to it. Van Dyck blew into the country like a warm southerly breeze.

His portraits of the small Court circle of Charles I are the first genuinely glamorous paintings of English people. The courtiers whom Holbein painted look as though they are behind glass that they may frost with their breath, but the courtiers whom Van Dyck painted are inside a bubble, whose thin and transparent membrane may break at any moment. He saw the world of the Stuarts as a fragile, gorgeous theatre on the edge of its own destruction.

He painted the women of the Court as irresistible but also haughty creatures. Van Dyck's ladies are of this world, real, desirable and desiring. But they are also not of it, because they have been elevated to a higher realm of fantasy by an artist who has been enthralled by depictions of the Assumption of the Virgin, painted by artists of Catholic

Southern Europe. Van Dyck's aristocratic sitters are often touched by a spirit of other-worldliness. His *Lucy Percy, Countess of Carlisle* invites the viewer with an arched eyebrow to join her behind the red curtain which hangs, invisibly supported, on the threshold of a dark interior. She is the sensual heroine of a mysterious erotic drama, but she also has the quality of an unattainable vision. Although she parts the red curtain with a gesture of her right hand, she does not actually need to touch it to make it move. She is a sorceress, not a mere human temptress, someone who seems to glide rather than walk and who can make things happen simply by willing them.

The same mood of unreality pervades his breathtakingly sexy painting of a young woman whose name is now unknown and who survives to posterity only as *A Lady as Erminia, Attended by Cupid* [23]. Although the sitter herself is now anonymous, the character which she has assumed (presumably for one of the Stuart Court's many theatrical entertainments) can be traced. Erminia was the heroine of the Italian poet Torquato Tasso's sixteenth-century romance *Jerusalem Delivered,* and Van Dyck has painted the moment when she disguises herself as a knight in armour. The painting's theme of disguise also makes it an allegory of Van Dyck's consummate skill as an artist: a study in self-transformation painted by a man who was himself a great transformer of selves.

Van Dyck painted male power as well as female beauty. His portrait *Thomas Wentworth* is a tremendous if not entirely sympathetic picture of a man with steel in his soul, and a reminder that not all cavaliers were fops. Wentworth was one of the chief enforcers of Charles's autocratic rule, the Lord Deputy and brutal suppressor of a colonized Ireland. His meek Irish wolfhound is the mute symbol of the country he has tamed, but his real emblem is his black armour, shivered through with darting highlights of paint as mobile as electricity, which, perhaps, are meant to trigger a tiny reminiscence of the lightning bolts of Jove. These passages also demonstrate Van Dyck's extraordinary inventiveness with the basic matter of art, paint itself.

The beauty of Van Dyck's art is often the beauty of improvisation, of paint's own qualities rejoiced in as art becomes its own landscape of shape, colour and texture. Van Dyck was a brilliant animator of the inanimate and almost nothing in his pictures is allowed to be merely, inertly present. If Holbein was one of the greatest painters of stillness to have lived, Van Dyck was one of the greatest painters of movement. Silk in his art is always wind-blown, and few painters have ever made more of the impossible swag of drapery whipped up into an improbable shape by an invisible gust of wind.

He was also a painter of more subtle kinds of movement: a painter of trembling emotional disturbance and the delicate motions of the heart. His portrait *Thomas Killigrew and William, Lord Crofts* [22] is one of the most remarkable and poignant paintings of friendship. Its genius lies in the effect of instantaneity conjured up by Van Dyck, and also in the sense that the quality of a human relationship has been revealed in the *precise* instant caught in the painting. We see two men alone. The man on the right has been discussing some papers, but he has broken off to look at his friend with concern. His friend stopped listening to him long ago and is gazing sadly into space.

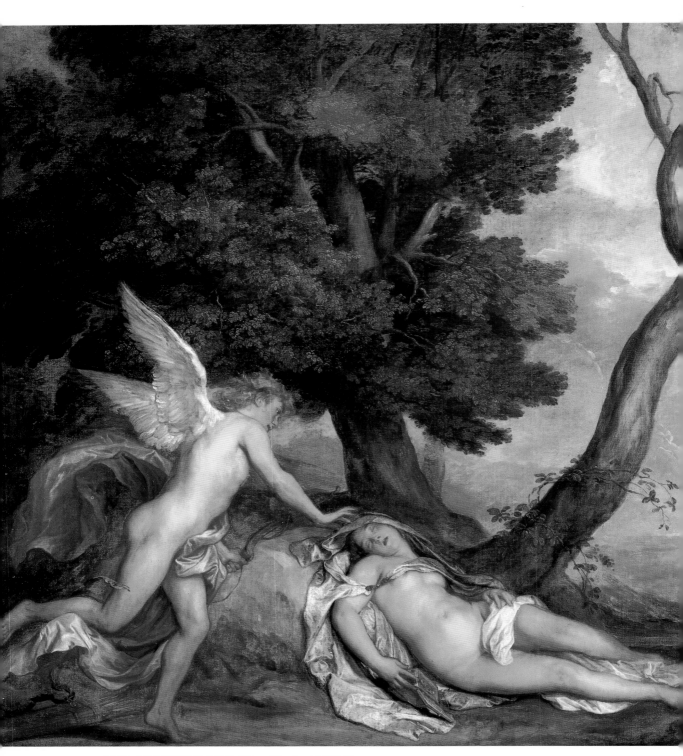

24 SIR ANTHONY VAN DYCK *Cupid and Psyche,* c.1639-41.

Van Dyck painted him in such a way that he seems to be staring at us but in fact he is looking through us, thinking of someone else. When Van Dyck painted them Thomas Killigrew's wife had recently died of the plague.

Van Dyck's greatest English painting was not, however, a portrait, but a narrative painting made for Charles on a subject drawn from the Latin poet Ovid's *Metamorphoses*. Ovid's tale recounts the moment when Cupid, god of love, falls in love himself with a mortal woman. It inspired Van Dyck to one of the most unforgettable visions of erotic myth in all of Western art. In *Cupid and Psyche* [24] his art rises, fleetingly, to the heights of the very greatest sensual paintings in history: Giorgione's *Tempest,* Titian's *Venus of Urbino* or Velázquez's *Rokeby Venus*. It is a brilliant image of desire for a female beauty so arresting that it is untouchable, a painting of love and the yearning for all that Love knows is out of reach. Psyche is lost in her dreams. Cupid is frozen suddenly in trepidation, having burst upon her impetuously with a clamour of wings. These naked bodies have been breathed, not painted, on to the canvas and even the landscape seems to quiver and glow with a warm physical beauty.

The freedom and the sensuality of Van Dyck's handling makes the painting doubly a dream: a fantasy of love made yet more fantastical by the texture of paint that dances and flickers and moves. It is the epitome of Van Dyck's sensuality, his alertness to the moving beauties of a mobile world, his daring, transformative way with the very stuff of painting. *Cupid and Psyche* is the *ne plus ultra* of his genius and it contains, as clearly as though inscribed in a will, all that he bequeathed to the visual arts in Britain.

Holbein and Van Dyck are the Romulus and Remus, the founders of British painting. They are also deities presiding over the post-Reformation landscape, because in their work we find made visible the two defining extremes not just of British art, but of British thought itself. They are the North and the South of the mind, the two poles between which the national imagination has oscillated for more than three hundred years.

The styles of the great artists implicitly contain within them entire worlds of belief and feeling. Van Dyck was far more than just a painter of portraits or mythologies. He was the inventor of painted dreams so lively and compelling that his work became a monument to the faculty of dreaming itself in Britain: a perpetual vision of the seductive power of art, and a lasting reminder that the exuberance and sensuality and colour so often associated by the British with other countries have had (and can have again) a home in Britain.

Holbein's great invention was the Northern opposite of all that Van Dyck stood for. His was an art of unadorned, understated realism. It was an art of simplicity and honesty, an art that did not fly dreamily upwards to the realm of fantasy but which remained earthbound, rooted in observed truth. In Holbein's art we can see, bounded within the quiet, strong lines of his draughtsmanship, not just the faces of one generation of British men and women but the values on which one of the most lasting ideals of Britishness itself would be built: common sense, precision, empiricism, determination, a capacity for inward reflection and a strong consciousness of responsibility.

Holbein had few direct followers and he founded no school of British painting, but his moral influence was enormous. The art traditions on which the British were to pride themselves would more often be rooted in observation than imagination. Hogarth's vigorous, no-nonsense robustness – epitomized by his *O The Roast Beef of Old England,* which defines the true Briton as a creature as substantial as a joint of meat – would later be one solution to the question of what might constitute a genuinely patriotic style of art. There were to be many others, but nearly all of these would be grounded in some form of realism. They would often be styles of self-effacement, modesty and a certain reserve, qualities which the work of painters as diverse as Devis, Wootton, Reynolds, Ramsay, Raeburn and Stubbs may all be said to share.

None of which is to say that it would be impossible to be a fantasist or a dreamer in Britain, because there would be those too. The fragile beauty of the dreams of Van Dyck would haunt generations of later painters, including two of the greatest, Gainsborough and Turner. But they would be exceptions, men swimming against the tide.

The history of art tells us that the North has exerted a stronger pull on the British imagination than the South for more than three centuries, but there was none the less a time when the balance could have swung the other way. The shape of the British painting tradition was to a very great extent determined in a battle between the two great opposing forces which Holbein and Van Dyck have decisively and eternally epitomized: the forces of realism and the forces of fantasy. The forces of fantasy, it will be remembered, lost the battle.

The King's Head

It is one of the larger ironies of history that no one did more to set back the cause of exuberant, fantastical, enchanting art than Charles I, who probably loved it more than anyone else in the history of the British Isles. He played an enormous and decisive role in the British art tradition during the course of his spectacular and spectacularly ineffective reign. But he had exactly the opposite effect to the one he set out to achieve.

Van Dyck made several memorable paintings of Charles. In the famous triple portrait [25] that survives in the Royal Collection he is a proud but also melancholic figure, the ghost of a king in triplicate. The painting was intended as a model for the Italian sculptor Bernini who, over 1000 miles away in Rome, had been commissioned to carve a bust of the English monarch. But Van Dyck's helpfully three-dimensional method of painting him twice in profile and once full face has retrospectively acquired another significance, independent of its original function. The three Charleses on a single canvas make the painting a secular Trinity: the ruler of England seen as a little god, but also as one with weaknesses. Van Dyck caught the superciliousness of his gaze and he traced, with infinite care, the weak line of his jaw. It is the vision of a man living in a world of his own.

'You are a little GOD to sit on his throne and rule over other men', James I told his son. Charles took the statement too literally and spent much of his life playing at omnipotence in a theatre of dreams.

In his great equestrian portrait of Charles, Van Dyck gives us another set of keys to the personality of England's most enthusiastic art collector. Charles sits on his huge and obedient stallion with complete, hoity-toity self-assurance. The symbolism of this exuberantly Baroque equestrian portrait asserts the king's most important powers. Mastering his horse he metaphorically masters his own lower passions; mastering his horse he also masters the nation which it is his divine right to rule. Charles rules the world he inhabits but he is not quite of it. The landscape painted by Van Dyck is animated by a wind that moves the leaves of the English oak in the background and the curls of the horse's mane. Charles, his hair lightly tousled by the breeze, remains quite unruffled.

To master a horse was much more than just a skill in the circle of Charles I and in many respects the art of equestrianism holds the key to the aloofness, the love of fantasy and the unworldly pride that characterized the king all his life. He was taught to ride by the Duke of Newcastle, whose later work on the principles of the *haute-école* method of riding, *A General System of Horsemanship,* reflects the style of the absolutist Stuart Court under Charles. The engravings to Newcastle's work, in which we see whole stables of surreally obedient horses bowing down to worship an ideal king [14], encapsulate the curious and doomed hubris of Stuart culture itself. Charles's tragedy would be that he mistook his kingdom for a horse.

The fierce determination to master the principles of *haute-école* horsemanship was only one aspect of the Stuarts' desire to remodel courtly life in England on fashionable European lines. The chilly self-possession of Elizabeth's style of rule gave way under James I, but above all under Charles, to a style far bolder and far more attuned to the styles of rule favoured by the kings and queens and princes of Continental Europe.

The first monument to the new courtly ambition of the Stuarts was a grand state building by the architect and stage designer Inigo Jones. Begun under James I's rule and completed under that of his son, the Banqueting House in Whitehall, London, must have looked more spectacular than it does today. Made of white stone, with its clear lines and elegant proportions, it was England's first truly classical Renaissance building. Its ornate columns of light stone originally rose out of a dark, Tudorbethan London of thatch and wood. For the interior Charles commissioned Peter Paul Rubens, the unquestioned master of the heady, illusionistic Baroque style, to create a vast painted ceiling hymning the Stuart dynasty. Rubens's contribution was a grand, painted opera devoted to the theme of the English monarchy and its might: a teeming allegory peopled with muscle-bound giants allegorically crushed by dimpled naked ladies who symbolize Stuart virtues, while kings ascend to heaven amid clouds of swooning putti. There is still something incorrigibly odd about walking into the Banqueting House off the streets of London. Suddenly, you leave Whitehall and find yourself in another country, a place that feels more like Spain or Italy or France than grey Britain.

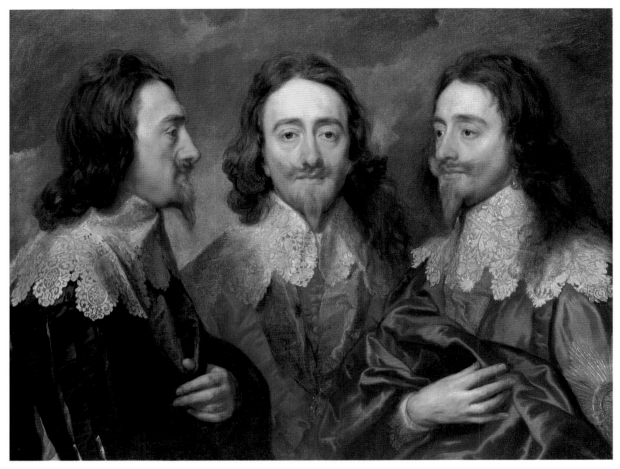

25 SIR ANTHONY VAN DYCK *Triple Portrait of Charles I,* 1635.

The effect of foreignness must have been even more pronounced in 1635, when Rubens's paintings were finally installed. In commissioning Rubens to cover the large spaces of the Banqueting House ceiling with images of royal magnificence and royal apotheosis, painted in the most exuberant manner of international Baroque painting, Charles had taken a great risk. The Banqueting House celebrated a Protestant monarchy, but it did so in a style of painting absolutely identified with the Catholic rulers and the Catholic religion of mainland Europe. The result was one of the very few instances of grand architectural painting in England. But as propaganda it was politically disastrous. Charles had already heightened public anxiety over his religious sympathies by marrying the Roman Catholic princess Henrietta Maria, daughter of Henry IV of France, in 1625. By erecting the equivalent of a Catholic shrine to his own dynasty with, at its centre, an image of the monarch ascending heavenwards like a rocket-propelled Baroque saint, he also created a rich and gilded symbol of the potential evils of his rule.

26 INIGO JONES *'A Page, like a Fiery Spirit'*, from
The Lords' Masque, c.1613.

Charles's great fondness for Renaissance and Baroque painting seems to have dated back to 1623, when his father sent him south to Madrid to woo the Infanta Maria, sister of King Philip IV of Spain. It was the first time Charles had left England, and he was entirely seduced – not by the Infanta, but by the art collection of the king of Spain, one of the greatest in the world at the time.

Having discovered Renaissance art, Charles set out to buy it. He returned to England with one of the masterpieces of Florentine Renaissance painting, the Raphael cartoons which had been made for tapestries that were to be hung in the Sistine Chapel in Rome. He would eventually own more paintings by Titian than any other collector before or since. He was a rarity, an English monarch desperately eager to enter the competitive courtly culture of seventeenth-century Europe, where kings and queens and princes outbid one another for the finest and most precious objects in the world. But Charles was not an especially rich king and England was not at all a rich country in the 1620s and

1630s. His profligate expenditure on art was regarded with increasing disapproval by certain of his less docile subjects.

For Charles, collecting art was not merely and trivially the expression of what is now commonly called connoisseurship. To collect was to affirm the power and the learning of the king, and to commission art was to bring into being images which themselves allegorized those same attributes of the monarch. It was, above all, the creation of an image which obsessed Charles: an image which might, however distantly or imperfectly, evoke his own semi-divinity and blessedness. He vested all his most passionate beliefs about himself and his Court in the world of the image and he took that world to be a truer reflection of reality – his own, higher reality – than the real world itself. Because of that, he became the ruler of a vision, the fantasy king of a fantasy land. This was, of course, politically suicidal.

We can still see Charles living out his oddest dreams, but we have to flesh out much of what we see with imagination. Fragments are all that survive of seventeenth-century England's most spectacular art form, the Stuart masques designed by Inigo Jones, pageant-master to the monarchy. The masque was a blend of allegory, fancy dress party and theatrical entertainment designed to be witnessed by the small, courtly elite who were also its actors. Although it was a performance of words as well as images, the spirit of the masque lay not in theatre but in spectacle.

Jones's costume designs for the masques of the Stuart Courts are among the earliest English watercolours and they have a quality of mannerist strangeness unique in the history of English art. An early Puckish image of a page with wings the colours of flame [26] is one of his finest: half spirit, half sprite, like Shakespeare's Ariel imagined in paint. Jones's stage sets survive mostly as black-and-white drawings, but none the less they are richly evocative of the peculiar painted world of wood and plaster in which Charles and his Court lived some of their most splendidly abandoned, oblivious moments.

No expense was spared even though each masque was generally performed only once. The most advanced stage machinery that had ever been seen in Europe was put to the service of peeling back one grand illusion after another in complex and extraordinarily ornate celebrations of the king's power and majesty. At the climax of the masque *Salmacida Spolia,* performed on 21 January 1640, a chorus playing the part of a fictively adoring British people sang the praises of their king, the great and glorious Charles I. Queen Henrietta Maria, surrounded by lady courtiers dressed as spirits of virginity, descended from the heavens in a painted wooden cloud. As she touched down, the king took her hand and they performed the formal dance that was another of the masque's symbols of their otherworldly perfection. Revels then continued for the rest of the night. There is something almost touching about the king and queen's blind and deaf isolation in their extravagant world of fictions. What strange people they are, as they survive to us now, in the mind's eye and in Jones's abbreviated sketches: figures in face-paint in outlandish clothes of gold and silver, emerald and lapis lazuli, with feathers in their hair, lost in the love of a dream.

The impropriety of these performances to those of a rigorously Protestant persuasion must have been almost beyond belief. The Banqueting House, with its great and gilded ceiling celebrating the monarch like a saint ascending heavenwards, was bad enough. But the Stuart masque, in which the king and his queen dared to play the parts of god and goddess, was intolerable, dangerous, insane hubris. It was royal mythmaking run wild. The harsh gaze of the English Puritans judged Charles and found him wanting.

Charles's love of art did not, in itself, plunge England into the Civil War. Religious and constitutional crisis had been deepening throughout his reign, but his excesses increased the general discontent. Civil war broke out in August 1642 and continued until August 1648 when the Royalists were finally defeated. Charles I was tried and convicted in January 1649 for treason. His death was nearly as carefully stage-managed as his life. The execution was choreographed to take Charles through the Banqueting House, the first theatre of his dreams, and on to a scaffold which had been erected just outside one of its windows. On 30 January 1649 he was led under Rubens's great painted ceiling and made to step outside. The executioner raised his axe and it glinted in the sun. The scaffold had been built so high that this sudden flash of light was all that the crowds in the street below saw of the event. The axe fell, and so did the king's head.

The material splendour and luxury of Charles I's Court were tainted for ever by association with him and his proud blind style of rule. Above all the art that he had so tirelessly collected and commissioned was tarnished by the association. So it was that, involuntarily but with remarkable effectiveness, Charles I ensured that his people were alienated for a second time from the visual culture of mainland Catholic Europe. A few of his pictures were allowed to remain in the country after his death. Some, including several works by Rubens, were thrown into the River Thames. But most were sold. Like a movie mogul in trouble Charles I had run up huge debts in the pursuit of grand spectacle and when he died he owed money to just about everyone in England. The selling of art was a quick way to settle the debts. The king's plumber was paid in Titians. His glazier was paid in Correggios. Charles had set out to buy the art of the Renaissance, but those who had chosen to punish him for his temerity proceeded to sell it off.

St Paul's

When the British turned their back on Charles and all his works, they also turned their back on a certain kind of art. They had already severed links with the great European traditions of religious painting. Now they severed links with the European traditions of secular painting too. By the middle of the seventeenth century, the two most decisive battles for the soul of British art had been won and lost. Religious art had been Reformed by the Protestant attitude, and secular art had been brought into alignment with it. Art that existed purely to create the fabric of a beautiful dream would forever afterwards

27 SAMUEL COOPER
Oliver Cromwell, c.1650.

make the British a little uneasy. A new consensus had come into being. Artists should stick to the facts and steer clear of extravagant, irresponsible fantasy. This view was certainly taken to heart by Samuel Cooper, who painted a small but brilliantly realistic miniature of Oliver Cromwell [**27**]. On sitting for his portrait, Cromwell told his painter:

> I desire you would use all your skill to paint my picture truly like me and not flatter me at all but remark all these ruffness, pimples, warts and everything as you see me; otherwise I will never pay a farthing for it.

Cooper gave him exactly what he asked for. The result is a work which skilfully reincarnates the tradition of unadorned and understated realism which Holbein had first introduced into the country in 1526. In this image of the other man at the centre of the English Civil War, we see that the militancy of Puritan theology and politics has become an ethics of style. It may be a small painting, but it is full of meaning. When the British aligned themselves with the spirit of Holbein, they did not just make an aesthetic decision. They decided who they were. This was a moment of national self-discovery and national self-definition.

28 SIR CHRISTOPTHER WREN the dome, St Paul's Cathedral, 1708.

No one expressed this more clearly and more resoundingly than the poet John Milton. His finest work, the epic poem *Paradise Lost,* is a huge affirmation of the death of irresponsible fantasy in Britain. Milton's poem is ostensibly a religious work, its subject the fall of man. But it can also be read as a political allegory, and a brilliant piece of national myth-making. The anti-hero of the poem, Satan, is a fantasist and an artist. He is Charles I, Van Dyck and Inigo Jones in demonized form. By embodying the idea of fantasy and fantastical art as Satan, Milton was describing them as the devil's work. *Paradise Lost,* the one great epic in English verse, is the grandest manifesto for the Protestant values that were to underpin a new Britain.

The physical monument to this national turning away from fantasy is St Paul's Cathedral. Like Milton's *Paradise Lost* Christopher Wren's architectural masterpiece is epic in scale. Like *Paradise Lost* it is ostensibly religious. But St Paul's, too, can be read as a broader kind of allegory: a summary of all that the nation had come to stand for, and against, by the time the most turbulent period in its history had come to an end.

The Protestant cathedral, begun in 1675 and finished in 1711, represents the coming of age of the British nation state and the values on which that state would be built. When we look at its great dome we see that a people who had spent nearly 200 years in crisis, questioning and destroying and purging their world in order to forge it anew, have finally finished their work. Wren's building sets in stone their rejection not just of the old faith, but of the old ways of seeing and dreaming too.

There is art in St Paul's, but its presence is only barely tolerated. There are paintings in the dome, but they are grey paintings, grisailles, pictures that have had the colour, the life and the magic drained out of them. There are statues, but they have been placed high up on the roof. The beauty of St Paul's is emphatically not the beauty of fantasy. But, although it is a place built on repudiation and rejection, the emblem of the nation's disenchantment, it does have its own grandeur and its own kind of visual power. It is the beauty of severe restraint, the beauty of blank walls, the abstract beauty of grand articulations of solid stone and void space. Wren's cantilevered spiral staircase, inside the west tower of the Cathedral, is an exquisite flaunt of human ingenuity: a large structure but as perfectly formed as a snail shell [29]. The scientific expertise that went into the making of St Paul's contains its own meaning. This is a building made by man, for man. A new and epic self-confidence is expressed by its huge scale.

The British were ready to look outwards, discover and perhaps to conquer. That is the message behind Wren's dome, those 65 000 tons of stone raised by human ingenuity and science into the London sky [28]. That too is the message written into the sublime geometry of Wren's tiled floor, that huge, beautiful diagram of spiky black-and-white diamonds. It is as though the visual world of the British, having been repressed for so long, suddenly and breathtakingly expanded. Large spaces no longer daunted. They exhilarated. The scale of St Paul's expressed a new sense of national possibility. When the British renounced fantasy for reality they did not only discover the real world. They began to take possession of it.

29 SIR CHRISTOPHER WREN the cantilevered staircase inside the west tower, St Paul's Cathedral, 1711.

THREE

MY WIFE, MY HORSE AND MYSELF

30 SIR ALFRED MUNNINGS *My Wife, My Horse and Myself,* 1932–3.

Whenever people talk to me about the weather,
I always feel quite certain that they mean something else.

OSCAR WILDE *The Importance of Being Earnest*, 1895.

Damn gentlemen, there is not such a set of
Enemies to a real artist in the world as they are,
if not kept at a proper distance.

THOMAS GAINSBOROUGH, letter to William Jackson, 2 September 1767.

The Britishness of British Art

On the evening of 28 April 1949, Sir Alfred Munnings made his last stand. The occasion was the annual banquet of the Royal Academy of Arts and as outgoing President he was expected to make a brief, gracious retirement speech. The speech that he made was neither brief nor gracious, and it was not at all retiring. Inspired by a lifetime's indignation and by the knowledge that his words were being broadcast simultaneously to the nation by BBC Radio, he chose the moment to deliver a diatribe.

Munnings's first target was 'this so-called modern art'. Being rather drunk at the time, he began to ramble almost as soon as he started to speak, but his meaning was clear enough to the assembled gentlemen (the Royal Academy banquet was barred to women in those days) who sipped their brandy, smoked their cigars and guffawed their approval. 'If you paint a tree', he thundered, '...paint it to look like a tree and if you paint a sky, try and make it look like a sky!' There were those in Britain, he warned, who had begun increasingly to succumb to the corrupting influence of the school of Paris. There were British painters who had begun to follow the example of those evil distorters of nature, Georges Braque, Henri Matisse and (The Devil Himself) Pablo Picasso. Munnings gesticulated in the direction of Winston Churchill, who was sitting next to him: 'I know he is behind me because once he said to me, "Alfred, if you met that Picasso coming down the street would you join with me in kicking his something something?" I said, "Yes sir! I would!"'

Munnings was an inebriated reactionary of indifferent ability and waning powers. But his speech swiftly became The Speech, and he became a popular cultural hero for the short remainder of his life, thus proving how strong and enduring a particular strain of British taste has remained, right into the twentieth century.

Castle House in Dedham, Essex, where Britain's most outspoken painter of horses spent the last forty years of his life, is a corner of the world that will be forever Little England. Its walls are covered with Munnings's work, pictures that amount to a microcosm of his career. They range from his early, bucolic pastorals to his later images of the well-heeled enjoying rural pursuits, of huntsmen and their dogs gathered in anticipation of the chase, of horses and jockeys awaiting starter's orders. It was here that Munnings painted the most defiantly British picture of the twentieth century.

He finished it sixteen years before he gave The Speech. *My Wife, My Horse and Myself* [30] is the distillation, in oil on canvas, of all his beliefs about art. The painter stands and faces us, dressed in the casual uniform of the country squire, wearing a trilby hat and a well-worn three-piece suit enlivened by a daringly colourful cravat. He has a palette in his hand and an expression of inscrutable self-confidence on his face. To his right and slightly in front of him, his wife Violet sits side-saddle on a well-groomed chestnut stallion. Poised and aloof, they are the master and mistress of their polite world. Behind them sunlight falls on the Munnings residence, Castle House, turning its walls the colour of butter.

Elsewhere in Europe at the time, the Dutch painter Piet Mondrian had just entered the most exuberantly abstract phase of his career as a painter, creating such extreme, simplified geometric arrangements of line and colour as the *Composition with Blue and Yellow*. In France, Picasso was soon to translate the outrage provoked in him by atrocities perpetrated in the Spanish Civil War into the convulsive energies and dislocated forms of a painting called *Guernica*. By contrast, Munnings's picture offers us an idyll from which all traces of modernism and the modern world have been studiously and pointedly excluded. It is a picture which (like so many twentieth-century British pictures) insists that the way forward, for art, lies in the way back. It harks back more than 150 years to what Munnings regarded – and many other people have agreed with him – as the golden age of British art.

Munnings spent much of his life trying to keep the flame of eighteenth-century British painting alight. In some respects he understood the history of art in his own country very well. *My Wife, My Horse and Myself* is not a masterpiece. It is painted in a tired and drily academic style and it represents the sad, exhausted cul-de-sac of the tradition which it occupies. Even so, it is a picture that exemplifies the essential singularity of that tradition.

When he painted it Munnings was, in his patriotic and nostalgic way, pointing out some of the larger peculiarities of British cultural history, above all the curious fact that the image of nothing more than a rather snooty man and a woman on horseback has become an emblem of nationhood as instantly recognizable as St Paul's Cathedral or the Union Jack. Munnings understood that an obsession with the record of private lives and private property lies at the centre of the British art tradition.

But there were other features of his own tradition that Munnings did not understand, just as there is more to art than painting trees that look like real trees and skies that look like real skies. Munnings was right to value the art that he did, but wrong to value it for his small-minded, conservative reasons. The most affecting works of art produced in Britain during the eighteenth century are works of genius that shine out despite, not because of, the plainness of their subject matter.

The fact that the Georgian era has been remembered as a long, serene, golden idyll, an endless tea party on a shaven lawn, is among other things a tribute to the special deviousness of British eighteenth-century art. The British spent a large part of the eighteenth century fighting wars, an activity to which they proved to be extremely well adapted. Imperial gains in the War of the Spanish Succession, early in the century, were consolidated during the War of the Austrian Succession in the 1740s. Then came the Seven Years War, and once that conflict had reached its bloody conclusion, in 1763, the nation stood confirmed as the unrivalled world power of the time. The British had conquered Canada, they had driven the French out of the majority of their colonial territories in India, West Africa and the West Indies, and they had taken Havana from Spain. But while the nation's elite acquired vast global power and wealth, they showed extraordinary restraint in their choice of images to reflect it.

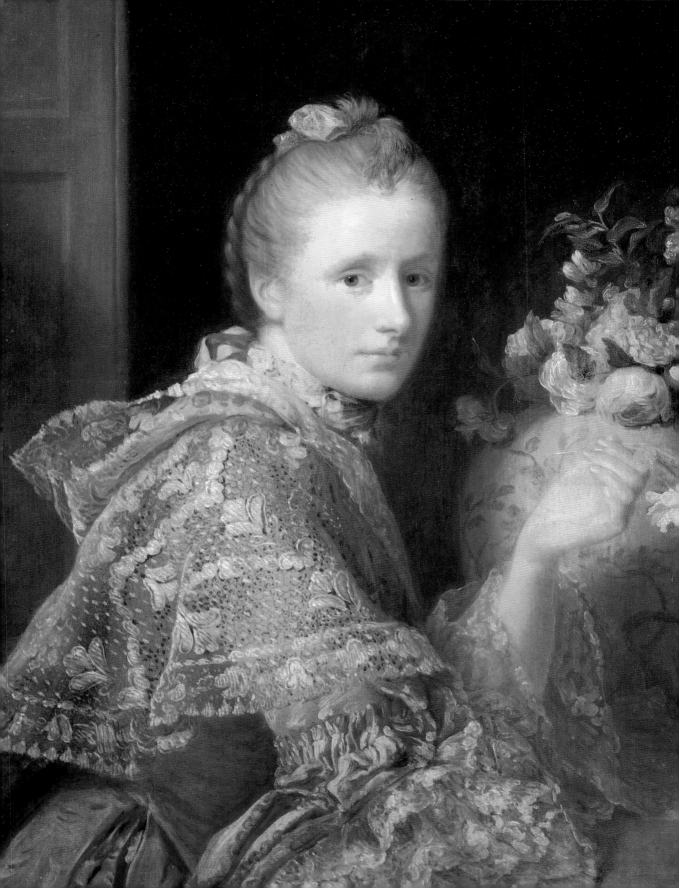

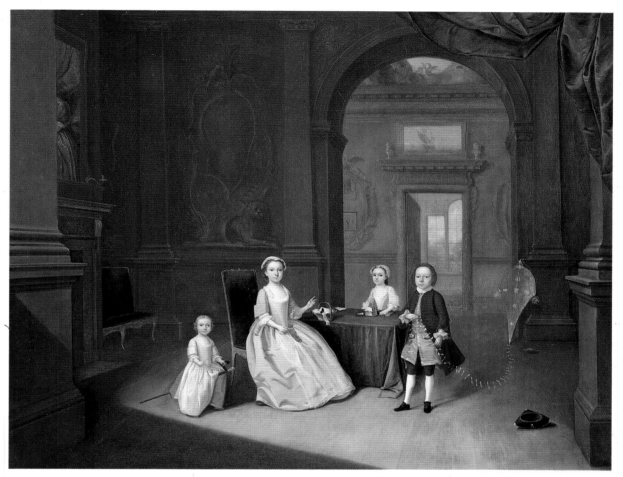

32 ARTHUR DEVIS *Children in an Interior,* c.1742–3.

While the world of British influence expanded, the world of British painting shrank. The grand Baroque group portrait of the seventeenth century became something altogether less assuming. It became the conversation portrait, as practised most memorably in the 1730s and 1740s by Arthur Devis. Devis was the epitome of the middling provincial portrait painter and in his pictures [32] we see the ancient notion of dynasty being replaced by a more modern and less daunting idea of family. He painted the minor gentry as groups of sometimes poignant mannequins, lit by an aquarium light in an airless indoors. The Baroque equestrian portrait of the proud king or courtier on his charger underwent a similar metamorphosis. It became the sporting picture as painted by artists such as John Wootton, the image of a gentleman riding across rolling downs and fertile

31 ALLAN RAMSAY *Margaret Lindsay, Mrs Allan Ramsay,* c.1759–60.

fields, usually depicted in the middle distance rather than in the foreground. The last vestiges of Baroque symbolism still survive in such pictures – the huntsman's control of his horse symbolizes his self-control and his power over the destiny of others – but only as faint echoes. Van Dyck's equestrian portrait of Charles I has become, indeed, a thing of the past.

The soul of British art in the eighteenth century is understatement – an understatement so restrained that it amounts to a form of disguised aggression. This is above all true of the portrait, the quintessential genre of British art in the Georgian period. The thousands of eighteenth-century portraits that may be seen on the walls of country houses and museums, many of them uncared for in their brown old age, amount to the corporate image of a society which disdains ostentation because it has nothing to declare but its uprightness and reliability. Such pictures may have been painted, for the most part, by anonymous or distinctly minor artists, but their significance lies precisely *in* their indifferent quality. During the last two centuries the British have shown themselves to be enamoured of pictures that are not very good. Mediocre pictures do not dignify them too much, but enough, and therefore they dignify them in just the way they require. A portrait of middling quality is the mark of a man who needs no visual assistance and who is content to be his own best propaganda.

The Scottish painter Allan Ramsay created some of the finest pictorial monuments to British restraint and reticence in the eighteenth century. His best portraits, such as those of the philosopher David Hume and of Margaret, his own wife [31], are quietly profound celebrations of frankness and simplicity. They are pictures of people at home who have been made to seem entirely at home with themselves too. Ramsay spent the bulk of his career in London, but he was one of the first painters in whose work it is possible to detect a self-consciously Scottish sensibility – a sense of restraint even more reined-in than English restraint. Ramsay gave visible form and a human dimension to the ethics and philosophy of the Scottish Enlightenment. He fleshed out Hume's belief that 'Everything in nature is individual', and it is hard to find a more solidly materialized vision of this belief than his portraits of the second half of the century. His finest pictures are of women. Becalmed, alone, quiet, they are also lively, sentient presences, filled with a sense of the secret, inward life of the individual.

British portraiture in the eighteenth century begins to pay a subtle, almost novelistic attention to the human being. The art may be limited in its subject matter, but like the novels of Jane Austen, which she described as miniatures painted on a 'little bit (two Inches wide) of Ivory', it draws strength from that. The pattern of British painting's development during this period is, in a sense, one of continual but knowing diminution. It is a pattern of descent from large, grand and assertively theatrical forms of painting to smaller and more modest and self-effacing ones. At the end of the century, the Royal Academy's Professor of Painting, Henry Fuseli, complained that art in his time had become 'snug, less, narrow, pretty, insignificant'. But sometimes the most apparently simple statements are the most penetrating ones.

This trend is visible across the entire spectrum of the visual arts. When the British were at the apogee of their power and influence they did not paint vast and intricate allegories, but conversation pictures, sporting pictures and portraits. They did not build grand public monuments, but private country houses. They did not design huge emblems of national affluence and might. They designed landscape gardens. The most expressive eighteenth-century memorials to the vexed British attitude to power and glory and their proper visual manifestation are in fact a house and a garden: Blenheim Palace and the park at Stowe.

A House and a Garden

Blenheim Palace in Oxfordshire was built early in the eighteenth century to celebrate a victory over the nation's arch enemy, France. Designed by Sir John Vanbrugh, it is a warlike building, intended to daunt and intimidate. The scale of the palace, which makes midgets of those who approach or enter it, is not so much inhuman as super-human. This is architecture that aspires to the condition of opera, a building of many parts that sings, like a chorus formed from stone and sculpture, a swollen song of hero-ism and national triumph. The pillars of the clock tower are surmounted by carved British lions mauling angry French cockerels. The entrance steps that lead up to the grand north front are flanked by carved trophies of war. High above, perched on top of a huge broken pediment, Pallas Minerva, goddess of victory, stands serene and triumphant while behind her two chained captives strain and grimace. An actual trophy of war has been placed high on the south front: a bust of Louis XIV, king of France, which stares stonily out over an English park and an English ha-ha, into English fields beyond.

The most impressive palace in England, Blenheim was built for an aristocrat, the first Duke of Marlborough, rather than for a monarch, but it was commissioned by Queen Anne in gratitude for the duke's military leadership. Blenheim does not only trumpet a victory over the French, it also symbolizes the reluctance of the post-seven-teenth-century monarchy to make grand statements on its own behalf for fear of calling attention to itself. It took a virtually ancient Egyptian workforce of hauliers, carters and stonemasons, working through some of the most bitterly cold winters on record, more than fifteen years to complete Blenheim. Queen Anne might have paid for it, but she would never have dreamed of living in such extravagant style herself. There would never be as grand a royal palace in Britain. The turn of the eighteenth century marks the moment when the monarchy finally reconciled itself to the loss of real power and began to turn into that line of barely tolerated figureheads which has persisted into the present in such timid and bourgeois style. Blenheim announces a large shift in the balance of power in Britain and proclaims the advent of a new and tremendously potent elite. With the building of Blenheim it was clear that the aristocracy had become the ruling class.

But although Blenheim signalled a new beginning it was also, in itself, another of Britain's many false starts. The eighteenth century was the high-water mark of the power of the aristocracy, a time when the ruling class – unlike any other in Europe – was unthreatened from above or below. The British aristocracy in their golden age of wealth and self-confidence remade their world. Land was both the base of their power and its greatest symbol, and they transformed the landscape of the nation, turning it, in the historian Roy Porter's phrase, into 'a federal republic of country houses'. But as they did so they turned away from the style of Blenheim, disliking its pomp and swagger.

It would be difficult to argue that the aristocratic houses were modest creations. They were built in the language of classical architecture. They evoked ancient Greek or Roman styles of architecture (as buildings all over Europe had done ever since the Renaissance) in order to suggest that those who lived in them were the rightful modern inheritors of the classical legacy. The aristocrats thought of themselves, in many respects, as the ancient Romans of their own day – noble, enlightened republicans – and their houses reflected that belief. But their architecture was lighter, more abstract and restrained than the Baroque of Blenheim. It was not opera but cool, steely oratory.

The pride and the nearly Roman arrogance of the aristocratic house were deliberately softened by its setting. The stately home in its grounds is the most conspicuous expression of that combination of self-confidence, diffidence and cunning which characterized the aristocracy throughout the eighteenth century. It is a palace, but also a retreat, and a place made faintly melancholic by being stranded in the countryside. The militaristic and jingoistic associations of the stately home – its columns and marble halls and great spreading facades, designed to evoke Greco-Roman splendours and declare their owners the true inheritors of Western European humanist civilization – are simultaneously tempered by associations of retirement, of ascetic withdrawal from the busy world of the city to the quiet and contemplative world of the country.

There is no better place to understand the nature of eighteenth-century patrician culture, and the nature of its classical ideal, than the greatest of all aristocratic estates. To visit Stowe and its garden in Buckinghamshire is to see what the new British ruling elite chose to put in place of Blenheim. It is to see how the aristocratic imagination remade the classical world in the image of its own fears and hopes and ideals.

Stowe's informal garden was created over a period of more than seventy years and the long list of those who contributed to it, whether actively or indirectly, includes many of the most influential architects, designers, thinkers and writers of the eighteenth century. William Kent, the Earl of Burlington's chief accomplice in the founding of the English Palladian movement in architecture, designed several of the buildings that it contains. Joseph Addison's essays on gardening and gardens in *The Spectator* and Alexander Pope's poetical dissertations on taste and nature played a formative role in the making and framing of its vistas. It was designed in great part by Capability Brown, one of the earliest pioneers of a distinctively British form of landscape garden. Stowe is the *gesamtkunstwerk* of eighteenth-century Whig liberalism,

a creation which embodies some of the most influential habits of thought in the Georgian era.

On one level Stowe was a great family's way of pointing out that they, and the class of society which they represented, were the real rulers of the nation. The Temple-Grenvilles, who presided over the making of this extensive architectural-horticultural allegory, were one of the most powerful families within the dominant Whig aristocracy. They had risen to power with Cromwell in opposition to Charles I and had also played a significant part in the Glorious Revolution of 1688, successfully standing against the absolutist ambitions of James II. Throughout the eighteenth century they stood for the shared beliefs that underpinned the authority of the Whigs in the Georgian period. They believed in a form of soft Republicanism, holding that Parliament, not the monarchy, should be primarily responsible for the destiny of the nation and, consequently, that the monarchy should necessarily be restricted in its powers. They believed in their own inalienable right to rule. They believed in Great Britain's greater glory. But, unlike almost any other ruling class in European history, they never made the mistake of taking themselves too seriously in public. Stowe is a monument to that fact and a model, too, of what was to become a perennial British upper and upper-middle class fondness for irony – a tendency to say one thing while seeming to say another.

There are thirty-two allegorical temples and many other monuments dotted around these green acres, a fact which has led some to regard the entire garden as an elaborate pun on the Temple-Grenville family motto: *Templa quam dilecta* (How beautiful are thy temples). But there is more to Stowe than meets the eye. Stowe is a large and complicated statement of national identity. It is an aesthetic and a political manifesto. It represents a persuasive ideal of Britishness and of what it should mean to be British.

The theme of Stowe, like that of Blenheim, is British power, but it is expressed more carefully here and Stowe is only sporadically unambiguous in its celebration of the glories of the nation. The garden revolves around a series of picturesque views. Nature and architecture have been composed to recall, from certain ideal vantage points, Poussin's or Claude's idealized paintings of the Roman campagna. A corner of England has been remodelled to resemble ancient Rome, not only for purely aesthetic reasons but also in order to make a point. The classicism of the buildings dotted throughout the garden delivers the same implicit message, announcing that Britain has become a new Rome and a new Greece.

But the way in which the garden has been designed means that this proud jingoistic message is forever being qualified, contested and modified. Walking through the garden, it is clear that the set-piece vistas are only temporary visual harmonies, transient moments of order and classical perfection, that dissolve into and are reclaimed by the shapelessness of an English landscape.

Stowe inaugurated a revolution in the history of British gardens and it remains the most perfect instance of the kind of artfully 'natural' landscape which that revolution produced. It is a place of wide and grassy vistas, mazy, serpentine lakes and

informally planted stands of trees, which are punctuated by grand triumphal arches, obelisks, follies and temples designed to resemble the buildings of classical antiquity in miniature. These effects of artlessness were not easily won. Eight villages were demolished and their inhabitants rehoused in the course of its creation (their opinions of the process are not recorded). Nevertheless the garden feels anything but dictatorially realized. This is a landscape that has the character of a dream made gently real. It is perhaps the British Eden, although it is not an innocent place because almost every one of its green and peaceful corners aims to insinuate a meaning or provoke a reflection.

The layout of Stowe as a whole encourages the visitor to meander, to drift irresponsibly through its planned views and to explore its subtle, hidden corners. It is a place designed to get lost in and it only reveals its true essence to those who do, indeed, get lost in it and surrender to contemplation. Wandering into the eastern part of the garden, visitors find themselves in the Elysian Fields, which were designed and laid out by William Kent in the 1730s. On the top of a slight rise stands one of the simplest and most beautiful of all Stowe's garden buildings, modelled on the Temple of Vesta at Tivoli and christened the Temple of Ancient Virtue by Kent. Inside the small domed interior stand four statues of heroes of Greek antiquity: the poet Homer, the philosopher Socrates, the general Epaminondas and the lawgiver Lycurgus. Ancient Greece, the Temple of Ancient Virtue implies, can be rebuilt in modern Britain. This small garden folly amounts to a microcosm of Whig political idealism, the model of a society to be reincarnated – poetically, philosophically, martially and legally – on British soil.

Other monuments in the Elysian Fields wittily suggest, however, that the British aspiration to emulate the ancients is still a fantasy rather than a reality. Some of the funniest effects are achieved through juxtaposition. Down the hill and across a lake, which Kent designed to look like a river, the visitor finds the Temple of British Worthies [33], a small, semi-circular exedra which houses the busts of eminent Britons. Here we find what amounts to a pantheon of virtuous men (and one woman) representing both the active and contemplative lives: the active are King Alfred, the Black Prince, Elizabeth I, Walter Raleigh, Francis Drake, John Hampden and William III; the contemplative are Inigo Jones, William Shakespeare, Francis Bacon, John Milton, John Locke, Isaac Newton and Sir Thomas Gresham. At each end of the monument, a single modern worthy has been allowed a place: the poet Alexander Pope and the now forgotten MP, Sir John Barnard.

The Temple of British Worthies adds up to a potted account of the Whig version of British history and as John Martin Robinson has acutely pointed out, 'It is significant that no priest appears among the national heroes; the Whig version of history is Protestant history'. The Temple of British Worthies is a small, secular shrine, modelled on an ancient Roman wayside shrine and consecrated to Whig values. It is a celebration, among other things, of the securing of the Protestant succession from Elizabeth I to William III, and of British freedom from religious and monarchical tyranny. But it is just as significant for where it is as for what it is. Placed so conspicuously below the heroes in

the Temple of Ancient Virtue, the heroes of the British national epic are being diminished as well as praised. The placement of the temple makes of them pygmies encamped at the foot of Mount Olympus. To add a final, clinching footnote of self-deprecation, one of the Temple-Grenville family made a last mischievous addition to the ranks of the British Worthies shortly after the temple had been completed. At the back of it, he built a small memorial to his favourite pet, a dog called Fido.

Stowe is a cautious, humane, open-minded, witty garden and it is perhaps the only garden in the world of which it is possible to say such things. Reverie, a kind of wandering day-dreaminess, is the mood which it most persistently induces in those who visit it; that, and a kind of sweet-sad melancholy. The fluid qualities of its landscape encourage such feelings. Gazing at the flickering, unstill reflections of its temples in the wind-ruffled surfaces of its artificial lakes, the very idea, not just of British worthiness but of Britishness itself, becomes unstable. Perhaps it is merely a chimera, an illusion of the wishful-thinking mind. This may or may not be intentional, but because so much nature is allowed into Stowe the thoughts prompted by its buildings and views are always being thus complicated. The monuments seem less convincing and, endearingly, less self-important than the emblems of nationhood created by other countries.

The great garden at Versailles – the model against which Stowe, as the British answer to that kind of French Baroque garden, deserves to be measured – works through thumping, cumulative repetition of a single theme, the power of the French king and France. It is announced in every detail of the garden, where the tendency is to control and subordinate nature, to arrange trees in avenues like columns of soldiers and to discipline the unruliness of water into the sculptural form of fountain jets. Stowe is far gentler and less insistent, a garden that fits in with the natural contours of the terrain, where nature may be allowed to dominate human structures by overgrowing or obliterating them.

Many of the Greco-Roman monuments often seem on the brink of disappearance, of being absorbed back into nature, and several, such as the small marble cameo that was erected in 1778 to the explorer Captain Cook to celebrate the addition of Australia to Britain's overseas possessions, have almost been thus reabsorbed. Stowe is a place where monuments to British heroes, to British imperial conquest and British artistic achievement, often appear to have been constructed in keen anticipation of nature's encroachments. Even the garden's most assertive and hubristic monuments – the grand triumphal arch at the northern end of the grounds, or the Temple of Concord and Victory, a reconstruction to scale of the ancient Roman Maison Carrée at Nîmes – seem surreal and stranded and take on the quality of ruins. The monuments at Stowe easily become anti-monuments, symbols not of human greatness but of human insignificance, *vanitas* motifs and *mementi mori*. The garden prompts thoughts of death, or the pride that comes before a fall. It is a cautious and, though not depressing, a faintly morbid place. Stowe implies that to be British is to emulate the ancients but it warns against putting on too many airs and graces, and demands recognition that all monuments will crack and fall into ruin one day.

Overleaf: **33** WILLIAM KENT the Temple of British Worthies, Stowe Landscape Gardens, c.1735.

Arrogant Modesty

In British culture the epic is always being muted and softened, its high ambitions gently ironized, by the pastoral. British landscape painting owes its origins to this pattern of thought and feeling. The aristocracy commissioned the first of such pictures in the form of paintings of their country houses and estates. The most proficient were painted by the talented but dissolute Welsh artist, Richard Wilson, who specialized in the classical picturesque like the landscape gardeners of the time. Most of his paintings were of idealized Italian landscapes, but occasionally they depict the grand, stately homes of his patrons. As painted by Wilson, aristocratic country houses, often seen at a distance through a tree's branches or across fields, look a little like the ruined monuments of the ruined classical world on which they were modelled. Grandeur is tempered by a mood of sad reverie. This is the equivalent in painting of the bittersweet irony of the gardens at Stowe.

The British were still Protestants in the eighteenth century, although not especially devout ones, and the legacy of the religious schisms of the past was felt more keenly than ever in the purely secular realm. Part of their birthright was the certainty that all worldly things, all power and glory, would eventually come to naught. The British retreated to nature to remind themselves – as Protestants always feel they need to be reminded – that no matter how rich or powerful they became, they would always be ruled by forces larger than themselves. The slow, ineluctable turning of the seasons, the diurnal changes wrought in the landscape by nature and the march of time, are a perpetual backdrop to the British sense of self.

'Modesty is the British form of arrogance', Northrop Frye once said, a remark which goes to the heart of eighteenth-century Georgian society. Stowe may be its masterpiece, but it is to be found everywhere in the art and architecture of the period, this modest arrogance, this arrogant modesty, running through the culture like a *leitmotif*. We see it in the faces and bearing of the aristocrats themselves and in all that they commissioned and called forth. In no other society in the history of the West has an elite formed a myth of itself so shot through with implicit self-deprecation.

In eighteenth-century Britain the majority of works of art and architecture, whether houses or gardens, paintings or sculptures, were created for a wealthy, predominantly English and aristocratic minority of the population. But those works express certain attitudes – above all the notion that the sense of one's own grandeur or self-importance is something to be cautiously and carefully expressed – which were shared by the nation as a whole. Those same attitudes are present, albeit in a very different form, in the art that stood at the opposite end of the spectrum from the art of the aristocracy.

The eighteenth century saw the beginnings of the British love of and genius for satire: the ironizing and diminishing of the noble, the wealthy, the famous, which has remained a stock-in-trade of popular art and journalism for more than two centuries. Britain was not the only nation to produce scabrous popular satire, but this particular

art form thrived in Britain in the eighteenth century as it did nowhere else in Europe. The caricaturist's favoured targets were, almost invariably, members of the ruling class, but the viciousness of such attacks – particularly in the hands of the greatest satirists – can be seen simply as confirmation from below of that same elite's need to be cautious in expressing its own power. A consensus came into existence, cutting across high and low society, across the divisions of wealth and class, according to which no one in Britain could be allowed to get so big for their boots that they could not take a joke at their own expense. The fact that a vital tradition of graphic caricature and satire was allowed to develop in Britain as early as the eighteenth century (censorship prevented this almost everywhere else in Europe at the time) underlines the strength of this new consensus.

The ruling class's unique tolerance of satire indicates the canniness that lay behind the pose of arrogant modesty. Tolerating satire, the British upper classes gave a place to and allowed the social expression of that strain of radical, egalitarian Protestantism which in earlier centuries had destroyed the fabric of the church, dissolved the monasteries, brought about the death of one king, the dethronement of another and caused the Glorious Revolution. Tolerating satire, the British elite allowed itself to be a target, but in a limited way – and perhaps because it allowed itself to be attacked in art, it escaped being attacked in reality. While the French aristocrat was submitting to the guillotine, the British aristocrat was submitting to the far milder criticism of satire.

So it was that the society that brought Stowe into being also came to produce the first and most influential English satirical artist. He was a man with a black and violent imagination, the natural milieu of whose art was neither the shaven lawn, nor the becalmed, aristocratic interior. His theme and his Muse was a city crawling with fops, whores, blaggards and drunks: London.

Iconoclasm as Satire

William Hogarth was the guilty conscience of the British eighteenth century and the chief chronicler in art of its darker life. A self-appointed scourge of the society in which he found himself, he spent his life railing vigorously against corruption and exposing the pride that comes before a fall. Hogarth is not a loveable artist, but amiability would have lessened him. His achievement is inseparable from his meanness of spirit.

Hogarth's fame rests not on his paintings but (and rightly so) on the prints derived from them. His chief invention was the narrative sequence of prints on a topical theme, and the black-and-white engraving was the perfect medium for the expression of his sooty, grubby view of society. Hogarth's contemporaries referred to his grim parables as painted novels, but he himself called them 'modern moral subjects'. The first, A Harlot's Progress [34], was engraved and published in 1732. It made Hogarth famous. Most of what he had to say about human nature has been squeezed into it.

34 WILLIAM HOGARTH *A Harlot's Progress,* 1732. Plate 1.

Plate 2.

Plate 4.

Plate 6.

A Harlot's Progress is a visual story of horrid inevitability, a journey from innocence to pox-ridden death recounted in six images. In the first plate we see Moll Hackabout, a robust young country girl, arriving in London in search of work and falling into the clutches of the owner of a brothel. In the second she is shown prospering as the kept mistress of a wealthy Jewish businessman, who has provided her with a richly furnished apartment, but that has not been enough for her and she has taken a lover, whom we see leaving by the back door while she stages a diversion by kicking over a tea-table. In the third plate we see her lazing in bed in a cheap and unpleasant room in Drury Lane, having descended to the life of a common prostitute. In the fourth she is beating hemp for her sins in a house of correction (but Moll's life, we know by now, has been the sort of mistake that cannot be corrected). In the fifth, while quack doctors argue over her last few pennies, she is quietly dying of the pox. In the last, she is in her coffin and while mourners gather round we notice that the officiating clergyman has his mind on other things. His hand is up the skirt of a robust young country girl, who has recently arrived in London to look for a job. As the cycle of corruption reaches its conclusion it is beginning all over again.

Repetitiveness is Hogarth's chief strength and his chief failing. He told many different tales, but every one of them recounts the same old story. Innocence always turns to depravity, hopes are always disappointed, ambitions always turn out to be built on sand and passions always turn sour. Every carefree before leads to a sad and embittered after. *A Rake's Progress,* the most celebrated of his modern moral subjects, is a repeat of *A Harlot's Progress,* but played this time with a male lead. Each plate in the series impeaches a different sin and the last delivers judgement. There is much of the fundamentalist, tub-thumping preacher about Hogarth. He has greatly relished noting every last detail of the Rake's ambition and vanity and pretentiousness and venality before awarding him the prize of madness.

The use of the word 'progress' in Hogarth's tales of the Rake and the Harlot was cruelly ironic. There is no progress in his world, only a steady slide down towards the pit. Hogarth painted with the relish of a pessimist bringing bad news. Even his most apparently innocent pictures, his portraits of children, are laden with ominous details portending doom, like the caged bird threatened by a beady-eyed cat in *The Graham Children,* or the bust of Newton that gazes coldly down on the play-acting boys and girls of the Conduitt family in *A Performance of 'The Indian Emperor'.*

Hogarth was clearly much influenced by Newton's theory of gravity, published in *Principia Mathematica* in 1687, ten years before he was born. Objects are always falling in Hogarth's world. It is a place full of overturned coaches and spilled chamber-pots, smashed wine bottles and toppling buildings. The only way is down and this is true of Hogarth's people too. The politician is falling off his chair into the pigswill in *An Election Entertainment.* The baby is tumbling to its death in *Gin Lane,* one of Hogarth's many scenes of drunken affray. *The Midnight Modern Conversation* is another such image. It is a lighter and bawdier drinking picture, but it too is subject to the gloomy gravitational

pull of Hogarth's imagination. When people get drunk in his art they do not leap about or sing and dance. They slump and they fall over.

Hogarth's prints made him one of the first truly rich and independent artists in British history, largely because they appealed to a new and growing moral majority of the moderately well-off. This sector of British society increased greatly during the eighteenth century, in a time of ever-increasing national prosperity. Hogarth brought works of art into the lives of men and women who had never owned or purchased images before. The troubled history of the nation, dating back to the first stirrings of the Reformation, had led to the visual disenfranchisement of the majority of people. When art was squeezed out of the Church images virtually disappeared from the lives of all but a very rich minority. Hogarth did more to reverse that than anyone before or since his own time. One of his most remarkable achievements lay in the extent to which he broadened the constituency of art in Britain. He was the chief pioneer of what was to become, in the hands of future generations of cartoonists and satirists, a genuinely popular visual art form.

Hogarth was fond of signing himself 'Britophil' and he was in many respects a figure who spoke for the nation, or at least a certain section of it which has ever since shown a particular affinity for satire and the satirical vision (perhaps finding in it a palatably verbal form of visual art). His audience was that part of the people, made up largely of newly prosperous artisans, merchants and tradespeople, whose growing influence Napoleon would recognize half a century later when he called Britain a nation of shopkeepers. The nation of shopkeepers has always loved to gloat over the misfortunes of others and has always enjoyed seeing vice punished and the profligate ruined, believing that hanging is too good for them. Hogarth was well adapted to please this audience, since he was himself an artist with the grim and punitive mentality of the hanging judge.

The action in his pictures almost invariably takes place indoors and what an airless, oppressive indoors it is. He saw the places where people live as the traps they devise for themselves. The room is always a box. There is no escape, and everything in his pictures is treated as evidence, to be registered, bagged and sealed. His father spent much of Hogarth's childhood in a debtor's prison, which may account for the strong hold prisons exerted on his imagination throughout his long career. There are many jails in Hogarth's art. One of his first pictures depicts the jail scene in John Gay's *The Beggar's Opera* and both the Rake and the Harlot spend time behind bars. He often seems to have regarded life itself as a form of imprisonment. It is a large if common misreading of his work to find in its busy clutter evidence of something like a Shakespearian appetite for life. Each and every detail in his work is designed to emphasize not the richness but the meagreness of human existence. The rutting dogs in the corner of the room stand for lust; the monkey on a lead symbolizes adultery; the plucked chicken under the table in the brothel is the sign of the virgin who has gone astray. Even objects are prisoners in his pictures, locked into a codified, moralistic iconography.

Hogarth's vision proves that the extreme, moralising Protestant imagination was still alive and well (and kicking) even in eighteenth-century Britain. His vicious, dark, world-hating art shows that the old, revolutionary violence had not left Georgian Britain but had merely turned into something else and found another way to express itself. The iconoclast's hammer and the regicide's axe have become the engraver's tool. But the old Protestant vigour has been tamed to a certain extent in his work, even though it endures in it. Satire can only ever be a sublimated form of iconoclasm, a form of mental rather than physical attack.

Hogarth did not only work as a satirist. Throughout his life he sporadically and rather disastrously experimented in the higher reaches of art. His portraits are better than the large narrative pictures which resulted from his occasional delusions of grandeur. They also show him capable of a limited kind of sympathy. This is most conspicuous in his portraits of self-made men like himself and the best of them is his large and wonderfully direct portrait of one of his closest friends, *Captain Thomas Coram*. The most sympathetic of his pictures, however, is the oil sketch of a London street crier known as *The Shrimp Girl* [35]. It is both the loveliest and the least Hogarthian of his works, a memorial to a girl once glimpsed but never forgotten: the only unmoralized, unspoiled moment of beauty Hogarth ever allowed himself in paint.

Hogarth's darkness is his truest and most enduring characteristic, and the most extraordinary of all his works is the blackest and also the last of all his prints. *The Bathos* [36] is his parting shot, a vicious goodbye to life and the pictorial equivalent of a curse. Here, the iconoclastic attitude of the satirist has darkened to the point where it has turned into something close to nihilism. Britain is pictured as a blasted heath, a dead and exhausted place, where even Time himself lies slumped and worn out. The familiar Hogarthian bric-a-brac of strewn, broken objects – a cracked bell, a snapped bow, a torn book and much else – has been gathered together one last time. Forget the Rake, forget the Harlot; *The Bathos* is the last plate in the world's progress. The sun will soon be extinguished. Nature has been used up and has become barren. Hogarth's final dart is aimed at no particular target and its message is one of generalized hopelessness. There is no point in fighting or dreaming or aspiring, because in the end only death and darkness await. Hogarth, who had always been one of the most literary and emblematic of English artists, even signed the end of his life as if it were a book. The slumped figure breathes his last, and the breath has been turned into a speech bubble. 'Finis', it says: 'the end'.

Hogarth was a flawed and narrow artist, but his significance within the history of British art was considerable. His legacy was twofold. On the one hand he was the founder of a vital and often brilliant tradition of subversion and dissent in British art: a low, satirical tradition which revelled determinedly in its own lowness. Later post-Hogarthian masters of cartoon and caricature such as Thomas Rowlandson and George Cruikshank were to exhibit a constant and very British delight in dragging the rich, the powerful, the prominent and the pretentious down into the mire and the muck of

35 WILLIAM HOGARTH *The Shrimp Girl*, c.1745.

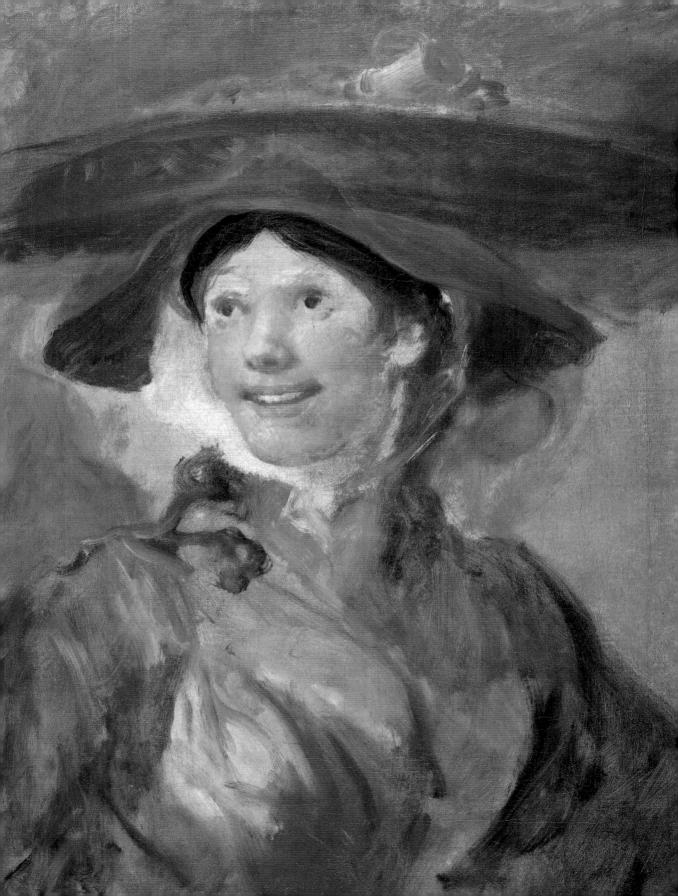

36 WILLIAM HOGARTH *The Bathos,* 1764.

satire. The greatest of all such artists was James Gillray, in whose hands satire became so strange and surreal that its ugliness acquired a curious, unsettling beauty: a form of negative visionariness. This scabrous, satirical counter-tradition, running against the grain not only of high society, but also of high art, was to remain a powerful force in British society for centuries.

But Hogarth's life and times mark another and yet more momentous development within British art. The personality of the artist; the artist's own life and feelings; the artist's sense of personal destiny; the shape and momentum of the artist's career are

subjects which have not, until now, received much explicit attention in this history. This is because in Britain, until the mid-eighteenth century, artists were resigned if not necessarily reconciled to the role of rich man's servant-cum-tradesman. With the arrival of Hogarth all that changed. He was one of the first British artists to earn his own living, to forge a career independent of the patronage of the wealthy, and his example was very important to the generation of artists to come directly after him.

As a direct consequence the history of British art after Hogarth cannot be told in quite the same way as the history of art before him. It must assume a different texture. It must take account of a growing sense of duty felt by artists to themselves. It must reflect a growing desire for what we have learned to think of in the twentieth century as self-expression. The lives and struggles of individual British artists will necessarily form a greater part of the story from now on.

The Phizmonger's Predicament

A new spirit of ambition and a new spirit of dissent entered British art sometime around the middle of the eighteenth century. The growing prosperity of an aristocracy keen to commission portraits of my wife, my horse and myself (not to mention my country estate, my servants and my dog) had opened a door of opportunity for an earlier generation of British painters. Artists such as Wootton or Devis had been quite content to paint within the narrow confines of their patrons' expectations of them. But a distinctly truculent attitude can be sensed among the leading British painters who came after them. They felt an imprisoning lack of opportunity in the narrowness of their patrons' requirements. They began to resent their patrons' entrenched belief that great art was created by dead foreigners, and that all they themselves were fit for was face painting, or 'phizmongering' in the slang of the time.

The Georgian age was a great age of patronage and collecting, a century when some of the most remarkable sculptures and paintings in the world found their way into British homes and museums. The German artist Johann Zoffany's portrait of British collectors abroad, *The Tribuna of the Uffizi,* brilliantly captures the subtle mix of connoisseurship and lubricity that characterized the British cognoscenti of the time. The great art of the past was first encountered (and bought) by the British gentleman during that essential part of his education, the Grand Tour through France and Italy. *The Tribuna,* Zoffany's quintessential and slightly mischievous Grand Tour picture – in which the eager connoisseurs are erotically transfixed by the Titians and Giorgiones, and the painted and carved nudes of modern and ancient Rome which surround them – cleverly makes a simple but important point about British taste.

By the mid-eighteenth century, the old divide in the British attitude to images was running like a fissure through the collecting and commissioning habits of British patrons. The aristocratic collector bought the art of the past to satisfy that part of

himself which remained fascinated by the dangerous sides of the image: its sexiness, its sensuality, its magical, almost living qualities. But he employed the British artist, by contrast, to cater to the other, greyer, more stolid and responsible parts of his temperament. The British artist was to paint portraits, pictures, not of the naked body in action, but the clothed body at rest. In the eyes of the native artist, the aristocrat's love of Renaissance painting and the sculpture of antiquity merely accentuated a terrble lack of imagination when it came to commissioning work from painters in his own country.

The letters of British artists after the mid-eighteenth century begin to resound with complaints about their thankless, repetitive lot, the drudgery of endless sittings and of entire lives spent contemplating the faces of the wealthy: the sullen Mr Smythe to sit at eight in the morning, the impertinent Master Fowles at eleven, the haughty Sir Fotherington Fop at two. The most eloquent Phizmonger's Lament was written by the most brilliant phizmonger of the century, Thomas Gainsborough. 'Damn gentlemen', he once wrote to a friend, 'there is not such a set of Enemies to a real artist in the world as they are, if not kept at a proper distance. *They* think (and so may you for a while) that they reward your merit by their Company and notice; but I, who blow away all the chaff and, by G— in their eyes too if they don't stand clear, know that they have but one part worth looking at, and that is their Purse.'

The restrictive taste of the aristocracy had gradually come to be seen as a kind of tyranny and after 1750 British artists began to form a resistance movement against it. Hogarth had created and exploited a small pocket of possibilities for independence, in the form of his modern moral subjects, but painters who did not want to work for a mass market in that way remained reliant on the patron classes for employment. They could not escape the subject matter laid down to them by the conditions of patronage and they continued to cater, to a greater or lesser degree, to the self-love and the proprietorial sense of the rich. But they also began ingeniously to defy or at least expand the limits of British painting in an attempt to achieve an art of deeper or broader meaning. Gainsborough was one of the principal artists leading the way. The other was his greatest rival, Sir Joshua Reynolds.

Reynolds, who was the founder of Britain's first serious confederation of professional artists, the Royal Academy of Arts, has himself been remembered as something of an institution: distantly venerable, perhaps, but hardly loveable. William Blake, the best known and the most vicious of all his critics, claimed that he was a man 'hired to depress art'. But the opposite is true. Almost single-handedly, Reynolds raised the status of the painter in Britain from craftsman to artist. Before Reynolds painters used the tradesmen's entrance. After him they were allowed – or at least some of them were – through the front door.

Reynolds's life is a parable of the awakening of the visual artist in Britain in the second half of the eighteenth century. The son of a Devonshire clergyman and school-master, he was apprenticed to the mediocre provincial portrait painter Thomas Hudson.

37 SIR JOSHUA REYNOLDS *Three Ladies Adorning a Term of Hymen: The Montgomery Sisters,* 1773.

But he was a rather more romantic young man than has generally been realized, and he always had his eyes on a brighter and bigger world. In his earliest *Self-Portrait* he painted himself as an eager young man, shading his eyes, staring off into the far horizon; he looks as if he is gazing into his own future. Shortly after he painted the picture he was given the opportunity to visit Italy for two years in 1750. While he was there he realized with the force of a revelation what painting could truly be. Reynolds consumed and was consumed by the art of the Italian Renaissance, and in Italy he filled sketch-book after sketch-book with studies after the Old Masters. His Pauline conversion came in Rome, where Michelangelo's fresco cycle on the ceiling of the Sistine Chapel – that great out-flung airborne panorama of biblical history – caused in him an admiration so powerful

it was almost a form of pain. For the rest of his life, he would regard Michelangelo as a virtual god, and the Sistine Chapel as the pinnacle of the world's art.

Reynolds came back to England fired with the ambition to establish a school of British painting to rival the great schools of the past. The Royal Academy, founded in 1768, was one product of that ambition. It was the first British institution to set British painters on the same footing as poets, dramatists and philosophers as literate, liberal contributors to the intellectual and spiritual fabric of society. Throughout his later life, as the Royal Academy's first president, Reynolds encouraged younger artists to aspire to more than mere face painting. To a limited extent, he practised what he preached. Although he made his fortune as a portrait painter to the very wealthy, he occasionally painted huge and overcooked narrative paintings in a melange of borrowed Old Masterly styles. Reynolds genuinely hoped that he would be remembered for pictures of this kind, such as the huge *Macbeth and the Witches* now languishing at Petworth House in Sussex. In fact it is a wreck of a painting, like most of his essays in grand narrative art. In his attempt to lend such works the venerable patina of age Reynolds indulged in technical experiments with his medium. He tried to make his pictures look ancient and Old Masterly by aging them with vinegar and candle wax, but the results were almost uniformly disastrous. Technique aside, Reynolds completely lacked the imagination and the ability to tackle the larger and more dramatic themes of art.

Nevertheless he found another, more successful way to import into his own art something of the grandeur of costume and pose that he had so admired in the Italian paintings he had seen. Reynolds's solution was a very English compromise: the grand manner portrait, in which he posed and clothed his sitters as though they were the *dramatis personae* of myth and legend. Thus, the Montgomery sisters became *Three Ladies Adorning a Term of Hymen* [37], after Poussin, and Mrs Musters became Hebe, after Parmigianino.

When Reynolds exhibited one of the most extravagantly odd of these portraits, *Lady Sarah Bunbury Sacrificing to the Graces,* one of Lady Sarah's acquaintances noted acidly that she 'never did sacrifice to the graces...; she used to play cricket and eat beefsteak'. But the exaggerated, witty fraudulence of such pictures was precisely the source of their appeal. The Royal Academy's president got richer as the lords and ladies of Georgian England queued up to be turned into Apollos and Dianas and cup-bearers to the gods. Reynolds's sitters could play at beings gods and goddesses, wood nymphs and sprites, while Reynolds himself could play at painting in the grand manner of the Old Masters. Best of all, the entire charade could be passed off as a game of extravagant fancy dress in which neither the painter nor his aristocratic sitter could be accused of taking their role entirely seriously. Reynolds was a shameless pasticheur of artists greater than himself, but he was also a realist. He knew that the grand manner portrait was the only way in which he could hope to incarnate, in his own work, even some of the splendour – however dim and faded, however travestied – of the Italian masters whose example had so excited him as a young man.

38 SIR JOSHUA REYNOLDS *Mrs Abington as 'Miss Prue' in Congreve's 'Love for Love'*, 1771.

The profundity that Reynolds sometimes managed in his art was achieved despite rather than thanks to his highest ambitions. His real strength was not, as he hoped, his grandeur but his humanity. Reynolds's career anticipated the fight of future artists in Britain, which was to be above all a fight for self-realization and self-betterment. He understood that the eighteenth century was an age of dawning self-discovery and of personal self-invention, and some of his best portraits could be described as allegories of this. He painted Laurence Sterne in 1760 as a writer choosing to hide behind the barrier of his own wit, arming himself against the world with a raised eyebrow. In a portrait of the late 1760s he depicted Doctor Johnson talking, his hands wrestling with the air as if striving to twist thought, somehow, into words.

Perhaps it was because he had had to struggle so hard to make his own life a success – Reynolds was not an artist of great innate talent – that he was such a fine observer of the struggles of others. His portrait of Mrs Abington [38], actress and courtesan, is a tremendously humane portrait of a girl who has pulled herself up into the higher reaches of society by sheer will and vitality. He painted her in the flirtatious role of Miss Prue, in William Congreve's Restoration comedy *Love for Love,* and the way in which he did so suggests a subtle bond of sympathy between artist and sitter. Reynolds, himself a frequently theatrical artist and a little bit of a prostitute, if only of his own talents, shows us someone more complicated than the stock character of a wanton. He presents Mrs Abington to us as she seemed to him, tough and beautiful. There is a mixture of artfulness and vunerability in her eyes.

If *Mrs Abington as 'Miss Prue'* is the equivalent in art of the lively and unscrupulous working-class heroine of Defoe's picaresque novel *Moll Flanders,* then Reynolds's portrait *The Ladies Waldegrave* shows us the more polite world inhabited by the heroines of Jane Austen's novels. This painting of three young women sitting at their sewing table, pretending not to notice that they have been noticed, is the world that inspired *Pride and Prejudice* put on to canvas. It is also one of the more poignant pictures of the English upper class ever painted, an image of a world where each and every young marriageable woman has a different price on her head and knows it. She keeps the drawer of her chastity locked shut, she cultivates her needlework, and she hopes that the elusive single man in possession of a good fortune may smile on her one day.

Reynolds's best picture of all is his least explicable, most touching image of a human predicament, the portrait *Mary, Countess of Bute* [39]. As painted by Reynolds, the countess is not particularly aristocratic in bearing, merely human. We see an old woman, growing older, out for a pensive and lonely walk with a yapping lap-dog, clutching her parasol to her with strange, subtle defensiveness. It is a picture which seems to anticipate that accidental quality of reality glimpsed, rather than fully seen, which was to preoccupy some of the greatest and most inventive painters of the next century, particularly the French masters Edouard Manet and Edgar Degas. The effect is poignant and also a little disconcerting, like being plunged, suddenly, into the painful details of someone else's difficult life.

All the diagonal lines - trees, parasol, skirt, echoing each other, too obvious, too contrived

39 SIR JOSHUA REYNOLDS *Mary, Countess of Bute*, c.1777–86.

Thomas Gainsborough has commonly been regarded as Reynolds's opposite. Gainsborough contributed to this perception, describing himself as a very ordinary painter of very ordinary things, a man who had no patience, in his own words, for 'poetical impossibilities'. But his art is always full of poetry and alive with dreams of the impossible. Behind it, though differently expressed, may be sensed the same spirit of dissent and the same will to exceed mere depiction which animated the life and work of Reynolds.

Like Reynolds, Gainsborough was brought up in the English provinces. But unlike him he felt no pressing need to go abroad or to make his name in London, at least not in early life. Having spent his childhood in Suffolk, he set up his first studio in Ipswich, where he made a steady but unspectacular living by painting gentlemen farmers and their families in their natural habitat: a lush, pastoral England, which Gainsborough cultivated and improved in art just as his clients did in reality.

Mr and Mrs Andrews [40] is the most celebrated of such paintings, although the persistence of a particular misinterpretation of it has contributed to a damaging misconception of Gainsborough's place in the history of art. This picture has been taken to prove that he was a small artist, a charmer, a mere hireling of the rich, when it actually contains within it the seeds of all that would make him so much more than that. Gainsborough's worldly and watchful couple are alone in a landscape that is also an inventory of their domain. Husband and wife sit next to a field of corn, while beyond it in the distance we see another field where sheep graze, fringed by woodland. The painting is a gentle celebration of a well-off, recently married couple and the fertility of their land. But it is also a celebration of their own, personal fertility – quite appropriately for it is after all a marriage picture – and, in its quiet, understated way one of the masterpieces of erotic painting.

The picture is full of delicate eros. Mr Andrews, whose clothes are almost falling off him, they are so loose and floppy, wears an expression of complete self-satisfaction on his face. Mrs Andrews has a melted, languorous look about her. Mr Andrews carries a gun. The wheat field beside them may recall Shakespeare's famous lines in *Antony and Cleopatra* about ploughing and cropping. But there is nothing *louche* about the painting. Its hints remain hints rather than nudges, and what it celebrates is a beautiful rather than a crude sensuality and human fruitfulness. Mrs Andrews is an aristocratic Venus. Her blue silk dress is like a piece of fallen sky.

To all appearances Gainsborough spent his life painting portraits, but what he was actually doing was chasing the creature of his dreams: the idea of a perfect, completely desirable woman, which obsessed him as surely as it had any of the great sensualist painters of the past. Early on, the Gainsborough woman has something touchingly awkward about her. This is certainly true of Mrs Andrews and, also, of the portrait *Girl with a Book seated in a Park* [see frontispiece] which he painted at around the same time. This vision of a girl looking up with wide eyes from her book, in a garden much like the one at Stowe, is one of the most romantic of all eighteenth-century paintings, and also

one of the most mysterious. Is she waiting for her lover, or comforting herself in his absence? The question will never be answered. She is the English *Mona Lisa,* sitting beside an ornamental pond in a green English garden.

As Gainsborough grew older, the women he painted grew more sophisticated, but also more alike. His later paintings were made in an extremely free and broken style, for which many different explanations have been advanced. Gainsborough had moved to Bath, after his early years in Ipswich, and then to London, and he had had to find ways of pleasing a new and more sophisticated clientele. Turning women into goddesses simply by the way he painted them may in part have been his answer to the grand manner portraits of Reynolds. But nothing can really explain the Gainsborough woman except personal compulsion.

It is known that Gainsborough thought a great deal about sex. He used to sign letters to his many female acquaintances 'yours up to the hilt'. Sometimes he would become so sexually aroused by his sitters that he would have to go into town and buy himself the services of a prostitute. Once he got the clap so badly that his death was reported in the newspapers and he had to write in to inform his public that Thomas Gainsborough, the painter, was still alive. But although he was sometimes a vulgar man he was never a vulgar painter. The keenness of his attraction to beautiful women gave his pictures of them a charge of muffled sexuality: a mood of eroticism which, precisely because it has been channelled into the painting of a dress or the nape of a neck or a half-smile, is all the stronger.

The paintings may be of Mrs Thicknesse or Mrs Graham but the sitter is always the same long-necked creature. Gainsborough did not paint people, in the end, but Gainsboroughs. His women became dryads, unreally tall and gorgeously dressed spirits of nature, more like feathered creatures than beings of flesh-and-blood, inhabiting feathery arcadias of paint.

He went to great lengths to conjure up the effects of dreaminess and unreality in his art and during the course of his life he developed a curious and extremely personal way of working. He would go out for long walks, gathering together pieces of rock, bits of moss and lichen, and he would bring them back to his studio. There he would build them into intricate little tabletop landscapes, using pieces of mirrored glass to suggest water. Then he would black out all the windows in his house, light candles, and go to work copying the small, flickering, shaded worlds he had made. This partly explains the shimmering, almost abstract quality of his landscape paintings and of the landscapes in which he so often placed his sitters. He enhanced such effects in other ways too. His favourite paintbrush is said to have been six feet long and to have shaken like a fishing rod when he painted with it. Gainsborough wanted the effect of beautiful vagueness that this imparted to his pictures. Everything in his world had to look as though it had been touched by magic.

His greatest works are pictures that defy the limitations of the portrait and which proclaim, first and foremost, the genius and compulsions of the painter. Towards the

Overleaf: **40** THOMAS GAINSBOROUGH *Mr and Mrs Andrews* (detail), c.1748–9.

41 THOMAS GAINSBOROUGH *The Mall,* 1783.

end of his life he painted the two defining masterpieces of his career. Both are fantasies and both are profoundly confessional works. They are among the first British pictures to suggest, unequivocally, that the proper subject of art is the artist's personal loves and preoccupations.

He called the first of them *The Mall* [**41**]. In this beautiful and very pastoral town-scape, peopled by the ideal goddesses that had inhabited his imagination all his life, we see a compulsion finally and forever transfigured. The urge and the harassment of Gainsborough's continual sexual yearning has become the vision of an earthly paradise. At the centre of the painting, he has included what looks suspiciously like a disguised self-portrait: the figure of a soldier, pierced to the heart by the beauty around him.

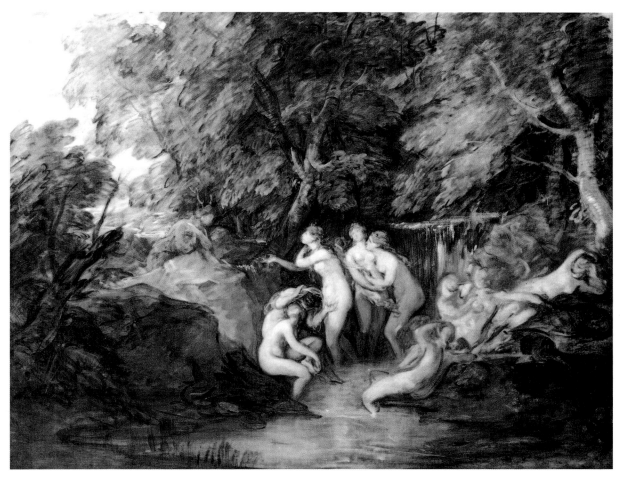

42 THOMAS GAINSBOROUGH *Diana and Actaeon*, c.1785.

Not long afterwards, Gainsborough began work on the only mythological painting in his oeuvre, *Diana and Actaeon* [**42**]. Again we see a man helpless before the vision of a goddess. Actaeon has spied on Diana the huntress and her attendants. He will be punished by being transformed into a stag, and hunted down by his own dogs. Beauty, pain and a sense of dissolution are combined in this exquisite and breathtakingly original picture, a work with the frail, flickering loveliness of a Cézanne painted 100 years *avant la lettre*. Actaeon has begun his own fateful metamorphosis, but in this picture everything seems to be turning into something else, water into smoke, nude women into water or trees. Gainsborough, whose hold on his paintbrush had loosened to such beautiful effect, was himself dying. *Diana and Actaeon* was one of his last pictures.

43 GEORGE STUBBS *Hambletonian, Rubbing Down*, 1799–1800.

Gainsborough's relationship with Reynolds had been troubled by fights and disagreements throughout their lives, but as Gainsborough lay on his deathbed in June 1788 he asked Reynolds to visit him and see his works, and they were reconciled. Later in the same year Reynolds devoted his Fourteenth Discourse to Gainsborough, the only one of his contemporaries to whom he ever gave such an accolade: 'If ever this nation should produce genius sufficient to acquire to us the honourable distinction of an English School, the name of Gainsborough will be transmitted to posterity...' Perhaps they recognized, in the end, their secret similarity to one another. What had united them was their desire to be other than they were. They had both fought the same battle.

Few have done as much as Reynolds and Gainsborough to raise the self-esteem of the British artist. The degree of struggle involved for each of them, as they strove to expand the narrow horizons of painting in England, must have been immense. They were fighting not only the narrowly prescriptive taste of their own society. They were fighting their own history. Reynolds wrote very perceptively about the Reformation and the legacy of its assault on the fabric of the British art tradition. He keenly felt himself to be an artist living in its aftermath (it is easy for us, coming so long after, to forget that he was born only seventy years after the death of Oliver Cromwell) and he spent much of his life attempting, however belatedly, to reintroduce or recreate, somehow, the conditions that might make possible the growth of a confident, native school of art.

He and Gainsborough had shared a predicament and their solution to it had been in many respects strikingly similar, despite the rhetoric of rivalry which led them to emphasize their differences from one another. They had both attempted to raise portraiture to the level of the highest art. But they had also shared a common flaw, as they undertook that enterprise: a lack of confidence, a sense that they were not quite worthy of true greatness. Both artists spent rather too much of their lives living with the ghosts of the past. In Reynolds's case, this showed itself in his constant habit of pastiche, the magpie eclecticism of his many borrowings from the art of the dead. He painted a wonderfully cruel self-portrait in about 1780, which says all that needs to be said on the subject. It is painted in the style of Rembrandt and it shows the artist wearing Van Dyck costume, with his hand resting on a bust of Michelangelo.

It is as if both artists were constantly overawed by the magnitude of their predecessors' achievements, and as if, secretly, they agreed with the view of the British aristocratic patron that great art was necessarily foreign art. Gainsborough's last words are said to have been 'We are all going to Heaven and Vandyke is of the company'. Reynolds, giving the last of his magisterial Discourses to the students of the Royal Academy, insisted that 'the last words which I should pronounce in this Academy, and from this place, might be the name – Michael Angelo'. These are touching statements, but they also reveal a sense of deficiency in both men. The greatest artists grow out of their awestruck admiration for the art of others and their last words concern themselves. Only one British artist of the eighteenth century managed to be himself and only himself, and to realize a grand vision, completely and perfectly.

Standing Alone: the Genius of George Stubbs

George Stubbs has been filed away as a sporting painter, but he was much greater than that confining, genteel description suggests. He remains a deceptive artist, because for the most part he was such an unassuming one. He was one of the quiet revolutionaries, a man who changed the world without the world even noticing.

Stubbs painted the subjects which English patrons required English artists to paint. He painted wives, selves and horses. Above all he painted horses. But his true subjects were not always exactly what they seemed to be. His greatest pictures, like the extraordinary, life-size painting of the racehorse *Whistlejacket*, or the masterpiece of his later years, *Hambletonian, Rubbing Down* [43], have a haunting, haunted, visionary quality entirely unique in eighteenth-century art. They do not describe animals, or at least they do not only do that. Stubbs's subject matter may seem small, but it is actually the largest subject of all: life, in its biological and moral essence.

One of Stubbs's greatest gifts was his ability to make reality seem charged with the intensity of myth, to make the present seem as mysterious and as beautiful as the classical past. In his hands Newmarket Racecourse became a sacred place. He made the rubbing-down house on Newmarket gallops look like a temple. Seen through his eyes, jockeys, grooms and stable-lads seem engaged not in anything as mundane as work but in a form of votive ritual, at the centre of which always stands the horse, the unspeaking focus of Stubbs's world, and an object of reverence. In one of his most abstract pictures, *Brood Mares and Foals*, grazing mares and suckling foals occupy a blank background which enhances the almost musical qualities of his art, his tremendously acute sense of space and interval and his pleasure in playing variations on a single theme. It also enhances the implicit classicism of his sensibility. Here nature has been composed into a frieze. *Parthenon*

Not a great deal is known about Stubbs but not much needs to be known since he said so much in his art. He was born in Liverpool and he studied anatomy as a young man, living in an isolated farmhouse in Lincolnshire, cutting up and drawing dead horses. Anatomy was his first and his last preoccupation (he spent much time during the last years of his life preparing a treatise on the subject), and this marked Stubbs out from his contemporaries. Most other British painters of the time had learned to paint by looking at other paintings. Stubbs learned to paint by looking with intense closeness at reality. The closeness of the scrutiny to which he subjected all things and creatures is evident in the drawings that survive by his hand. These are among the masterpieces of graphic art. A horse or a dog or even a mouse drawn by Stubbs is more poignantly alive than one drawn by almost anyone else. Looking at them is to see a great artist seeing through the conventions of art and reaching his own truths.

Stubbs's eye was absolutely unsentimental, but he was also a generous artist. Although he saw objects, people and animals with tremendous, undeceived clarity, he also saw them with sympathy, perhaps because his anatomical studies had given him

44 GEORGE STUBBS *Gimcrack on Newmarket Heath, with a Trainer, Jockey and a Stable-lad,* c.1765.

a strong and perpetual consciousness of the frailty of all life. Even his most matter-of-fact, workmanlike paintings are charged with an entirely personal morbidity.

In 1765 he painted a picture of a famous horse called Gimcrack winning a particularly valuable race at Newmarket. *Gimcrack on Newmarket Heath, with a Trainer, Jockey and a Stable-lad* [**44**] was painted for the horse's owner, the second Viscount Bolingbroke, who may have insisted on the peculiarly archaic composition. It is a painting which squeezes two events impossibly together: the horse and jockey each appear twice, once winning the race and once being greeted by lad and trainer. But despite this naive device, it was also in its time a new and original painting. Stubbs has left out the crowd that saw Gimcrack win the race, so the action takes place in an oddly empty landscape. The omission is a revealing one and it takes us to the centre of Stubbs's vision. There are never any crowds in his art. He was a painter of solitude, a painter whose tendency was always to isolate. There is a kind of melancholy at work here too. Only Stubbs could have painted the strange, rather sad, sleepwalking figure of Gimcrack's jockey.

Stubbs was an extremely acute observer of eighteenth-century England. He painted someone on almost every rung of the social ladder, from the aristocrat to those who harvested his grain, and there is no more accurate register of the many subtle gradations of the English class system in the century than his *oeuvre*. But he was never quite a sociable painter. There is a perpetual aloofness about him, which communicates itself to those whom he painted.

45 GEORGE STUBBS *Zebra* (detail), 1763.

The intensity with which Stubbs saw people and animals forced him to see them in a state of disconnection, cut off from one another. This may be why the act of touching, in his art, is tremendously and almost electrically charged. In that act the gap that separates all living entities from each other has been breached. The painter invests it with great and tender momentousness. *Whistlejacket and Two Other Stallions with Simon Cobb, the Groom* is one of the most affecting pictures of this. It is painted on a blank background – like the life-size *Whistlejacket* and the *Brood Mares and Foals*, and for the same patron – which enhances the isolation of the forms. Only man and horse touch. The groom rests his hand on the flank of Whistlejacket, to reassure or to comfort. Stubbs has concentrated much feeling in that hand placed on horseflesh. This is English painting's truest equivalent to the creating hand of God the Father, reaching out to spark life into Adam on the ceiling of Michelangelo's Sistine Chapel.

The largest of all Stubbs's paintings, *Hambletonian, Rubbing Down* is another great masterpiece of sympathetic art. It is also one of the most dreamlike and – despite its large scale – one of the most compressed of his paintings. Sir Henry Vane-Tempest commissioned it from Stubbs in 1799 after Hambletonian had won him a small fortune in a match, racing against another celebrated thoroughbred of the time called Diamond. Hambletonian had been whipped and spurred brutally by his jockey and he had finished the race almost dead, lathered with sweat and blood. Stubbs left out the blood but painted the exhaustion. The picture's true subject is the bond of affection that exists between the horse and its attendants. The horse is being consoled by a small, hard-faced man and a coarse-featured but tender boy. They have led their own hard lives and their sympathy for the horse is one of their ways of loving themselves.

Many of the animals which Stubbs painted were the trophies of a newly powerful and growing British Empire. They were symbols of the spread of British influence overseas, of the new worlds opening up before the gaze of explorers and colonizers such as Captain Cook or Sir Joseph Banks. Stubbs saw such creatures – monkeys, lions, tigers, rhinoceroses, arriving to form the first zoos – in all their animal otherness. He made exotic animals look peculiarly unexotic. He saw them as being simply (and rather sadly) out of place and he saw them with compassion, although he never resorted to the low, cute, Victorian trick of anthropomorphizing them. This is what makes Stubbs's pictures of animals so much grander and so much more profound than any other British pictures of animals. There is no more affecting image of loneliness, of confusion, of a sense of being out of place, than his extraordinary portrait of a zebra [45], painted with such incongruity amid the greens and russets of an English wood. If Gainsborough reincarnated the fantastical tradition introduced to Britain by Van Dyck, Stubbs was another Holbein. His realism was, like Holbein's, a form of moral vision.

Stubbs's sympathy extended naturally not just across the barriers of class, but across the barriers of species as well. He accorded the same even attention to each living creature that he painted, so that in his art a dog can easily be as dignified as an aristocrat. He was a great leveller and one of the greatest artists (far greater, in the end, than

Hogarth) of the Northern levelling imagination. Sometimes it is possible to sense the painter actively questioning certain notions of social and natural hierarchy. *Freeman, the Earl of Clarendon's Gamekeeper, with a Dying Doe and a Hound* is a painting entirely about hierarchy and about hierarchy under threat. It is a picture of the deer that dies to feed the man who cares for the dog, composed to form a triangle with man at its apex. Night is closing in on all of them and the certainty of man's innate superiority to the beasts, compositionally insisted upon, but implicitly subverted, suddenly seems less than totally certain.

There was a side of Stubbs which became preoccupied, almost to the point of obsession, with the dark side of nature. He became fascinated by violence, and especially by the relationship between predator and prey. Among his most dramatic pictures are those in which a white horse is stalked and killed by a fierce and cold-eyed lion. He repeats the theme so many times that it comes to assume the quality of a recurring nightmare in his art. This is Stubbs's most disquieting way of saying what he had, perhaps, always been saying in his pictures, his loudest enunciation of the stark facts of life and death as he saw them.

Stubbs was a great artist, by which is meant more than a great English artist. He was a great world artist, in the sense that a painting by him can hang next to a great Titian or Rembrandt or Rubens and not be embarrassed by the comparison. This is where Sir Alfred Munnings made his great mistake about the nature of the British art tradition. The subjects of Stubbs's art might have been my wife, my horse and myself, but that alone was not the point. Stubbs's pictures of horses have nothing in common with Munnings's cold, dry, academic paintings. What makes them great is not their subject matter, but the tremendous weight of feeling that has been invested in them.

Stubbs was not too complicated an artist. In the end he knew just a few truths. But he knew them, and he was moved by them, as profoundly as any painter who has ever lived. He knew that we are, all of us, just bodies moving through space. He knew that, finally, we are all alone.

MODERN ART

46 J. M. W. TURNER *A Bedroom in Venice,* 1840.

Painters no longer live within a tradition and so each one
of us must re-create an entire language. Every painter of our
times is fully authorized to re-create that language from A to Z.
No criterion can be applied to him *a priori*, since we don't believe
in rigid standards any longer. In a certain sense, that's a liberation but
at the same time it's an enormous limitation, because when the
individuality of the artist begins to express itself, what the
artist gains in the way of liberty he loses in the way of order …

PABLO PICASSO, in conversation with Françoise Gilot, early 1950s.

Pictures of nothing, and very like.

WILLIAM HAZLITT, describing the paintings of J. M. W. Turner.

The Progress of Human Culture

Ever since the Reformation art in Britain has been out of step with art elsewhere in the West. Usually, it has lagged behind or loitered apart, lost in its own idiosyncratic concerns. But this has not always been so. British artists did, once, play a crucial and formative role in the development of world art. John Constable and J.M.W. Turner are generally recognized as the greatest of all the British painters. The recognition, however, is more often dutifully conceded than genuinely felt. The magnitude of their achievement is still imperfectly experienced and understood. Constable and Turner are the Darwin and the Einstein of nineteenth-century painting, the artists who broke more radically and decisively with the assumptions of the past than any who have come after them. They invented modern art. But the story of how they came to do so has to begin with the story of another painter: the wrong man, in the wrong time, in the wrong place.

James Barry inherited the same discontent with the narrow confines of British taste that had animated Hogarth, Gainsborough and Reynolds. But he took it to greater lengths than any British painter had ever done before him. Barry was a new kind of British artist: the artist as hero. His legacy was, in essence, the notion that a painter could be a person with a *vision*, someone with a right and indeed a duty to develop and express that vision. Armed with it, the painters who followed him were eventually to change the face of painting itself.

Barry was an Irishman, the son of a builder and decorator, who left his native Cork in 1764 and came to London to pursue a career as an artist. He was determined to become more than just an ordinary painter. Having fallen under the influence of Sir Joshua Reynolds early in his career, he travelled to Italy in his twenties to see at first hand the masterpieces of antiquity and the Renaissance. Like Reynolds before him, he was profoundly impressed by what he saw. But unlike Reynolds, Barry would not compromise. He would actually attempt to walk in Michelangelo's footsteps. His chance came in 1777, when the Royal Society for the Encouragement of Arts, Commerce and Manufactures agreed to Barry's proposal that he paint the Great Room of its London premises. He did the work, as agreed, unpaid, living (it is said) on nothing but porridge and black tea. It took him seven years to complete the task. The result – British art's late, late riposte to Michelangelo's ceiling in the Sistine Chapel and Raphael's *Stanza della Segnatura* in the Vatican – still exists, in good condition but somewhat neglected, in the Royal Society's headquarters.

Barry was accused of many things during his lifetime, but setting his sights low was never one of them. In *The Progress of Human Culture* [47] he set out to tell the history of the world in six oil paintings. The first three pictures in the series trace the history of ancient Greece and culminate in a huge and nearly impressive frieze-like design in which we see the victors of an imagined Olympic Games approaching the judges in a procession. The next two pictures are less sure of purpose. Skipping 2 000 years of

history, Barry jumped straight into the eighteenth century and painted a pair of overcrowded allegories of Britain's commercial, military, political and cultural pre-eminence circa 1778. These images remain notable chiefly for the painter's eccentric use of the Rubensian device of mingling real and mythical personages. Much amusement was had, at Barry's expense, before his spectacle of the musician Dr Charles Burney wading in the River Thames while accompanied by semi-nude river nymphs. Finally, wrestling his grand enterprise back to high seriousness, Barry presents us with a huge vision of heaven and hell. Heaven is a vast plain in which we find dutifully assembled, as if for a school photograph, the illustrious dead of all ages. Hell [see page 129] is a turbulent black hole into which Barry has thrust a horde of twisting, tangled, falling bodies, among which may be found the likenesses of several of the painter's personal enemies.

Barry had many enemies, both real and imagined. His personal life during and after the completion of his *magnum opus* was marked by bitterness and disappointment. He argued constantly with Reynolds, whom he considered a traitor and hypocrite for encouraging younger painters to pursue grand narrative art while lining his own pockets as a face painter. He pursued a personal vendetta against the ageing president of the Royal Academy, and Reynolds, for his part, once admitted that although it was a sin to hate any man, he hated Barry. Barry remains the only member of the Royal Academy to have been expelled. In the last twenty-three years of his life, sorely discouraged by the indifference of his contemporaries, he completed only four narrative paintings. He died in 1806 at the age of sixty-four, having spent much of his last few years living alone, in a poor part of London, victimized by the local street urchins who entertained themselves by throwing stones through his windows and posting dead rats through his letter-box. He suffered increasingly from extreme paranoid delusions, and was afraid to go out after dark because he was convinced that the Royal Academicians meant to have him murdered. After his death, his largest and most ambitious work was destined to be regarded more as a folly than a work of genius. Barry was to be remembered, but more for what he had been than for his work.

The suffering, neglected artist is a figure who has loomed large in the landscape of modern times. We know him well, this man condemned by the combination of personal integrity and public indifference to tread the hard road of his own destiny. But perhaps we have forgotten where he came from. Today the artist-as-hero is most closely identified with the generation of French Post-Impressionists of the *fin-de-siècle*: the hermit Cézanne, the exile Gauguin and the suicide Van Gogh. Lord Byron in England and Géricault in France are earlier incarnations of the same doomed figure. But James Barry's life and his afterlife, during which he acquired the status of a martyr in the eyes of his followers, had set a precedent for them. The notion of the artist as a kind of secular prophet, an embattled seer at odds with his times, was current in Britain as early as the end of the eighteenth century. Barry was British art's rebel angel, British art's first revolutionary.

47 JAMES BARRY *The Progress of Human Culture: Elysium and Tartarus* or *The State of Final Retribution* (detail, right), 1777–84.

William Blake and Anxiety

During the late eighteenth century, Western civilization changed profoundly and for-ever. The event at the epicentre of that change was the French Revolution. With the dis-appearance of the *ancien régime* in France in 1789, an old regime of thought also disappeared. Never again would society seem quite settled or quite safe. Along with the old confidence of the oligarch, an old sense of certainty and stability – or at least the sense that such states might be attainable – had gone forever. If people saw the pre-Revolutionary universe as a clock, the new universe was a crucible, a vessel of constant, molten change. There was the world before the French Revolution and there was the world after the French Revolution. They were not the same place.

At the level of art and literature, rather than politics, this great shift was reflected earliest in the work of British painters and poets. The French Revolution did not create a revolutionary climate in the arts in France; if anything the French art created in its immediate aftermath, the neoclassical propaganda of Revolutionary and Napoleonic France, attempted to bolster rather than undermine old academic assumptions about the nature of art. The opposite was true in Britain, where the existing conventions of art and literature went through extreme and violent change. The two nations, as so often in their history, defined themselves again through difference. France after 1789 was a revo-lutionary nation with a conservative culture. Britain after 1789 was a conservative nation with a revolutionary culture.

A large number of British poets, philosophers, painters and intellectuals took the French Revolution as the model for their own activities. Although they were, for the most part, men and women of the political left, their aim was not necessarily to revolutionize the political structures of Britain but to revolutionize British thought: to develop new ways of reading and writing, seeing and painting. James Barry, who was a political libertarian and defender of the causes of both American and French revolutions, was one of them. Thomas Paine responded to this climate of change with his book *The Rights of Man*; Mary Wollstonecraft wrote the proto-feminist tract *A Vindication of the Rights of Woman*; her husband William Godwin was a prominent and vocal atheist. The rhetoric of revolution also runs through English poetry of the late eighteenth and early nineteenth centuries. William Wordsworth and Samuel Taylor Coleridge described their joint enterprise, the *Lyrical Ballads* of 1798, as a French Revolution carried out at the level of words. They would write in the plain language of plain men, they declared, prophesying that a new order of demotic and proletarian verse would replace the *ancien régime* of ornate poetical diction.

At the centre of this web of religious, political and intellectual history we find a man who has often been wrongly consigned to the margin by historians of culture. William Blake was a deeply restless, rebellious and unorthodox man, but this is precisely why his work is such an exemplary expression of the spirit of the times. He had studied the ideas and philosophies behind many forms of Christianity, radical politics and Northern European mysticism. One of his poems was called *The French Revolution*. The revolutions that concerned him most, however, took place not in the physical world but in the mind. A critical need to decide what to believe, and how to believe in it, lies behind almost everything that Blake ever created, and this is what lends so much of his work its distinctive sense of urgency.

Like Barry, Blake spent much of his life working alone and the knowledge that another had done the same sustained him greatly in moments of self-doubt. 'Barry was Poor and Unemploy'd except by his own energy... I am hid' he wrote plaintively. Blake, who once planned to write a six-book epic poem entitled 'James Barry', certainly believed that Barry had given him much of the courage he needed to be his own man.

Blake was a poet and a painter but he preferred to think of himself as a visionary. He spent his life imagining a world and realizing it in words and images. Blake's world of fantasy is a vivid, intricate place: an unreality which has been brought into being, not dreamily or vaguely, but in sharp detail. Its strangeness is abiding because Blake's pictures and poetry manage to be at once opaque and startlingly clear, constantly obscure in meaning but shot through with piercingly immediate and memorably odd images. He shows us coiling, writhing, leaping figures, like ballet dancers trying to jump out of their skins; Isaac Newton does sums under water; tigers burn bright and airborne worms fly under cover of darkness.

In an age when the established church had splintered, in Britain, into more than fifty sects, Blake became his own religious sect: a one-man church. Questions of faith

preoccupied him throughout his life and making pictures and writing poems were his ways of resolving them. His art was his cathedral. As a young man, while an apprentice to the engraver James Basire, Blake made precise drawings of the tombs and monuments in Westminster Abbey. He spent several years among them and they clearly had a lasting effect on his imagination. Blake's love for such art remained with him throughout his life. His own work would forever afterwards be full of Gothically stiff figures, subordinated to Gothically stiff compositional symmetries. The memory of medieval statues was certainly still with him when, many years after his apprenticeship, he embodied the figure of Christ in *The Body of Christ Borne to the Tomb* as a horizontal, marmoreal effigy. But Blake's style is never settled and his self-conscious Gothic stasis easily gives way to a restless dynamism, often said to be inspired by the tumbling, falling figures in Michelangelo's *Last Judgement* but also influenced by the twisting damned in Barry's *The Progress of Human Culture.*

The constant dialogue between movement and stillness, between change and monumentality, betrays a kind of anxiety in Blake, and Blake's anxiety remains his most revealing and affecting characteristic. He had a deep-seated desire to disown himself, to leave himself out of his art – or at least to claim that that was what he was doing. This is why he was so insistent that what he drew and painted and described in his poetry was not merely dreamed up by him but genuinely witnessed. When he said he was a visionary he meant it literally, not metaphorically, and some of his strangest pictures are images of spirits he claimed to have actually seen, such as *The Man who Taught Blake Painting in his Dreams* and *The Ghost of a Flea.* Just occasionally he managed the trick of making his visions seem credible. In one of the simplest and most delicate of all his watercolours, *Christ in the Sepulchre, Guarded by Angels* [48], he presents us with a pair of beings, seemingly made of liquid or light, whose wings touch to form a Gothic arch. Blake was one of the last artists to paint angels you can almost believe in.

He always said that he had seen heaven for the first time when he was about eight years old. While walking on the common at Peckham Rye, on the outskirts of London, he saw 'a tree filled with angels, bright angelic wings bespangling every bough'. He ran home and told his father, who threatened to beat him and called him a blasphemer. The memory stayed with Blake, and in later life he rarely mentioned either of his parents. He spent much of his life playing out versions of this same child's act of rebellion against parental authority. His art is full of sinister, tyrannical fathers. Often they are evil versions of God the Father, mock-deities, bearded and vengeful Old Testament patriarchs who pass judgement and mete out punishment. In the most memorable of such images, he re-imagines the creation of Adam not as a blessing but as a curse, an evil gift of materialization. In the colour print *Elohim Creating Adam* [49] of 1795 an evil god, a creator more smothering than benevolent, pulls his son out of the earth by his face.

Blake's life work was a single, long-drawn-out cry for freedom from rule, a prolonged Oedipal attempt to kill the father again and again in art. His art and poetry are open

48 WILIAM BLAKE *Christ in the Sepulchre, Guarded by Angels,* c.1805.

49 WILLIAM BLAKE *Elohim Creating Adam,* 1795.

invitations to psychoanalysis partly because they are, themselves, so openly psychoana-lytical in character; his view of the mind, particularly his tendency to equate certain aspects of the human psyche with mythical characters and archetypes, makes him a pre-cursor of Freud and Jung. The freest and most startlingly original development of Blake's imagination is to be found in his ethereal and besettingly odd illustrations to Dante's *Divine Comedy.* In *The Circle of the Lustful* [50] figures are swept up into grand coils and whorls, rivers of humanity that are being swept towards nameless forms of salvation and damnation. In Blake, man is a creature possessed by the immutable facts of his own psychology. The Dante illustrations declare that we are all swept through life by forces within us larger and more universal than we can, perhaps, ever fully understand.

50 WILLIAM BLAKE *The Circle of the Lustful (The Whirlwind of Lovers),* 1824–7.

Blake's spirituality always carried with it a hatred of the heavy, the set, the fixed. He greatly disliked what we have learned to think of as the materialistic approach to life, because he saw that to love things is to risk becoming fixed, like an inanimate object, instead of free like a living being. In his art, to be damned is to be made solid, substantial, like the cursed *Nebuchadnezzar*, who is pictured by Blake as a creature ruled entirely by base, material instincts – a man on the brink of turning into stone or becoming a tangle of dried roots. By contrast, to be blessed in Blake is to be made light, to be turned into a figure that flickers like a flame or shimmers like an ungraspable vision, rising

above the material world. Blake's best-known works, the small illustrated books of poetry which he created by hand and published in limited editions, display this at the level of their form. As he illustrates his own words, he teases them into shapes suggesting wispy foliage, or flames. It is as though text itself has somehow been freed from the tyranny of a typeface and has begun to metamorphose into something freer, more organic, wilder.

But Blake also had a tendency to overstructure his own imagination in an attempt to pull it back from hallucination into meaningfulness. This often produced a certain overemphatic and claustrophobic quality in his work. There is something oppressive about the way Blake's imagery constantly circles and repeats itself. It is as if the same cast of characters (bad father, victimized boy, host of angels and devils) have been condemned to act out the endless, Blakean soap opera of damnation and redemption in endless different permutations. This communicates something sinister to his technique too. His figures often have a slightly raw and unpleasant character. They look flayed as if skinned alive. Or they teem nastily like worms in a bait box.

Blake's work was perhaps, among other things, a form of recompense for doubt. Painting a spiritual world was his way of attempting to convince himself that there really was such a place. But was there, really? Did Blake see God, or was it just a trick of the light? The nervousness in his art, the constant anxiety which it betrays, suggests that he himself, deep inside that visionary mind of his, was not quite sure. He once said, 'I must Create a system, or be enslav'd by another Man's', a remark which goes to the centre of the paradox which so perplexed him. Blake hated what he yearned for. He detested authority of any kind, but he passionately desired that his own work should seem morally and spiritually authoritative. His intense love for the art of English cathedrals, for Michelangelo's Sistine Chapel paintings, for Milton's *Paradise Lost* and Dante's *Divine Comedy* are all forms of admiration which betray this uncertainty. Blake suspects that he may only be a midget standing in the shadow of their great, impregnable, fortress-like works of religious art. He fears that his own belief system may lack the hard, adamantine qualities of their great systems.

His deepest fear was the terror of the solipsist. It was the fear of the awful possibility that his truths and visions might be his and his alone – the possibility that he was not divinely inspired at all, but merely subject to fits of extreme, vivid imagination. Behind that lay his terror of the possibility that he might only be a disconnected, solitary mind, working in the void of his own subjectivity. Blake had picked up the baton which Barry passed to him, and he pursued his own vision. But in the process of doing so he realized (although he only realized it obscurely, through fear and nerves) that it is a dreadful as well as a liberating experience to become your own man. Blake was a fascinating, late eighteenth-century incarnation of that questioning, radical spirit which had informed the British Protestant tradition for centuries. In his art we see that tradition entering a new and convulsive stage of crisis. We see the play of a new and free subjectivity. But we also see a new and desolate solitariness.

I, Me, Myself

The world of the early nineteenth century was a world dimly lit by the dawn of a new and difficult truth. A huge and frightening idea had crept up, quite unawares, on society. The idea was (like all powerful ideas) a simple one: *nothing, nothing at all, is certain.* The British had suspected as much for centuries, and now their fondest wish and worst fear was realized. Having been a nation of people whose perpetual tendency had been to call everything into question, these men and women finally discovered the freeing and terrifying possibility that there might be no truths, no higher certainties, no ultimate source of authority. The early Protestants' urgent quest for true divinity, not in images but in the word of God, not in art but inside themselves – this passionate self-inquisition – had finally and fatefully turned into modern individualism. In the memorable words of the historian Christopher Hill, 'the desperate search for God has ended by squeezing him right out of the universe'.

The British were the first people to understand the true implications of 1789, and the first people to begin, gropingly, to search for solutions to it. Once God had been, if not altogether squeezed out of the universe, challenged more seriously and fundamentally than ever before, what certainty was left? Only the self, the questioning, doubting, troubled self.

The same religious paradoxes that had beset Blake lie behind the narrow but momentarily brilliant art of Samuel Palmer. Palmer, who idolized Blake as Blake had idolized Barry, attempted literally to obey the advice of Blake's poetry and 'discover a world in a grain of sand, a heaven in a wild flower – or a blade of grass'. Palmer's corner of heaven was Shoreham in Kent and in its dells and nooks and fruitful, sheltered landscape he briefly managed to see intimations of paradise. His exaggerated images of blossoming pear and apple trees are his strangest and most powerful works. Coils and blooms of a mysterious, germinative nature, they resemble candelabra held up to ward off the encroaching darkness of a materialistic, atheistic age.

Palmer's vision burned out quickly and he subsided into an enfeebled repetition of the same motifs, spending the rest of his life in a sad condition of unillumination. The most striking of all his pictures is the small self-portrait, in black chalk, which he drew at the outset of his so-called 'visionary years'. There is hysteria behind the solemnity of this fervent, handsome, wide-eyed man. This is one of the most brilliant of all nineteenth-century pictures: the absolute incarnation both of the artist-as-seer, and as an anxious prisoner of his own identity. It is one of the first existential self-portraits.

If the self was the great subject of art at this time the self-portrait was the natural medium for the age. More self-portraits were painted during this period than ever before in British art. Self-preoccupation easily became self-obsession and bred a generation of painters fascinated by its own reflection in the mirror. At the level of taste, it also bred the first generation of viewers, collectors and critics to value the late self-portraits of Rembrandt and to find in such documents of pure being masterpieces to rank with the

works of Michelangelo. The fact that it was only at this time that the seventeenth century's greatest student of the self and its unreliable fictions came to be seen in Britain as a true Old Master carries its own message. Taste is one of the ways in which we confess our deepest preoccupations and define ourselves.

The self was *the* subject to which British writers and artists working in the first part of the nineteenth century always reluctantly returned. British literature of the time became self-preoccupied to the point of fixation and poets recognized this most profoundly in their attempts to deny it. Coleridge spent his early life desperately trying to salvage faith in some form of benevolent deity from the wreckage of the old order of belief, and simultaneously trying to stifle his own, errant, refractory (and beautifully imaginative) self. He spent his later life in stupefied disappointment, having failed to find God and, worse, having decided that he definitely did not care for all that he was left with, namely the contents of his own mind.

Coleridge's uneasy colleague in doomed self-abnegation, Wordsworth, attempted throughout his life to turn nothing more significant than the personal experiences of his own childhood into an epic meant to match Milton's earlier English epic *Paradise Lost*. Wordsworth's originality lay in the very idea of framing egotism so grandly. Begun in the late eighteenth century, *The Prelude* was rewritten in draft after draft. Wordsworth was still working on it when he died in 1850 and it bears witness to the perverse nature of such a project. In Wordsworth, Protestant reflection became another and more morbid form of inwardness. The poet's attempt to build a memorial from the materials of his own identity was necessarily an attempt to make what he called 'the history of a man's affections' far grander than it can ever be. Wordsworth's desire (which makes him more of a Blakean than is commonly supposed) was to armour his own frail subjectivity by making it appear a monument. But the self cannot be this and the moments in which Wordsworth found the most significance may now seem simply and mysteriously personal: rowing on a lake under the shadow of a mountain; watching an old man walking down a road. That piece of life which the poet experiences as a form of epiphany, a moment of release and communion with things larger than one's own being, is easily taken by others as evidence for just the opposite, final confirmation of the subject's complete quirkiness.

It is difficult to separate the verbal from the visual in the late eighteenth and early nineteenth centuries, largely because writers and artists themselves found it difficult to do so. One of the qualities that makes this period unique in the history of British art is the special slipperiness of all the arts at the time. In an age suffering from a crisis of identity, art forms themselves became confused. Under pressure to define new or emergent forms of self-awareness, poetry became pictorial and pictures became poetical. The development had been prefigured in the work of two of the finest English novelists of the earlier eighteenth century, Samuel Richardson and Laurence Sterne, some of whose most remarkable innovations must properly be counted contributions as much to the realm of the visual as to that of literature. When the heroine of Richardson's novel

Clarissa is raped, the author conveys her disordered frame of mind by deliberately disordering the typography of his book so that the words are set in print sideways or upside down, jostling in a free-associative morass of anguish. Sterne, still more daringly, pictured a black mood in his novel *Tristram Shandy* by the simple expedient of including an entirely black page. These are ingenious visual metaphors for the truancies and unpredictabilities of the thinking, breathing, living self.

In the age of introspection, all art forms turned inexorably into versions of surrogate autobiography. In the case of the Swiss émigré Henry Fuseli, the Royal Academy's Professor of Painting, the surrogate autobiography is also surreptitious, something the painter is anxious to disclaim (although he knows, inside, that it cannot be denied). Fuseli, whom William Hazlitt called 'a nightmare on the breast of British art', looked into the dark places of the imagination and painted what he saw there. But he did so guiltily and nervously, shrouding the scenes that his mind dreamt up in the smoke and shadow of a heavily bitumenized oil-painting technique. In private he drew and painted numerous scenes of extreme sexual violence, torture and humiliation, but in his exhibited works he toned his obsessions down to the point where they survive only as memories or hints of real nastiness. He was forgotten for almost a hundred years until the Surrealists rehabilitated him by making him one of their own.

There was also an architecture of introspection, the greatest work of which is the wonderfully labyrinthine house which Sir John Soane converted from three adjoining houses in Lincoln's Inn Fields in London. Soane was Surveyor at the Bank of England for many years and he designed the first public art gallery in Britain, the Dulwich Picture Gallery, but his most remarkable project of all was his own house.

Soane made his house into the model of a mind, a mind that knows itself to be full of devious, strange little corners even while being occasionally capable of perfect lucidity. It is best explored from the top down. Upstairs, in the two main withdrawing rooms, painted a brilliant and blinding yellow apparently suggested to Soane by the pictures of his close friend J.M.W. Turner, you find yourself in a chamber of lucid enlightenment. A clock ticks, nothing seems out of place, sunlight floods in. But descend and you enter a series of rooms that turn from strange to stranger. Convex mirrors distort everything seen in them (the house is full of such mirrors) as if to conjure a metaphor for mental distortions and alterings of the truth.

Sir John Soane's Museum [51], as it is now known, has been called a monument to British eccentricity. But although it is certainly odd, it is not merely odd, because the nature of its oddness is charged with significance. This is eccentricity raised to a philosophy of being. Soane was a great collector and hoarder of objects, and the lower rooms of his house are surfeited with curios: stone and plaster hands, legs and heads, bits and pieces of Gothic sculpture, Greek and Roman fragments, Egyptian hieroglyphics, a sarcophagus, coins and many, many other things. The effect is stunning and entrancing. The old, antiquarian version of the collecting mind – with its desire to tabulate, to order and to understand – has here become suddenly irrational.

51 The Atrium, Sir John Soane's Museum, London, 1812–14.

The climax of the house is an atrium where so many fragments are competing for attention that they seem like thoughts competing for space within an overexcited brain. A temporary respite is provided in the form of the picture gallery, where an ingenious filing system allows rows of pictures to be stacked one behind the other – an equivalent to the faculty of memory, in which things are like facts ready to be called upon. But then you descend, finally, into the cellar of the house, the most irrational of all its spaces, the darkest of them, the most crowded with oddities, and the most morbid (it contains the sarcophagus). This is the place where the mind dreams of its own final unmaking.

At the Soane Museum, we can see one belief system and one world view collapsing and giving place to another. In this building the world of order and shared beliefs, certainty and stability has become another more relative and changeable world. The objective world has become the subjective world. The world of the 'It is', has become the world of the 'I am'. The Soane Museum is a compelling, remarkable monument to the most momentous shift in the fabric of European life and thought to have occurred during the last 150 years. It is the truest of all the products of the age of the self – and the age of the self is, still, our age. At the Soane Museum, we can witness the very origins of the modern world, and we can see not just Sir John Soane himself but ourselves too.

John Constable's Snow

John Constable's art has often been dismissed and, just as often, fondly admired on account of its presumed sentimentality. The truth is that he was one of the most revolutionary nineteenth-century artists, a man whose work profoundly changed the notion of what a painting could look like.

Painters like Blake and Barry had redefined the role of the artist in Britain, and they had reinvented the imagery of art to express a new and troubled order of self-consciousness. But no one, until the advent of Constable and his great contemporary Turner, had found a way of altering the language of paint – its texture, its material essence – to speak of the new concerns, loves and worries of man. Constable's gift to painting was to be a new vocabulary of self-expression.

The Hay-Wain [53] is the most popular of Constable's works and virtually a national institution, but like many celebrated pictures it has been obscured by its fame. When Constable painted it, in his forties, the picture was a manifesto for change and a statement of radical intent. Today it is difficult to imagine how it could ever have been seen as an inflammatory painting. It seems so patently mild and inoffensive, this fresh and breezy picture of a man and a boy crossing a river in a hay-cart while mowers reap in a distant field beneath a typically unpredictable British sky.

The style, which may seem calm in the light of much art that has intervened between Constable and us, was none the less vivid and new in 1821, when *The*

52 JOHN CONSTABLE *Flatford Mill from the Lock* (sketch) c.1811.

Hay-Wain was first exhibited. The most advanced French painters of the time, Théodore Géricault and Eugène Delacroix, were entranced by the subtle network of dots and flecks with which Constable had bedewed everything in his painting. They were fascinated by the moist, mobile, atmospheric qualities of this new art. But the most evidently revolutionary aspect of *The Hay-Wain* was that it treated apparently humble subject matter on a grand scale.

The Hay-Wain is a big picture, one of Constable's 'six-footers'. The doctrines which had governed the academies of Western painting for centuries made it quite clear that only the greatest and most morally uplifting subjects, drawn from myth or history, were

53 JOHN CONSTABLE *The Hay-Wain,* 1821.

important enough to warrant a canvas of this size and prominence. Yet Constable's subject was, scandalously, nothing more than a mere genre scene, a patch of land where the painter had happened to spend much of his childhood. The implications behind this simple act were large. Constable had torn up an ancient agreement concerning just what might constitute serious subject matter for painting. He had dared to suggest that a picture of no more than a stretch of water and a field, seen and remembered by a man who once lived there, could amount to a great theme. He would have perfectly understood what Cézanne meant when, more than half a century later, the French painter said 'I want to stun Paris with an apple'. Constable had already stunned London with a horse and cart.

This was the direct equivalent in painting to Wordsworth's *The Prelude,* that would-be epic about the history of a man's memories of the places where he had grown up. 'I should paint my own places best,' Constable once said, and those places remained his lifelong preoccupation as a painter, even when he no longer lived in Suffolk. But his

insistence that they were 'his' places suggests that the locations themselves were not perhaps his truest subject. His truest subject was himself. Like so many artists of the period, he had discovered – and like them he discovered it a little uneasily – that auto-biography was his inevitable vocation. But he did more with that discovery than any of the artists who came before him.

Constable had realized early in life that he was incapable of painting anything that did not move him. He studied at the Royal Academy Schools in London, where he conceived a violent dislike of the rote of set subjects, and as soon as he had finished his training he returned to Suffolk, to immerse himself in the territory of his youth. He gradually evolved an extremely original way of turning what he saw and felt into paint, and the oil sketches that he produced in the years after leaving art school are the harbingers of his greatest innovations as a painter. Improvisations rather than depic-tions, they are attempts to conjure up in art not still exactitude but the moving, shifting vibrancy of nature. These small oils on paper or canvas are among the most powerful and original of all nineteenth-century pictures, full of tremendously inventive visual equivalences for nature on the wing: coils of paint like blurred shaving cream, to suggest scudding clouds; little dabs of silvery paint alternating with green to suggest the shimmer of a poplar's leaves as, wind-blown, they show first a dark surface and then a silvery underside.

In the sketch *Flatford Mill from the Lock* [**52**], which he painted in about 1811, Constable has brilliantly evoked both a place and a moment. It is a wonderful picture of the mill, trees and water the colour of gun-metal under a sky full of fast-moving clouds. In it may be discerned a lesson for that later school of artists, the French Impressionists. But Constable's painting is more than merely impressionistic. It is charged with human energies and emotions. The changeable world has become a metaphor for the change-able, mobile life of a man. In his most untroubled works of all in this experimental vein, his cloud studies, the texture of painted skies come to seem like a distillation of the texture of thought itself: a void where truant shapes wander and chase each other like ideas or feelings.

Constable never sold any of these pictures, painting the odd portrait for money rather than part with his treasures to people whom he felt sure would misunderstand them. A shy but obstinate man, he remained little changed from youth into middle age, living in his own world of pictorial experiment and sustained almost always, as his letters show, by a slightly obscure sense that he was chosen. He could afford to do so because, like many of the more innovative painters of the century, he was a man of independent means. Constable's father, Golding Constable, was a wealthy mill-owner who virtually ran Dedham Vale. The corner of Suffolk painted by his son was literally Constable country, and the money earned by Golding's mills and boats paid for John's paints and canvases. Constable infuriated his parents by living the life of a perpetual art student. 'Dear John,' his mother wrote to him in 1809, 'how much I do wish your profession prove more Lucrative. When will the time come that you realize!!!'

54 JOHN CONSTABLE *The Leaping Horse* (sketch; detail, left), 1824−5.

Constable's mother exerted an influence on him in other ways too. Brought up within the Anglican church to believe that nature is God's book, she rather disapproved of painting. She was not interested in art because she saw religious symbols everywhere in nature. The sight of reapers at harvest time, for instance, would put her in mind of Adam and Eve's original sin and God's punishment for it, work. Constable inherited her stiff, politically conservative, morally unbending character. He also tried his best to share her habit of seeing landscape in religious terms, and in the middle part of his career he filled his art with religious hints and suggestions. A skeletal canal boat, seen under construction in a verdant riverscape, managed to put him in mind of Noah's ark. He made sure the dung-hill had a rose growing in it, to symbolize Christ's death and his resurrection. He often terminated the vistas of his pictures with a church spire, as if to suggest that the scene of his life was bounded by religion, enfolded and enclosed under the benevolent eye of God.

But as his passions worked themselves more and more deeply into his work, the conventional Arcadian schemes of his landscape painting buckled and cracked. 'Painting is with me but another word for feeling', he once declared, in a remarkably clear statement of the changed priorities of art in his time. The most outstanding demonstration of what he meant by that is the full-size oil sketch [54] for a painting called *The Leaping Horse*. Constable completed it in early 1825, and it is the masterpiece of his life.

The painting's subject is a horse and rider, pulling a barge, leaping over a stile on the towpath of the River Stour. That, at least, is its official subject. This is one of those rare pictures where we can see an artist realize the whole of his vision and drive home the full implications of his achievement in a single work. The intensity of the painting is still as shocking as it must have been to Constable himself when he first painted it. The loose, free touch of the early oil studies of Dedham Vale, as well as the network of moist dabs, coils and flicks that the painter had developed in six-footers like *The Hay-Wain* reached their unsettling culmination in this picture.

To look at *The Leaping Horse* sketch is to see feeling come untethered from meaning. A great surge of inexplicable emotion, which cannot be resolved into a vision of religious or any other kind of harmony, has whipped paint up into a sort of frenzy. Something extraordinary has happened in the art of the West. A new order of experience has announced itself in a fundamental change to the very nature of painting. The continuous surface, the smooth skin of a painted illusion, for so many centuries the ideal of painting, has been shattered. This is one of the most compelling pieces of early modern art.

There had been painters in the past, such as Tiepolo and Fragonard, who had made a virtue out of a sketchy finish, but their sketchiness was that of the virtuoso, a demonstration of ease not passion. There had also been painters in the past who had disturbed the emotional surface of their pictures with rough and blatant brushstrokes, such as Rembrandt and most remarkably of all Titian in his last and most moving work, the *Pietà*. But their dissolved styles of painting had been very different in mood and

intention from Constable's style. Their broken styles were less extreme and clamorous, more renunciatory. Quite simply, there had never been anything quite like this yowling welter of discontinuous marks in painting before. By the conventions of the time, Constable's picture was entirely unexhibitable and could only be regarded as a sketch.

Constable's contemporaries did dimly recognize the shift he had engineered in art, although they tended to phrase their insights as criticisms. 'It is evident that Mr Constable's landscapes are like nature', wrote one English critic, 'it is still more evident that they are like paint.' This is true, and when painting came to resemble itself, more than anything in the world outside painting, it acquired a new dimension. Constable's paint in *The Leaping Horse* sketch tells us not only what the painter sees but what he feels. Paint has become like a liquid emission of excitement, so that the surface of the canvas is literally covered with a screen of white flecks.

Constable, who knew that the technique had become his signature, called this effect 'my snow'. It seems doubtful that he realized where it was to lead him when he began experimenting with it. To judge by the constant reference made in his letters to fresh-ness and breeziness and his love of such qualities in nature, it seems to have started out as a way of evoking them. But in *The Leaping Horse* sketch the snow has become a blizzard, and what emerges through the storm is not a vision of nature, but of human nature. In painting his great picture Constable made absolutely explicit, in the texture of art, the fact that we can only know the world subjectively, through the screen of our own thoughts and memories and emotions. That, above all, is what his 'snow' stood for: all that clouds human vision and all that makes every experience a personal one. This is a new form of self-consciousness turned into paint.

But there is also something disturbing about the picture, a sense that the emotions invested in it are not at all happy ones. The kind of truth which it tells us about the world and how we occupy it is lonely and alienating. There is desolation in this image of man and horse striving to resist gravity under a stormy and darkening sky.

It was Constable's sad fate to be alienated by his own originality. Many of his later paintings are dark, blasted, miscalculatedly overpainted works, as if the attempt to paint his vision back into order could only turn it blacker and bleaker. He never actually exhibited *The Leaping Horse* oil sketch, but embarked on another, slightly calmer version of the same subject, which he decided to call the 'finished' version. There is still a trace of sketchiness to the picture, but it is much closer to the breezy naturalism of *The Hay-Wain*. Constable even painted a little church tower onto the horizon, as if to seal the painting off from the disorderly world from which it had sprung. He had taken revenge on his masterpiece by demoting it to the level of preparatory work.

Constable's view of his own work should certainly be treated with respect, but also with circumspection. This was a volatile, fantastically experimental moment in the history of art. The difference between 'preparatory' and 'finished', between sketch and exhibitable painting, is almost impossible to determine at this time – partly because the essence of painting was being reinvented so radically that painters themselves could not

be entirely sure. One symptom of this new and complex situation, in which the very nature of painting itself was being opened to question, was the fact that painters were keeping their 'sketches' in quite unprecedented quantities. Constable, after all, did not destroy his masterpiece, but kept it until the end of his life. That fact may tell its own story. Having painted a revolution, Constable knew that he could not unpaint it.

Constable's influence on Western painting is much greater than has been widely recognized. His work is the root of that aspect of modern painting manifest in the art of Géricault and Delacroix: a powerful, melancholy subjectivism brought to another climax in the boiling world of Van Gogh; a strand of patently self-expressive art finally and most wildly wound to its conclusion by Jackson Pollock in the United States in the late 1940s and the 1950s, in the skeins and loops and whorls of paint spun across his canvases. Constable shook up the still world of Western art like a child shaking a toy snowstorm. After him painting would never look quite the same again.

Turner's Light

J.M.W. Turner, Constable's rival and colleague in the reinvention of nineteenth-century art, must be counted the greatest British painter in history. Like Constable, he pursued his own vision with tremendous stubbornness and singleness of intent. Like Constable, he had an innate and pessimistic sense of what it might mean to live in the new and revolutionary conditions of the early nineteenth century. But unlike Constable, and unlike so many of his contemporaries, Turner managed to go through doubt and experiment and the travails of discovering his own originality and arrive at another and brighter view of the world.

Turner persisted through the agonies of self-consciousness which darkened the thoughts of others and he went beyond, far beyond. In his art, beauty and awe are the last compensations for the awful mystery of being alive in a world where older kinds of faith have become untenable. Turner saw the world as a void but, for him, its emptiness was not made of darkness but of light.

If critics were bewildered by Constable's 'snow', they were as bewildered by Turner's even more adventurous and unruly working practices. The excessiveness of the insults levelled at him – far worse than those levelled at any of the more notoriously misunderstood painters of the later nineteenth century – should perhaps alert us to the magnitude of his own revolution. The painter and author Lawrence Gowing, Turner's most perceptive admirer, may have been right to say that Turner's critics wrote about him as they did because the artist had goaded them 'to the point at which they almost realized that painting was uncovering, not only new means of representation, but a new substance, a different order of reality.'

From the beginning of his career, in the 1790s, Turner's work prompted a barrage of inventively mocking metaphors from uncomprehending critics. The frothy waves in his

55 J.M.W. TURNER *Interior at Petworth,* c.1837.

earliest, Dutch-influenced seascapes were compared to slabs of heavily veined marble and in the course of his lifetime his paint would be compared to all kinds of other substances and vapours: soap, coal-dust, custard, cream, tinted steam and smoke. Now, inevitably, such criticisms seem more like compliments – daringly advanced remarks to have made about such daringly advanced painting. But while that specialist in erotically charged murk, Henry Fuseli, may have meant to express a sneaking admiration when he described one of Turner's paintings as 'like the embryo or blot of a great master of colouring', more or less all Turner's other contemporaries were united by their dislike for his most adventurous works. Sir George Beaumont summed up the prevailing aesthetic climate when he sonorously proclaimed that 'Turner is perpetually aiming to be extraordinary, but rather produces works that are capricious and singular than great'.

In late life, when he was confident in his own, new vision of things, when he knew that he was both singular *and* great, Turner rather liked to flaunt his 'capriciousness'. He made a habit of finishing his paintings for exhibition in public, to make an exhibition out of the act of painting a picture. He was in this respect both the Liszt and the Paganini of painting, an artist who flaunted the improvisatory nature of his talents. One of his contemporaries, the painter E. V. Rippingille, described Turner at work on a painting in the mid-1830s, in language that alternates between the mock-biblical and the mock-superstitious. Turner at work, he said, was like 'a magician, performing his incantations in public'; beginning with a canvas so barely begun that it could only be described as 'a mere dab of several colours, and "without form and void", like chaos before the creation', Turner would create from it an entire, coherent world. Rippingille meant to mock but accidentally got to a truth about Turner. There was something dangerous and inflammatory about him, like a shaman or magician, and he did create the world anew in art.

Turner himself, as he went further and further into the etherized imaginative world of his last years, developed a protective armour of brusqueness. He could hardly bear to speak to the young John Ruskin, the enthusiastic critic-cum-whippersnapper who dogged him so by writing all those long and biblically portentous passages in *Modern Painters*. He had little time for those who misunderstood his grand disdain for literal depiction. When C. R. Leslie informed Turner that a New York buyer had commented on the troubling indistinctness of his work, Turner, who was entering the last and most radiant phase of his career, retorted 'you should tell him that indistinctness is my forte'.

Looking at a late picture such as *Norham Castle, Sunrise*, one of the most tremblingly, evanescently delicate of all his works – a painting that seems not only to depict the fall of light but to be actually made of light – it is plain that indistinctness was more than a matter of style. Turner's apparent vagueness was actually a form of precision. It was his way of shaping, with brilliant and loving clarity, a new idea of beauty and a new perception of the world. We can never fully understand the process by which Turner liberated himself into the miraculous and prescient visionariness of his late work. But we can, perhaps, follow its course. Turner's struggle to achieve his vision – and it was a huge struggle – presents one of the most heroic spectacles in art

Turner's originality is discernible in everything he painted, and almost all his earlier works can now be seen to contain slight, subtle auguries of his maturity. Often, in the topographical watercolours he made in his first years as a painter, patches of sunlight seem to eat into rather than simply define the surfaces that they strike, as if to predict the grand devouring storms of light that swallow everything into indistinctness in his last works. In Turner's first seascapes, the sea may seem just a little too strangely turbulent, as if preparing to whip itself up into the vortex of light and mist and water that we find in a late masterpiece such as *Snowstorm – Steam-Boat off a Harbour's Mouth*. But such small prophecies cannot obscure the fact that Turner in his early years was, if not quite a conventional painter, then a painter extremely keen to gain recognition of a

conventional kind. He must have been bitterly disappointed by Sir George Beaumont's criticisms in particular, because Turner in his youth wanted to be anything but singular. He wanted to fit in, and he wanted to paint pictures that fitted in.

In many ways he was remarkably similar to Sir Joshua Reynolds, so often mistakenly regarded as his antithesis. Like Reynolds, Turner was an inveterate technical experimenter. Like Reynolds, he was a passionate upholder of the values of the academy. ('He stabbed his mother', was his one brutal comment when he learned that the artist Benjamin Robert Haydon, the most outspoken opponent of the Academy during Turner's lifetime, had shot himself.) Like Reynolds, he spent much of his life seeking respectability by imitating the art of others, invariably dead Old Masters. Almost throughout his life, Turner painted mythological landscapes in the style of the French masters, Claude and Nicolas Poussin, and genre paintings in the style of the Dutch masters Jacob van Ruisdael and Aelbert Cuyp. He painted several homages to Rembrandt, and one of the most eccentric of all his pictures is the homage to Raphael which he painted in 1819 – a doomed project if ever there was one, since it is hard to imagine a painter whose sensibility had been further from Turner's own. Turner was in his forties by then and even that late he was still seeking to join the great tradition, as Reynolds had done, by imitating artists already enshrined within its pantheon.

Turner was reluctant to recognize the extreme turbulence of his own nature. But we should also remember that before the generation of Constable and Turner no one had tried to be a modern artist in quite this way. The notions of vision and personal destiny that are taken for granted in the language of much art criticism today were still being forged, and forged in lives such as Turner's. This surely helps to account for the fact that the pattern of his development, until well into the 1820s, was both frustrating and frustrated. He almost allowed himself to be himself, but then he always pulled back from the brink, disguising his difference from all other artists by forcing himself to assume shapes that distorted him.

He was particularly adept at impersonating painters of fashionably 'sublime' scenes of apocalypse. *The Fifth Plague of Egypt* is a fine example of his ability to paint melodramatic crowd-pleasers. This work later inspired the most melodramatic of all English painters, John Martin, to paint his own popular gaslit pictures of what the end of the world might look like; and Martin's fantasies, with their casts of thousands, in their turn were to fire the imagination of the first directors of Hollywood spectaculars, such as Cecil B. de Mille. Turner seems to have especially relished painting scenes of violence, possibly because such scenes gave him most occasion to develop his own ways of seeing and perhaps they suited an abiding pessimism in his character. Throughout his life he worked desultorily on a long and dismally depressing poem called *The Fallacies of Hope*. His picture *The Fall of an Avalanche in the Grisons,* in which we see a cottage in the Swiss Alps being crushed like matchwood by great plummeting boulders, expresses the same numb fatalism. The best of all Turner's apocalyptic pictures is also the undisputed masterpiece of the first part of his career.

56 J.M.W. TURNER *Snowstorm: Hannibal and his Army Crossing the Alps*, 1812.

He exhibited *Snowstorm: Hannibal and his Army Crossing the Alps* [56] in 1812 and in it we see Turner, if not daring to be Turner, then at least attempting to work out the implications of allowing himself to be. He is still operating in disguise – pretending on this occasion to be a painter of grand narrative history – but the disguise is a thin one. Turner does not seem terribly interested in Hannibal and his army, who exist only as ants in a huge, disturbed vortex of paint. He seems, rather, to be asking himself some pressing questions, among them, perhaps, the larger questions of his time. Can beauty be won from a world ruled by violent change? Can catastrophe become an occasion, not just for fear, but for enlightenment? The storm that threatens is beautiful. Something that changes the world forever, it is not necessarily to be fought or resisted, but entered into. The picture begins to provide the answers that will form Turner's late style.

It was to be Turner's destiny to make irrelevant old, conventional distinctions between beauty and terror, hope and despair, turbulence and tranquillity. In the end, turbulence was to become another kind of tranquillity in his art and violence was to become another kind of calm. At the eye of the storm, in *Hannibal,* we see a great glow. The first Turner vortex, it is like a firework exploding in mist, both radiant and diffuse. There had been nothing like it in oil painting before. Turner was eventually to find the courage to dive into that pool of light.

We think of most of the great revolutions in world art as having happened in romantic famous places: Rome, Montmartre, New York. But Turner's revolution took place, almost without anyone noticing, in a quiet corner of rural West Sussex. In 1828, Turner was invited to stay at Petworth House by the independent-minded George O'Brien Wyndham, third Earl of Egremont, who possessed an extremely large income, most of which he spent on wine, women and painting. He loved art with a large and sensual passion and he built a huge echoing marble hall to house his large if slightly uneven collection of predominantly British, predominantly contemporary paintings. Egremont was that rare phenomenon, in the early nineteenth century, a British patron who actually supported living British artists and enjoyed making them feel cherished and respected.

Turner enjoyed his time at Petworth, and Egremont cherished him more than any other artist. He was given exclusive use of the old North library, with its north-east light, to use as his studio. Some artists find it easier to do great things when they feel loved. Turner treated Petworth as a playground of the imagination – an arena where, free from the need to please others or confine himself, he could experiment. The water-colours which he painted during his several visits to Petworth amount to a diary of the house. They are full of enigmatic details which, filtered through Turner, combine the mundane with the phantasmal. An unmade bed, no one in it, becomes a scarlet appari-tion of sensuality, sexiness transmuted into sheer, heavy colour. Billiard players loom as black and strange silhouettes out of a sunburst of light and colour. To look through Turner's painted journal is to see him suddenly and marvellously accelerate towards the brilliance of his maturity.

Turner often went fishing at Petworth, or at least that was what he claimed to be doing. He may have spent more time looking than baiting a hook and casting a line. He once said that 'every glance is a glance for study. Every look at nature is a refinement upon art', and water particularly fascinated him. The endless twinkle of light on water, the endless play of reflections on a surface of infinite planes and infinite reflectivity, contained a deep truth for him. In his work at Petworth we can see the very substance of the world, as he perceived it, undergoing a kind of watery shift, becoming disembodied, mobile, unfixed.

Many of his Petworth works are watercolours, and this marks the moment when he realized that the watercolour was central to his art, not a peripheral, minor form as it was generally regarded at the time. He began to import the effects of watercolour into oil painting, a process which reached its first fluid climax in a large oil painting called *Interior at Petworth* [55]. By the standards of the 1830s, this must have seemed an almost incomprehensible work of art. In it, we see an aristocratic country house, reconceived in art, turning into a strange, elemental, primal world, a place such as the universe might have been before the advent of objects. Only Turner could have won a vision of such apocalyptic force from the subject matter of the conversation painter.

The second formative event in Turner's creative life occurred on the evening of 16 October 1834. That night the Houses of Parliament burst into flames and a huge crowd gathered at the edge of the River Thames to watch the largest bonfire of the century. Turner was among them, and the watercolours that he painted from the memory of the event are among the most exhilarating pictures in the world [57]. No artist before Turner had ever captured the essence of fire as vividly as he did in these small but tremendously free works, perfect evocations of flame reflecting off water, glowing out of a dawn sky, or fading down to embers. If Prometheus had been a painter, this is what his work would have looked like. Perhaps what Turner saw when he looked into those consuming flames was his own, Promethean destiny as a painter. The fire that devoured the Houses of Parliament was Turner himself, because he was the fire that would burn down the established order of art.

There is no structure in fire, no order, and no point at which a fire is fixed. Fire is transient, perpetual, unending motion. Fire, like water, fascinated Turner because it was such a potent emblem of his conviction that change, not stasis, was the ruling principle of the world. Painting fire was also his way of announcing that he was ready to embrace both change and his own revolutionary aspect, rather than resist it as he had done for so long.

But fire, in itself, was a subject that Turner was to leave behind. Fire was to become colour, the glittering tissue of chromatic touches that makes his work of the later 1830s so tremendously, ravishingly seductive – and colour, finally, was to become light. Turner was not, of course, the first artist to have been obsessed by the elusiveness and beauty of light. Caravaggio's drama, Rembrandt's morbidity and Vermeer's bewitched, heightened realism were all inseparable from their handling of light and its fall, on objects and

57 J.M.W. TURNER *The Burning of the Houses of Parliament* (detail), 1834.

bodies, in time and space. But despite their differences, all those great artists – indeed all artists before Turner – shared one common assumption. In their paintings light's function was to model form. Light worked at the *service* of form. But to look at the masterpieces of Turner's later years is to see that, in his art, it is the other way round. For him form exists to give reality to light. It is light that is real, form the inessential, the shadow, the incidental. This insight is what Turner's many pictures of destruction and apocalypse had been leading up to. Empires will fall, buildings will crumble, men and women will die. But light will always endure.

It was to take a considerably later generation of viewers and painters to appreciate the true extent of Turner's originality. In the later nineteenth and early twentieth centuries Turner's importance would be understood and his influence would be disseminated by the French Impressionists and, above all, by Claude Monet, who had been deeply impressed by Turner's paintings when he was in London in the early 1870s. A decade later, in a letter signed by Monet himself and Pissarro, Renoir, Degas, Morisot, Boudin and Cassatt, the French Impressionists stated their shared aesthetic and acknowledged the size of their debt:

> A group of French painters united by the same aesthetic tendencies, struggling for ten years against convention and routine to bring art back to the scrupulously exact observation of nature, applying themselves with passion to the rendering of the reality of forms in movement, as well as to the fugitive phenomena of light, cannot forget that it has been preceded in this path by a great master of the English School, the illustrious Turner.

Although in later life Monet desperately tried to play down Turner's influence, it was clear enough to leading French artists in the 1880s that Turner was the giant of painting in their time. The message was never conveyed to Turner himself who had been dead for over thirty years when the Impressionists wrote their letter. It must have been a huge burden for him to be painting pictures that were so far ahead of their time that almost no one, other than he himself, could have really begun to understand them.

The scorn that was poured on his most daring and radiant work was relentless, and Turner's response – a characteristically independent one – was to invent a second, secret identity for himself. For much of the final period of his career he lived a double life. Officially, he remained Mr Turner the Royal Academician, painter of increasingly eccentric but still just tolerable history paintings and landscapes. Unofficially (and much of his time was spent unofficially) he lived out of the public eye in secret, passing himself off as a character called Admiral Puggy Booth, a retired admiral of the fleet, and painted as he pleased.

Turner's need for a second identity has aroused the curiosity of his biographers (his secrecy was such that their curiosity has never been sated, however) and also the faint embarrassment of art historians. But Turner's invention of Admiral Puggy Booth now

seems neither particularly mysterious, nor particularly shaming. It was, surely, his way of gaining the space and the freedom to experiment that he had first found at Petworth. It was his way of liberating himself from a hostile and foolish world of critics, to paint what he wanted, how he wanted, and thus to renew himself over and over again. That is what he did, in his last and most incandescently brilliant works.

Turner left over 19 300 works to the nation on his death, with the telling stipulation 'Keep them together. What is the use of them but together?' The remark suggests that he realized that we might be able to see him whole one day. Of those works, perhaps the most striking of all is a miraculous late watercolour in which Turner depicted the bedroom of a hotel he had stayed in in Venice [46]. It is an endlessly fascinating picture, and within these few square inches of paper stained by coloured water we can see, almost as if mapped out for future generations, the entire course of what we call modern art. In Turner's instinctive disregard for conventional perspective, we can see the spatial freedom of Cubism. In his colour, we can see the saturated colour and sensuality of Matisse. In his line we can see the imperious free geometry of Mondrian. In the shimmering touch that brings a blank wall to life we can see predicted the sublimity of the finest abstract American paintings of the twentieth century. It seems barely credible that he should have painted it in 1840.

Remarkably, there are still many who persist in regarding works such as this as being peripheral to his achievements – as works which he somehow could not have meant, or which he never got around to finishing. Of course he meant them, and of course they are not unfinished. They are Turner's most extreme statements of his own vision. They are the essence of Turner, purged finally and forever of story, anxiety, and academy.

In them we can see that Turner did not just predict modern art. He anticipated at least some of the poetry and adventure and uncertain, speculative beauty of modern science. He sensed, by some subtle prescience that no one will ever explain, that it was above all in examining and pondering the phenomenon of light – its elusiveness, its beauty, its mystery and strangeness – that mankind would come to ask itself the biggest questions about the universe.

Gazing into the sublime, beautiful almost-nothingness of his last works, it seems plain that Turner realized that there would be, could be, no definitive answers to those questions. He realized that there was no God, and no reason to existence. He had come to see the universe as a succession of inexplicable events taking place in an uncertain void of indefinite origin. But his response to doubt was simple. He set himself free. He became his own god. And Turner said let there be light. And there was light.

ALL CHANGE

58 WILLIAM POWELL FRITH *The Railway Station,* 1862.

I have tired the eyes of the mind
regarding the colours and lights.
I have felt for His Wounds
in nozzles and containers.
I have wondered for the automatic devices.
I have tested the inane patterns
without prejudice.
I have been on my guard
not to condemn the unfamiliar.
For it is easy to miss Him
at the turn of a civilisation.

DAVID JONES *A, a, a, Domine Deus*, 1966.

Beware the Jabberwock, my son.

LEWIS CARROLL *Jabberwocky*, 1871.

British Art Changes Trains

The character of art in Britain after Turner's death was formed by an act of aesthetic rejection as surprising as any in the history of the nation. Having witnessed the most prophetic art of the nineteenth century, the British turned away as if dazzled by Turner's fire and light.

The difference between the art of Turner and the art that followed Turner may be measured in the gap that separates two paintings. In 1844, seven years before his death and seven years after Queen Victoria had come to the throne, Britain's most brilliant painter exhibited one of the most outstanding paintings of his later years. He called it *Rain, Steam and Speed* [59] and its subject was an early steam train, rushing across a bridge through swirling fog and vapour during a torrential downpour. Turner's train is a beautiful, extraordinary apparition. It is the painter's emblem, his alter-ego.

The train was not just a contraption which moved Turner from place to place more quickly than ever before. It moved him emotionally. It made him *see* the world as never before. He put this into the very style of his picture, conjuring up effects of blur and rush to celebrate a new speeded up vision. Turner had looked the future full in the face. He had found it beautiful. He had found it exhilarating. But those who came after him were to take a different view.

In 1862, William Powell Frith, pillar of the Victorian art establishment, painted his version of the Railway Age. It is called *The Railway Station* [58] and it is indeed a stationary picture. Turner's onrushing monster has been stilled and made entirely unthreatening. The train in Frith's painting does not move. The engine does not face us, but sits, placidly smoking, in the middle distance with its face averted. This train is not a painter's self-image, nor a vehicle of change, but a very Victorian machine, an emblem of social stability.

Frith's main subject is the crowd that throngs the busy Paddington platform, and his picture exists to make visible what he saw as a natural hierarchy of social order. The crowd has been organized as if in alignment with the train's compartments, third class, second class and first class, so to read the painting from left to right is to ascend smoothly from the lowest level of society to the highest. There is room on board Frith's train for everyone, or at least everyone who plays by the rules. Two detectives arrest a crook who is about to climb aboard.

Frith engages the eye with the almost inordinate amount of minute detail beloved of so many Victorian painters and viewers. Turner's inclusiveness, his way of cramming universal forces and truths within the narrow confines of an oil painting, has here become a different kind of inclusiveness. The universal vortex has become a social panorama. Like so many Victorian paintings (like so many Victorian objects, buildings and books) *The Railway Station* is an image, and a somewhat wishful one, of British society as the bourgeois conservative Victorian mind thought of it. The political conservatism of the painting is mirrored by the conservatism of its style. There is none of

59 J. W. M. TURNER *Rain, Steam and Speed – The Great Western Railway,* before 1844.

Turner's beautiful exuberance here. All that has been timidly turned away from. Frith's painting does not say yes to change, yes to the future, yes to new ways of seeing. No, it says. No thank you.

Soot, Soap, Society

Victorian conservatism often produced an art infected by the drowsy dullness of escapism, or, as often, one which fell into the different tedium of moral earnestness. But Victorian conservatism itself was never tedious. It was complicated and urgent. It was a society's attempt to stay sane.

The Victorians often give the impression of being obsessed with reality. Their elaborate paintings, their baggy novels and the cluttered rooms in which they contemplated

those things are all surfeited with detail, so crammed to bursting with bric-a-brac that they seem to speak of an immense, insatiable hunger for the things of the real world. But Victorian materialism was devious, and there were many things in the real world that most middle- and upper-class Victorians could not bear to think about, let alone stare full in the face.

The nineteenth century witnessed the largest changes seen in Britain since the turbulent years of the Reformation. The Industrial Revolution, which had begun in the second half of the eighteenth century, transformed the character of the British landscape and townscape forever. New science meant new industries. New industries meant new working practices, new cities and new living conditions as huge numbers of people switched from agricultural work to form dense urban communities organized around mining and manufacturing. The Victorians changed the face of their world, industrializing it, girdling it with railways and burrowing into it to mine its wealth. Yet as steadily, as boldly and as ruthlessly as they did so, their artists as resolutely refused to register those changes in their work.

In October 1851, Queen Victoria visited Manchester and was horrified by what she saw there. 'As far as the eye can reach,' she wrote in her diary, 'one sees nothing but chimneys, flaming furnaces, many deserted but not pulled down, with wretched cottages around'. A 'thick, black atmosphere', she noted, hung over everything. The watercolour which she commissioned from William Wyld to commemorate the trip is a remarkable instance of bafflement in the face of industrial change. In the foreground of the picture, rustic swains dally, and a clear river curves its way into the hazy distance. Within the frame of these conventional, Claudian devices, Wyld has placed Manchester's brick forest of smoking chimneys. The attempt to blend an industrial city into a vision of Arcadia is embarrassing, like trying to disguise a heavyweight boxer as a shepherdess. The make-believe is so unconvincing that a kind of truth has reluctantly been conceded. This new reality, this place called Manchester, cannot be made to conform to the old pictorial formulae. Victorian patrons, from Victoria down, cannot be made to love it.

At the start of the Industrial Revolution it had seemed, briefly, as though the new facts of a new world – factories, mills, furnaces – might call forth a new school of art. In the last quarter of the eighteenth century Joseph Wright of Derby had painted mills by moonlight and factories in twilit gloamings as if they were eerily romantic, beautiful objects. *Arkwright's Cotton Mills by Night*, which Wright painted in 1782, is one of the loveliest and most haunting of such works. It makes visible not just a factory but a rare moment in British taste – the first and almost the only time when an artist and his patrons could unite in finding beauty in industrial modernity.

Wright's romantic mills soon lost the charm of novelty and after him the world of the Industrial Revolution vanished almost completely from visual art in Britain. (Turner, who painted steamers and tugs and factory chimneys, as well as the train in *Rain, Steam and Speed*, remains the great exception to this rule of avoidance.) A general consensus

grew up, among those painting and those for whom they painted, that it was an unfit subject for art. The faster the express train of industrial and scientific change travelled, the more Victorian artists, architects and their patrons came to think of painting and buildings as brakes to apply to all those turning wheels. So it was that a people who transformed the world through industry decided that industrial progress could not itself be contemplated in or as art.

The greatest drawing of the Victorian period was drawn not on paper in graphite, but on the sky, in steel. Sir John Fowler's and Benjamin Baker's Forth Bridge in Scotland was one of the first cantilevered bridges to be built. Constructed in the 1880s, it was the most daring and impressive feat of engineering seen in Britain since the building of St Paul's Cathedral. But even the most eminent and sophisticated Victorians could not conceive of the possibility that anyone might find visual pleasure in such a structure. When William Morris described it as 'the supremest specimen of all ugliness' he spoke for a whole generation of thinkers. By the end of the nineteenth century the British had been taught by their intellectual elite to regard the technology and the engineering which generated their wealth as, at best, necessary evils. The origins of this opposition to modernity and modern things may be seen right at the start of the Victorian period, when patrons had already begun to turn their faces from the world of work and to develop, instead, a great appetite for small, clean and highly polished images of society at home and at play.

During the 1830s and 1840s there was an enormous increase in the demand for pictures of real people, in real dress, in the real rooms of real houses, living their often morally complicated lives. The large and comfortable living room of journey-work Victorian painting is thronged with ordinary fathers, mothers and children doing ordinary things. The subjects of such pictures range from newly weds to pillars of society, from orphaned waifs to plutocrats. But they are all underpinned by those middle-class values which have come to be remembered as the defining values of the Victorian age itself: a belief in the sanctity of the home; a belief in the God-given duty of man to pursue the good active life, and of woman to cultivate the more passive virtues of prudence and chastity; a belief in the importance of piety; and, most fervently held of all, a belief in the goal of constant self-improvement. Pictures of this kind are commonly referred to as genre paintings but the phrase is a little too vague. They are the first ancestors of the modern soap opera: meticulously mundane, morally loaded slices of life.

They show us a society where members of all classes aspire to be middle class. This applies not only to the poor, aspiring upward, but also to the richest and most powerful, who aspire downward to be more ordinary than they truly are. This is why the eye can move effortlessly from Frith's *Many Happy Returns of the Day*, a placid image of an archetypal middle-class family (Frith's own in fact) gathered to celebrate a child's birthday, to Sir Edwin Landseer's portrait of the royal family, *Queen Victoria, Prince Albert and Victoria, the Princess Royal*. Landseer's picture, in which we see Victoria and Albert relaxing at home with their eldest daughter, is a remarkably uneventful, unostentatious painting of

royalty. Aside from its slightly eccentric emphasis on the quantity of game which Albert has bagged during his afternoon's shooting – a last vestigial emblem of princely dominion over land which lends the picture a certain quality of oddness – this is one of the dullest portraits of royalty ever painted. It is the visible image of a dynasty that no longer wants to present itself as anything of the kind but, rather, as something much more suburban and cosy.

Painters anxious to please their patrons naturally looked back to Britain's first Painter by Appointment to the Middle Classes, William Hogarth. They inherited his work at a slight remove. The Hogarthian tradition had been kept alive in the first half of the nineteenth century by the Scottish painter, David Wilkie. In his most successful paintings, such as *The Blind Fiddler*, or *Village Politicians*, Wilkie had not only furthered the Hogarthian tradition of the modern moral subject, he had also subtly adjusted it. Wilkie's sensibility was gentler than Hogarth's, and his interest in plain lives was heightened by a Wordsworthian sentimentality. He did not impale his subjects on the blade of satire and his paintings of the poor are more observant than sneering. It would be wrong to describe Wilkie as a proto-Victorian, because he was too subtle and too honest a realist for that to be true. But his softening of Hogarth's punitive morality prefigured the much sweeter and much more saccharine ameliorations of Hogarth's black satirical vision practised by the painters who came after him.

The Victorians did not want an art that damns everyone, although they did want every picture to tell a story. This is why the nineteenth century saw a great resurgence of that old British desire to make the image subservient to the word. It also saw the rise to eminence of the art critic, the professional explainer of paintings. Schools of Victorian artists painted pictures which aspire to the condition of literature, bookish paintings, which exist to have their narratives explicated and their moral meanings teased out. Finding the sermon in the painting became one of the favourite occupations of the time.

Augustus Egg was the most inventive and interesting of such self-consciously literary, self-consciously Hogarthian artists. His best-known work is the tripartite painted novel, *Past and Present*. As in a Hogarth, the action in the story is told serially. A woman's adultery is discovered in the first pictorial chapter of this sorry tale, while in the second we see her destitute under a bridge and in the third we see her daughters, fully grown, still regretting her absence and attempting to comfort one another. Egg departs from Hogarth in that the second and third scenes in the series occupy the same moment, a fact which he signals by including the same moon and the same configuration of clouds in the sky of each painting. This is a way of saying that things could have turned out differently, if another set of moral choices (by the mother, or perhaps by the father) had been taken at the moment of earlier crisis. The moral of Hogarth's art, at its most extreme, had been that we are all corrupt and therefore all damned inevitably. The moral of Egg's art is that each moment of time, and each human action, is full of alternative possibilities.

60 AUGUSTUS EGG *The Travelling Companions*, 1862.

Past and Present also enshrines certain uncomfortable Victorian attitudes to women. It was painted one year after the passing of the Matrimonial Causes Act, in which it was laid down that a woman could not divorce her husband for adultery alone but that a man could divorce his wife solely on those grounds. People are what they choose to be in Egg's ethical scheme, but women's choices are regarded to be more morally dangerous and consequential than men's.

Egg showed a more subtle and ambiguous interest in female morality in a picture called *The Travelling Companions* [**60**]. A painting of two young women in matching grey shot-silk dresses, confined within a railway carriage, it is a work full of muffled

eroticism. The painter has associated one of the young women with virtue, in the form of an improving book, and the other with vice (or at least forbidden fruit). The young women look exactly the same, like twins, and the precise symmetry of the picture's composition makes each look as if folded out of the other. This is because Egg meant us to see them as the embodiments of a single girl's two potential personalities. The picture is an ingenious attempt to make visible notions of inner potential and ethical choice. It is not really a picture of two people seen from the outside, but a picture of one person seen on the inside. The effect, however, is perhaps not quite as morally improving as it was meant to be. Egg's painting looks like the work of a man who is secretly quite excited by the idea that inside every quiet young woman there is a bad girl waiting to get out.

Most Victorian painting strenuously attempts to keep that kind of subversive excitement at bay. The individual, the unfathomable being within, is a creature who scares the Victorian sensibility. 'The narrow chamber of the individual mind', in Walter Pater's memorable phrase, is a room in which these people wished to spend as little time as possible. They did not want to relive the nightmares of Fuseli, the doubts of Blake and the subjective glooms of Constable. They were repelled by such forms of introspection, disquieted by the unreliable inner self and all its vagaries. They preferred to contemplate the public self and the relationship of that self with others.

The fear of the inner self was complemented by the fear of the mob. At a time of great social change and unrest in Britain, the well-to-do Victorian's suspicion of the masses was heightened by what sometimes seemed like an almost constant state of revolution in the countries of mainland Europe. Questions of social control and responsibility were at the forefront of many people's minds. This pattern of anxieties explains why there are so many Victorian paintings of crowds. Painting crowds was a way of encompassing that mass of jostling subjectivities which formed the huge and sprawling entity we now call nineteenth-century Britain – and a way of hoping or pretending that it amounted to something coherent, something that could be tagged and labelled 'Society'.

Frith's *Derby Day* is the most extensive of all Victorian social panoramas. It is a record of the most popular mass spectacle of the Victorian social calendar. From the mid-nineteenth century thousands of people would gather every year on Epsom Downs to watch and bet on England's most hotly contested twelve-furlong race for Thoroughbreds. A crowd of this magnitude, which had only been made possible by the advent of the sophisticated Victorian railway network, was an entirely new phenomenon and a spectacle in itself. To many Victorians the sight was both fascinating and quite disturbing.

At first sight, *Derby Day* is a picture which seems to represent the final frenzy of Victorian art's relentless anecdotalism – a scene in which many events are chaotically taking place, and are being performed by a bewilderingly disparate crowd of people. Look more closely, however, and each individual reveals him or herself to be, not a real person, with a real, unpredictable, idiosyncratic character, but instead – just as in that

other Frith panorama, *The Railway Station* – a Type. We see, as if ordered up from the Frith pattern book of British life, Toffs, Rakes, Flirts, Urchins, Drunks and Gamblers. We see nothing but reassuringly familiar stereotypes. The effect is reminiscent of the novels of Charles Dickens, which are preferable as art but frequently exhibit the same combination of apparent human plenitude and actual human thinness. We see no-one strange, no-one inexplicable, no one who cannot be made to fit some sort of preconception about society, about the sorts of people who constitute it, and about what value we should place on them. *Derby Day* represents a uniquely Victorian achievement: a painting with a cast of thousands which manages to contain not one full human being.

The same impulses that led the Victorians to paint crowds also led them to devise that most Victorian of institutions, the National Portrait Gallery, which was founded in 1856. The first such museum of its kind, this slightly stuffy mausoleum of Great British venerability was the crowd painting turned into an art gallery. This was how the Victorians took the biggest crowd of all – the warring inhabitants of the past – and tried to turn them into another of their imaginary peaceful societies. The museum remains one of the most eloquent monuments to Victorian paternalism.

Lord Palmerston, Prime Minister of the day, told Parliament on 6 June 1856 that: 'There cannot be a greater incentive to mental exertion, to noble actions, to good conduct on the part of the living than for them to see before them the features of those who have done things which are worthy of our admiration, and whose example we are more induced to imitate when they are brought before us in the visible and tangible shape of portraits.' The National Portrait Gallery is in reality a little more eccentric than his words suggest. The perverse nature of the enterprise may be partially masked by the conservative air of the boardroom and the committee meeting, the slight whiff of cigar smoke that hangs over the whole museum. But there is nonetheless something inevitably odd about this forced gathering of portraits of people (Queen Elizabeth I and Queen Elizabeth II; Francis Bacon the philosopher and Francis Bacon the painter), so many of whom in real life would almost certainly have detested one another.

The National Portrait Gallery combined two strains in British cultural history. The old national attachment to portraits joined forces with Victorian moral fervour to create a new kind of art gallery: a museum of good behaviour. Its proximity, in London's Trafalgar Square, to the National Gallery, is a nice piece of unintended comedy. The National Gallery is an emblem of the nation's reluctance or inability to renounce altogether the past and its spiritual, sensual, glorious visions: a museum thronged with the bright ghosts of Catholic European religious art. The National Portrait Gallery by contrast is the most Protestant of British art institutions: a museum consecrated to grey spectres of emulable probity. Between them, the two Victorian art institutions amount to the museological symbol of a large divide in the national psyche.

The lasting influence of the National Portrait Gallery on the life of the nation should not be under-estimated. The idea behind it quickly spread outwards from the

centre like the ripples from a stone thrown into a pond. Company boardrooms were filled with portraits of past chairmen; town halls and council chambers were filled with portraits of dignitaries (they still are, and official portraiture continues to thrive in Britain, at least commercially, as in no other developed nation). Victorian cities themselves were turned into National Portrait Galleries of a kind. The community of the past, this time in the form of stone statues on columns, colonized the grand civic squares of nineteenth-century town planning. The new, proud, rich cities of the North, such as Liverpool and Manchester, vied with each other and outdid London in setting up these many lapidary symbols of the illustrious dead, designed to inspire and intimidate the living. Society was confronted, on every side, with images of how society was meant to be.

Still Missing

The Victorians were forever constructing imaginary ideal communities. It was, in part, a way of pretending that all was well in the real world. It was also a way of dreaming of other and more harmonious types of existence. The most eloquent of all such dreams of social harmony, the dream which was dreamed most vividly and often, was that of reviving the Middle Ages.

The medieval world of the nineteenth-century imagination was everything that the thoroughly modern world was not: a time when all things were bright and beautiful, when all, from the lowest serf to the richest lord, knew their place and were united by a pure and simple faith in God; a time when there was no doubt, only certainty. The broken medieval remains of the old Catholic faith had haunted the British ever since the first destructions of the Reformation. The desire to return to the ruined choir out of love or curiosity – to see what, if anything, it might still contain, to note its appearance and to muse upon its significance – has been a constant theme in British life. But Victorian designers, architects and artists took this fascination with the so-called 'Gothic' art and architecture of the past further than Britons from any other period in history. For them, defining the Gothic style became one of their most powerful ways of defining themselves.

During the late eighteenth and early nineteenth centuries, Gothic (or 'Gothick' as it was romantically spelt) had become the architectural equivalent of the rich man's diversion, a style particularly beloved of eccentrics and rakes. Horace Walpole, author of the Gothic novel *The Castle of Otranto*, built Strawberry Hill in Middlesex in the Gothic manner. William Beckford, author of the Gothic novel *Vathek*, built Fonthill Abbey in Wiltshire, a private neo-medieval folly of far more extravagant and sacrilegious dimensions, the spectacular collapse of which (due to the questionable practices of Beckford's architect James Wyatt) was generally greeted as an act of God. But by the middle years of the nineteenth century, Gothic had acquired sobriety and *gravitas*.

61 AUGUSTUS PUGIN St Giles's Church, Cheadle, 1840–46.

The Houses of Parliament, built to Charles Barry's neo-medieval design between 1840 and 1867, cemented the new seriousness of the style. Gothic seemed, to many at the time, the only possible choice for the flagship building of the nation's politics. To have built the Houses of Parliament in the neoclassical idiom, as for instance a modern Parthenon, would have seemed much too French and therefore too potentially Republican and revolutionary. The choice of Gothic was meant to signal the nation's perpetual benign conservatism. But as the century progressed it came to mean more than that to some people. In the hands of Augustus Pugin, Gothic's first demagogue, the style became a form of idealism. The first in a line of British thinkers to argue that Gothic was good for the soul, Pugin saw the architecture of the Middle Ages as a scourge with which to beat the British back towards a virtuous life.

Pugin's mother was an evangelical Protestant and he himself was in many ways an evangelist too. One of his earliest works is a polemical book called *Contrasts*, in which he juxtaposed drawings of degenerate modern cities and buildings with his own imaginary views of a better medieval past. The resulting paired pictures are rather like the 'before' and 'after' imagery often seen in early advertising, the difference being that for Pugin the terms are morally reversed: his 'after' is meant to point us back to a better and truer 'before', because in his mental universe regression is the only form of progress.

Pugin converted to Catholicism in an attempt to reform himself as he wanted to reform English architecture – to make himself more Gothic, more pre-Reformation, more authentically medieval. The ruse did not quite work, although his willed Catholicism could occasionally rise to full-blooded passion. He once wrote an extraordinary, turbulent description of his feelings for the Gothic style, in which he looked forward to its revival as 'truly ravishing, the realisation of all our longing desires' and went on to conjure forth a vision of the Catholic faith resplendent in all its arcane rites and superstitions:

> Oh! then, what delight! what joy unspeakable! ... The rood is raised on high; the screen glows with sacred imagery and rich device; the niches are filled; the altar is replaced sustained by sculptured shafts, the relics of the saint repose beneath, the body of our Lord is enshrined in its consecrated stone; the lamps of the sanctuary burn bright; the saintly portraitures in the glass windows shine all gloriously; and the albs hang in the oaken aumbries, and the cope chests are filled with orphreyed baudekins; and pix and pax, and chrismatory are there, and thurible and cross.

This is the most remarkable celebration of Gothic in all of English literature, a passage that thrills with a positively sexual energy in anticipation of a spiritual homecoming. The return of Catholicism is yearned for as a romantic overwhelming of the mind and the senses. Pugin relishes the descent of language, as it describes the piling of riches on riches and rite upon rite, into a wild and obscure incoherence ('orphreyed baudekins ...

pix and pax ... chrismatory ... thurible') which seems both sensual and also affectionately obscene, like the private made-up language of lovers.

His most complete building in the uncompromised Puginesque Gothic style is the Catholic church of St Giles, at Cheadle in Staffordshire [61], which was meant to embody his dreams and ideals. The rich neo-medieval Catholic theatricality of its interior must have stunned the first congregations: a burst of colour and decoration not seen in a British church for over two centuries. But something is missing. Pugin's church has none of the vitality and sensuality and exuberant spirituality of true British medieval art. The few carved figures he has allowed in cannot be said to reincarnate the old, visceral traditions of pre-Reformation English or Welsh Catholic sculpture. There is no Mercer's Hall Christ, no Abergavenny Jesse in here. The old spirit of excess, the spirit of the baboonery, is nowhere to be found. Instead, a group of anaemic angels occupy the base of the high altar.

Pugin's decorative scheme as a whole is markedly abstract. The repeating patterns he has had painted on to the walls are much more like Victorian wallpaper than medieval embellishment. At the centre of the church a barely suffering carved Victorian Christ, who has been raised into untroubling far-awayness by the height of Pugin's rood screen, makes little impression. His suffering is subordinate to the effects of Pugin's decor. Nothing could be further from the mind, in this church, than Christ's agony and our redemption. Reinventing the past was to be far harder than the Victorians imagined.

Pugin himself seems to have suspected that his emasculated, genteel and more than slightly camp Gothic was lacking in authenticity. In his last years, he succumbed to increasingly troubled fits of mania and by his death in 1852 he had become insane. But the ambitions which had animated him were to bear more and stranger fruit as the century progressed.

In 1850 the young Dante Gabriel Rossetti completed *Ecce Ancilla Domini!*, one of the earliest Victorian attempts to accomplish in art what Pugin had tried and failed to accomplish in architecture. Rossetti's subject is the Annunciation, and his picture announces the early stirrings of religious medievalism in High Victorian painting. The influence of the sacred art of the early Northern Renaissance may be felt in Rossetti's style, which he wanted to evoke the linear purity and simple, hand-made holiness of painting in a purer time. The effect is not entirely successful, because as in Pugin's church the quality of this archaism is so decidedly Victorian that it ends up reluctantly betraying its own modernness. Rossetti's vision of a nervous, sallow, tubercular maiden confined to her bed does not truly evoke pre-fifteenth-century art at all. Instead it looks forward to the dismal necrophiliac visions of late nineteenth-century Symbolist painting, dimly prefiguring that mood of alienation and terminal depression of which so much was to be made by that overrated artist of the Northern *fin-de-siècle*, the Norwegian painter Edvard Munch. Rossetti's troubled ghost of a virgin may be anticipating the fitful anxiety that seems to run through most religious art in the second half of the nineteenth century.

62 JOHN EVERETT MILLAIS *Lorenzo and Isabella,* 1848–9.

Along with William Holman Hunt and John Everett Millais, Rossetti was one of the three principal founder-members of the Pre-Raphaelite Brotherhood. The name 'Pre-Raphaelite' reflected their joint determination to turn back history, to go back beyond the time of Raphael and the Italian High Renaissance, and into the Middle Ages. Like many other European painters of their time, such as the Nazarenes in Germany, they were united by their disgust for the decadence into which they believed narrative art had fallen. To look at their works now is to see that there was something pathological about their need to get back to the other worlds of an imaginary past.

The aims of the Pre-Raphaelites, as first formulated in 1848 in the house of Millais's parents, have the authentic ring of gauche student idealism, uncertain what it is idealistic for:

1. To have genuine ideas to express;
2. to study Nature attentively, so as to know how to express them;
3. to sympathize with what is direct and serious and heartfelt in previous art, to the exclusion of what is conventional and self-parading and learned by rote; and
4. and most indispensable of all, to produce thoroughly good pictures and statues.

The Pre-Raphaelites' first pictures, which were not always as thoroughly good as they hoped they would be, show the same confusion of purpose betrayed in this almost-manifesto. Holman Hunt's earliest attempt to show the world what the Pre-Raphaelites stood for is a curious little medieval costume drama of death and vengeance called *Rienzi,* which actually looks back less to art before Raphael than to Jacques-Louis David's eighteenth-century neoclassical masterpiece *The Oath of the Horatii.* David's inflexible trio of Roman soldiers has become Hunt's single hero shaking a fist ineffectually at the sky – an image of the early Pre-Raphaelites' unfocused but intense desire to do something, anything, extreme.

The same combination of archaism and powerful but undirected energies can be found in perhaps the weirdest of all early Pre-Raphaelite paintings, Millais's *Lorenzo and Isabella* [62]. Millais based the work on Keats's poem *Isabella,* and for reasons too tedious to rehearse in detail, the men on the left-hand side of the table are plotting to kill the man opposite them for having fallen in love with their sister. The conspirator closest to the viewer grimaces, cracks a nut with the release of a man firing a gun in anger and stretches his leg towards his offending sister as though willing his body to turn into a switchblade. The rest of the party concentrate on their food, sip their wine and belch discreetly. Millais has spent a very long time painting the wallpaper. Perhaps he did so to distract the eye with decor and thus divert attention from the violent and peculiar quality of his imagination. Perhaps he had discovered – as many painters after him were to discover – the strangely soothing effect of repeating patterns.

The idiosyncrasy of the Pre-Raphaelites' early works shows that the group was not so much a true spiritual brotherhood as a temporary association of disparate sensibilities. Despite this disunity there was something undeniably impressive and singular in the fervency of Pre-Raphaelitism in the first flush of its youth. The Pre-Raphaelites wanted to make a difference of some kind, to stand out, to depart from what they believed were the tired stereotypes of existing British painting. To many this must have seemed like a strong antidote, both to the cosy lassitude of all those unambitious hireling painters to the Victorian bourgeoisie and to the stale formulae that prevailed in academic figure

painting of the day. The Pre-Raphaelites soon found themselves at the centre of a loose coterie of painters, all working in what they thought of as the medieval style and all keen to discover where the ambition for 'truth', so fraught with potential complication and difficulty, might take them.

Between the Book and the Flower

This moment was encapsulated by a single work and the responses which it engendered. In 1851 a now largely forgotten disciple of the Pre-Raphaelites, Charles Allston Collins, completed a small and botanically precise picture called *Convent Thoughts* [63]. Collins chose for his subject a nun beside a lily pond within an enclosed garden. She holds a medieval book, which is open at an illumination showing the crucifixion. She is not looking at it, however, but contemplating a passion flower, a traditional symbol of Christ's Passion. She is thinking of the incarnation and the crucifixion, of how Christ suffered and died on the cross that we might all be saved. Out of the debate which this picture provoked the Pre-Raphaelites were to acquire, temporarily, a common sense of purpose.

Like most nineteenth-century religious paintings, *Convent Thoughts* seems to lack the courage of its convictions. It presents the empty shell of religious art, not its reincarnation. Collins's nun, like Rossetti's Virgin Mary in *Ecce Ancilla Domini!*, is a morbid *femme fatale* in fancy dress. The notion that she is undergoing some mystical process of inner spiritual enlightenment is patently absurd. The sadness of Collins's picture lies in its inability to connect the religion of the Bible with the facts of the real world. Between the book and the flower, in the blank expanse of the nun's habit, we find the painting's one eloquent passage. An expanse of fabric has become an abstract landscape of grey hills and shadow, an unblessed emptiness at the heart of the painting.

Convent Thoughts prompted John Ruskin, the most influential and neurotic of Victorian writers on art, to address the spiritual crisis which he correctly sensed deepening and darkening in its shadows. Ruskin was a Protestant (albeit a very complicated one) and he greatly disliked what he saw as the taint of Catholicism in Pre-Raphaelite art. British artists, he said, should not be painting figurative religious pictures, nor attempting to resurrect the old Catholic art of signs and symbols. He suggested that they should be attempting to find God in his greatest creation, the natural world. Ruskin had been taught at university by disciples of the eighteenth-century Anglican priest, William Paley, and he subscribed to Paley's 'Natural Theology', according to which a true and deep knowledge of the beautiful, perfect machine of nature would lead inevitably and upliftingly to an enhanced sense of God.

Ruskin translated this slightly old-fashioned theology into hard, practical advice. All was not lost, he told Collins. The artist simply had to reorder his priorities. Concentrate on nature, and nature alone, as the best and simplest way to God. Do not paint nuns or

63 CHARLES ALLSTON COLLINS *Convent Thoughts,* 1850–51.

Virgin Maries. Paint plants. Paint rocks. Paint nature. The advice was taken to heart in the Pre-Raphaelite circle. A clear-eyed style of depiction had always been a part of their programme ('study nature attentively'), but under the impetus of Ruskin's remarks on *Convent Thoughts* Pre-Raphaelite realism acquired a new moral and spiritual urgency.

The art that resulted is dutifully myopic, but also permeated with hopeful yearnings. Eyes are being strained in the hope of sighting divinity. An every-last-leaf, every-last-dewdrop minuteness of handling came to characterize the work of the Pre-Raphaelites and all their followers. Intense realism supercharged with unrealistic expectations produced visions of the world so stark and heightened that they approach a form of Surrealism. This may be seen at its most fiendishly detailed in works as various in their subject matter as Hunt's *The Hireling Shepherd*, John William Inchbold's *In Early Spring* and John Brett's *Val d'Aosta*.

The work that went into a Pre-Raphaelite painting was perceived by the painters themselves as a vitally important part of its moral authority. Study became an end in itself. They made much of the weeks and months that went into their productions. The ever more elaborate and ever more technically demanding pursuit of that chimera, truth to nature, became the Pre-Raphaelite painter's road to Calvary. In *A New and Noble School* Quentin Bell gives a concise description of the technical hoops which Hunt felt obliged to put himself through in order to paint a picture:

> Hunt's initial drawing had to be a very careful and exact line drawing in black ink upon an absolutely dry, hard white surface; over this the painter laid a coat of white from which nearly all the oil had been extracted. This second coat was so thin that the drawing could be seen below it. The colour was then applied to this 'wet white' ground with such delicacy that it would not mix with the paint to which it was applied. This, naturally, involved extremely slow working, so that it was impossible to cover more than a few inches of surface each day and this had to be done before the wet white dried up ... no correction was possible; the entire area had to be removed with a palette knife and started anew if a single mistake was made.

Such self-imposed torments as these lie behind the overwhelming impression of deadness and overwork produced by so much High Victorian painting of nature. It is as if the Victorian terror of spontaneous, subjective feeling has been written into technique itself. Painting so precisely almost turns the painter himself into an inanimate object. Millais reckoned he could cover no more than an area equivalent to a five-shilling piece in an entire day.

The pain of work is one of the themes to which Pre-Raphaelite painters itchily returned, as if seeking to find a subject to reflect their own arduous practice. When John Brett painted a young pauper breaking stones in the Sussex landscape, in *The Stonebreaker* [64], he was not only protesting against the lot of the poor, but finding a

64 JOHN BRETT *The Stonebreaker,* 1857–8.

metaphor for the exhausting labour of painting Pre-Raphaelite art. The painstaking rendering of naturalistic effect – the precise fall of light, the precise angle of each blade of grass, the precise contour of each and every stone – has here been pursued to the last degree by one of its most exacting practitioners. Yet how purposeless the activity has been made to seem – as unilluminating and unenlightening, perhaps, as breaking rocks. The picture has a muted poignancy because what it shows us is that the more the Victorian gazes at the natural world the more he realizes that he cannot, after all, see heaven in nature. He can only see nature in nature. But *The Stonebreaker* is not just a subtle allegory of the Pre-Raphaelite crisis of faith. At a much more literal level, it is a picture of what lay behind that crisis: a heap of broken rocks.

The study of rocks had led other Victorians – not painters armed with paintbrushes, but geologists armed with hammers – to make certain discoveries. They had found tiny

pictures, images created by nature which transformed man's image of the world and his place in it. The truths revealed by the ammonite, the trilobite and the brachiopod made the world seem larger and more indifferent to man than it had ever seemed before. Visible fragments of life from previously undreamed-of aeons of antiquity confronted the Victorians with hard proof that the old biblical account of creation was a myth. A new and disconcerting awareness of time had opened up before them. The origin of life itself was being called into question. Did the roots of man lie in the garden of Eden, or at the bottom of some primeval sea?

In 1860 one of the most decisive of all Victorian scientific debates took place in the newest and largest Victorian repository of fossils and other broken rocks, the University Museum, in Oxford. Science defeated theology as the evolutionist Thomas Henry Huxley annihilated the arguments of the Anglican preacher Bishop Samuel Wilberforce. It was clear, from the finality of Huxley's closing remarks, that Charles Darwin's theory of evolution, outlined in *On the Origin of Species*, had won the day:

> If … the question is put to me would I rather have a miserable ape for a grand-father or a man highly endowed by nature and possessed of great means of influence and yet who employs those faculties and that influence for the mere purpose of introducing ridicule into grave scientific discussion – I unhesitatingly affirm my preference for the ape.

Ruskin, who had hoped as passionately as anyone to find confirmation rather than denial of divinity in natural history, must have felt the fine irony of defeat with particular sharpness. He had been closely involved in the planning and building of the University Museum. On the basis of his confidence in the tenets of Natural Theology, the museum had been built in the Gothic style – the style, for Ruskin as for Pugin, of religious faith. He must have been mortified by his museum's sudden transformation by Darwin and his ideas about apes into a temple of atheistic scientific discovery. Baboonery had found a way into Victorian Gothic after all.

Beside the Sea

The places where land meets sea have meant much to the British mind. The tideline draws the map of any island. It also, in the case of this particular island, marks a distinctive sense of national separateness. This was first reflected in the art of royalty. In the 1390s the unknown painter responsible for the *Wilton Diptych* [11] included a tiny map of Britain, floating in a sea of now-tarnished silver, in the orb at the top of the banner held by an angel. Two centuries later, in the *Armada Portrait*, Elizabeth I had herself painted beside the sea as the guardian and protector of Britain's watery perimeter. To safeguard the tideline was to safeguard the nation – a point made differently but as

forcefully, two centuries later, by James Gillray in his early nineteenth-century print *The French Invasion*, in which he depicted George III as a human map of England and Wales excreting into the face of the Napoleonic fleet.

The beach as a subject began to exert a special pull over British painters in the early years of the nineteenth century, partly perhaps because the Napoleonic Wars had sharpened British awareness of the importance of this natural frontier, but also for more purely painterly reasons. Constable painted many pictures of Brighton beach in the 1820s, including some of his most relaxed open-air studies of water and weather; Turner constantly painted by the sea, fascinated by marine light effects; Richard Parkes Bonington continued this tradition in his beautiful coastal studies of the late 1820s. A handful of wonderfully delicate pictures of *Rhyl Sands* [65] in North Wales, painted in the 1850s by David Cox, demonstrate that this tradition of British open-air painting was still alive well into the mid-nineteenth century.

Cox painted the beach as a place of leisure, and a place for leisurely contemplation. He saw that it was a natural subject for painters because the beach is itself a kind of painting made *by* nature, the stretch of sand a bare canvas touched into life by light and shade and passing incident. Like Bonington, Cox had been deeply influenced by Turner and he painted his beach with a gentle profundity that he never achieved in the rest of his works. A stretch of seaside on the north coast of Wales has been made into a touching metaphor for life itself: a place where people, seen at a distance like blurred ghosts, are evidently just passing through.

After Cox's death in 1859 this type of painting no longer thrived in Britain but in France. The heirs to the tradition of English *plein-air* painting were not Englishmen but Frenchmen: Eugène Boudin, Edouard Manet and above all Claude Monet, whose paintings of the beaches at Trouville and Etretat, created in the 1870s and 1880s, are among the key works of French Impressionism. Cox himself had been an exception to the rule in Britain in the second half of the nineteenth century, a throwback to an earlier moment in British art and thought. To many Victorians the beach was not at all a place for gentle contemplation of light and shade and the passing show of humanity. It was a tragic place – the most tragic place, even, because it had become so explicitly identified with the washing away of all their most treasured values and traditions.

Matthew Arnold captured its sadness in *Dover Beach*, the grandest Victorian poem of religious disillusionment.

Listen! You hear the grating roar
Of pebbles which the waves draw back, and fling,
At their return, up the high strand.
Begin, and cease, and then again begin,
With tremulous cadence slow, and bring
The eternal note of sadness in.

65 DAVID COX *Rhyl Sands,* c.1854.

Sophocles long ago
Heard it in the Aegean, and it brought
Into his mind the turbid ebb and flow
Of human misery; we
Find also in the sound a thought,
Hearing it by this distant northern sea.

The Sea of Faith
Was once, too, at the full, and round earth's shore
Lay like the folds of a bright girdle furl'd.
But now I only hear
Its melancholy, long, withdrawing roar,
Retreating, to the breath
Of the night-wind, down the vast edges drear
And naked shingles of the world.

66 WILLIAM DYCE *Pegwell Bay,* 1858–60.

William Dyce's *Pegwell Bay* [66] is the defining Victorian painting of this bleak maritime
mood. At first glance, Dyce's picture of a family seaside outing, painted in the smooth
and palatable style of so much Victorian art may seem entirely untroubled. But there are
uneasy details. How grey the sky seems, how bleak the cliffs and sea appear. How large
is nature; how small by contrast is humanity. Dyce was an amateur geologist and
astronomer, and he has included Donati's comet flashing through the sky to remind us
that the earth, too, is just a rock orbiting space. The family in the picture are gathering
fossils and therefore collecting the materials for their own disenchantment. Something
has gone awry in the teatime world of Victorian genre painting. A bourgeois idyll has
turned into a lament.

On the beach, Victorians like Dyce and Arnold sensed the imminence of an ending:
not the end of the world, but certainly the end of a world view. God's presence in the
universe had become harder than ever to believe in. No surprise, perhaps, that seekers
after God had a way of going mad in the nineteenth century. Pugin went mad; Ruskin

67 WILLIAM HOLMAN HUNT *The Scapegoat,* 1854–5.

went mad in the 1880s; the preacher-turned-painter, Vincent Van Gogh, was to go mad in France a few years later.

William Holman Hunt, the most genuinely devout of all the Pre-Raphaelites, went to greater lengths than any other English painter to deny or somehow ameliorate this reluctantly discovered condition of religious alienation. He attempted to bridge the yawning gap between reality and divinity that so troubled not just the Pre-Raphaelite imagination but nineteenth-century thought itself. He tried to envisage the continuity between worldly and heavenly realms which Ruskin's desperate theology had taught him and the other Pre-Raphaelites to dream of, and to reimagine God back into the real, mundane Victorian world. He failed, but he failed heroically. Rather than trying to detect God's handwriting in minute botanical study, Hunt decided to travel. With almost admirable naivety he believed that it might be easier to find traces of God's im-

manence in the real world if he went to a part of the world which Christ had once inhabited. So in the mid-1850s, Hunt went to Palestine, the land of Christ, where he pursued the logic of High Victorian theological literalism to its extreme and bitter end. In the hope that revelation might ensue, he set up his portable easel in one of the most inhospitable corners of the earth, at the site of ancient Sodom, on the scorched shore of the Dead Sea, and he began to paint.

Instead of finding a place more closely touched by God than any other he had known, what Hunt encountered in the Middle East was a sulphurous environment of pure, vivid hostility. He painted it with the awe and wonder of an astronaut landing on the moon. All was registered with as much literal fidelity as Hunt could summon: dead mountains, dead salt flats, the Dead Sea, all lit by the staring eye of a sun shining from a sodium yellow sky.

Then Hunt cast around for a way of painting this terror back into meaningfulness. He remembered the story of the Scapegoat, in the book of Leviticus, in the Old Testament, where in accordance with the prescriptions of Yahweh a goat charged with all the sins of mankind was led each year into the desert and left there to die. In this obscure tale of animal sacrifice, Hunt claimed to find a prefiguration of Christ's sacrifice on behalf of man. He added the pitiful animal which we see in his picture [67], with its coat of mangy fur, mired in salt flats. Hunt had not found God, any more than the other High Victorian literalists of the 1850s had done. What he had painted was the last sad frenzy of Victorian religious art: the portrait of a goat *in extremis*.

The Dream of a Dreamless Sleep

It is odd that the Victorian period should have been remembered as a time of flat and straight-faced convention, just occasionally disturbed by the tremors of illicit, irregular thoughts and feelings. Irregular feelings, a sense of great trouble and disturbance – these emotions are the *rule*, rather than the exception, in the art of the Victorians. Many of their works seethe with fear and strangeness, which is why Lewis Carroll's Alice, beset by all those curious and psychosexually troubling dreams about unenterable gardens and obstructed chimneys, is one of the archetypes of the age.

A state of hallucinatory disquiet was one of the fundamental Victorian modes of being, a fact which becomes more apparent as the century progresses and as all Victorian visions of wished-for order turn, ineluctably, into views of chaos. Ford Madox Brown's most famous painting, *Work* [68], is one of the most telling instances of this. Long and eccentrically regarded by art historians as one of the classically Victorian paintings of 'official' Victorian values it is actually the opposite. It is a picture which literally falls apart as you inspect it, demonstrating both the chaos that so haunts the Victorians and the ease with which the Victorian mind submits to a form of near insanity.

68 FORD MADOX BROWN *Work,* 1852–65.

Although Brown was not a member of the group, he was closely associated with the Pre-Raphaelites and *Work* is Pre-Raphaelitic both in its effects of hyper-realism and in its vigorous eccentricity. A world of human differences has been squeezed too tight within a single frame. Navvies toil while a pair of intellectuals, theorists of labour, loiter and think. Vagrants sleep, urchins act mischievously, do-gooders do good and posh types sneer. But what (if anything) does this all add up to? Brown encouraged the reader of his picture to see it as a statement about the place of different kinds of workers in society, but during the thirteen years that he toiled over his painting it evidently became hopelessly confused.

Work presents us not with meaning but its opposite: an atomized world full of alienated, grotesque individuals. Brown signals his own alienation from a social reality that seems to him like a nightmare by painting it as if indeed realizing a bad dream. This is the most troubled of all Victorian crowd paintings. Things and people have materialized on to the canvas with a sudden, strange, apparitional force, making it impossible to read the painting as a coherent whole. It is, instead, a frenzied concatenation of hallucinatory detail: a sunburned arm; a gash under a man's eye; a baby with a face like a goblin's;

69 RICHARD DADD *The Fairy Feller's Master Stroke,* c.1855–64.

a Shakespearean Fool, who has gone beyond wisdom into insanity, bearing a basket of flowers off to who knows where. The most disconcerting element in the entire painting is the tiny still life in the wheelbarrow: a trowel and some meaningless rubbish, painted with infinite pains.

Although the resemblance has not often been noted, *Work* has its pair in the most deranged fantasy of Richard Dadd, a briefly promising but ill-fated Victorian painter who spent most of his life in a lunatic asylum after strangling and stabbing his father to death in 1843. Dadd like Brown is one of the most characteristic of all Victorian artists because he is one of the most visibly and eloquently disturbed. *The Fairy Feller's Master Stroke* [69], which took him about nine years to paint for the Steward of Bethlem Hospital, is his masterpiece (although that is not quite the right word). Exactly contemporary with Brown's best-known painting, Dadd's most popular picture is a strikingly similar vision of chaos and of bad dreaming and it too is executed with a miniaturist intensity.

It is a fairy version of *Work*, the fantasy of a shrunken world which could, perhaps, be taking place in the Fool's flower basket in Brown's picture. Dadd's is another (yet another) Victorian vision of a fractured world and like *Work* it is one that revolves around a scene of labour: a minute woodcutter is exerting all his strength to split a hazelnut. The disconcerting suddenness of detail in Brown's work is yet further enhanced in Dadd's. The thronged population of this bad dream looks warped. The figures have been painted as if viewed through a magnifying lens that has been moved erratically from point to point across the scene.

Sensing that madness was a constant threat to them, later Victorians desperately took refuge from lunacy in an affected indifference to the big questions they found so troubling. Not to care was to be safe, even if it was also to produce rather poor art. Later Victorian painting is a grim business, oscillating between mercenary indifference and a pained, enervating lassitude.

Like a virus, Victorian cynicism took many forms. It resulted in the hypocritical careers of later painters of social concern, men like Luke Fildes or Hubert von Herkomer, who dabbled in scenes of poverty and hardship but ended up as wealthy portrait painters living in large houses in St John's Wood, London. It resulted in those so-called reconstructions of ancient Greece and Rome, barely disguised pornography-for-gain, painted by later Victorian painters of 'history' such as Lawrence Alma-Tadema, the Master of the Barely Submerged Nipple. (His work is the last, low refuge of the Spartan history painting tradition which James Barry had tried to seed a century earlier.) It also resulted in an art of pure, self-indulgent retreat, a curling away from the world into the warm, dark bedclothes of personal fantasy.

Later Victorian painters of fantasy – the Post-Pre-Raphaelites, as they have been rather clumsily categorized – were forever combining dream and melancholy to no good purpose in their work. Their fantasies are often fantasies of derangement and death, made safe by their flaccidity. Ophelia and a host of sickly nymphs like her die again and

70 DANTE GABRIEL ROSSETTI *Lady Lilith*, 1862.

71 EDWARD BURNE-JONES *The Legend of the Briar Rose: The Rose Bower*, 1870–90.

again in late Victorian painting, and this preoccupation must say something about Victorian society itself in its later phase. The necrophilia of artists announces that something has gone missing, that something has died in the life of man.

Dante Gabriel Rossetti spent much of his later life trapped in a recurring fetishistic dream about a woman with long, dark, entangling hair: a nest where he could lose himself, forever, in sensuality, and sleep the dulling sleep of eternal satiation [70]. But the most perfect, High Victorian expression of the desire to escape from all Victorian anxiety was created by Edward Burne-Jones in the cycle of paintings he created for the saloon of Buscot Park in Oxfordshire. Burne-Jones called them the *Briar Rose* paintings [71] and they derive from the story of Sleeping Beauty. The dense and cloying surface of Victorian art has here become a kind of drug. Everyone in the pictures is asleep except Prince Charming, and he is so enmired in the brambles and tangles of Burne-Jones's Post-Pre-Raphelite fairy wood that he will, evidently, never reach anyone to wake them up.

The canvases filled with unconscious women make of the room a harem of drowsy escapism. Burne-Jones furnished it with heavy gilt-wood panels, making his paintings into a frieze that runs right around the walls. The effect is oppressive unless surrendered to as to the effect of a sleeping draught. The saloon at Buscot is a palace of sleep, a monument to the Victorian desire to leave off fussing and idealizing and worrying. Trouble has been forgotten here, and so have all the nightmares and chimeras of the age of change.

Burne-Jones's closest friend, William Morris, wrote some rather inappropriately energetic poetry to accompany the *Briar Rose* paintings, various lines of which have been written on to the picture frames at Buscot. The figure of Prince Charming, in the cycle of paintings, may have been Burne-Jones's way of returning the compliment. Morris was himself a man who wanted to smite the sleeping world awake: a Prince Charming with designs on late Victorian society who got dozily entangled in brambles.

Wallpaper and Machines

Morris claimed to be ethically disgusted by the recourse to languorous quietism pursued by so many Victorian painters and thinkers. He wanted to rouse the world and make it a better place. He dreamed of setting people free from the factories, and of creating an ideal society where everyone would be a fulfilled and happy craftsman. What Morris actually made now seems rather curiously at odds with such noble ambitions. A founder of Morris, Marshall, Faulkner & Co., designer and marketer of stained glass, textiles and wallpaper, his chief contribution to Victorian society was to provide the wealthier class of Britain with decorative schemes for their homes.

Morris was a socialist, and his dreams – which were, for the time, radical ones – rested on the belief that ordinary working people should be empowered. But, unlike his

more ambitious contemporaries and fellow idealists, Karl Marx and Friedrich Engels, Morris's was a dream indifferent both to the real world and the real people living in it. He was not a revolutionary, but a nostalgic utopian. As Engels once said: 'Morris is all very well as far as he goes, but it is not very far.'

Morris may not have wanted a return to feudalism but he was as mired in impossible fantasies of recapturing the past as any Victorian medievalist. Like so many of the idealists who had preceded him – Pugin, Ruskin, Carlyle, Arnold – he reflected the alienation and nostalgia of the intellectual classes in Britain. He was a man who looked at the world around him and found it, as they had done, to be a sad, bad and ugly place. His intentions were good but his imaginary conversion of Britain back to an artisanal culture from a mechanized one was clearly never going to happen. However, Morris's visual ingenuity and eclectic brilliance should not be underestimated. From the craft traditions of the East, particularly Persia, he brought a whole new vocabulary of shape and pattern to Western European design. Morris's designs for textiles and wallcoverings have had a great and universally acknowledged influence on twentieth-century decoration. He invented the Morris Style, a style widely recognised and much copied. Few designers have managed as much.

His dense, sleepy labyrinths of shape and pattern, the rose and the bird and the leaf intertwined forever, sit very uneasily with Morris's supposedly progressive ideology. The illustrated Arthurian romances which he published under the imprint of the Kelmscott Press reveal a man who was just as enraptured as Pugin had been by a dream of Merry Olde England. Morris never intended his activities as designer and publisher to express his political beliefs but they do encapsulate precisely that dreaminess and nostalgia which, in the end, deflected him from radical political action. Marxism changed the world; Morrisism did not. There is something rather poignant and peculiarly English about a theorist of social revolution who has been remembered by posterity primarily for his hand-blocked floral wallpaper.

Unworldliness was not Morris's real sin. Every self-respecting utopian is unworldly. His real sin was the reactionary nostalgia of his taste. His aesthetic was retrograde and, like that of so many other Victorian thinkers, it was an aesthetic which turned people against their own world.

Morris never visited Papplewick Pumping Station in Nottinghamshire [72], built by the North Western Water Authorities in the 1880s. One of the grandest industrial monuments in the world, it is an impeachment of the Victorian intellectual's ethics and aesthetics of rejection. Outside, the pumping station could be a Victorian library or town hall mysteriously transplanted to the middle of nowhere. All the buildings, from the pumping house to the pumping tower to the workers' houses, have been built in a mild Italianate (Sienese) red brick version of Victorian Gothic. Inside, at the mechanized heart of the building complex, the Machine Room, the pump itself dwarfs everything.

This machine is beautiful, although its beauty is not of the kind that men like Pugin or Ruskin or Morris ever thought of appreciating: a physical beauty of greased moving

parts, a beauty that has touched emotions ever since the dawn of mechanization. The Victorian water industry was relatively benevolent, and the men who worked at Papplewick were freer than most in Victorian Britain to enjoy their working lives. They were stirred by this machine. Maybe they even felt a kind of love for it. They hung their spanners on polished boards on the walls, each placed in minutely exact order of descending gauge. This is more than efficiency. It is beauty. The tools of repair have been treated as carefully as any artist ever treated his paintbrush. We can see here the beginnings of an unpretentious, largely male, largely working-class pleasure in seeing machines in good working order which has persisted into the present: the aesthetic of the motorbike enthusiast or the weekend mechanic.

Victorian paternalism (like Marxism, in this one respect) could not recognize that men were capable of regarding something as modern and technological as a machine with affection. The Water Authority's architect, Ogle Tarbotton, patronizingly intruded some columns in the romanesque manner into the Machine Room – as if trying to civilize a place of work by making it resemble a Victorian withdrawing room. The columns are adorned by capitals in which we perceive the Christian pelican pecking its breast to feed its young. The effect is absurd, the equivalent of Morris's Communism in pointy boots, because the silliness of the preconception which it betrays is so manifest and so rebuked by the setting. This decoration says that a *machine* cannot, surely, be beautiful in its own right. But that is not true, and to see the machinery at Papplewick proves it.

Papplewick does not need Gothic details. Indeed, Papplewick is the nineteenth century's great unacknowledged indictment of Victorian nostalgia's fraudulence and irresponsibility. Papplewick proves that all the qualities which the Victorian intellectual had spent so much time fantasizing about – community, shared social purpose, a shared sense of beauty – did not have to be revived in medieval fancy dress. They were here all the time, at least potentially: here in a real place lived in by real people.

Papplewick is proof that there were people ready to face reality rather than run from it in High Victorian horror. It is proof that there were people who were prepared to find the best in the modern technological world – to be moved by its potential for beauty as Turner had been, all those years ago, when he painted *Rain, Steam and Speed*. But because they were working men nobody listened to them. No one ever devoted a book to their aesthetic so it never impinged on aesthetic debate in Britain. Papplewick is not only a monument to their feelings and perceptions and potential for optimism, concerning the future. Papplewick is also (and this is the sadness of the place) a monument to the narrow-mindedness of the designing, planning, thinking, paternalistic, we-know-better-than-you class of architects, aesthetic theorists, moralists, evangelists and idealists who dictated the terms of nearly every argument during the Victorian period – an entire class of opinion formers, too damaged and traumatized to think properly about what the future might hold, and whose legacy has been a national distrust and dislike of the very idea of the future.

72 OGLE TARBOTTON Papplewick Pumping Station, 1882–4.

It is, perhaps, too easy to blame the Victorian intellectual for turning aside at the machine room door. Factories, cities, the whole vast sprawl of things that go under the name of the new – these things had changed his world with the suddenness of a lightning strike, so no wonder they seemed like terrors to him. But we should blame him at least a little. It was a mistake on his part to transfer his perfectly honourable dissatisfactions with his society to all those modern objects and situations which he associated with change. Once you have decided that the modern is ugly you are halfway to making sure that the modern stays ugly. The Victorian aversion to modernity has much to do with why our houses, our cities, our lives are not better and more beautiful.

Port Sunlight

The factory village of Port Sunlight [73] is calm, quiet and well ordered (almost disturbingly well ordered). It was named after the bar of soap which made its founder, the first Viscount Leverhulme, a wealthy man. Begun in 1888, it was one of the first serious attempts at modern town planning. Port Sunlight is an early example of a garden city, built to provide decent housing for urban factory workers. It was designed as a proper functioning community with a school, an art gallery, shops and leisure facilities. Such philanthropic ideals were eventually to lead to the establishment of the welfare state. In many respects Port Sunlight is an extremely progressive place.

In one crucial respect, however, Port Sunlight demonstrates the persistence of a typically Victorian form of nostalgia that has continued into modern Britain. The houses in its wide, tree-lined streets and closes are built in a variety of architectural styles, almost all of them variations on a Tudor theme. Social hierarchy may have been reflected to a degree in these styles. The large, half-timbered, fully-detached houses which line Museum Avenue were reserved for upper and middle management; the simpler cottages a stone's throw away, behind a hedge and along a path, for manual workers. The implication behind this ubiquitous architectural archaism is clear: whoever you are you will be wanting to live in a house that dreams of the past.

The ideals behind this model community have had a great influence on architectural style and taste throughout the nation. A very large number of people in Britain today live in houses like these. At Port Sunlight we can see that the High Victorian desire to escape from the present did not die at the end of the Victorian era. It became part of the British way of life. Every house has a lawn in full public view which is still mowed weekly at the company's expense. Neatness is all. There will be no unrest, no misbehaviour, no public disturbance here (there may be a fist of steel inside the philanthropic industrialist's glove but it seems unlikely that the supposition will ever need to be tested). The street where village life meets work life is one of the most quietly telling places in Britain. Here, a high blind wall screens the row of cottages from the one thing that this architectural dream of order cannot face: a modern thing: the factory.

73 Port Sunlight Village, Merseyside, begun in 1888.

Port Sunlight represents the afternoon nap of High Victorian Gothic: a Gothic which, certain in its victory over the hearts and minds of the people, can relax to the point where it does not even need to be built in a rigorously Gothic style. This is what the Victorian ideal of calm community finally produced: a snooze of the soul given architectural form, a love of retreat and renunciation expressed at the level of bricks and mortar. The British entered the twentieth century looking backwards.

SIX

OUR HOUSE

74 RACHEL WHITEREAD *House,* 1993.

As for being tied to the art of the past,
what other home have we got?

HOWARD HODGKIN letter to John Elderfield, 23 February 1995.

I want to be
Anarchy

JOHN LYDON lyrics to the song *Anarchy in the UK,* 1977.

House

Before it was turned into a work of art, 193 Grove Road was a late Victorian terraced house of no great distinction in the East End of London. In 1993 the houses around it were scheduled for demolition by Tower Hamlets Council, but this one house was granted a stay of execution because an artist had designs on it. Extensively remodelled, improved beyond habitability, the vacant property became both monument and memorial. It became *House* [**74**], by Rachel Whiteread: a strange, fantastical object and one of the most beautiful and melancholic public sculptures of the late twentieth century.

As transformed by Whiteread, 193 Grove Road was no longer a home but the ghost of one perpetuated in art. *House* was made simply (although the process was complicated, the idea itself was simple) by lining the interior of the house with a metal mesh structure, which was sprayed with layers of concrete. The mould – that is, the house itself, roof tiles, bricks and mortar, doors and windows – was then stripped away. The result was the shadow of a home, since what it consisted of was a cast of the spaces once contained by one. Rooms that had once been lived in became blocks of stone. Sash windows that had once looked out on the world became blind, heavy, cruciform reliefs. Doors that had once opened became sealed panels of concrete. The house became a giant sarcophagus, a mausoleum containing (but also concealing, as mausoleums do) the lives and memories of all the people who had lived there.

To visit *House* was to be suddenly and disconcertingly transported to another world, like and yet completely unlike this one: the world of the photographic negative, with its phantom-like reversals of known fact; the world that Alice enters through the looking glass; the world that lurks behind the molten silver mirror in Jean Cocteau's *Orphée*, where normal relations between objects have been summarily suspended. Denatured by transformation, things turned peculiar. The traces of late twentieth-century living habits and technology survived, etched into its concrete by the casting process, as odd details like the impressed patterns of fossils caught in its surface: the zigzags of wooden stairs, trapped within the structure, or the indents of plug sockets. An English terraced house had become as alien as an archaeological find.

But what a rudimentary structure, too, it turned out to be: just a squat arrangement of spaces, a stack of caves honeycombed together. To solidify the interior spaces of a house may be to conceal them but it is also to reveal how basic our needs have remained through the centuries. Unlike other kinds of monumental statuary, which may suggest that history is made by the great and merely lived by the rest of us, *House* was stubbornly unheroic and democratic: an image of how we all live, caught between solitude and sociability, formed from the separate but abutting cells of the rooms in a London home.

The idea of creating such an object, and then designating it as an art object, would have been quite alien to artists of earlier periods in history. *House* could never have come into existence without the considerable changes to the notion of what art is, or what art can be, that have been wrought during the course of the last century. The sculpture was

not aggressive in itself. But behind it lay the vigour and aggression of a multitude of twentieth-century artists, whose habit has been constantly to challenge, question and test the limits of that imponderable category of objects to which we assign the word Art. *House* may have seemed perverse to those (and in Britain, even in 1993, there were many) persisting in the belief that fine artists should restrict themselves to easel painting and carving. But in many respects it was an extremely traditional work of art, both in method (casting is an ancient technique) and in effect. Something very ordinary – but no more ordinary than the painter's oil and ground pigment or the carver's block – had been turned into something extraordinary.

House was also a traditional *British* work of art, both in its close focus on the ordinary and the everyday and in its implied distaste for the grand or sweeping gesture. What could be more British than a monument which, like the monuments in the gardens of Stowe, disavows the very idea of monumentality? Like the paintings of Holbein, or Stubbs, the sculpture concentrated the attention of those who contemplated it on the simple truth that we are all, at base, merely mortal creatures.

On 11 January 1994, despite appeals and protests by the artist who created it and by others on her behalf, *House* was bulldozed into oblivion on the instructions of Tower Hamlets' council leader, Eric Flounders. *House* was never meant to be more than a temporary work of art. But Flounders, whose Council had initially approved Whiteread's scheme, was horrified by the result of the commission and only a short extension on the lease of the site was allowed. All that remains of *House* today are a few fragments which were retrieved from the wreckage by admirers.

In the twentieth century, art in Britain has caused much outrage and prompted a high incidence of vandalism. Jacob Epstein, a Jewish immigrant from New York in the early years of the century, was the first artist to suffer British iconophobia in some of its twentieth-century forms. His sculpture *Rima* was subjected to a day of public insult by J. Edward Homerville Hague RA, who stood before the work and reviled it (for its alienness, modernism and vulgarity among other things) from 8 a.m. to 8 p.m. on 14 June 1925. A decade later, following a concerted campaign in the press against the unseemliness and obscenity of the naked figures which Epstein had sculpted on commission for the facade of the British Medical Association headquarters in 1907 to 1908, the offending carvings were virtually demolished.

In the 1950s, Winston Churchill's widow kept this British tradition of rigorous art criticism alive by destroying Graham Sutherland's frank portrait of her late husband. Twenty years later, a national furore erupted over the Tate Gallery's acquisition of Carl Andre's *Equivalent VIII,* an arrangement of 120 bricks, and various attempts were made to deface the work. Only in late twentieth-century Britain, perhaps, could a figure such as Andre, an American Minimal artist of quiet but serious intent, achieve such unwanted nationwide notoriety.

Twentieth-century British iconophobes wear different clothes to those of their predecessors. Their objections to art are generally more trivial than those of the Protestants

of the past, although they certainly have something in common with them. They distrust the modern artist for old-fashioned puritanical reasons, being suspicious of any work of art which appears, to them, to have involved little work. They also suspect modern art of trying to fool them with a spurious jiggery-pokery. They regard the artist who claims that ordinary things like lumps of concrete or piles of bricks are works of art much as their ancestors regarded the old, Catholic fashioning of fraudulent images. Modern iconophobes see collectors and other lovers of modern art as people who have been made monkeys of by false idols.

The modern image-war has, of course, been fought on a different scale and with different weapons. Iconophobia in the twentieth-century, in word or deed, is history replayed not as tragedy but as farce. Attacks have not been as vicious, nor have they been directed at works of art as deeply rooted in national consciousness as those of the sixteenth and seventeenth centuries. Eric Flounders is not Archbishop Cranmer and *House* was not Ely Cathedral. In the twentieth century matters of religious worship have become matters of mere taste. Despite that, there is something impressive about the persistence of a dislike so active that it requires demolition of the object. In Britain, it seems, the old emotions aroused by art – particularly the old negative passions – have never quite gone away. Perhaps partly because of that, passion *in* art has found difficulty flourishing.

Fearfully Tasteful

Ever since the death of Turner the majority of artists in Britain have been afflicted by two related conditions: a lack of that consuming moral and emotional conviction without which greatness in any art form is seldom attained; and a chronic inclination to subside, even from the most vigorous beginnings, into a tame and soft compliance with genteel taste. The greatest European artists of the last century have rocked the boat of modern thought, modern perception and modern morality, and in so doing they have played a vital part in shaping the landscape of modern awareness. However, rocking the boat has not been part of the ethos of art in Britain in the twentieth century. Punting it into a tranquil backwater has been more the national style. Some of the best twentieth-century artists have been British. But those who have achieved greatness have had to work against the grain.

The triumph in late nineteenth-century Britain of an aesthetics of genteel retreat was, to a large extent, responsible for this state of affairs. No counter-tradition in which artists worked together and supported one another was ever firmly established in Britain. After 1870, when Monet first came to London and began to absorb and build upon the lessons of Turner, the initiative and momentum of early modern art passed gradually but decisively to Paris. French art in the years after 1870 saw one of the densest flowerings of art and artistic innovation in history. Monet, Degas, Gauguin,

75 JOHN SINGER SARGENT *Lady Agnew of Lochnaw*, c.1892–3.

Cézanne, Seurat, Van Gogh, Picasso, Braque, Bonnard, Vuillard and Matisse were the great visual philosophers of the time. They were the painters who dared to think about the new conditions of a new world and to embrace the difficult, different, perplexing life of a time that was accelerating into the future as no time had ever done before. They saw the new city and the new technology and the new potentialities of man (some exhilarating, some dreadful) as catalysts to art. Their work was a sunburst of activity and invention, illuminating the dim fears and anxieties of a nascent age.

New styles, new media and new ideas were peculiarly unwelcome in Britain. Initially this rejection had been motivated by fierce moral principle and emotional disgust, but by the later nineteenth century the ethical fervour of men such as Ruskin and Morris had been largely replaced by a complacent, morally void cynicism. Much British art of the *fin-de-siècle* was slick but emotionally and intellectually vacant. This transition was most eloquently effected in the paintings of two Americans working in London: James McNeill Whistler and John Singer Sargent. In the glistering vacancy of their creations we can see, distilled to an exquisite essence, the enervated state of art in Britain in the half-century leading up to the first large trauma of the twentieth century, the First World War.

Whistler's finest works are his *Nocturnes,* painted in the 1870s, smooth, occasionally brilliant but toned-down homages to Turner. In Whistler's night-time views of London, fog on the River Thames and diffused gaslight became the pretext for near abstraction. This is not the charged near abstraction of Turner, however, but a very different and much less consequential form of art. Whistler made Turner's radiant and radical vision grey and philosophically empty. He dimmed its colours and he stripped it of its episte-mological profundity. A new way of making sense of the world became a new way of making patterns. A lusciousness, an aesthete's relish which translates into a lack of compulsion also infects these pictures. The suspicion that Whistler had very little to say about the world, in the end, is confirmed by the bathos of his later life when he slowly degenerated into a painter of occluded, mannered portraits and interiors.

If Whistler's career announced a turn away from content towards style in British art, Sargent's career confirmed it. His milieu and his subject matter was anglophone high society at the turn of the century. It was a society whose capital city was London, but one which lived much of its life in a state of perpetual migration, from rainy England to the bright South of France, from beach resort to casino town to spa. Sargent was the darling and the paradigm of his age, the exemplary British artist of the late Victorian and Edwardian period. His art was beautiful but affectless, breathtakingly well executed but entirely without moral or intellectual energy. He was gifted with a heartless virtuosity, perfectly adapted to the sensibility of the turn-of-the-century patron of art in Britain.

Sargent benefited greatly from the failure of other forms of painting to take root or develop in Britain. The traditions of early modern high art had failed altogether in Britain by the turn of the century, while that more traditional medium of high painterly

ambition and seriousness, the academic *grande machine,* the large-scale narrative and didactic work, had entirely faded from popularity. That ancient staple of the British artist's diet, the portrait, had become once again almost the only genre in which it was possible to practise.

Sargent invariably made the best of his subjects. He transformed Lady Agnew [75] into an unforgettable siren, or at least an untouchable flirt, answering her effortless, self-possessed and sensual manner with his own, arrogant cursoriness of brushstroke. His incomparably smooth female portraits are the index of an enduring aspect of British taste, a love for the infinite reassurance of profoundly unchallenging art. *The Misses Hunter* is exemplary, a triple portrait of perfect decorum, an image made of silk, money, confidence, a little decorously revealed flesh, a just slightly awkwardly placed lap-dog (in acknowledgement of Reynoldsian wit) and a sense of precious things gleaming dully in an understated but opulent background.

Sargent's contemporary, the sculptor Auguste Rodin, called him the 'Van Dyck of our times', but while Rodin was right to remark on Sargent's retrospectiveness he placed him in the wrong century. Sargent inherited Van Dyck at a remove, mediated by the eighteenth century. The coolness, the sense of arrogant modesty that permeates his work is shot through with recollections of Georgian painting, particularly of the art of Reynolds and Gainsborough. His work was doubly seductive to those able to afford the cost of being memorialized by him. This was portraiture that flattered twice over, once in the act of representation itself, a second time in the recollection of other and older images echoed by that very representation. Sargent's art seems self-consciously out of date, one last revival of a doomed art form, consecrated to a doomed society.

Sargent's *oeuvre* incarnates values that underpin Edwardian painting itself because it contains within it, perfected, the mannerisms of so much other art of the time. Philip de Laszlo's slickness and William Orpen's and John Lavery's love of large dark opulent spaces, where twinkling light picks out gilt and jewels and silver, are all incorporated and outdone by Sargent. There is something frightening about Edwardian materialism. The art that speaks of it most fully was well suited to an imperial nation that was shortly to lose its empire. It shows a huge hunger for the things of this world, but it is devoid of value, purpose or meaning.

While Sargent was in mid-career, in 1907, Picasso painted his most famous picture of women in a room, the painting of a brothel which he called *Les Demoiselles d'Avignon.* In Britain there would be little frenzy, little convulsion, little abandonment of old morals or embrace of new visions. The critic Roger Fry's two exhibitions of French Post-Impressionist painting, held in London in 1910 and 1912, fell mostly on blind eyes. 'I am absolutely sceptical as to their having any claim whatever to being works of art', was Sargent's own, brief remark on the works of Seurat, Gauguin and Cézanne, proving that painters can be as iconoclastic as anyone. Robert Ross, reviewing Fry's first Post-Impressionist exhibition, claimed to detect in it 'the existence of a widespread plot to destroy the whole fabric of European painting'.

A small coterie of mainly upper-middle-class, self-styled bohemian intellectuals gathered around Fry and, enthused above all by the work of Matisse, they attempted to put this new, foreign aesthetic to some use in Britain. But although the Bloomsbury Group saw themselves as a cure for the disease of aesthetic gentility they ended up as another symptom of it. Duncan Grant's *The Tub,* Vanessa Bell's textile designs and Fry's own paintings were homages to Matisse and to the ideals of Fauvism which distorted and emasculated precisely what they set out to elevate. An art of sensual self-abandonment, transplanted to the polite world of polite English people such as these, was doomed to failure. The small horrors of Charleston Farmhouse in East Sussex, the rural retreat which Grant and Bell spent their lives perfecting, offer conclusive proof of this. Decorated throughout in the English Fauvist manner, the house is a monument to the stifling force of British conservatism. An avant-garde and passionate style of art, nurtured by Gauguin and Van Gogh, inherited and passed on by Matisse, has been anglicized and killed off in the process. This is an English country house murder with a difference, because the death takes place in every room at the same time: murder by pastiche in the withdrawing room, the dining room and the library.

Fry, at least, had the self-knowledge to admit his own deficiencies (perhaps, because he was primarily a critic rather than an artist, they mattered less to him). 'We are fearfully tasteful,' he wrote to Vanessa Bell in 1918. One of the founders of the Bloomsbury Group, he was also its most concise and accurate critic.

A more fruitful route of escape was planned by a group of artists who, gathered around the figure of Wyndham Lewis, created a new form of British urban art which they termed Vorticism. The Bloomsbury Group, who had been conditioned by their patrician background to regard all native innovation askance, could not see any potential in it. In 1917 the critic Clive Bell sneered at 'the new spirit in a little backwater, called English Vorticism, which already gives signs of being as insipid as any other puddle of provincialism.' He was quite wrong. Vorticism was strong and vital. It was the first and almost the only British twentieth-century art to celebrate the modern world.

A Little Narrow Segment of Time

The invention of Wyndham Lewis, Vorticism was the closest thing Britain has had to a modern art movement or to an avant-garde in the twentieth century. It was never quite either though, being too sudden, explosive and short-lived to count as a movement and too suspicious of military metaphors to be happily counted a vanguard. Ezra Pound, the poet who later assisted T.S. Eliot at the birth of *The Waste Land,* was one of the many figures who circled around Lewis during the Vorticist moment. He defined the Vortex as 'a radiant node or cluster … from which, and through which, and into which, ideas are constantly rushing.' Lewis's own most eloquent term to describe the ambitions that lay behind his various schemes and projects was the title he gave to the first Vorticist

76 WYNDHAM LEWIS *Workshop,* 1914–15.

manifesto, published on 20 June 1914. He called it 'BLAST!', printing the word in thick black capitals, sans serif and sans apology.

Lewis was a great attacker of the styles and personalities of his time, a man with a talent for blasting others out of the water. He railed against the shallow respectability of Edwardian and Victorian taste ('BLAST … BOURGEOIS VICTORIAN VISTAS'). He railed against the *amour-propre* of the well-to-do classes and the rich men's gigolos prepared to paint it ('BLAST their weeping whiskers, hirsute RHETORIC of EUNUCH and STYLIST'). He railed against the dead hand of 'respectable art' and indeed repectability itself ('BLAST PURGATORY of PUTNEY'). He railed against the tasteful emasculation of modernism by the Bloomsbury Group and Fry's Omega Workshop, describing it as '… Roger Fry's little belated Morris movement …'.

Vorticism was born out of a spirit of rejection, but for every one of its negatives there was a positive, for every BLAST a corresponding BLESS. For the first time, in Britain, pleasure in the urban, the technological and heavy industry found a sophisticated voice. Lewis blessed the 'great PORTS – HULL/LIVERPOOL/LONDON/NEWCASTLE-ON-TYNE/BRISTOL/ GLASGOW' and he blessed all the things associated with them, 'scooped-out basins/heavy insect dredgers/monotonous cranes/stations/lighthouses, blazing/through the frosty/ starlight, cutting the/storm like a cake.' He blessed the 'steep walls of/factories'. He wrote 'BLESS ENGLAND – industrial island machine'. This was an England that had never been blessed before. It was blessed even more eloquently in Vorticist art – that brief but magnificent outburst of images that flowed out of Lewis and his circle in the years leading immediately up to the First World War.

The essence of Vorticist art lies in the excited, scatter-shot nature of the enthusiasms which it declares. To look at Lewis's painting *Workshop* [76] is to see so much that had been omitted from art in Britain since the middle of the nineteenth century – bright colour, the shapes of modern engineering and architecture, a sense of visual excitement and exhilaration in the face of change – suddenly rushing into an English painting as if into a vacuum. Lewis was keen for reasons of rivalry to dissociate himself from both the Cubists and the Futurists. But the Futurist cult of machines, speed and electricity is reflected throughout the art of the Vorticists and Picasso's interest in the fractured quality of modern urban reality, expressed in the broken surfaces of Cubist painting, certainly informs much Vorticist painting. The Vorticist city, rendered in the paintings of Lewis, Edward Wadsworth and David Bomberg is a hard, beautiful, but shattered place.

Like Picasso, who once said he wanted to paint a woman you could smell as well as see, the Vorticists wanted to capture the spirit of their time, but they also wanted to recapture some of the most ancient and atavistic powers of art. Vorticism produced idols as well as abstractions – Henri Gaudier-Brzeska's *Hieratic Head of Ezra Pound* turned the poet into an intimidating, lantern-jawed votive figure; Jacob Epstein's *The Rock Drill* merged a man with a machine to form a new kind of tribal-mechanical deity, phallically potent, a centaur for the machine age.

The Vorticists wanted people to have something resembling the oldest, most indecent and ritualistic human experiences when contemplating art, rather than responding to it in a merely civilized manner. This ambition may be sensed before Bomberg's painting *The Mud Bath*. The title of the picture refers to the mud baths in East London which Bomberg sometimes frequented, but the picture itself would seem to depict nothing of the kind. A group of mechanomorphic shapes cavort around a black pillar, as if performing a dance of worship. *The Mud Bath* has something of the bacchanal about it and it is indeed reminiscent of the pagan revels once painted by Poussin, despite the fact that the language of French classicism has been translated into the Vorticist language of abstracted form. *The Mud Bath* is Poussin's *Adoration of the Golden Calf* (which Bomberg knew and had copied in the National Gallery in London) reimagined for the twentieth century.

The First World War brought to an end Britain's one moment of celebratory experimental modern art. Gaudier-Brzeska died during the conflict. Lewis and the remaining Vorticists were so disillusioned that they never re-formed into their original 'radiant node', and became saddened apostates from most that they had once believed in. As Lewis remarked, by the time the Great War had reached its bloody end and art, rather than fighting, became a possibility once more, 'the geometrics which had interested me so exclusively before, I now felt were bleak and empty. They wanted *filling*.'

The catastrophic, stupid, mismanaged conflict changed the mental landscape of early twentieth-century Europe. The scale of the war's effect on art and the life of artists is incalculable. It wiped out almost an entire generation and it destroyed the most vivid hopes and ideals of those who survived.

'I am no longer an artist', wrote Paul Nash, one of several official war artists appointed by the British government in the later stages of the conflict. 'I am a messenger who will bring back word from the men who are fighting to those who want the war to go on forever. Feeble, inarticulate, will be my message, but it will have a bitter truth and may it burn their lousy souls.' Nash's pictures of blasted war-torn landscapes are scenes of aftermath which can only attempt to conjure up the evil done to men's bodies by showing the holes and craters in the war-pitted land. Nash was reduced to such stratagems, which he attempted to toughen by the apposite choice of ironic titles – *We Are Making a New World,* he called the most memorable of them – because he was forbidden by the government from depicting human corpses.

The stunned and vacant quality of Nash's wartime work has its own pathos, but the most affecting war art is that which managed to smuggle blunter human truths across the borders of official reluctance to own up to the horrors of it all. Paul's brother, John Nash, painted one of the truest and grimmest of all British First World War pictures. *Over the Top* shows trench warfare as the blind, stupid, deadly game it was. It depicts soldiers struggling up and out of a hole in the ground and stumbling off, wrapped in heavy greatcoats, to their inevitable and undistinguished deaths. The shock of the picture lies not in any brilliance of vision or virtuosity of handling but in the grim

77 HENRY TONKS *Disfigured Soldier no. 18,* 1916-17.

simplicity and homeliness of the image. This is death not as anything glorious, marvel-lous or heroic, but just a walk in the countryside that ends with a bullet in the heart or the head.

The Lee Enfield rifle and the Mauser automatic pistol shot down the modernist fantasy of a bright new age as well as about ten million young soldiers. Henry Tonks, Professor of the Slade, served in the Medical Corps of the British Army and made sketches of the results of such weaponry on the bodies and faces of the wounded [77]. His drawings are among the most compelling and disgusting of all war images – chill-ingly neutral studies of twisted, broken faces, records of distortion in which academic life drawing has been turned into an art that looks like Cubism by the dislocations wrought on life itself by war. How hard it must have seemed to return to Cubist or Vorticist experiment in post-war Britain, where broken people such as these – people with missing arms and legs, people with noses where their mouths ought to be – were seen on every street in every city.

Writing in 1947, Wyndham Lewis poignantly described the Vorticist period as 'a little narrow segment of time, on the far side of World War I. That first war, you have to regard, as far as I am concerned, as a black solid mass, cutting off all that went before it.' The post-war years were, before they could be anything else, years of struggle to come to terms with the scale and implications of an international conflict that had been greater and more catastrophic than any seen before. They were years consecrated to memory, to the halting recollection and description of what had been a nearly indescribable abomination, and to the building of memorials. The most haunting is Charles Jagger's *Royal Artillery Memorial,* that generally ignored, stranded monolith of regret on Hyde Park Corner in London.

Part of Jagger's memorial is almost Vorticist in style. On top of it stands a marble carved gun, a metal mechanism cut in stone. Beneath, though, the memorial turns still and almost neo-Assyrian in style, showing generalized artillerymen in bas-relief straining in situations of muted but distinct horror. The monument also displays another change of mood (or change of mind), exhibited in the form of three stern upright soldiers, cast in dark bronze. Much more highly realized, they grimly stand guard over yet a different memory of the Great War: neither a triumph for machine, nor for human heroism, not even an event to be comprehended but something simply to be got through, stoically, until it reached its grim end. Almost as an afterthought, Jagger added the bronze figure of a dead soldier covered over with his greatcoat at the north of the memorial. There is a certain euphemistic fraudulence about it, because most death in war was not this dignified sleep of a whole body, but a dreadful strewing of parts. Despite that, this still seems the most honest part of the monument: giving up the attempt to find significance in all that death, it simply marks the fact of death itself.

A Mild Modern Art

The Great War had the immediate effect (among its many other effects) of stopping up the imagination. It was plain that there could be no swift return to the old Edwardian complacency. The men and women whom Sargent painted, living among gilt and cigar smoke, had become for many the enemies within – a generation which had lied to and cheated another and younger generation out of their lives.

However, despite this rejection of the old Edwardian order British pre-war aesthetic conservatism resumed its grip on taste in the years after 1918. Although initially provoked by the war, the suspicion of new art movements lasted so long that memories of the trauma of 1914 to 1918 cannot be held solely accountable for the dominance of the safety-first aesthetic in Britain. An atmosphere was created in which the energies of Vorticism could not thrive, but in which the small and stifling tastes of the Bloomsbury set could persist. There was a general meek return to old genres and manners, on the part of British artists, as if they were attempting to restore order to a disturbed world.

A hysterical quality may be sensed in the willed calm of such images. In the 1920s Edward Wadsworth began a series of maritime still lifes which combine apparent placidity with implications of simmering disquiet. Various pieces of beached sea-side bric-a-brac, such as shells, anchors and propellers, are disposed in puzzling configurations. There is a sense of threat about Wadsworth's pictures, an implication that the world itself makes no more sense than these mute arrangements of objects.

The masterpieces of this post-war English mode of small moves and strangulated panic are the portraits painted by Meredith Frampton. *Marguerite Kelsey* is the best known and perhaps, too, the best of them. A lady in a white shift, painted in a style of tense polished realism, sits motionless on a purple sofa in a red room. Frampton's world is a hushed place, its presiding mood one of quiet but palpable *anomie*. His colour schemes recall the work of his contemporary Max Ernst, the German-born Surrealist, but his art is closest in mood to those stilled, sad, metaphysical pictures of empty city squares painted by Giorgio de Chirico in post-war Italy – images of 'a convalescent world', to borrow de Chirico's phrase, recovering from the shock of atrocity.

By the late 1920s the urban avant-garde of the pre-war years seemed like a distant memory. Those Vorticists who survived the war had subsided into a listless, disillusioned mediocrity. Wyndham Lewis devoted himself more to writing than art, painting only a few heartless portraits in which faint echoes of the crystalline forms of Vorticism may be detected in the multi-faceted, mask-like faces of his sitters. David Bomberg went abroad to Palestine, where he buried his Vorticist past and the visions of war in his head by painting many dull and lilac-coloured pictures of the Holy City. His old energy, touched by memories of pain, was occasionally to surface again, notably in his drawings of Rhonda in southern Spain, of the later 1930s, in which he created landscapes like wounds conjured up in dark, slashing calligraphy, and in his paintings of St Paul's withstanding the blitz in the 1940s. But he never truly recovered the fire and vigour of his art of the pre-war years.

The fate of modern styles of architecture in Britain in the first half of the century mirrors this state of affairs. In vernacular architecture the Tudorbethan style spread and spread, foresting the new suburbs and the new garden cities with half-timbered dwellings, to incarnate an ancient dream of empire while confirming a well-established national habit of retreating into the past. In civic architecture, the most important commissions were given to Beaux-Art traditionalist architects and the modernists were left to fight over scraps. The pattern was set early in the century. Britain's most influential early modern architect, the young Charles Rennie Mackintosh, built one work of innovative genius – that thrilling combination of Scottish baronial pomp and proto-modernist purity, the Glasgow School of Art – but then spent the rest of his life deprived of the grand commissions which he deserved. Styles tainted with modernist associations did persist but only under sufferance, and innovative architectural design occurred only at the margins of culture, as freak or folly. This is why some of the most beautiful and adventurous architectural creations of the twentieth century, in Britain,

78 BERTHOLD LUBETKIN the Penguin Pool, London Zoo, 1934–5.

are to be found in such curious or out-of-the-way corners: Eric Mendelsohn's light-filled pavilion at Bexhill-on-Sea and Berthold Lubetkin's Penguin Pool in London Zoo [78] are among the most memorable examples of this marginalized avant-gardism, small jewels of utopian modernism in the most unexpected places.

Lubetkin's Penguin Pool symbolizes the fact that modernism itself, as far as the British were concerned, was mostly for the birds. A touching parable of this state of affairs is provided by the curious case of Kurt Schwitters, the leading Hanoverian Dadaist, who came to England in the early 1940s as a refugee of war only to find himself no longer a figure of controversy but a man regarded with mild curiosity and suspicion. Whereas European Jewish artists of lesser stature who emigrated to New York were feted and greeted as mentors by the younger members of the artistic avant-garde, Schwitters in England met first with scepticism and then indifference. He moved to the Lake District, where he went literally to earth, creating that brilliant, erotically charged anglo-Dadaist object, his *Merzbarn,* working quite alone, in a barn in Ambleside, while occasionally painting portraits of local people to earn a little money.

Schwitters claimed that there was no avant-garde for him to join, and he was right. But that is not to say that there was no modern art in Britain between the First and Second World Wars, because there was. It simply did not take the form of anything resembling the ideas of an avant-garde, as a strident, radical, resolutely anti-bourgeois group of cultural storm troopers, prevalent in Europe in the 1920s and 1930s. British artists were much less metropolitan creatures than their counterparts in other countries, in many cases through choice as much as necessity. They were not entirely unhappy to occupy the margins of society, to work alone and apart. To many of them, the edge of life felt like home, rather than exile. Their modern art was not avant-garde but rear guard, content to remain apart or aside from the larger concerns of history. It was not vehement, ambitious to inflame the world with visions of hectic change, but benevolent, mild and cautious.

That gentle suburbanite Stanley Spencer was in many respects the epitome of this peculiarly British type of artist. Like Henry Tonks, he had served in the Medical Corps of the British Army during the First World War and the sight of much pain and death had bred in him a habit of using art to dream of better worlds. The Sandham Memorial Chapel in Burghclere, which he decorated with large murals between 1927 and 1932, is not so much a war memorial as an amelioration of war in art. *The Resurrection of the Soldiers* on its east wall, showing a throng of bodies pressing up out of their graves, was Spencer's way of digging up the cemeteries of northern France, at least in his imagination, and bringing the young bodies of a dead generation back to life again.

Most of Spencer's pictures elaborate the personal vision of a blessed place. Spencer's is a heaven very much on earth, an idealized version of the village where he himself had been brought up and spent most of his life: Cookham, in Berkshire, in London's commuter belt. Religious events take place in ordinary settings and ordinary places are seen to be full of religious significance in his art, so Spencer's *The Baptism of Christ* is set in a

79 STANLEY SPENCER *Self-Portrait with Patricia Preece,* 1937.

municipal bathing pool, where commuters taking early morning exercise crowd around the son of God, while *The Temptation of Saint Anthony* takes place in Cookham church yard. There is something of the Pre-Raphaelite about Spencer's dreams of finding or making a spiritual home for himself. His overwrought, laborious technique is reminiscent of Pre-Raphaelite art as well.

The most distinctive quality of Spencer's utopia is its quaint and original combination of cosiness and sexiness. His art is partly a dream of returning to childhood things, a fantasy of reversion to some soft remembered domestic bliss, a world of wardrobes and laundry baskets and the bustle of mother making the beds while a smell of brewing tea fills the air. But it is also a dream of love and being loved, a fantasy of being pressed among the bodies of others (preferably women). Spencer's art is full of crowds, bodies squeezing against one another as in *Unveiling Cookham War Memorial.*

In *Love on the Moor* that crowd has become actively sexual, a community on the brink of comic orgy. This imagined communal carnality was at the centre of Spencer's

fantasy and it was another of his ameliorations of war. 'During the war,' he wrote some years after 1918, 'when I contemplated the horror of my life and the lives of those with me, I felt that the only way to end the ghastly experience would be if everyone suddenly decided to indulge in every degree and form of sexual love.' His most piercingly immediate pictures remain those in which this fantasy came up against the unpalatable reality of his own unhappy second marriage to Patricia Preece. Spencer's appetite for her body was not reciprocated and in the portraits that he painted of her his yearning has bred a subtlety in the handling of paint absent from his other work [79]. Because the painter is held back from physically possessing her in life he dwells on her with his eyes and his brush in compensation. The naked body of a woman, ripe and powerful, is not only an object of desire but veneration.

Much British art between the wars preferred the female principle to the male, as if British artists who had served in the war could not bring themselves to admire or reincarnate aggressive masculinity in their work. While Stanley Spencer was deifying Patricia Preece, his contemporary Henry Moore spent his life putting his idea of the ideal woman on a pedestal.

Moore, like many other sculptors of the twentieth century, was much influenced by non-Hellenistic art, in particular Aztec and Toltec sculpture and the masks of the Gabon in Nigeria. But the true father of Moore's art was his European contemporary, Pablo Picasso, whose chthonic 'bone drawings' of the late 1920s provided the English artist with a blueprint for every sculptural form he created during the rest of his life.

Moore was not a great formal innovator, but he made Picasso's language over into his own style by subtly changing it. As he elaborated his own, carved versions of Picasso's disturbing broken anatomies, he made them rounder and more comforting, the holes in their bellies not wounds but places of refuge [80]. Moore's most impressive and monumental works remain those grand undulant giantesses, his reclining female figures. These are the fittest idols of his cult of woman and maternity. The contours of Moore's dreamed-of woman echo the contours of the landscapes which she occupies. She herself is part woman and part fertile, benevolent, sheltering landscape. She is a retreat from the storms of a violent century.

In the same period the mother of all mothers, mother nature, preoccupied a genera-tion of artists for the first and only time in the history of British art. A mood of wistful, quiet pastoralism pervades the painting of the 1930s, 1940s and much of the 1950s. John Piper and Paul Nash travelled England sketching and painting the rural scene as if seeking to lose themselves in it: Piper's love of dense undergrowth and Nash's fondness for moonlit gloamings speak of a longing for enclosure and protection. More mystical versions of landscape art thrived too, keeping alive the venerable British tradition of wilfully cultivated eccentricity. Cecil Collins produced small odd landscape images requiring, but not entirely meriting, ornate exegesis. The Welsh artist David Jones drew dense and neurotic skeins of vegetation in which symbolic forms and shapes of obscure personal mythological significance have been snagged like clothing on brambles.

80 HENRY MOORE *Reclining Figure,* cast in 1983.

Nature became the redemptive force of the era, a calmative for twentieth-century living. Ben Nicholson and Barbara Hepworth, inhabitants of a colony of artists in St Ives, Cornwall, adapted the styles of contemporary European urban abstraction (much as Moore adapted the style of Picasso to suit his purposes) to the expression of landscape themes. In the 1940s Hepworth made delicate abstract wooden sculptures, some of them extremely sensual, intended to evoke the clean curves of the Cornish landscape. Nicholson made reliefs in homage to Mondrian and the art of Purist Paris, in which the sharp edges and planes of urban abstraction have been made to speak not of new objects but of old and familiar ones, ships and sails and the sides of barns. A weakened strain of pastoral abstraction has rambled on in St Ives ever since, an art of soft sighs and exhalations of colour.

Many of the artists responsible for this move back to the land liked to feel that they were part of a great tradition of landscape painting in Britain, and many art historians

have been rather too content to take this claim at face value. The notion that there has been a great British tradition of landscape painting is, in fact, a twentieth-century concoction. There was no landscape painting of note whatsoever in Britain in the seventeenth century. There was not much landscape painting of quality in the eighteenth century, with the exception of the work of Richard Wilson, much influenced as he was by Claude, and a few watercolourists. There was little landscape art of great merit in the nineteenth century, apart from the work of Turner (who did not consider himself a landscape painter at all), that of Constable (who considered himself anything but a *mere* painter of landscapes) and the devout fidelities of the Pre-Raphaelites. France and Holland have, historically, been considerably richer in landscape painting than Britain.

It is true that the British mind has been much preoccupied by nature and the natural world during the course of the last four centuries. However, the origins of that preoccupation do not lie in painting but in the radical theology of the Reformation – not in a tradition of art, in other words, but in a tradition of anti-art. The twentieth-century artist to have most eloquently revived this attitude to nature is Richard Long. Born in 1945, he is a sculptor of a much later generation than Moore, Nicholson and Hepworth, but his work looks back to a much earlier period in British history than theirs.

Long's work often consists of no more than the photographic record of an act performed in the landscape. He shows us a straight line which he has made in a field of grass by the act of repeated walking. He shows us a pattern made from water splashed on to rock. His gallery sculptures consist of ritualistically and often commandingly simple arrangements of material. Stones may be set on their ends in a line, or arranged in a circle. These exercises have been carried out for no apparent purpose other than to mark time spent devotedly paying ritual homage to the natural world. Long absents himself from his work to present us with what he hopes will be an experience of renewed awareness, a small epiphany of beauty. There are religious overtones to this.

The early Protestants preferred God's creation to the feigned creations of man. They preferred nature itself seen through clear and transparent glass to the pictures in stained glass. They preferred the real world to false images of it. Like the Protestant devotee of the past, Long loves nature with a love that implies rejection of other things and a certain degree of violence. *Carrara Line* is a sculpture which expresses this particularly clearly. It consists of a rectangular field of marble fragments, over fourteen metres in length, placed directly on the floor. The title is a small nudge. Carrara marble, it may be remembered, was the marble from which Michelangelo carved his *David*. It is the material of the European figurative sculpture tradition. But Long's marble fragments amount to an anti-sculpture, sculpture so cracked that it can hardly be described *as* sculpture.

Long's violence is a way of stating values, a sign of his preference for the unformed over the formed, for nature over culture. He makes art that enact its own destruction, whether literally, in the works that he creates outside, photographs and then leaves to the mercy of the elements, or metaphorically, as in the case of *Carrara Line,* a sculpture made in the likeness of a destroyed sculpture. Long dreams of an art that approaches

81 WALTER SICKERT *Noctes Ambrosianae*, 1906.

so closely to nature that it will cease to be art at all. In his work twentieth-century British landscape art does not only rediscover its oldest roots in British Protestant theology, it finally discovers the common ground that connects it to its apparent opposite: another iconoclastic, realist art. This art is not of the land, however, but of the city.

Real Life

'The plastic arts are gross arts, dealing in gross material facts', wrote Walter Richard Sickert, spelling out the ethos at the heart of modern British art's other dominant tradition.

'No one could be more English than I am', he once said archly: 'Born in Munich in 1860, of pure Danish descent!'. Sickert valued impurity in all its forms and was proud of his own. To what he called 'the wriggle-and-chiffon school' of late Victorian and

Edwardian portraiture he opposed another and much less cosmetically acceptable view of urban reality. It was not the Vorticist view of the city but an urban art nonetheless, and one that was rooted in an earlier moment in modern European history.

Sickert had studied in Paris in the last decade of the nineteenth century, where he had been evidently much impressed by the new urban realism developed by Manet and Degas. From Degas, in particular, he had learned to value the haphazard and impure texture of modern city life, and to cultivate a style of painting with that glancing, snap-shot quality which would produce so much of the most extraordinary art of the early modern period – capturing the sense of the city as a patchwork of lives being lived, in every corner, too intensely to be ignored and too variously to be comprehended.

In his early career Sickert frequented London's music halls: The Standard, where George Leybourne sang 'Champagne Charlie', the Eagle Tavern, the Grecian Saloon and, his favourite haunt, The Old Bedford. He painted the celebrated artiste Minnie Cunningham as a spectral waif, a glow of flowing red drapery set against an expanse of dull, dark stage flats. Her face has been oddly rubbed by the painter, revealing the weave of the canvas. This is precisely the sort of elegant, impromptu tactic (it enhances the ghostly effect that Sickert was doubtless after in the painting) that lends Sickert's art its power. He also painted the music hall audiences, and they too have a ghostly quality but also an animal aspect, rapt monkeys in a dark, flickeringly gaslit human zoo [81]. The popular theatre became a metaphor for existence as Sickert saw it.

Sickert wanted his pictures to be like a 'page torn from the book of life' and his best work combines melancholy with a brilliant, ragged vitality. In 1905 he settled in Camden Town, in North London, living among the navvies, shift-workers and prosti-tutes who became his subjects. His Camden Town nudes, painted in liverish green colours, sprawl on unmade beds in dark and dingy rooms. Mute recriminations aimed at the society dames and damsels who were painted by Sargent and his like, pictures such as *La Hollandaise* are powerful memorials to another side of Edwardian life.

In the late 1920s and 1930s Sickert pushed painting into places where it had never been before. His abrupt, knowing uses of photography and other media in his work anticipated that habit of appropriating found mass media imagery which swept through European and American art during the 1970s and 1980s. But Sickert's chief legacy to British art was his realism. He gave renewed moral and pictorial force to the ideal of an undeceived, disillusioned vision in British art. It was his lasting achievement to have given the British back a part of their own temperament.

The tradition of city painting has produced some of the best but also some of the most unregenerately dull British twentieth-century art. Sickert's lineage is easiest to trace within the city he loved and hated so much. The spirit of his Camden Town was kept alive first by his followers, who formed the amorphous Camden Town Group. Then it was passed, somewhat watered down, to the Euston Road School, a group of artists who organized themselves around William Coldstream in the 1930s and who painted scenes of ineffable dullness and dreariness – buses in the rain, factories in the rain,

82 LUCIAN FREUD *Girl with a White Dog,* 1950–51.

streets in the rain – with incredible patience. Their work, for all its drabness, does go to the heart of a distinctively British twentieth century aesthetic. The mood of the unswept street, the spirit of the abandoned car park at night, the milieu of the overflowing urinal or the uncomfortable, unmodernized football stadium through which a cold wind blows – the British have taken a grim, stoical, self-flagellatory pride in such things.

Euston Road finally led into the cul-de-sac of painting as pursued by those later twentieth-century depicters of the urban scene, Frank Auerbach and Leon Kossoff. Both artists pile an almost comical superfluity of paint on to their canvases. It is an unusual and interesting device as well as a confession of failure. Neither artist has a great talent for the truly memorable depiction or evocation of real places and people (Sickert's Camden Town is infinitely more present in his art than Auerbach's Primrose Hill or

83 FRANCIS BACON *Crucifixion,* 1965.

Kossoff's Kilburn). Their piled paint is a confession of this and, simultaneously, an attempt to compensate for it by getting some sense of reality, at least, into art through the creation of this thick and muddy deposit, the texture of sludge and the colour of dust or excrement. Their work is a late and somewhat strained mannerism of the urban realist impulse.

A wide range of work, made in widely differing media and sustained by widely differing rhetorics of intention, has sprung from this preoccupation with dirt, dinginess and seediness. John Bratby's series of Kitchen Sink paintings of the 1950s, those quietly

dyspeptic memorials to bedsitland, to the milieu of the stained lavatory and the table piled high with dirty dishes and full ashtrays; Gilbert and George's large photographic montages of inner city rot and decay; Ian Davenport's dripped abstracts of the 1980s and 1990s evoking the stained walls, mucky flux and eros of the city – all reflect the dirty, teeming, raucous, disjointed character of London.

Lucian Freud's career reflects a deepening love affair with grubbiness, expressed in an art which has progressively been thickened and begrimed. His earlier pictures, like *Girl with a White Dog* [**82**] of 1942, stem more from his admiration for Holbein than

Sickert. They also have much in common with the contemporary portraits of Meredith Frampton. Tense, silent people, tensely and silently observed, they are the *ne plus ultra* of controlled hysterical portraiture in twentieth-century British art. As the century progressed, Freud's realism became less crystalline and less pure. He became a painter of naked people in dingy rooms under electric lightbulbs, a student of the sagging breast and the stretch mark, rendered in much more tactile paint than he had used in his youth. His sitters seem overwhelmed by the tedium of remaining so still under his gaze, and his art is deeply melancholy in its confinement to the milieu of the unfurnished studio. Life has been shrunk to a room where all people have to do is keep still and wait, as the artist studies them and as they and the world grow older.

The greatest painter to have worked in this tradition of disaffected realism in Britain in the twentieth century was Francis Bacon. At the age of seventeen he had a vision, a modern-day epiphany to set beside Blake's tree of angels on Peckham Rye: 'I remember looking at a dog-shit on the pavement and I suddenly realized, there it is – this is what life is like.' Bacon's art dealt in the prime biological fact, the stink and the gore and the flesh of us all. In his work people are lurid agglomerations of bodily matter, bearing out his assertion that 'we are meat, we are potential carcasses'. A certain kind of greatness often stems from the strong recognition of banal truths, and part of Bacon's distinction lies in the fact that he was so strongly affected by the simplest facts of life and death.

The great British satirists had reduced grand narrative art to the scale of the caricature. Bacon did the opposite, turning the small, scabrous observations of the satirist into works of art conceived on the scale of the monument. He also looked back to the traditions of Catholic art, and practised some of his most telling, iconoclastic distortions on its forms. In the 1950s he painted a series of pictures based on Diego Velázquez's portrait *Pope Innocent X*. Velázquez's original is sober and inscrutable, veiling his thoughts behind the frown of authority and the pomp of office. Bacon's transfigured popes scream betially, vestments scrawled in dry, sketchy strokes of pigment, the body reduced to a gaping, toothy mouth, canvas spattered with bloody flecks of paint. There is calm underneath the initial appearance of convulsion, a slow and dilettantish pleasure in the manipulation of paint. Bacon's backdrops have something of the stage flat about them, as if the memory of Sickert's Old Bedford is still there, with him, in British painting.

Bacon was both iconoclast and baboonerist, and he combined these two sides of himself by perpetrating some of his most atheistic babooneries in the form of iconoclastic triptychs [83]. Creatures without heads wander about in pools of blood, monsters scream soundlessly in pink voids and crippled children perform for an invisible audience while pieces of detached flesh float through the air. In Bacon's painting, what had always been on the edge of the page or in the subversive margins of life is suddenly at the centre. The unspeakable has become the altarpiece.

Despite his insistence that the swastika he once included on the armband of one of his figures was only a formal device, Bacon was a painter called forth by the atrocities of the Second World War. His subjects are denied cosy location in story or character, but

that makes them generic. His enigmatic anti-narrative narrative art offers pictorial equivalents to the literature of alienation that developed in the 1930s and 1940s, originating in existentialist Paris where Bacon spent much time during the years leading up to his maturity as a painter. The title of Jean-Paul Sartre's most ambitious account of existentialist philosophy, *Being and Nothingness,* could be a generic title for Bacon's *oeuvre,* although Bacon was perhaps spiritually closest to Samuel Beckett.

For Beckett, the driving concern of literature was the isolation of those moments when our stories about ourselves, our consoling fictions of who we are, break down. These are 'the perilous zones in the life of the individual, dangerous, precarious, painful, mysterious and fertile, when for a moment the boredom of living is replaced by the suffering of being.' In his finest and most innovative paintings of all, his triptych portraits of heads, Bacon painted people as wheeling, turning, mobile matter isolated in space. His rendering of the human figure, creating instants of biological essence from the random accumulations of pigment, was the essential device of his art. This randomness, this isolation of hectic paint on the surface of the canvas, this fluid, volatile process reflects man's own futile and fugitive metamorphoses between cradle and grave. The paradox is that a form of strength and a great sense of beauty is won from such grimness. Bacon's best portraits have a savage, joyous vigour and carnality which communicates not gloom but celebration – something like the manic celebration of someone who knows he does not have long to live but has decided (what the hell) to enjoy being alive while he can. Bacon once said that for him the most exciting person was one 'totally without belief, but totally dedicated to futility'. He was describing himself.

Pop and Not Pop

In 1957 Richard Hamilton wrote a letter proposing the desiderata of a new art. He wrote: 'Pop art is Popular (designed for a mass audience), Transient (short-term solution), Expendable (easily forgotten), Low cost, Mass produced, Young (aimed at youth), Witty, Sexy, Gimmicky, Glamorous and Big business.' A year earlier Hamilton had created the first instance of what he believed such an art might look like, a collage to which he gave the title *Just what is it that makes today's homes so different, so appealing?* [85]. It has become one of the defining images of the dreams and aspirations of an era, a wry homage to the forces which were about to transform post-war Britain into a consumer society.

The stripper and her friend the muscle-man inhabit a split-level flat in the fashionable centre of town. They are amidst a cornucopia of mass-manufactured objects of desire. The lampshade is emblazoned with the Ford Motor Company logo; there is a massive tin of Del Monte ham on the table; on the wall is a framed cover of *Young Romance* magazine; a television set stands in the corner; a reel-to-reel tape recorder is open on the floor. *Just what is it ...* is a picture of a world of possibilities, an Eden of consumer durables inhabited by the Adam and Eve of a new mass culture. But Hamilton's

collage is as much satire as celebration of a future which was yet to arrive in Britain. It is a prophecy laced with irony, an anatomy of bright conformity in which the artist has discerned early symptoms of a media and market-driven late twentieth-century species of conformism. Hamilton shows us a world where all are encouraged to dream the same dream of material satisfaction and to divert themselves with the same diversions. Andy Warhol, the affectless apostle of American Pop Art, once remarked that 'I want everyone to think alike … Russia is doing it under government. It's happening here all by itself …' He was right, but Hamilton had already seen it coming.

Pop Art was unusual, in the history of twentieth-century art movements, in that it was born twice, each time in a different place. The twins were not identical. American Pop Artists created the dumbest, grandest icons of art in the 1960s: Andy Warhol's multiple *Marilyns* and *Elvises;* Roy Lichtenstein's *Whaam!,* that comic-book dogfight on the scale of a nineteenth-century history painting; James Rosenquist's *F-111,* that vast horizontal jet-plane of a painting, a dizzying, filmic collage of twentieth-century imagery. But in the post-war Britain of the tightened belt and the ration book – the world of Spam not *Whaam!* – artists' attitudes to the consumer paradise of the future were touched with a mixture of longing and diffidence.

Peter Blake made a belated British attempt to achieve the blatancy of American Pop Art in his painting but produced an art of quaintness and fairground nostalgia instead. Richard Hamilton's work is exemplary of British Pop, reined-in and therefore not really Pop (in Hamilton's first sense, namely 'Popular') at all. His later paintings, works such as *Hommage à Chrysler Corp* and *AAH!* are restrained, conceptually intriguing works of art. A low-toned imagery which combines elements of the female anatomy with elements of automotive design has been put to the service of cultural analysis. Hamilton's art does not surrender to the sex appeal of cars but attempts to dissect and understand it. It is, in fact, yet another expression of the British impulse to view the world through the sardonic eyes of the realist.

Pop, in Hamilton's sense of the word, never truly came to pass in art, only in popular music. Certain forms of visual self-expression – convulsive, violent, hallucinogenic, disorientating, subversive – could not flourish in the world of fine art in Britain so they took the form of rock music instead. Britain did not produce Salvador Dali, but David Bowie. Britain did not produce Dadaism, but The Sex Pistols.

Rock music, which is an extremely visual medium, catholically combining sound and spectacle and a degree of ritualistic devotion, is the strongest contemporary expression of that old British desire to escape from puritanical restraints and restrictions. Although fine artists in Britain have in general behaved with less abandon than rock stars, a few have incarnated this desire in their art. Their careers have been more like the careers of rock musicians than artists, beginning in a blaze of publicity and almost immediately fading away into a mild remembered notoriety.

In the mid-1960s Bridget Riley created a series of dizzying, optically buzzing and humming geometrical abstract pictures. Made out of patterns and orders of design that

84 BRIDGET RILEY *Current,* 1964.

sway and heave and swell, her pictures practise a subversive, narcotic disorientation of the senses upon the viewer [84]. Riley's motifs were quickly appropriated by the fashion industry, turned into dress designs, and converted into the status of Modern Classics. Christened Op Art, Riley's was really Pop: 'Sexy, Gimmicky, Glamorous'. Riley has never surpassed her early pictures and they remain some of the more moving abstract works of the later twentieth century.

85 RICHARD HAMILTON *Just what is it that makes today's homes so different, so appealing?*, 1956.

Between 1960 and 1962 the only other true British Pop artist, David Hockney, created some of the most sensuous, exuberant and unbuttoned painting seen in Britain since the Second World War. The young Hockney brought a coarseness, a vigour and a passion to all that he touched. In his youth he was clearly much moved by the rich, spontaneous, tactile qualities of American Abstract Expressionist painting. He also drew on that strain of modern European art, inaugurated by Picasso and continued by Jean Dubuffet in Paris during the 1940s and after, which aimed to inject the spontaneity of

86 DAVID HOCKNEY *We Two Boys Together Clinging,* 1961.

children's art into grown-up painting. Hockney's first paintings are touchingly naked in an almost childish way, because they speak so plainly and blurtingly of his loves and preoccupations: *The Third Love Painting* is a dream of a penis (or penises in general) transmuted into thin, scrawled, almost inchoate paint; *Doll Boy* portrays a nameless beloved youth rendered as a toothy diagrammatic figure wearing a white shift, his head bowed beneath the weight of a great red shape like a human heart.

Many of his sources of inspiration lay in London, particularly the walls of London, smudged and stained, bearing graffitied messages of sudden, transient poignancy, which became the templates for his own wall-like paintings of awkward confession. What Hockney was confessing to was his homosexuality. The two doll boys whose forms and faces are mashed against one another in *We Two Boys Together Clinging* [**86**] make a bold erotic emblem of the painter's sexual desire. Hockney's mistake was to leave Britain in 1963 for the warmer and more sexually tolerant climate of Los Angeles – a move to realize in life the desires implicit in his art which proved fatal to his painting.

Finding peace and a form of satiation in California, Hockney soon subsided into a painter of lotus-eating blandness. As Los Angeles' icon-maker, Hockney homed in on its distinctive features with uncanny, numb accuracy: the blankly reflective sheet glass of its pool-side architecture; the rippling surface of its swimming pools; its tall, inconsequential palms, presiding over a place where nothing, nothing at all, seems to be going on. The apogee of his Californian art (and it is an apogee reached painfully early on) is that incarnation of vapid, sunstruck melancholy, *The Bigger Splash*. Painted by an artist who no longer seems fully present in his work, it is appropriately a picture of someone who is no longer there, the diver who, springing off the board, has left only his splashy residue, a flurry of white painterly scribble.

Hockney's most important legacy to British art has been the memory of what he once was and what he once stood for: an artist who painted what moved him, as few artists have done in Britain in the second half of the twentieth century, with passion and attack and a shameless, total emotional involvement in his subject matter. This would be done with more conviction and skill by two less precocious but longer lasting painters, Hockney's contemporaries Patrick Caulfield and Howard Hodgkin.

Patrick Caulfield is a subtle and affectionate student of all those visual collisions of which the modern, artificial urban environment is made. His milieu is the world of fake-Alpine style restaurants, English pubs decorated in the Victorian manner and bland, blank office interiors. He has forged his art from the incongruities of experience, from the visual blends of style from which much life is now uneasily made. There is no more brilliant, succinct and affectionate account of the world in which most twentieth-century urban experience takes place than his *oeuvre,* and he is a much more considerable artist than his relatively slight reputation suggests.

Town and Country [87] is one of his indisputable masterpieces, a picture into which Caulfield has crowded much of his considerable genius and love for life and art. We see a cheap salad bar with fake woodgrain-effect vinyl surfaces and haywire carpet of uncertain synthetic origin. Behind is a view of autumnal trees. Painted in a blurred, dreamy style which is the fine art equivalent to Vaseline on the camera lens, it is unclear whether this is a real landscape or a fake, photo-printed on to a plastic-laminated wall.

One of the more common themes of art during the twentieth-century's *fin-de-siècle* has been the extent to which the real world, or what we like to think of as such, has been supplanted by the world experienced at a remove, distanced by reproduction. This has long been home territory for Caulfield, whose art has consistently patrolled the boundary between the real and its representations. He is the painter of environments where it is almost impossible to distinguish between the actual and the immaterial. But the apparent cheapness of the interior depicted in *Town and Country* may be deceptive, since it is also among other things a place formed from the styles of twentieth-century high art, an anthology of the styles open to the painter: there is Seurat's pointillism in the carpet; Gris's collage-like Cubism in the place where wallpaper meets wood-grain formica; there is Pop Art (fading away) in the sign that reads 'Salads'.

In the hands of later artists of an appropriationist disposition this sense of coming after so many other forms of art has bred a sense of lassitude and diminished possibility. But in Caulfield the effect is one of abundance, a sense of joy in living among so many possibilities, so many ways of seeing. There are few figures in Caulfield's art but many vital signs. He is a poet of life lived, as most modern lives are, among codes and reproductions and simulacra.

There is also room for dreaming in Caulfield's world, and things often hold out promise or send out signals of hope in his work. Simple objects, placed and lit with infinite care, made radiant by the tremendous, spare rigour of the artist's design and the force of his colour, are invested with such hallucinatory power that they turn into symbols of states of mind or feeling. Three lamb chops on a counter acquire a sacrificial solemnity. A glass of whisky evokes the holy wine in the chalice. Irony turns easily into enchantment, disillusionment gives way to fantasy. The real world seen through the eyes of this painter becomes a model for a certain kind of real life: not cut off from the actual and impure world that is the world of the late twentieth century, but accepting of its limits and open to its beauties. In Caulfield, undeceived realism does not militate against the finding of pleasure and even a sense of potential for transfiguration in the real world. How old-fashioned the ambitions behind the work of this late twentieth-century British artist can seem.

Howard Hodgkin is Caulfield's contemporary and though his art may be formally different, it is not entirely dissimilar in spirit. This painter, too, does not see the art traditions of the past as a prison but as a home. His own art is sensual, generous, tremendously bold and hungry for life in its colour. It speaks a less apparently coherent language of form and colour than that of Caulfield but that is Hodgkin's own, different and more introspective way of talking about the discontinuities of modern experience. The bright, fuzzy shapes, the blobs and twinkles, curves and dots from which he has gradually evolved his own, personal vocabulary as a painter are forms that oscillate between representational suggestion and enigma. The curve of blue may evoke water but as often it is simply and only itself. This is a painter's way of mimicking life's character, an experience that can be shared to a certain degree but which also, and always, must remain a private affair.

Because of their colour and sensuality, and their emphatic, naked displays of emotion, Hodgkin's pictures have provoked a certain uneasiness in Britain. They have been shrugged off as mere knick-knacks, dismissed as trivia. In fact, every one of them is a rebuke to narrow-minded puritanism, especially that intellectual puritanism which is so embarrassed by pleasure or indeed any strong feeling, and which can only take pictures seriously once they have been translated into abstract ideas. Hodgkin's art speaks a different language, aimed at the heart and the eye.

His paintings are compelling puzzles. Intense or seductive, saturated with dense and bright colours, they are urgent but also cloaked. Their titles are teasing and allusive, indicating events in the artist's life, things seen and feelings felt, which the pictures

87 PATRICK CAULFIELD *Town and Country,* 1979.

88 HOWARD HODGKIN *Patrick Caulfield in Italy*, 1987–92.

themselves communicate only through hints and suggestions. In Hodgkin's painting *Patrick Caulfield in Italy* [**88**], Caulfield's likeness is not to be discovered. However, a Caulfield-like pleasure in abrupt visual collisions may be discerned in its light, dense patchwork. The painting's subject may not be a memory of seeing Patrick Caulfield at all, but of seeing something in Italy, some sudden luminous exchange of blue and black and orange, perhaps in a restaurant, perhaps in an art gallery, which reminded the painter of Caulfield's work.

Where Caulfield finds scenes capable of reflecting the emotions which preoccupy him, Hodgkin has worked the other way around, allowing emotions to take form as paint to the point where they themselves generate a form of scenery – complicated theatres of the mind, thronged with shapes and forms of varying indefiniteness. This

element of theatre is perhaps necessary to a painter whose life has been spent in attempting to paint an equivalent to the texture of mental and emotional events. A subject so private needs staging and his art presents the unfolding *mise-en-scene* of an entire emotional life which, distanced in art, becomes a moving analogue for any life.

Caulfield and Hodgkin are among the few painters of the late twentieth century in whose work it is possible to see strong and vital links to the painting of the start of the century. Both men have thought much about the implications of the crowded, discontinuous space of Cubism. Both men know the power of colour as Bonnard and Matisse knew the power of colour. How typical of British art to throw up heirs to the tradition of early modern painting at a moment in history when that tradition had entered a phase of almost complete corruption and listlessness.

Rootless

On 9 April 1974 guests arrived at a gallery in London. They had come to see a private view of works of art by Michael Craig-Martin. At first it seemed that the gallery was entirely empty. But eventually an exhibit (the only exhibit) came to their notice. It was a glass of water on a glass shelf hung over two and a half metres high on the longest wall. To this small arrangement the artist had given the title *An Oak Tree*. Leaflets were distributed purporting to contain an interview with the artist in which he explained the nature of this enigmatic object. In fact, Craig-Martin had written both the questions and the answers himself. The auto-interrogative interview proceeded as follows:

> A: What I've done is to change a glass of water into a full-grown oak tree
> without altering the accidents of the glass of water.
> Q: The accidents?
> A: Yes, the colour, feel, weight, size …
> Q: Do you mean that the glass of water is a symbol of an oak tree?
> A: No, it's not a symbol. I've changed the physical substance of the glass of water
> into that of an oak tree …
> Q: It looks like a glass of water.
> A: Of course it does. I didn't change its appearance.

An Oak Tree was one of the more terse and theatrically momentous examples of what art critics of the early 1970s decided to term Conceptual Art. The concept behind it is relatively straightforward. The unreachable glass of water is a metaphor for the unverifiability of most human propositions, and a reminder, too, of how fundamentally peculiar and perverse most art is. *An Oak Tree* is a light-hearted demonstration of the artist's omnipotence within his own domain. If Craig-Martin chooses to assert that what looks like a glass of water is an oak tree ('I didn't change its appearance', he is careful to

say in his text) then that is his privilege. The assertion is not as eccentric as it may, to some, appear. The suspension of disbelief which *An Oak Tree* requires is no greater than that required by the conventional painter who asks us to see an oak tree in a flat surface which he has daubed with coloured dirt. The suspension of disbelief which *An Oak Tree* requires is no greater than that demanded of the laity at a Catholic Mass, asked by their religion to believe that a chalice of wine has become the blood of God.

An Oak Tree is, in these respects, a traditional work of art, and one which indicates that the old, superstitious, ritual functions of art have persisted into the late twentieth century. The modern white art gallery is a church, of a kind. The modern art object attempts to effect a transfiguration, of a kind. But we have clearly come a long way from St Mary's Priory Church in Abergavenny and the great oak figure of the prophet Jesse. What a small, ironical, self-consciously diminished object *An Oak Tree* is by contrast. How transparent, how rootless.

As Picasso pointed out, what the modern artist 'gains in the way of liberty he loses in the way of order'. Art in the later decades of the twentieth century has taken the early modernist belief in free experimentation to its logical extreme. There are no rules, no orthodoxies (save perhaps the orthodoxy of the unorthodox) for artists to follow. There is no context for their work to occupy, other than the cavernous void of the art gallery or the modern art institution. There are no accepted methods for teaching art, painting, drawing and carving now being regarded, in most art schools, as painfully old-fashioned activities. There are no accepted criteria for judging art. Indeed, there is no useful definition of what art is any more. A work of art is that which one who claims to be an artist claims to be a work of art.

The late twentieth century has seen the collapse of the old, European and American notions of avant-garde enterprise and the substitution of a new, much cosier and less threatening form of avant-gardism: a woozy pluralism of styles and attitudes, in which more or less anything goes. What is left is an academy of unorthodox gesture, full of would-be transgressive, challenging, questioning and radical artists discovering that acts of artistic transgression are subject to the law of diminishing returns. Many of the ideas behind the new artistic styles of the 1920s and 1930s have survived, but they have done so for the most part as rather empty and purposeless parodies of their former selves. The old avant-garde idea of the artist as a kind of holy fool, whose noble task it is to dissent from all orthodoxy, has been weakened to the point where all it can produce are dull sighs of mildly subversive intent. The old avant-garde idea that all artists should pursue their own individual paths and that originality, above all, is what should be enshrined in art has led hundreds of would-be avant-garde artists into small, small corners of obscure specialization.

This has been as true of British art, during the last several decades, as it has been true of art anywhere in the West. An enormous quantity of late twentieth century British works of art amount to little more than mild bleeps and buzzes of self-consciousness, fears or fantasies embodied in objects or actions, images or texts, dreamily shared with

an audience that is relied upon rather too heavily to take an interest in them. This is not necessarily a sign of aesthetic catastrophe. The vast majority of art produced at any time is mediocre and every age produces its own, specially obnoxious form of artistic mediocrity. In the eighteenth century it was the dread dullness of the brown incompetent portrait. In the nineteenth century it was the pneumatic nude in dubious historical circumstances. But late twentieth-century art's tendency to solipsism and self-regard is peculiarly damaging because it gives the impression that art is only really for that small minority of people who make it and know about it. This has had an unhappy effect on the perceived place of art in society. The work of those artists intelligent enough to recognize these pitfalls is often touched with desperation, a violent desire to break through the carapace of personal quirkiness and achieve some form of communication.

The art of Damien Hirst, the most celebrated young British artist since David Hockney, is a poignant instance of this. His work, which consists to a great extent of real dead animals or parts of real dead animals exhibited in glass cases filled with formaldehyde, may appear exemplary of late twentieth-century art. The artist's personal quirk has become his signature. But Hirst's art strives to escape from mere quirkiness and in doing so it speaks eloquently, too, of the later twentieth-century artist's disaffection with his lot. It speaks of his desire to make an art, like that of Francis Bacon, which might be as viscerally affecting as the contents of a butcher's shop. It speaks of his desire to make an art which addresses the largest and most broadly human concerns, and to rejoin a history from which the avant-garde cult of difference and originality has cut him off. What is a Hirst, after all, but a Stubbs in reverse, the anatomy lesson without its translation into a painting? The shark in formaldehyde is a late attempt to reanimate the morbid beauty of much earlier English art. Behind the mask of subversiveness and radical novelty, Hirst is extremely respectful of the art of the past. He is indeed almost an academic artist. This betrays a melancholy yearning to join the grand tradition and to build on the past, not merely to be free of it as of a dead weight.

Hirst was taught by Michael Craig-Martin and his predicament may stand for the predicament of the British artist now. Since the early 1970s, when Craig-Martin and others were busy planting their acorns of dissidence, many, many artists in Britain have tasted the freedoms of the late twentieth-century modern artist, discovering in the process that liberation of this kind is not always entirely liberating. The barriers between modern art in Britain and modern art elsewhere have now been mostly dismantled. A new spirit in British art schools, a new openness to works made in unconventional ways and from unconventional materials on the part of collectors and museums have, with other circumstances, seen the work and the attitudes of modern British artists move closer to that of their counterparts abroad than at any time for several centuries. This lends a curious symmetry to the history of British art. The British visual tradition was originally broken into fragments by the Reformation: a moment of severance from the rest of the world. It has now been fragmented by the opposite: a moment of joining up with the rest of the world.

Epilogue

Walking into the room you are confronted by a forbidding, dark, eerily reflective lake. The lake, which is roughly waist high, could be formed from water but it is in fact formed from oil which has been poured into a large steel tank, filled so full that only surface tension holds it back from spilling. The lake almost completely fills the room – only almost, though, because a V-shaped incision has been cut into the tank containing it, forming a narrow channel into which it is possible to walk, like Moses at the parting of the Red Sea. As you walk along this channel, which extends halfway across the lake, no further, it tapers and rises slightly in relation to the oil. The passage resembles a gangplank. Looking down into the surface of the oil is a disorientating experience. Reality meets its reflection, everywhere, in a dead and unbalancing calm.

Richard Wilson, whose creation this is, called it *20:50* [89], a title which gives little away. It refers simply to the standard viscosity of the sump oil used in the work's fabrication Some may admire the purity of its effects, noting the way it wins quiet from the blood of machines, the way it stills the busy world and seems a place almost out of time. Others may see it as a more sinister apparition: a dark pool for the prompting of dark thoughts in an age when environmental catastrophe, it is said, impends; a dead image of a dead future and prophecy of oily ruin. It may look forward but it certainly looks back too. It looks back to the world of late Victorian heavy industry, to the world of Papplewick, the Forth Bridge and the railway age, this late, late, hymn to the beauty of such things, sung long after the world of work which gave rise to that beauty has gone. It looks back to Vorticism, too, the V-shaped cut in Wilson's tank being reminiscent of the wedges and Vs of Vorticist draughtsmanship; but in it we see the energies of Vorticism, too, entropically diminished. It looks back further yet, being made almost exclusively of matter that was forming under the earth's crust long before the evolution of man. *20:50* is a work of art of and for the late twentieth century. Its beauty is elegiac.

The end of a century usually prompts a certain degree of melancholy. Thoughts at times like these turn naturally to deaths and endings, and history turns to eschatology. This is simply human habit. But there are grounds for optimism as well as despondency. *20:50,* like *House,* is in my opinion a masterpiece, and I find that encouraging. The fact is that there will always be artists who demand and make a place for themselves in tradition; who manage to forge works of lasting vitality from the concerns and the materials of their time, and who are able to seduce, beguile, terrify, perplex, enchant, mystify and haunt – to possess the human imagination through the human eye.

The greatest struggle of the contemporary artist is the struggle to avoid becoming no more than a mannerist of his or her own methods and devices. The loneliness and the difficulty of being an artist in such circumstances should not be underestimated. But to say all this is neither to announce a death nor an ending, merely to announce a new start and a new set of problems. The British artist, history indicates, is well equipped to cope with adversity.

89 Overleaf: RICHARD WILSON *20:50*, 1987.

NOTES ON WORKS

This list provides details of all the works discussed in *A History of British Art*. In cases where a work or building is not illustrated in this book a reference is given, when possible, to another title where a reproduction of it may be found. Full details of all the books referred to can be found under *Further Reading*.

The numbers in bold are the figure numbers of the illustrated works, listed below in the order that the illustrations appear in this book. All works not illustrated are listed in the order that they are referred to in the text.

Frontispiece
Girl with a Book seated in a Park, c.1750.
Thomas Gainsborough, 1727–88.
Oil on canvas, 75.8 x 66.7 cm.
Yale Center for British Art, Paul Mellon Collection, New Haven.

CHAPTER ONE
DREAMS AND HAMMERS
Pages 12–45

1 The Lady Chapel, begun 1321, completed 1348.
Ely Cathedral,
Ely, Cambridgeshire.

2 *The Last Judgement*, c.1490.
Artist unknown.
Panel.
St Peter's Church,
Wenhaston, Suffolk.

3 The Ranworth Antiphoner, c.1460.
Artist unknown.
Parchment or vellum, 52.7 x 39.4 cm (page size).
Church of St Helen,
Ranworth, Norfolk.

Ranworth Screen, including the Lady Altar and the Altar of St John the Baptist, late 15th century.
Perhaps egg tempera on panel.
Church of St Helen,
Ranworth, Norfolk.

4 Figure of Christ, c.1500–20.
Sculptor unknown.
Oolithic stone, 171.5 x 63.5 cm.
The Mercer's Hall, London.

The Lamentation over the Dead Christ, late 1480s–early 1490s
Andrea Mantegna, 1430/1–1506.
Tempera on canvas, 68 x 81 cm.
Pinacoteca di Brera, Milan.
See *Further Reading*: Lightbown, *Mantegna*.

Pietà, 1498–9.
Michelangelo Buonarroti, 1475–1564.
Marble, 48.3 cm.
St Peter's Basilica, Rome.
See *Further Reading*: Goldscheider, *Michelangelo*.

5 Golgotha, remains of a rood base.
Sculptor unknown.
Wood.
Church of St Andrew,
Cullompton, Devon.

6 *The Crucifixion*, late 15th century.
Artist unknown.
Panel, 160 x 401.4 cm.
Foulis Easter Church, near Dundee.
See *Further Reading*: Macmillan, *Scottish Art: 1460–1990*.

7 Figure of Jesse, late 15th century.
Sculptor unknown.
Wood.
St Mary's Priory Church,
Abergavenny, Gwent.

The Gorleston Psalter, c.1310–20 and c.1325.
Artists unknown.
Parchment, 37.4 x 23.5 cm (page size).
British Library, London.
See *Further Reading*: Royal Academy, *Age of Chivalry*.

8 The West Front, begun 1329, finished 1349, upper row of figures are 15th century.
Exeter Cathedral,
Exeter, Devon.

The Minstrels' Gallery, mid 14th century.
Exeter Cathedral,
Exeter, Devon.

9 Church of St Mary Magdalene, begun late 11th/early 12th century.
Withersdale Street, Suffolk.

Remains of a figure of Christ from All Hallows Church, Gloucestershire, c.1130.
Sculptor unknown.
Wood.
British Museum, London.

Angels in the tie-beam roof.
Wood.
Holy Trinity Church,
Blythburgh, Suffolk.

10 Remains of a Tree of Jesse, 1470s.
Stone.
St Cuthbert's Church,
Wells, Somerset.

The font, c.1450.
Wood.
Church of St Mary.
Ufford, Suffolk.

11 *The Wilton Diptych: Richard II Presented to the Virgin and Child by his Patron Saint John the Baptist and Saints Edward and Edmund*, c.1395–9.
Artist unknown.
Egg on oak, each wing 53 x 37 cm.
National Gallery, London.

12 Installation of black paintings, 23 December 1966 to 15 January 1967.
Ad Reinhardt, 1913–67.
Jewish Museum, New York.

Onement I, 1949.
Barnett Newman, 1905–70.
Oil on canvas, 183 x 86 cm.
Museum of Modern Art, New York.
See *Further Reading*: Anfam, *Abstract Expressionism*. The works of Barnett Newman, Mark Rothko and other Abstract Expressionists are discussed and illustrated in Anfam, *Abstract Expressionism*.

The round-vaulted ceiling,
15th century.
Wood.
Church of Merthyr Issui,
Partrishow (Patricio), Powys.

The rood screen, late 15th century.
Wood carver unknown.
Wood.
Church of Merthyr Issui,
Partrishow (Patricio), Powys.

13 *Time.*
Artist unknown.
Media unknown.
Church of Merthyr Issui,
Partrishow (Patricio), Powys.

CHAPTER TWO
NORTH AND SOUTH
Pages 46–79

14 *A General System of Horsemanship
In all its Branches*, 17th century.
William Cavendish, Duke of Newcastle,
c.1593–1676.
British Library, London.

15 Burghley House, built 1553–87.
Sir William Cecil, 1520–98.
near Stamford, Cambridgeshire.

Hardwick Hall, built 1590–97.
Robert Smythson, c.1535–1614.
near Chesterfield, Derbyshire.
See *Further Reading*: Summerson,
*Pelican History of Art: Architecture in
Britain 1530–1830.*

Longleat House, completed 1580.
Sir John Thynne, 1515–80.
Warminster, Wiltshire.
See *Further Reading*: Summerson,
*Pelican History of Art: Architecture in
Britain 1530–1830.*

Wollaton Hall, built 1580–88.
Robert Smythson, c.1535–1614.
Wollaton Park, Nottingham,
Nottinghamshire.
See *Further Reading*: Summerson,
*Pelican History of Art: Architecture in
Britain 1530–1830.*

16 *Diana, the huntress*, late 16th
century.
Abraham Smith.
Plasterwork.
Hardwick Hall, Derbyshire.

Four Seasons, c.1611.
Sheldon Tapestry Workshop.
Tapestry.
The Marquess of Salisbury, Hatfield
House.

A Young Man Amongst Roses,
c.1588.
Nicholas Hilliard, 1547–1619.
Oil on vellum, 13.5 x 7.3 cm.
Victoria and Albert Museum,
London.

17 *A Man Against a Background
of Flames*
16th century.
Isaac Oliver, before 1568–1617.
Watercolour on vellum, 6.9 x 5.4 cm.
Victoria and Albert Museum,
London.

Elizabeth I: The Ditchley Portrait,
c.1592.
Marcus Gheeraerts the Younger,
1562–1636.
Oil on canvas, 241.3 x 152.4 cm.
National Portrait Gallery, London.
See *Further Reading*: Piper,
The English Face.

Elizabeth I: The Armada Portrait,
c.1588.
Attributed to George Gower, d. 1596.
Oil on panel, 105.4 x 133.5 cm.
The Collection of The Marquess of
Tavistock, Woburn Abbey.
See *Further Reading*: Strong,
Gloriana.

18 *Elizabeth I: The Rainbow Portrait*,
c.1600–1603.
Isaac Oliver, before 1568–1617.
Oil on canvas, 127 x 99.1 cm.
The Marquess of Salisbury,
Hatfield House.

19 *Lady with a Squirrel and a Starling*,
c.1526–8.
Hans Holbein the Younger,
1497/8–1543.
Oil on oak, 56 x 38.8 cm.
National Gallery, London.

Sir Thomas More, 1527.
Hans Holbein the Younger,
1497/8–1543.
Oil on panel, 74.9 x 60.3 cm.
The Frick Collection, New York.
See *Further Reading*: Piper,
The English Face.

Henry VIII and Henry VII, 1536–7.
Cartoon for the left-hand section of
the wall-painting made for Whitehall
Palace.
Hans Holbein the Younger,
1497/8–1543.
Ink and watercolour on paper,
257.8 x 137.2 cm.
National Portrait Gallery, London.
See *Further Reading*: Piper,
The English Face.

20 *Thomas Elyot*, c.1532–4.
Hans Holbein the Younger,
1497/8–1543.
Chalk, bodycolour and indian ink on
paper, 28.6 x 20.6 cm.
The Royal Collection.

21 *Henry VIII*, 1536.
Hans Holbein the Younger,
1497/8–1543.
Oil and tempera on panel,
27.5 x 19.5 cm.
Thyssen-Bornemisza Foundation,
Paseo del Prado, Madrid.

Lucy Percy, Countess of Carlisle,
c.1637.
Sir Anthony van Dyck, 1599–1641.
Oil on canvas, 218.4 x 127 cm.
Private Collection.
See *Further Reading*: Wilton,
The Swagger Portrait.

22 *Thomas Killigrew and William,
Lord Crofts*, 1638.
Sir Anthony van Dyck, 1599–1641.
Oil on canvas, 132.7 x 143.5 cm.
The Royal Collection.

23 *A Lady as Erminia, Attended by
Cupid*, c.1638.
Sir Anthony van Dyck, 1599–1641.
Oil on canvas, 109.2 x 129.5 cm.
His Grace The Duke of Marlborough,
Blenheim Palace.

Thomas Wentworth, 1633–6.
Sir Anthony van Dyck, 1599–1641.
Oil on canvas, 229.9 x 142.9 cm.
Private Collection.
See *Further Reading*: Wilton,
The Swagger Portrait.

24 *Cupid and Psyche*, c.1639–41.
Sir Anthony van Dyck, 1599–1641.
Oil on canvas, 199.4 x 191.8 cm.
The Royal Collection.

The Tempest, c.1506–8.
Giorgione, 1476/8–1510.
Oil on canvas, 83 x 73 cm.
Gallerie dell'Accademia, Venice.
See *Further Reading*: Pignatti,
Giorgione.

Venus of Urbino, 1538.
Titian, c.1485–1576.
Oil on canvas, 119 x 165 cm.
Galleria degli Uffizi, Florence.
See *Further Reading*: Zuffi, *Titian*.

*The Toilet of Venus: The Rokeby
Venus*, 1647–51.
Diego Velázquez, 1599–1660.
Oil on canvas, 122.5 x 177 cm.
National Gallery, London.
See *Further Reading*: Harris, *Velázquez*.

O The Roast Beef of Old England, 1748.
William Hogarth, 1697–1764.
Oil on canvas, 78.8 x 94.5 cm.
The Tate Gallery, London.
See *Further Reading*: Paulson,
Hogarth, vol. 1.

25 *Triple Portrait of Charles I*, 1635.
Sir Anthony van Dyck, 1599–1641.
Oil on canvas, 84.5 x 99.7 cm.
The Royal Collection.

Equestrian Portrait of Charles I,
c.1637–8.
Sir Anthony van Dyck, 1599–1641.
Oil on canvas, 367 x 292.1 cm.
National Gallery, London.
See *Further Reading*: Piper,
The English Face.

The ceiling of the Banqueting House,
Whitehall, installed 1635.
Sir Peter Paul Rubens, 1577–1640.
The Banqueting House, London.
See *Further Reading*: Courtenay-
Thompson, *The Visual Dictionary of
Buildings*.

26 'A Page, like a Fiery Spirit', from
The Lords' Masque, c.1613.
Inigo Jones, 1573–1652.
Pen and ink, and watercolours,
28.9 x 15.9 cm.
His Grace the Duke of Devonshire,
Chatsworth.

27 *Oliver Cromwell*, c.1650.
Samuel Cooper, 1609–72.
Watercolour on vellum, 8 x 6.4 cm.
His Grace The Duke of Buccleuch and
Queensbury KT.

The Life of St Paul, 1716–19.
Sir James Thornhill, 1675/6–1734.
Grisaille.
St Paul's Cathedral, London.

The statues of the Apostles and the
Evangelists, 1721.
Francis Bird, 1667–1731.
St Paul's Cathedral, built 1675–1711.
Sir Christopher Wren, 1632–1723.
London.

28 The dome, completed 1708.
St Paul's Cathedral, built 1675–1711.
Sir Christopher Wren, 1632–1723.
London.

29 The cantilevered staircase, inside the
west tower.
St Paul's Cathedral, built 1675–1711.
Sir Christopher Wren, 1632–1723.
London.

CHAPTER THREE
MY WIFE, MY HORSE AND MYSELF
Pages 80–123

30 *My Wife, My Horse and Myself*,
1932–3.
Sir Alfred Munnings, 1878–1959.
Oil on canvas, 101.6 x 127.1 cm.
Sir Alfred Munnings Museum,
Dedham, Essex.

Composition with Blue and Yellow,
1935.
Piet Mondrian, 1872–1944.
Oil on canvas, diagonal 112 cm.
Kunsthaus, Zurich.
See *Further Reading*: Blotkamp,
Mondrian: The Art of Destruction.

Guernica, 1937.
Pablo Picasso, 1881–1973.
Oil on canvas, 350 x 777 cm.
Cáson del Buen Retiro, Madrid.
See *Further Reading*: Hilton, *Picasso*.

31 *Margaret Lindsay, Mrs Allan Ramsay*,
c.1759–60.
Allan Ramsay, 1713–84.
Oil on canvas, 76.2 x 63.5 cm.
National Galleries of Scotland,
Edinburgh.

32 *Children in an Interior*, c.1742–3.
Arthur Devis, 1711–87.
Oil on canvas, 99 x 122.5 cm.
Yale Center for British Art, Paul Mellon
Collection, New Haven.

Mary Martin, 1761.
Allan Ramsay, 1713–84.
Oil on canvas, 127 x 108.1 cm.
City Museum and Art Gallery,
Birmingham.
See *Further Reading*: Smart,
Allan Ramsay.

David Hume, 1766.
Allan Ramsay, 1713–84.
Oil on canvas, 76.2 x 63.5 cm.
Scottish National Portrait Gallery,
Edinburgh.
See *Further Reading*: Smart,
Allan Ramsay.

Blenheim Palace, built 1705–22.
Sir John Vanbrugh, 1664–1726.
Woodstock, Oxfordshire.
See *Further Reading*: Summerson,
*Pelican History of Art: Architecture in
Britain 1530–1830*.

Stowe Landscape Gardens, laid out
c.1680–1780.
near Buckingham, Buckinghamshire.

33 The Temple of British Worthies,
c.1735.
William Kent, c.1685–1748.
Stowe Landscape Gardens, laid out
c.1680–1780.
near Buckingham, Buckinghamshire.

Versailles Palace gardens, first laid
out 1661–8.
Gardens laid out by André le Nôtre,
1613–1708
Versailles.

34 *A Harlot's Progress*, 1732.
William Hogarth, 1697–1764.
Plate 1: engraving, 29.6 x 37.1 cm.
Plate 2: engraving, 29.8 x 36.8 cm.
Plate 3: engraving, 29.8 x 36.9 cm.
Plate 4: engraving, 30 x 37.6 cm.
Plate 5: engraving, 30.2 x 37.5 cm.
Plate 4: engraving, 30 x 37.6 cm.
Hogarth House, London.
See *Further Reading*: Shesgreen,
Engravings by Hogarth.

A Rake's Progress, 1733–4.
William Hogarth, 1697–1764.
Plate 1: oil on canvas, 62.3 x 74.9 cm.
Plate 2: oil on canvas, 30.5 x 38.8 cm.
Plates 3–8: oil on canvas, each
32.1 x 38.8 cm.
Sir John Soane's Museum, London.
See *Further Reading*: Paulson,
Hogarth, vol. 1.

A Rake's Progress, 1735.
William Hogarth, 1697–1764.
Plate 1: engraving, 32.1 x 38.7 cm.
Plate 2: engraving, 31.4 x 38.7 cm.
Plate 3: engraving, 31.8 x 38.7 cm.
Plate 4: engraving, 32.1 x 38.7 cm.
Plate 5: engraving, 31.6 x 39.1 cm.
Plate 6: engraving, 32.7 x 38.7 cm.
Plate 7: engraving, 31.8 x 38.5 cm.
Plate 8: engraving, 31.6 x 38.7 cm.
Hogarth House, London.
See Further Reading: Paulson,
Hogarth's Graphic Works.

The Graham Children, 1742.
William Hogarth, 1697–1764.
Oil on canvas, 160.5 x 181 cm.
National Gallery, London.
See Further Reading: Paulson,
Hogarth, vol. 1.

A Performance of 'The Indian
Emperor', 1732.
William Hogarth, 1697–1764.
Oil on canvas, 130.8 x 146.6 cm.
Private Collection.
See Further Reading: Paulson,
Hogarth, vol. 1.

An Election Entertainment,
1754–5.
William Hogarth, 1697–1764.
Oil on canvas, 101.6 x 127.1 cm.
Sir John Soane Museum, London.
See Further Reading: Paulson,
Hogarth, vol. 3.

An Election Entertainment,
1754–5.
William Hogarth, 1697–1764.
Engraving, 40.3 x 54.1 cm.
British Museum, London.
See Further Reading: Paulson,
Hogarth's Graphic Works.

Gin Lane, 1750–51.
William Hogarth, 1697–1764.
Engraving, 35.7 x 30.5 cm.
British Museum, London.
See Further Reading: Paulson,
Hogarth's Graphic Works.

A Midnight Modern Conversation,
1732–3.
William Hogarth, 1697–1764.
Engraving, 32.8 x 45.7 cm.
British Museum, London.
See Further Reading: Paulson,
Hogarth's Graphic Works.

Captain Thomas Coram, 1740.
William Hogarth, 1697–1764.
Oil on canvas, 239 x 147.5 cm.
Thomas Coram Foundation, London.
See Further Reading: Paulson,
Hogarth, vol. 1.

35 The Shrimp Girl, c.1745.
William Hogarth, 1697–1764.
Oil on canvas, 63.5 x 50.8 cm.
National Gallery, London.

36 The Bathos, 1764.
William Hogarth, 1697–1764.
Engraving, 26 x 32.5 cm.
British Museum, London.
See Further Reading: Paulson,
Hogarth's Graphic Works.

The Tribuna of the Uffizi, 1772–7.
Johann Zoffany, c.1733–1810.
Oil on canvas, 123.5 x 154.9 cm.
The Royal Collection.
See Further Reading: Lloyd,
The Queen's Pictures.

Self Portrait, c.1747.
Sir Joshua Reynolds, 1723–92.
Oil on canvas, 63.5 x 74.3 cm.
National Portrait Gallery, London.
See Further Reading: Royal Academy,
Reynolds.

Macbeth and the Witches, 1786–9.
Sir Joshua Reynolds, 1723–92.
Oil on canvas, 271.8 x 366 cm.
Petworth House, Sussex.
See Further Reading: Royal Academy,
Reynolds.

Mrs Musters as Hebe, 1785.
Sir Joshua Reynolds, 1723–92.
Oil on canvas, 238.8 x 147.8 cm.
The Iveagh Bequest, Kenwood.
See Further Reading: Wilton,
The Swagger Portrait.

37 Three Ladies Adorning a Term of
Hymen: The Montgomery Sisters,
1773.
Sir Joshua Reynolds, 1723–92.
Oil on canvas, 233.5 x 295 cm.
Tate Gallery, London.

Lady Sarah Bunbury Sacrificing to
the Graces, 1763–5.
Sir Joshua Reynolds, 1723–92.
Oil on canvas, 242 x 151.5 cm.
The Art Institute, Chicago.
See Further Reading: Royal Academy,
Reynolds.

Laurence Sterne, 1760.
Sir Joshua Reynolds, 1723–92.
Oil on canvas, 127.3 x 100.3 cm.
National Portrait Gallery, London.
See Further Reading: Piper,
The English Face.

Dr Samuel Johnson, c.1769.
Sir Joshua Reynolds, 1723–92.
Oil on canvas, 76.2 x 63.8 cm.
The National Trust, Knole, Kent.
See Further Reading: Royal Academy,
Reynolds.

38 Mrs Abington as 'Miss Prue' in
Congreve's 'Love for Love', 1771.
Sir Joshua Reynolds, 1723–92.
Oil on canvas, 76.8 x 63.7 cm.
Yale Center for British Art, Paul Mellon
Collection, New Haven.

The Ladies Waldegrave, 1780–81.
Sir Joshua Reynolds, 1723–92.
Oil on canvas, 143.5 x 168 cm.
National Galleries of Scotland,
Edinburgh.
See Further Reading: Piper,
The English Face.

39 Mary, Countess of Bute, c.1777–86.
Sir Joshua Reynolds, 1723–92.
Oil on canvas, 236 x 145 cm.
Private Collection.

40 Mr and Mrs Andrews, c.1748–9.
Thomas Gainsborough, 1727–88.
Oil on canvas, 69.8 x 119.4 cm.
National Gallery, London.

Mona Lisa, c.1505–14.
Leonardo da Vinci, 1452–1519.
Oil on canvas, 77 x 53 cm.
Musée du Louvre, Paris.
See Further Reading: Whiting,
Leonardo.

Anna Ford, later Mrs Philip Thicknesse,
1760.
Thomas Gainsborough, 1727–88.
Oil on canvas, 196.9 x 134.6 cm.
Cincinnati Art Museum, Ohio.
See Further Reading: Cormack, The
Paintings of Thomas Gainsborough.

Mrs Graham, 1777.
Oil on canvas, 237.5 x 154.3 cm.
National Galleries of Scotland,
Edinburgh.
See Further Reading: Cormack, The
Paintings of Thomas Gainsborough.

41 *The Mall*, 1783.
Thomas Gainsborough, 1727–88.
Oil on canvas, 120.6 x 147 cm.
The Frick Collection, New York.

42 *Diana and Actaeon*, c.1785.
Thomas Gainsborough, 1727–88.
Oil on canvas, 158.1 x 188 cm.
The Royal Collection.

Self-Portrait, c.1780.
Sir Joshua Reynolds, 1723–92.
Oil on wood, 127 x 101.6 cm.
Royal Academy of Arts, London.
See *Further Reading:* Royal Academy,
Reynolds.

Whistlejacket, 1762.
Oil on canvas, 292 x 246.4 cm.
Private Collection.
See *Further Reading:* Tate Gallery,
George Stubbs 1724–1806.

Brood Mares and Foals, c.1762.
George Stubbs, 1724–1806.
Oil on canvas, 99 x 190.5 cm.
Private Collection.
See *Further Reading:* Tate Gallery,
George Stubbs 1724–1806.

43 *Hambletonian, Rubbing Down*,
1799–1800.
George Stubbs, 1724–1806.
Oil on canvas, 209 x 367.3 cm.
The National Trust, Mount Stewart.

44 *Gimcrack on Newmarket Heath, with a
Trainer, Jockey and a Stable-lad*, c.1765.
George Stubbs, 1724–1806.
Oil on canvas, 101.6 x 193.2 cm.
Private Collection.

*Whistlejacket and Two Other Stallions
with Simon Cobb, the Groom*, 1762.
Oil on canvas, 99 x 187 cm.
Private Collection.
See *Further Reading:* Tate Gallery,
George Stubbs 1724–1806.

45 *Zebra*, 1763.
George Stubbs, 1724–1806.
Oil on canvas, 103 x 127.5 cm.
Yale Center for British Art, Paul Mellon
Collection, New Haven.

*Freeman, the Earl of Clarendon's
Gamekeeper, with a Dying Doe and a
Hound*, 1800.
George Stubbs, 1724–1806.
Oil on canvas, 101.5 x 127 cm.
Paul Mellon Collection, Upperville,
Virginia.

See *Further Reading:* Tate Gallery,
George Stubbs 1724–1806.

A Lion Devouring a Horse, 1767.
George Stubbs, 1724–1806.
Enamel on copper, 24.3 x 28.2 cm.
Tate Gallery, London.
See *Further Reading:* Tate Gallery,
George Stubbs 1724–1806.

CHAPTER FOUR
MODERN ART
Pages 124–159

46 *A Bedroom in Venice*, 1840.
J.M.W. Turner, 1775–1851.
Watercolour and bodycolour on grey
paper, 23 x 30.1 cm.
Tate Gallery, London.

47 *The Progress of Human Culture*,
1777–84.
1. *Orpheus*.
Oil on canvas, 360 x 462 cm.
2. *A Grecian Harvest-Home* or
*Thanksgiving to the Rural Deities,
Ceres, Bacchus, etc.*
Oil on canvas, 360 x 462 cm.
3. *Crowning the Victors at Olympia*.
Oil on canvas, 360 x 1308 cm.
4. *Commerce or the Triumph of the
Thames*.
Oil on canvas, 360 x 462 cm.
5. *The Distribution of Premiums in
the Society of Arts*.
Oil on canvas, 360 x 462 cm.
6. *Elysium and Tartarus or the State
of Final Retribution*.
Oil on canvas, 360 x 1308 cm.
James Barry, 1741–1806.
Royal Society of Arts, London.
See *Further Reading:* Pressly,
James Barry.

The Body of Christ Borne to the Tomb,
c.1799–1800.
William Blake, 1757–1827.
Tempera on canvas, 26.7 x 37.8 cm.
Tate Gallery, London.
See *Further Reading:* Butlin, *The
Paintings and Drawings of William
Blake*.

Last Judgement, 1536–41.
Michelangelo Buonarroti, 1475–1564.
Fresco.
Sistine Chapel, Rome.
See *Further Reading:* Richmond,
*Michelangelo and the Creation of the
Sistine Chapel*.

*The Man who Taught Blake Painting
in his Dreams*, c.1818–20.
William Blake, 1757–1827.
Pencil, 30 x 24.5 cm.
Private Collection.
See *Further Reading:* Butlin,
*The Paintings and Drawings of
William Blake*.

The Ghost of a Flea, c.1819–20.
William Blake, 1757–1827.
Tempera heightened with gold on
panel, 21.4 x 16.2 cm.
Tate Gallery, London.
See *Further Reading:* Butlin,
*The Paintings and Drawings of
William Blake*.

48 *Christ in the Sepulchre, Guarded by
Angels*, c.1805.
William Blake, 1757–1827.
Pencil, pen and watercolour on paper,
42 x 30.2 cm.
Victoria and Albert Museum,
London.

49 *Elohim Creating Adam*, 1795.
William Blake, 1757–1827.
Colour print finished in pen and water-
colour on paper, 43.1 x 53.6 cm.
Tate Gallery, London.

Nebuchadnezzar, 1795.
William Blake, 1757–1827.
Colour print finished in pen and water-
colour on paper, 43.1 x 53.6 cm.
Tate Gallery, London.
See *Further Reading:* Butlin,
*The Paintings and Drawings of
William Blake*.

50 *The Circle of the Lustful (The
Whirlwind of Lovers)*, 1824–7.
William Blake, 1757–1827.
Pen and watercolour over pencil,
36.8 x 52.2 cm.
City Museum and Art Gallery,
Birmingham.

Self-Portrait, c.1826.
Samuel Palmer, 1805–81.
Black chalk heightened with white,
on buff paper, 29.1 x 22.9 cm.
Ashmolean Museum, Oxford.
See *Further Reading:* Lister, *Catalogue
Raisonné of the Works of Samuel
Palmer*.

51 Sir John Soane's Museum, 1812–14.
Sir John Soane, 1753–1837.
London.

52 *Flatford Mill from the Lock,*
 (oil sketch) c.1811.
 John Constable, 1776–1837.
 Oil on canvas, 24.5 x 29.5 cm.
 Victoria and Albert Museum,
 London.

53 *The Hay-Wain,* 1821.
 John Constable, 1776–1837.
 Oil on canvas, 130.2 x 185.4 cm.
 National Gallery, London.

54 *The Leaping Horse* (oil sketch),
 1824–5.
 John Constable, 1776–1837.
 Oil on canvas, 129.4 x 188 cm.
 Victoria and Albert Museum,
 London.

 The Leaping Horse, 1825.
 John Constable, 1776–1837.
 Oil on canvas, 142.2 x 187.3 cm.
 Royal Academy of Arts, London.
 See *Further Reading:* Parris,
 Constable.

 Pietà, 1576.
 Titian, c.1485–1576.
 Oil on canvas, 353 x 348 cm.
 Gallerie dell'Accademia, Venice.
 See *Further Reading:* Wethey, *Titian.*

 Norham Castle, Sunrise, c.1845.
 J.M.W. Turner, 1775–1851.
 Oil on canvas, 90.8 x 121.9 cm.
 Tate Gallery, London.
 See *Further Reading:* Wilson, *Tate
 Gallery: an Illustrated Companion.*

 *Snowstorm – Steam-Boat off a
 Harbour's Mouth,* exh. 1842.
 J.M.W. Turner, 1775–1851.
 Oil on canvas, 91.4 x 121.9 cm.
 Tate Gallery, London.
 See *Further Reading:* Butlin and Joll,
 The Paintings of J.M.W. Turner.

 The Fifth Plague of Egypt, 1800.
 J.M.W. Turner, 1775–1851.
 Oil on canvas, 124 x 183 cm.
 Tate Gallery, London.
 See *Further Reading:* Butlin and Joll,
 The Paintings of J.M.W. Turner.

 *The Fall of an Avalanche in the
 Grisons,* exh. 1810.
 J.M.W. Turner, 1775–1851.
 Oil on canvas, 90.2 x 120 cm.
 Tate Gallery, London.
 See *Further Reading:* Butlin and Joll,
 The Paintings of J.M.W. Turner.

55 *Interior at Petworth,* c.1837.
 J.M.W. Turner, 1775–1851.
 Oil on canvas, 90.8 x 121.9 cm.
 Tate Gallery, London.

56 *Snowstorm: Hannibal and his Army
 Crossing the Alps,* exh. 1812.
 J.M.W. Turner, 1775–1851.
 Oil on canvas, 146 x 237.5 cm.
 Tate Gallery, London.

57 *The Burning of the Houses of
 Parliament,* 1834.
 J.M.W. Turner, 1775–1851.
 Watercolour on paper,
 23.3 x 32.5 cm.
 Tate Gallery, London.

CHAPTER FIVE
ALL CHANGE
Pages 160–197

58 *The Railway Station,* 1862.
 William Powell Frith, 1819–1909.
 Oil on canvas, 116.7 x 256.4 cm.
 Royal Holloway and Bedford New
 College, Egham.

59 *Rain, Steam and Speed – The Great
 Western Railway,* before 1844.
 Joseph Mallord William Turner,
 1775–1851.
 Oil on canvas, 90.8 x 121.9 cm.
 National Gallery, London.

 *Manchester from Kersal Moor, with
 rustic figures and goats,* 1852.
 William Wyld, 1806–89.
 Watercolour with gum, 31.7 x 49 cm.
 Royal Collection.
 See *Further Reading:* Treuherz,
 World of Art: Victorian Painting

 Arkwright's Cotton Mills by Night,
 c.1782.
 Joseph Wright of Derby, 1734–97.
 Oil on canvas, 99.7 x 125.7 cm.
 Private Collection.
 See *Further Reading:* Egerton,
 Wright of Derby.

 Forth Bridge, 1882–90.
 Sir Benjamin Baker, 1840–1907 and
 Sir John Fowler, 1817–98.
 Steel
 Firth of Forth, Scotland.
 See *Further Reading:* Mignot,
 Architecture of the Nineteenth Century.

 Many Happy Returns of the Day, 1856.
 William Powell Frith, 1819–1909.
 Oil on canvas, 81.3 x 114.4 cm.
 Art Gallery, Harrogate.
 See *Further Reading:* Wood,
 Victorian Panorama.

 *Windsor Castle in Modern Times:
 Queen Victoria, Prince Albert and
 Victoria, the Princess Royal,* 1841–5.
 Sir Edwin Landseer, 1802/3–73.
 Oil on canvas, 113 x 143.8 cm.
 The Royal Collection.
 See *Further Reading:* Treuherz,
 World of Art: Victorian Painting.

 The Blind Fiddler, 1806.
 Sir David Wilkie, 1785–1841.
 Oil on wood, 57.8 x 79.4 cm.
 Tate Gallery, London.
 See *Further Reading:* Treuherz,
 World of Art: Victorian Painting.

 *Village Politicians. Vide Scotland's
 Skaith,* 1806.
 Sir David Wilkie, 1785–1841
 Oil on canvas, 57.2 x 75 cm.
 Private Collection.
 See *Further Reading:* Bayne,
 The Makers of British Art.

 Past and Present, no. 1, 1858.
 Augustus Egg, 1816–63.
 Oil on canvas, 63.5 x 76.2 cm.
 Tate Gallery, London.
 See *Further Reading:* Treuherz,
 *World of Art: Victorian
 Painting.*

 Past and Present, no. 2, 1858.
 Augustus Egg, 1816–63.
 Oil on canvas, 63.5 x 76.2 cm.
 Tate Gallery, London.
 See *Further Reading:* Treuherz,
 *World of Art: Victorian
 Painting.*

 Past and Present, no. 3, 1858.
 Augustus Egg, 1816–63.
 Oil on canvas, 63.5 x 76.2 cm.
 Tate Gallery, London.
 See *Further Reading:* Treuherz,
 *World of Art: Victorian
 Painting.*

60 *The Travelling Companions,*
 1862.
 Augustus Egg, 1816–63.
 Oil on canvas, 64.5 x 76.5 cm.
 City Museum and Art Gallery,
 Birmingham.

The Derby Day, 1856–8.
William Powell Frith, 1819–1909.
Oil on canvas, 101.6 x 223.5 cm.
Tate Gallery, London.
See *Further Reading*: Wood,
Victorian Panorama.

Houses of Parliament, built 1840–67
Charles Barry, 1795–1860
Westminster, London.
See *Further Reading*: Hitchcock,
*Architecture: Nineteenth and Twentieth
Centuries*.

61 St Giles's Church, 1840–46.
Augustus Welby Northmore Pugin,
1812–52.
Cheadle, Staffordshire.

Ecce Ancilla Domini!, 1849–50.
Dante Gabriel Rossetti, 1828–82.
Oil on canvas, 72.4 x 41.9 cm.
Tate Gallery, London.
See *Further Reading*: Tate Gallery,
The Pre-Raphaelites.

*Rienzi Vowing to Obtain Justice
for the Death of his Young Brother,
Slain in a Skirmish between the
Colonna and Orsini Families*, 1849.
William Holman Hunt, 1827–1910.
Oil on canvas, 86.3 x 122 cm.
Private Collection.
See *Further Reading*: Tate Gallery,
The Pre-Raphaelites.

The Oath of the Horatii, 1784.
Jacques-Louis David, 1748–1825.
Oil on canvas, 329.9 x 424.8 cm.
Musée du Louvre, Paris.
See *Further Reading*: de Nanteuil,
David.

62 *Lorenzo and Isabella*, 1848–9.
John Everett Millais, 1829–96.
Oil on canvas, 102.9 x 142.9 cm.
Walker Art Gallery, Liverpool.

63 *Convent Thoughts*, 1850–51.
Charles Allston Collins, 1828–73.
Oil on canvas, arched top
82.6 x 57.8 cm.
Ashmolean Museum, Oxford.

The Hireling Shepherd, 1851–2.
William Holman Hunt, 1827–1910.
Oil on canvas, 76.4 x 109.5 cm.
City Art Gallery, Manchester.
See *Further Reading*: Tate Gallery,
The Pre-Raphaelites.

In Early Spring, 1855.
John William Inchbold, 1830–88.
Oil on canvas, 53 x 35 cm.
Ashmolean Museum, Oxford.
See *Further Reading*: Tate Gallery,
The Pre-Raphaelites.

Val d'Aosta, 1858.
John Brett, 1830–1902.
Oil on canvas, 87.6 x 68 cm.
Private Collection.
See *Further Reading*: Tate Gallery,
The Pre-Raphaelites.

64 *The Stonebreaker*, 1857–8.
John Brett, 1830–1902.
Oil on canvas, 49.5 x 67.3 cm.
Walker Art Gallery, Liverpool.
See *Further Reading*: Maas,
Victorian Painters.

University Museum, 1855–60.
Benjamin Woodward, 1816–61.
Oxford.
See *Further Reading*: Russell-Hitchcock,
*Architecture: Nineteenth and Twentieth
Centuries*.

Elizabeth I: The Armada Portrait,
c.1588.
Attributed to George Gower, d. 1596.
Oil on panel, 105.4 x 133.5 cm.
The Collection of The Marquess of
Tavistock, Woburn Abbey.
See *Further Reading*: Strong,
Gloriana.

*The French Invasion or John Bull
Bombarding the Bum-Boats*, 1793.
James Gillray, 1757–1815.
Engraving (coloured impression),
32.4 x 24.8 cm.
British Museum, London.
See *Further Reading*: Colley,
Britons

65 *Rhyl Sands*, c.1854.
David Cox, 1783–1859.
Oil on canvas, 45.8 x 63.5 cm.
City Art Gallery, Manchester.

66 *Pegwell Bay, Kent: A Recollection of
October 5th*, 1858–60.
William Dyce, 1806–64.
Oil on canvas, 63.5 x 88.9 cm.
Tate Gallery, London.

67 *The Scapegoat*, 1854–5.
William Holman Hunt, 1827–1910.
Oil on canvas, 33.7 x 45.9 cm.
City Art Gallery, Manchester.

68 *Work*, 1852–65.
Ford Madox Brown, 1821–93.
Oil on canvas, arched top
137 x 197.3 cm.
City Art Gallery, Manchester.

69 *The Fairy Feller's Master Stroke*,
c.1855–64.
Richard Dadd, 1817–86.
Oil on canvas, 54 x 39.4 cm.
Tate Gallery, London.

70 *Lady Lilith*, 1862 (repainted 1872–3).
Dante Gabriel Rossetti, 1828–82.
Oil on canvas, 95.2 x 81.3 cm.
Delaware Art Museum, Wilmington.

71 *The Legend of the Briar Rose*, 1870–90.
1. *The Briar Wood*, 1870–90.
Oil on canvas, 124.5 x 249.7 cm.
2. *The Council Chamber*, 1871–90.
Oil on canvas, 124.5 x 249.7 cm.
3. *The Garden Court*, 1870–90.
Oil on canvas, 125.1 x 231.3 cm.
4. *The Rose Bower*, 1870–90.
Oil on canvas, 125.8 x 228.7 cm.
Sir Edward Burne-Jones, 1833–98.
Buscot Park, Faringdon, Oxfordshire.
See *Further Reading*: Harrison and
Waters, *Burne-Jones*.

72 Papplewick Pumping Station, 1882–4.
Ogle Tarbotton, 1835–87.
Ravenshead, Nottinghamshire.

73 Port Sunlight Village, begun 1888.
Merseyside.

CHAPTER SIX
OUR HOUSE
Pages 198–239

74 *House*, 1993.
Rachel Whiteread, 1963–.
Demolished 1994.

Rima, 1923–5.
Jacob Epstein, 1880–1959.
Portland stone.
Hyde Park, London.
See *Further Reading*: Buckle, *Epstein,
an Autobiography*.

Sculptures for the façade of the British
Medical Association headquarters,
1907–8.
Jacob Epstein, 1880–1959.
Portland stone.
Demolished 1937.
See *Further Reading*: Cork, *Beyond
the Gallery*.

Winston Churchill, 1954.
Graham Sutherland, 1903–80.
Destroyed 1955/6.

Equivalent VIII, 1966.
Carl Andre, 1935–
12.7 x 68.6 x 229.2 cm.
Tate Gallery, London.
See *Further Reading*: Wilson, *Tate Gallery: an Illustrated Companion*.

75 *Lady Agnew of Lochnaw*, c.1892–3.
John Singer Sargent, 1856–1925.
Oil on canvas, 125.7 x 100.3 cm.
National Galleries of Scotland, Edinburgh.

The Misses Hunter, 1902.
John Singer Sargent, 1856–1925.
Oil on canvas, 229.2 x 229.9 cm.
Tate Gallery, London.
See *Further Reading*: McConkey, *Edwardian Portraits*.

Les Demoiselles d'Avignon, 1906–7.
Pablo Picasso, 1881–1973.
Oil on canvas, 244 x 233 cm.
Museum of Modern Art, New York.
See *Further Reading*: Hilton, *Picasso*.

The Tub, c.1913.
Duncan Grant. 1885–1978.
Watercolour and tempera on paper, 76.2 x 55.9 cm.
Tate Gallery, London.
See *Further Reading*: Naylor, *Bloomsbury*.

76 *Workshop*, 1914–15.
Wyndham Lewis, 1882–1957.
Oil on canvas, 76.5 x 61 cm.
Tate Gallery, London.

Hieratic Head of Ezra Pound, 1914.
Henri Gaudier-Brzeska, 1891–1915.
Marble.
Private Collection.
See *Further Reading*: Cork, *Beyond the Gallery*.

Torso in metal from *The Rock Drill*, 1913–14.
Jacob Epstein, 1880–1959.
Bronze, 70.5 x 58.4 x 44.5 cm.
Tate Gallery, London.
See *Further Reading*: Cork, *Bitter Truth*.

The Mud Bath, 1914.
David Bomberg, 1890–1957.
Oil on canvas, 152.4 x 224.2 cm.
Tate Gallery, London.

See *Further Reading*: Compton, *British Art in the 20th Century*.

The Adoration of the Golden Calf, c.1634.
Nicolas Poussin, 1594–1665.
Oil on canvas, 154.3 x 214 cm.
National Gallery, London.
See *Further Reading*: Verdi, *Nicolas Poussin 1594–1665*.

We Are Making a New World, 1918.
Paul Nash, 1889–1946.
Oil on canvas, 71.1 x 91.4 cm.
Imperial War Museum, London.
See *Further Reading*: Cork, *Bitter Truth*.

Over the Top, 1918.
John Nash, 1893–1977.
Oil on canvas, 79.4 x 107.3 cm.
Imperial War Museum, London.
See *Further Reading*: Cork, *Bitter Truth*.

77 *Disfigured Soldier, no. 18*, 1916–17.
Henry Tonks, 1862–1937.
Pastel on paper, 23.5 x 17 cm.
Royal College of Surgeons, London.

Royal Artillery Memorial, 1921–5.
Charles Jagger, 1885–.
Stone and bronze.
Hyde Park Corner, London.
See *Further Reading*: Cork, *Bitter Truth*.

Marguerite Kelsey, 1928.
Meredith Frampton, 1894–1984.
Oil on canvas, 120.8 x 141.2 cm.
Tate Gallery, London.
See *Further Reading*: Morphet, *Meredith Frampton*.

De la Warr Pavilion, 1934–6.
Eric Mendelsohn, 1887–1953.
Bexhill-on-Sea, Sussex.
See *Further Reading*: Sharp, *Twentieth Century Architecture, A Visual History*.

78 Penguin Pool, 1934–5.
Berthold Lubetkin, 1901–1990.
London Zoo.

Merzbarn (incomplete), 1947–8.
Kurt Schwitters 1887–1948.
See *Further Reading*: Elderfield, *Kurt Schwitters*.

Sandham Memorial Chapel paintings, 1927–32.
Stanley Spencer 1891–1959.
Burghclere, Hampshire, 1927–32.
See *Further Reading*: Bell, *Stanley Spencer*.

The Resurrection of the Soldiers, 1928–9.
Stanley Spencer 1891–1959.
Oil on canvas.
Sandham Memorial Chapel, Burghclere, Hampshire.
See *Further Reading*: Bell, *Stanley Spencer*.

The Baptism of Christ, 1952.
Stanley Spencer 1891–1959.
Oil on canvas, 76.2 x 127 cm.
Private Collection.
See *Further Reading*: Bell, *Stanley Spencer*.

The Temptation of Saint Anthony, 1945.
Stanley Spencer, 1891–1959.
Oil on canvas, 122 x 91.5 cm.
Private Collection.
See *Further Reading*: Bell, *Stanley Spencer*.

Unveiling Cookham War Memorial, 1922.
Stanley Spencer, 1891–1959.
Oil on canvas, 155 x 147.5 cm.
Private Collection.
See *Further Reading*: Bell, *Stanley Spencer*.

Love on the Moor, 1937–55.
Stanley Spencer, 1891–1959.
Oil on canvas, 79.1 x 310.2 cm.
Private Collection.
See *Further Reading*: Bell, *Stanley Spencer*.

79 *Self-Portrait with Patricia Preece*, 1937.
Stanley Spencer, 1891–1959.
Oil on canvas, 61 x 91.5 cm.
Fitzwilliam Museum, Cambridge.

80 *Reclining Figure*, cast in 1983.
Henry Moore, 1898–1986.
Bronze, 1036 cm (length).
Perry Green, Henry Moore Foundation.

Carrara Line, 1985.
Richard Long 1945–.
Carrara white marble, 135 x 1430 cms.
Private Collection.

Minnie Cunningham, 1892.
Walter Richard Sickert, 1860–1942.
Oil on canvas, 76.5 x 63.8 cm.
Tate Gallery, London.
See *Further Reading*: Baron, *Sickert*.

81 *Noctes Ambrosianae*, 1906.
Walter Richard Sickert, 1860–1942.
Oil on canvas, 63.5 x 76.2 cm.
Castle Museum and Art Gallery.

La Hollandaise, c.1906.
Walter Richard Sickert, 1860–1942.
Oil on canvas, 51.1 x 40.8 cm.
Tate Gallery, London.
See *Further Reading*: Baron and
Shone, *Sickert*.

82 *Girl with a White Dog*, 1950–51.
Lucian Freud, 1922–.
Oil on canvas, 76.2 x 101.6 cm.
Tate Gallery, London.

Pope Innocent X, 1650.
Diego Velázquez, 1599–1660.
Oil on canvas, 140 x 120 cm.
Galleria Doria-Pamphili, Rome.
See *Further Reading*: Harris, *Velázquez*.

*Study after Velázquez's Portrait of
'Pope Innocent X'*, 1953.
Francis Bacon, 1909-92.
Oil on canvas, 153 x 118 cm.
Des Moines Art Center, Iowa.
See *Further Reading*: Russell,
World of Art: Francis Bacon.

83 *Crucifixion*, 1965.
Francis Bacon, 1909-92.
Oil on canvas, each 198 x 147.5 cm.
Bayerische Staatsgemäldesammlungen,
Munich.

84 *Current*, 1964.
Bridget Riley, 1931–.
Synthetic polymer on board,
148.1 x 148.1 cm.
Museum of Modern Art, New York.

85 *Just what is it that makes today's homes
so different, so appealing?*, 1956.
Richard Hamilton, 1922–
Collage, 26 x 25 cm.
Kunsthalle, Tübingen.

Marilyn Diptych, 1962.
Andy Warhol, 1928–87.
Acrylic on canvas, 410.8 x 289.6 cm.
Tate Gallery London.
See *Further Reading*: McShine,
Andy Warhol, A Retrospective.

Triple Elvis, 1962.
Andy Warhol, 1928–87.
Silkscreen ink on aluminium paint
on canvas, 208.3 x 152.4 cm.
Virginia Museum of Fine Arts,
Richmond, Virginia.
See *Further Reading*: McShine,
Andy Warhol, A Retrospective.

F-111, 1965.
James Rosenquist, 1933–.
Oil on canvas, 305 x 2621 cm.
Private Collection.
See *Further Reading*: Fineberg,
Art Since 1940, Strategies of Being.

Whaam!, 1963.
Roy Lichtenstein, 1923–.
Acrylic on canvas, 172.7 x 406.4.
Tate Gallery London.
See *Further Reading*: Waldman,
Roy Lichtenstein.

Hommage à Chrysler Corp, 1957.
Richard Hamilton, 1922–.
Oil, metal foil and collage on panel,
122 x 81 cm.
Private Collection.
See *Further Reading*: Tate Gallery,
Richard Hamilton.

AAH!, 1962.
Richard Hamilton, 1922–.
Oil on panel, 81 x 122 cm.
Hessisches Landesmuseum,
Darmstadt.
See *Further Reading*: Tate Gallery,
Richard Hamilton.

The Third Love Painting, 1960.
David Hockney, 1937–.
Oil on board, 119 x 119 cm.
Private Collection.
See *Further Reading*: Hockney,
*David Hockney by David Hockney,
My Early Years*.

Doll Boy, 1960–61.
David Hockney, 1937–.
Oil on canvas, 152.4 x 121.9 cm.
Private Collection.
See *Further Reading*: Webb,
Portrait of David Hockney.

86 *We Two Boys Together Clinging*, 1961.
David Hockney, 1937–.
Oil on board, 121.9 x 152.4 cm.
Arts Council.

The Bigger Splash, 1967.
David Hockney, 1937–.
Acrylic on canvas, 242.6 x 243.8 cm.
Tate Gallery, London.

87 *Town and Country*, 1979.
Patrick Caulfield, 1936–.
Acrylic on canvas, 231.1 x 165.1 cm.
Private Collection.

88 *Patrick Caulfield in Italy*, 1987–92.
Sir Howard Hodgkin, 1932–.
Oil on wood, 110.5 x 146 cm.
Private Collection.

An Oak Tree, 1973.
Michael Craig-Martin 1941–.
Objects, water and printed text,
13 cm (height).
Australian National Gallery,
Canberra.
See *Further Reading*: *Michael Craig-
Martin, a Retrospective*.

*The Physical Impossibility of Death
in the Mind of Someone Living*,
1991.
Damien Hirst, 1965–.
Tiger shark, glass, steel,
formaldehyde solution,
213 x 518 x 213 cm.
Saatchi Gallery, London.
See *Further Reading*: Kent,
*Shark-Infested Waters: The Saatchi
Collection of British Art in the 90s*.

89 *20:50*, 1987.
Richard Wilson, 1953–.
Used sump oil and steel,
dimensions variable.
Saatchi Gallery, London.

FURTHER READING

Many more works have been consulted than space permits me to include here. Obviously some books have meant more to me than others and those that I have found particularly enlightening are marked with an asterisk.

CHAPTER ONE

Alexander, Jonathan, and Binski, Paul (ed.), *Age of Chivalry: Art in Plantagenet England 1200–1400*, exh. cat., Weidenfeld and Nicolson, 1987.

Anfam, David, *Abstract Expressionism*, Thames and Hudson, 1990.

*Aston, Margaret, *England's Iconoclasts, Volume 1: Laws Against Images*, Oxford University Press, 1988.

Aston, Margaret, *The King's Bedpost: Reformation and Iconography in a Tudor Group Portrait*, Cambridge University Press, 1993.

Clark, Kenneth, *The Gothic Revival: An Essay on the History of Taste*, 3rd edn with a new introduction by J. Mordaunt Crook, John Murray, 1995.

*Collinson, Patrick, *From Iconoclasm to Iconophobia: The Cultural Impact of the Second English Revolution*, University of Reading, 1989.

Daniels, Stephen, *Fields of Vision: Landscape Imagery and National Identity in England and the United States*, Polity, 1993.

*Duffy, Eamon, *The Stripping of the Altars: Traditional Religion in England c.1400–c.1580*, Yale University Press, 1992.

*Freedberg, David, *The Power of Images: Studies in the History and Theory of Response*, University of Chicago Press, 1989.

Gimpel, Jean, *The Cathedral Builders*, tr. Teresa Waugh, Cresset Library, 1988.

Gimpel, Jean, *Against Art and Artists*, Polygon, rev. edn, 1991.

Goldscheider, Ludwig, *Michelangelo: Paintings, Sculptures, Architecture*, Phaidon, 5th edn, 1975.

Hilton, Timothy, *World of Art: Picasso*, Thames and Hudson, 1976.

Janowitz, Anne, *England's Ruins: Poetic Purpose and the National Landscape*, Basil Blackwell, 1990.

Lightbown, Ronald, *Mantegna, with a Complete Catalogue of the Paintings, Drawings and Prints*, Phaidon, 1986.

*MacCulloch, Diarmaid, *The Later Reformation in England 1547–1603*, Macmillan Education, 1990.

*Macmillan, Duncan, *Scottish Art 1460–1990*, Mainstream, 1990.

CHAPTER TWO

Aston, Margaret, *The King's Bedpost: Reformation and Iconography in a Tudor Group Portrait*, Cambridge University Press, 1993.

Brown, Christopher (et al.), *Van Dyck: Paintings*, Thames and Hudson, 1991.

Courtenay-Thompson, Fiona (ed.), *Eyewitness Visual Dictionaries: The Visual Dictionary of Buildings*, Dorling Kindersley, 1992.

Foister, Susan, and Roberts, Jane, *Holbein and the Court of Henry VIII: Drawings from the Collection of Her Majesty The Queen*, Pierpont Morgan Library, 1983.

Girouard, Mark, *Robert Smythson: The Elizabethan Country House*, Yale University Press, 1983.

Harris, Enriqueta, *Velázquez*, Phaidon, 1982.

*Hill, Christopher, *The English Bible and the Seventeenth-Century Revolution*, Penguin, 1994.

Lloyd, Christopher, *The Queen's Pictures: Royal Collectors through the Centuries*, exh. cat., National Gallery Publications Ltd, 1991.

MacGregor, Arthur (ed.), *The Late King's Goods: Collections, Possessions and Patronage of Charles I in the Light of Commonwealth Sale Inventories*, Oxford University Press, 1989.

Millar, Oliver, *Van Dyck in England*, exh. cat., National Portrait Gallery, 1982.

Zuffi, Staffano, *Titian*, Electa, 1995.

*Orgel, Stephen, and Strong, Roy, *Inigo Jones: The Theatre of the Stuart Court*, University of California Press, 1973.

Pignatti, Terisio, *Giorgione*, Phaidon, 1971.

*Piper, David, *The English Face*, National Portrait Gallery, rev. edn, 1992.

Rowlands, John, *Holbein: The Paintings of Hans Holbein the Younger*, Phaidon, 1985.

Sharpe, Kevin, *The Personal Rule of Charles I*, Yale University Press, 1992.

Starkey, David (ed.), *Henry VIII: A European Court in England*, Collins and Brown, 1991.

Stone, Lawrence, *The Causes of the English Revolution 1529–1642*, Ark Paperbacks, 2nd edn, 1986.

Strong, Roy, *The Cult of Elizabeth: Elizabethan Portraiture and Pageantry*, Thames and Hudson, 2nd edn, 1987.

*Strong, Roy, *Gloriana: The Portraits of Queen Elizabeth I*, Thames and Hudson, 1987.

Summerson, John, *Pelican History of Art: Architecture in Britain 1530–1830*, Yale University Press, 9th edn, 1993.

Thurley, Simon, *The Royal Palaces of Tudor England: Architecture and Court Life 1460–1547*, Yale University Press, 1993.

*Wilton, Andrew, *The Swagger Portrait: Grand Manner Portraiture in Britain from Van Dyck to Augustus John 1630–1930*, exh. cat., Tate Gallery, 1992.

*Yates, Frances, *Astraea: The Imperial Theme in the Sixteenth Century*, Routledge and Kegan Paul, 1975.

CHAPTER THREE

*Barrell, John (ed.), *Painting and the Politics of Culture: New Essays on British Art 1700–1850*, Oxford University Press, 1992.

Blotkamp, Carel, *Mondrian: The Art of Destruction*, Reaktion Books, London, 1994.

Brilliant, Richard, *Portraiture*, Reaktion, 1991.

*Colley, Linda, *Britons: Forging the Nation, 1707–1837*, Pimlico, 1994.

Cormack, Malcolm, *The Paintings of Thomas Gainsborough*, Cambridge University Press, 1991.

Deuchar, Stephen, *Sporting Art in Eighteenth-Century England: A Social and Political History*, Yale University Press, 1988.

Fussell, Paul, *The Rhetorical World of Augustan Humanism: Ethics and Imagery from Swift to Burke*, Clarendon Press, 1965.

Jackson-Stopes, Gervase, *The Treasure Houses of Britain: Five Hundred Years of Private Patronage and Art Collecting*, Washington National Gallery of Art, 1985.

Paulson, Ronald, *The Art of Hogarth*, Phaidon, 1975.

Paulson, Ronald, *Hogarth*, 3 vols, Lutterworth Press, 1992.

Paulson, Ronald, *Hogarth's Graphic Works*, The Print Room, 3rd edn, 1989.

Penny, Nicholas (ed.), *Reynolds*, exh. cat., Weidenfeld and Nicolson, 1986.

Piper, David, *The English Face*, National Portrait Gallery, rev. edn, 1992.

Pointon, Marcia, *Hanging the Head, Portraiture and Social Formation in Eighteenth-Century England,* Yale University Press, 1993.

*Robinson, Martin, *Temples of Delight: Stowe Landscape Gardens*, National Trust, 1990.

Saumarez Smith, Charles, *Eighteenth-Century Decoration: Design and the Domestic Interior in England*, Weidenfeld and Nicolson, 1993.

*Shawe-Taylor, Desmond, *The Georgians: Eighteenth-Century Portraiture and Society*, Barrie and Jenkins, 1990.

Shesgreen, Sean (ed.), *Engravings by Hogarth*, Dover Publications Inc., 1973.

Smart, Alastair, *Allan Ramsay: Painter, Essayist and Man of the Enlightenment*, Yale University Press, 1992.

Solkin, David, *Painting for Money: The Visual Arts and the Public Sphere in Eighteenth-Century England*, Yale University Press, 1993.

Tate Gallery, *George Stubbs 1724–1806*, exh. cat., Tate Gallery, 1984.

Waterhouse, Ellis, *Painting in Britain 1530 to 1790*, Yale University Press, 1994.

Wethey, Harold E., *Titian: The Religious Paintings*, vol. 1, Phaidon, 1969.

Whiting, Roger, *Leonardo: A Portrait of the Renaissance Man*, Barrie and Jenkins, 1992.

CHAPTER FOUR

Ackroyd, Peter, *Blake*, Sinclair-Stevenson, 1995.

Bindman, David, *William Blake: His Art and Times*, Thames and Hudson, 1982.

Butler, Marilyn, *Romantics, Rebels and Reactionaries: English Literature and its Background 1796–1830*, Oxford University Press, 1981.

Butlin, Michael, *The Paintings and Drawings of William Blake*, 2 vols, Yale University Press, 1981.

Butlin, Michael, and Joll, Evelyn, *The Paintings of J.M.W. Turner*, 2 vols, Yale University Press, 2nd rev. edn, 1984.

*Gowing, Lawrence, *Turner: Imagination and Reality*, Museum of Modern Art, 1966.

*Harbison, Robert, *Eccentric Spaces*, Knopf, 1977.

*Honour, Hugh, *Romanticism*, Penguin, 1979.

*Janson, H.W., and Rosenblum, Robert, *Art of the Nineteenth Century: Painting and Sculpture*, Thames and Hudson, 1984.

*Klingender, Francis, *Art and the Industrial Revolution*, revised and extended by Arthur Elton, Evelyn, Adams and Mackay, 1968.

Lindsay, Jack, *Turner: The Man and his Art*, Granada, 1990.

Lister, Raymond, *Catalogue Raisonné of the Works of Samuel Palmer*, Cambridge University Press, 1988.

Parris, Leslie, *Constable: Pictures from the Exhibition*, exh. cat., Tate Gallery, 1991.

*Paulson, Ronald, *Literary Landscape: Turner and Constable*, Yale University Press, 1982.

*Pressly, William, *The Life and Art of James Barry*, Yale University Press, 1981.

*Pressly, William, *James Barry: The Artist as Hero*, exh. cat., Tate Gallery, 1983.

Richmond, Robin, *Michelangelo and the Creation of the Sistine Chapel*, Barrie and Jenkins, 1992.

Rosenblum, Robert, *Transformations in Late Eighteenth-Century Art*, Princeton University Press, 1967.

*Rosenblum, Robert, *Modern Painting and the Northern Romantic Tradition, Friedrich to Rothko*, Thames and Hudson, 1975.

Rosenthal, Michael, *Constable: The Painter and his Landscape*, Yale University Press, 1983.

Summerson, John, *Pelican History of Art: Architecture in Britain 1530–1830*, Yale University Press, 9th edn, 1993.

*Wilton, Andrew, *Turner in his Time*, Thames and Hudson, 1987.

Wilson, Simon, *Tate Gallery: an Illustrated Companion*, Tate Gallery, 2nd edn, 1991.

CHAPTER FIVE

Baron, Wendy and Shone, Richard (ed.), *Sickert*, exh. cat., Royal Academy, 1992.

Bayne, William, *The Makers of British Art*, Walter Scott Publishing Co. Ltd, 1903.

Bell, Quentin, *A New and Noble School: The Pre-Raphaelites*, Macdonald, 1982.

Chandler, Alice, *A Dream of Order: The Medieval Ideal in Nineteenth-Century English Literature*, Routledge and Kegan Paul, 1971.

Colley, Linda, *Britons: Forging the Nation, 1707–1837*, Pimlico, 1994.

*Conrad, Peter, *The Victorian Treasure House*, Collins, 1973.

Cowling, Mary, *The Artist as Anthropologist: The Representation of Type and Character in Victorian Art and Victorian England*, Cambridge University Press, 1989.

Egerton, Judy, *Wright of Derby*, exh. cat., Tate Gallery, 1990.

Fuller, Peter, *Theoria: Art and the Absence of Grace*, Chatto and Windus, 1988.

*Harbison, Robert, *Deliberate Regressions*, Knopf, 1980.

Harrison, Martin, and Waters, Bill, *Burne-Jones*, Barrie and Jenkins, 2nd edn, 1989.

Hilton, Timothy, *The Pre-Raphaelites*, Thames and Hudson, 1970.

Hilton, Timothy, *World of Art: Picasso*, Thames and Hudson, 1976.

Hitchcock, Henry-Russell, *Architecture: Nineteenth and Twentieth Centuries*, 4th edn, Penguin, 1977.

*Klingender, Francis, *Art and the Industrial Revolution*, revised and extended by Arthur Elton, Evelyn, Adams and Mackay, 1968.

Maas, Jeremy, *Victorian Painters*, Barrie and Jenkins, with revised bibliography, 1978.

MacCarthy, Fiona, *William Morris: A Life for our Time*, Faber and Faber, 1976.

Mignot, *Architecture of the Nineteenth Century*, Evergreen, 1994.

Nanteuil, Luc de, *David*, Thames and Hudson, 1990.

Rolt, Lionel Thomas Caswall, *Victorian Engineering*, Penguin, 1974.

Strong, Roy, *Gloriana: The Portraits of Queen Elizabeth I*, Thames and Hudson, 1987.

Tate Gallery, *The Pre-Raphaelites*, exh. cat., Tate Gallery, 1984.

Treuherz, Julian, *World of Art: Victorian Painting*, Thames and Hudson, 1993.

Wood, Christopher, *Victorian Panorama: Paintings of Victorian Life*, Faber and Faber, 1976.

CHAPTER SIX

Bell, Keith *Stanley Spencer: A Complete Catalogue of the Paintings*, Phaidon, 1992.

Buckle, Richard, *Epstein, an Autobiography*, Studio Vista Ltd, 1984.

Compton, Susan (ed.), *British Art in the 20th Century*, Prestel, 1986.

Cork, Richard, *Art Beyond the Gallery in Early Twentieth-Century England*, Yale University Press, 1985.

Cork, Richard, *A Bitter Truth: Avant-Garde Art and the Great War*, Yale University Press, 1994.

Elderfield, John, *Kurt Schwitters*, Thames and Hudson, 1985.

Farson, Daniel, *The Gilded Gutter Life of Francis Bacon*, Pantheon Books, 1993.

Fineberg, Jonathan, *Art Since 1940, Strategies of Being*, Laurence King Publishers, 1995.

Graham-Dixon, Andrew, *Howard Hodgkin*, Thames and Hudson, 1994.

*Hamilton, George Heard, *Painting and Sculpture in Europe 1880–1940*, Yale University Press, 2nd edn, 1993.

Harris, Enriqueta, *Velázquez,* Phaidon, 1982.

Harrison, Charles, *English Art and Modernism 1900–1939,* 2nd edn, Yale University Press, 1994.

Hockney, David, *David Hockney by David Hockney, My Early Years,* Thames and Hudson, 1988.

Hughes, Robert, *The Shock of the New: Art and the Century of Change,* Thames and Hudson, updated and enlarged edn, 1991.

Kent, Sarah, *Shark-Infested Waters: The Saatchi Collection of British Art in the 90s,* Zwemmer, 1994.

McConkey, Kenneth, *Edwardian Portraits: Images of an Age of Opulence,* Antique Collectors' Club, 1987.

McShine, Kynaston, *Andy Warhol, A Retrospective,* exh. cat., Museum of Modern Art, 1989.

Michael Craig-Martin, a Retrospective, exh. cat., Whitechapel Art Gallery, 1989.

Morphet, Richard, *Meredith Frampton,* exh. cat., Tate Gallery, 1982.

Naylor, Gillian *Bloomsbury: The Artists, Authors and Designers by Themselves,* Octopus, 1990.

Russell, John, *World of Art: Francis Bacon,* Thames and Hudson, rev. edn, 1993.

Spalding, Frances, *British Art Since 1900,* exh. cat., Thames and Hudson, 1986.

Sharp, *Twentieth Century Architecture, A Visual History,* Lund Humphries, 1991.

*Sylvester, David, *Interviews with Francis Bacon,* Thames and Hudson, 1993.

Tate Gallery, *Richard Hamilton,* exh. cat., Tate Gallery, 1992.

Waldman, Diane, *Roy Lichtenstein,* Solomon R. Guggenheim Foundation, 1993.

Webb, Peter, *Portrait of David Hockney,* Chatto and Windus, 1988.

Wees, William C., *Vorticism and the English Avant-Garde,* Manchester University Press, 1972.

Wilson, Simon, *Tate Gallery: an Illustrated Companion,* Tate Gallery, 2nd edn, 1991.

Verdi, Richard, *Nicolas Poussin 1594–1665,* exh. cat., Royal Academy, 1995.

NOTES ON SOURCES

Every effort has been made to trace the sources of the quotations in this book. Extracts on the pages listed below come from the following sources:

Page 6: 'Out of the chaos...', Mervyn Peake, 'Out of the Chaos of my Doubt', *Selected Poems,* Faber & Faber, 1972.

INTRODUCTION
Page 9: 'We are after all, a literary people', Kenneth Clark, '*English Painting*', *Art in England,* R.S. Lambert (ed.), Penguin, 1938. p.23.
Page 9: 'There is no tradition ...', Douglas Lord, 'France Looks at English Painting', *Art in England,* Penguin, 1938. p.27.

CHAPTER ONE
Page 13: 'What are the roots ...', T.S. Eliot, *The Waste Land,* Faber and Faber, 1961.
Page 13: 'At Clare ...', *The journals of William Dowsing, of Stratford, Parliamentary Visitor, appointed under a warrant from the Earl of Manchester, for demolishing the Superstitious Pictures and Ornaments of Churches, etc., within the County of Suffolk in the years 1643–1644,* Woodbridge, 1786.
Page 14: 'Great nations ...', E.T. Cook and Alexander Wedderburn (eds), Preface, 'St Mark's Rest', 1884–5, *The Complete Works of John Ruskin,* vol. 24, George Allen, 1906. p.203.

Page 14: 'there was not the clarity ...', Nikolaus Pevsner, *The Buildings of England: Cambridgeshire,* Penguin, 1970. p.361.
Page 16: Story told to the author by Graham Howes of Trinity Hall,Cambridge.
Page 17: Lawrence Stone, *The Pelican History of Art: Sculpture in Britain: The Middle Ages,* Penguin, 1972. p.1.
Page 21: Duffy, *The Stripping of the Altars.* p.8.
Page 32: Old Testament, Exodus 20:1.
Page 34: Aston, *England's Inconoclasts.* p.63.
Page 36: Duffy, *The Stripping of the Altars.* p.404.
Page 38: *The journals of William Dowsing, of Stratford, Parliamentary Visitor, appointed under a warrant from the Earl of Manchester, for demolishing the Superstitious Pictures and Ornaments of Churches, etc., within the County of Suffolk in the years 1643–1644,* Woodbridge, 1786.
Page 39: 'Of Reformation', *Complete Prose Works of John Milton, 1624–42,* vol. 1, Yale University Press, 1953. p.556.

CHAPTER TWO
Page 47: 'the King's majesty ...', Orgel and Strong, *Inigo Jones.* p.733.
Page 47: 'paint my picture truly like me ...', Piper, *The English Face.* p.89.
Page 54: William Shakespeare, *Antony and Cleopatra,* Act IV, scene xiv.
Page 71: Orgel and Strong, *Inigo Jones.* p.50.
Page 76: 'paint my picture truly like me ...', Piper, *The English Face.* p.89.

CHAPTER THREE
Page 81: 'Whenever people talk to me ...', Oscar Wilde, *The Importance of Being Earnest,* Penguin, 1987. Act 1.
Page 81: 'Damn gentlemen', Mary Woodall (ed.), *The Letters of Thomas Gainsborough,* Lion and Unicorn Press, 1961. Letter to William Jackson, 2 September 1767. p.101.
Page 82: BBC Radio broadcast, 28.4.1949.
Page 86: 'Everything in nature is individual', quoted in Macmillan, *Scottish Art 1460–1990.* p.104.
Page 86: 'little bit (two Inches wide) of Ivory', R.W. Chapman (ed.), *Jane Austen's Letters,* Oxford University Press, 1952. Letter to J. Edward Austen, 16.12.1816. p.134.
Page 86: 'snug, less, narrow ...', Henry Fuseli, 'On the Present State of the Art and the Causes which Check its Progress', quoted in John Knowles (ed.), *The Life and Writings of Henry Fuseli,* vol. 3, Henry Coburn and Richard Bentley, 1831, p.48.
Page 88: Roy Porter, *English Society in the Eighteenth Century,* Allen Lane, 1982, p.78.
Page 90: Robinson, *Temples of Delight.* p.91.
Page 104: 'Damn gentlemen', Mary Woodall (ed.), *The Letters of Thomas Gainsborough,* Lion and Unicorn Press, 1961. Letter to William Jackson, 2.9.1767. p.101.
Page 104: 'hired to depress art', Robert R. Wark (ed.), *Sir Joshua Reynolds's Discourse on Art,* Yale University Press, London, 1975. p.284.

Page 106: Penny, *Reynolds*. p.224.
Page 110: Mary Woodall (ed.), *The Letters of Thomas Gainsborough*, Lion and Unicorn Press, 1961. Letter to the Earl of Dartmouth, 18.4.(year unknown). p.53.
Page 111: Mary Woodall (ed.), *The Letters of Thomas Gainsborough*, Lion and Unicorn Press, 1961. Letter to William Jackson, 14.9.(year unknown). p.103.
Page 118: 'If ever this nation ...' Robert R. Wark (ed.), *Sir Joshua Reynold's Discourses on Art*, Yale University Press, London, 1975. p.248.
Page 118: 'We are all going to heaven ...', William T. Whitley, *Thomas Gainsborough*, Smith, Elder and Co., 1915. p.306.
Page 118: 'the last words that I shall pronounce ...', Robert R. Wark (ed.), *Sir Joshua Reynolds's Discourse on Art*, Yale University Press, London, 1975. p.282.

CHAPTER FOUR
Page 125: 'Painters no longer live within a tradition ...', *Life with Picasso*, Françoise Gilot and Carlton Lake, Virago, 1990. pp.67–68.
Page 125: 'Pictures of nothing ...', quoted in Paulson, *Literary Landscape*. p108.
Page 130: Robert R. Wark (ed.), *Sir Joshua Reynolds's Discourse on Art*, Yale University Press, 1975. p.284.
Page 131: Ackroyd, *Blake*. p.34.
Page 135: William Blake, *Jerusalem*, 1804–20. Plate 10.
Page 136: 'the desperate search for God ...', Christopher Hill, *God's Englishman: Oliver Cromwell and the English Revolution*, Pelican, 1972. p.234.
Page 136: 'discover a world ...', Peter Conrad, *The Victorian Treasure House*, Collins, 1973.
Page 138: 'Life of Sir Joshua Reynolds', *The Collected Works of William Hazlitt*, vol. 10, J.M. Dent and Co., 1902, p.200.
Page 142: 'I want to stun Paris with an apple', reported in Meyer Schapiro, *Modern Art: 19th and 20th Centuries*, Chatto and Windus, 1978. p.30.
Page 142: 'I should paint my own places best', C.R. Leslie, *Memoirs of the Life of John Constable*, Phaidon, 1980. Letter to Mr Fisher, 23.10.1821. p.86.
Page 143: Quoted in Rosenthal, *Constable*. p.44.
Page 146: Quoted in C.R. Leslie, *Memoirs of the Life of John Constable*, Phaidon, 1980. Letter to Mr Fisher, 23.10.1821. p.86.
Page 147: Quoted in Gowing, *Turner*. p.10.
Page 148: Gowing, *Turner*. p.16.
Page 149: 'like the embryo or blot ...', quoted in Gowing, *Turner*. p.9.
Page 149: 'Turner is perpetually aiming to be extraordinary ...', quoted in Gowing, *Turner*. p.9.
Page 150: 'a magician ...', 'Personal

Recollections of Great Artists by the Late E.V. Rippingille', *Art Journal*, 1860. p.100.
Page 150: 'you should tell him ...', quoted in Gowing, *Turner*. p.31.
Page 155: Quoted in Gowing, *Turner*. p.13.
Page 158: Quoted in Eric Shanes, *Impressionist London*, Abbeville Press, 1994. Letter to Sir Coutts Lindsay. p.21.
Page 159: Quoted in Gowing, *Turner*. p.31.

CHAPTER FIVE
Page 161: 'I have tired the eyes ...', David Jones, 'A, a, a, Domine Deus', *The Sleeping Lord and Other Fragments*, Faber & Faber, 1974.
Page 161: 'Beware the Jabberwock, my son', Lewis Carroll, 'Jabberwocky', *Alice's Adventures in Wonderland and Through the Looking Glass*, Oxford University Press, 1971.
Page 164: Queen Victoria, Journal, II, October 1851.
Page 165: Quoted in Rolt, *Victorian Engineering*, p.174.
Page 168: 'The Renaissance', *The Works of Walter Pater*, vol. 1, Macmillan and Co., 1900, p.235.
Page 169: 'Miscellaneous Estimates', Hansard, 6.6.1856.
Page 172: 'truly ravishing, the realisation of all our longing desires', Augustus Pugin, 'Remarks on articles in the *Rambler*', quoted in *William Burges and the High Victorian Dream*, J. Mordaunt Crook, John Murray, 1981. p.22.
Page 172: 'Oh! then, what delight! what joy unspeakable! ...' *ibid*.
Page 172: 'orphreyed baudekins ... pix and pax ...' *ibid*.
Page 175: William Michael Rossetti, *Dante Gabriel Rossetti: His Family Letters, with a Memoir*, Ellis and Elvey, 1895. p.135.
Page 178: Quentin Bell, *A New and Noble School: The Pre-Raphaelites*, Macdonald, 1982. p.48.
Page 180: Quoted in J. Vernon Jensen, *Thomas Henry Huxley: Communicating for Science*, University of Delaware Press, 1991. p.74.
Page 193: Quoted in P. Henderson, *William Morris*, Penguin, 1973, p.308.

CHAPTER SIX
Page 199: 'As being tied to the art of the past, what other home have we got?' Quoted in Michael Auping (et al), *Howard Hodgkin Painting*, Thames and Hudson, 1995, p.76.
Page 199: 'I want to be/Anarchy', John Lydon, lyrics to the song *Anarchy in the UK*. p.1.
Page 205: the 'Van Dyck of our times', quoted in Robert Hughes, *Nothing if not

Critical: Selected Essays on Art and Artists*, Collins Harvill, 1989. p.100.
Page 205: 'I am absolutely sceptical ...', quoted in Wees, *Vorticism*. p.22.
Page 205: 'the existence of a widespread plot ...', quoted in Frances Spalding, *Roger Fry*, Granada, 1980. p.136.
Page 206: 'We are fearfully tasteful', quoted in Compton, *British Art in the 20th Century*. p.20.
Page 206: 'the new spirit ...', Clive Bell, *Burlington Magazine*, 31, 1917. p.37.
Page 206: 'a radiant node or cluster ...', quoted in Compton, *British Art in the 20th Century*. p.138.
Page 208: 'BLAST ... BOURGEOIS VICTORIAN VISTAS', 'BLAST their weeping whiskers ...', *Blast*, no. 1, 20.6.1914.
Page 208: 'Roger Fry's little belated Morris movement', *Blast*, no. 2, July 1915.
Page 208: 'great PORTS ...', 'BLESS ENGLAND ...', *Blast*, no. 1, 20.6.1914.
Page 209: 'the geometrics which had interested me ...', Wyndham Lewis, *Rude Assignment: A Narrative of My Career Up-To-Date*, Hutchinson, 1950. p.129
Page 209: 'I am no longer an artist ...', Paul Nash, *Outline: An Autobiography and Other Writings*, Faber and Faber, 1949.
Page 211: Wyndham Lewis, *The Letters of Wyndham Lewis*, W.K. Rose (ed.), Methuen, 1963. Letter to James Thrall Thoby, 9.4.1947. p.406.
Page 216: Quoted in Maurice Collis, *Stanley Spencer*, Hurrell Press, 1962. pp.138–9.
Page 219: 'The plastic arts...', Walter Richard Sickert, *Art News*, 12.5.1910.
Page 219: 'the wriggle-and-chiffon school', Walter Richard Sickert, *New Age*, 6.6.1910 quoted in Osbert Sitwell, *A Free House: The Writings of Walter Richard Sickert*, Macmillan, 1947. p.82.
Page 220: Walter Richard Sickert, *New Age*, 2.6.1910, quoted in Osbert Sitwell, *A Free House: The Writings of Walter Richard Sickert*, Macmillan, 1947. p.59.
Page 224: 'I remember looking at a dogshit ...', Sylvester, *Interviews with Francis Bacon*, p.133.
Page 224: 'we are meat.', Sylvester, *Interviews with Francis Bacon*, p.46.
Page 225: 'the perilous zones in the life ...', Samuel Beckett, *Proust and the Three Dialogues with Georges Duthuit*, J. Calder. 1969.
Page 225: 'one totally without belief...', Sylvester, *Interviews with Francis Bacon*, p.134.
Page 225: 'Pop art is Popular ...', quoted in Tate Gallery, *Richard Hamilton*, p.149.
Page 226: G. R. Swenson, 'What is Pop Art?: Answers from 8 Painters, Part 1', *Art News*, 62, November 1963. p.26
Page 235: *Life with Picasso*, Françoise Gilot and Carlton Lake, Virago, 1990. p.68.

INDEX

PICTURE CREDITS

Page 2, Yale Center for British Art, Paul Mellon Collection; p.12, By courtesy of The Mercers' Company/photo: Nicholas Turpin; p.15, Courtesy of the Dean and Chapter of Ely Cathedral/photo: Eileen Tweedy; p.18 &19, Courtesy Wenhaston St. Peter Church/photo: Eileen Tweedy; p.20, Courtesy Ranworth St. Helen's Church/photo: Eileen Tweedy; p.22-3, By courtesy of The Mercers' Company/photo: Nicholas Turpin; p.25, Courtesy of Cullompton Church, Devon/photo: Nick Tilly; p.26-7, © Joe Rock; p.28-9, Courtesy St. Mary's Church, Abergavenny/photo: Eileen Tweedy; p.31, Courtesy Exeter Cathedral/photo: Eileen Tweedy; p.33, Courtesy St. Mary Magdalene Church, Withersdale/photo: Eileen Tweedy; p.37, Courtesy St. Cuthbert's Church, Wells/photo: Eileen Tweedy; p.40-41, Reproduced by courtesy of the Trustees, The National Gallery, London; p.43, Jewish Museum/Art Resource, New York. © ARS, NY and DACS, London 1999; p.44, Courtesy Merthyr Issui Church, Patrishow/photo: Eileen Tweedy; p.46, photo: Eileen Tweedy; p.50, © Country Life Picture Library; p.52-3, National Trust Picture Library/photo: John Hammond; p.56, By courtesy of the Board of Trustees of the Victoria & Albert Museum/photo: Sarah Hodges; p.57, Courtesy of the Marquess of Salisbury; p.60, Reproduced by courtesy of the Trustees, The National Gallery, London; p.61, The Royal Collection, © Her Majesty the Queen; p.62, Museo Thyssen-Bornemisza, Madrid; p.64, The Royal Collection, © Her Majesty the Queen; p.65, Reproduced by kind permission of His Grace the Duke of Marlborough; p.68

& 72, The Royal Collection, © Her Majesty the Queen; p.73, Devonshire Collection, Chatsworth/Photographic Survey Courtauld Institute of Art; p.76, In the collection of the Duke of Buccleuch & Queensberry KT; p.77, Collections/photo: John Miller; p.78, ©1986 Malcolm Crowthers; p.80, © The Sir Alfred Munnings Art Museum, Dedham, Essex; p.84, National Gallery of Scotland; p.85, Yale Center for British Art, Paul Mellon Collection; p.92-3, National Trust Photographic Library/photo: Jerry Harpur; p.96-7, Courtauld Institute Galleries, London; p.101, Reproduced by courtesy of the Trustees, The National Gallery, London; p.102, © The British Museum; p.105, The Tate Gallery, London; p.107, Yale Center for British Art, Paul Mellon Collection; p.109, Private Collection/photo: The Royal Academy of Arts, London; p.112-13, Reproduced by courtesy of the Trustees of the National Gallery, London; p.114, © The Frick Collection, New York; p.115, The Royal Collection, © Her Majesty The Queen; p.116-17, National Trust Photographic Library; p.120, Private Collection; p.121, Yale Center for British Art, Paul Mellon Collection; p.124, The Turner Collection, Tate Gallery, London; p.128 & 129, Courtesy Royal Society of Arts, London/photo: A.C.Cooper Ltd.; p.132, By courtesy of the Board of Trustees of the Victoria & Albert Museum; p.133, Tate Gallery, London; p.134, Birmingham Museums & Art Gallery; p.139, Sir John Soane Museum/photo: Ole Woldbye; p.141, By courtesy of the Board of Trustees of the Victoria & Albert Museum; p.142, Reproduced by courtesy of the Trustees, The National Gallery, London; p.144-5, By courtesy of the Board of Trustees of the Victoria & Albert Museum; p.149, 152-3 & 156-7, The Turner Collection, Tate Gallery, London; p.160, Holloway Collection, Royal Holloway College; p.163, Reproduced by courtesy of the Trustees, The National Gallery, London; p.167, Birmingham Museums and Art Gallery; p.171, photo:

Jeremy Cockayne/ARCAID; p.174, The Board of Trustees of the National Museums & Galleries on Merseyside; p.177, © Ashmolean Museum, Oxford; p.179, The Board of Trustees of the National Museums & Galleries on Merseyside; p.182, © Manchester City Art Galleries; p.183, Tate Gallery, London; p.184 & 186, © Manchester City Art Galleries; p.187, Tate Gallery, London; p.189, Delaware Art Museum. Samuel and Mary R. Bancroft Memorial; p.190-91, The Faringdon Collection Trust, Buscot Park; p.194, John Birdsall Photography; p.197, © BBC Worldwide; p.198, Courtesy Artangel and Karsten Schubert, London/photo: Nicholas Turpin; p.203, National Gallery of Scotland; p.207, Tate Gallery, London/© Wyndham Lewis and the estate of Mrs. G. A.Wyndham Lewis, by kind permission of the Wyndham Lewis Memorial Trust; p.210, Reproduced by kind permission of the President and Council of the Royal College of Surgeons of England/Crown Copyright. Reproduced with the permission of the Controller of HMSO; p.213, photo: Chris Gascoigne 1990/ARCAID; p.215, Fitzwilliam Museum, Cambridge/© Estate of Stanley Spencer 1999. All rights reserved DACS; p.217, © The Henry Moore Foundation; p.219, City of Nottingham Museums; Castle Museum and Art Gallery/© Henry Lessore; p. 221, Tate Gallery, London; p.222-3, Staatsgalerie moderner Kunst, Munich/Andreas Freytag, Artothek; p.227, The Museum of Modern Art, New York. Philip Johnson Fund/Courtesy Bridget Riley (Karsten Schubert, London); p.228, Kunsthalle Tübingen, Sammlung G.F. Zundel/© Richard Hamilton 1999 All rights reserved DACS; p.229, Arts Council Collection/© David Hockney, 1961; p.232, Collection Michael D. Abrams/© Patrick Caulfield 1999 All rights reserved DACS; p.233, Private Collection, Mexico. Courtesy Anthony d'Offay Gallery; p.238-9, Originally commissioned and shown at Matt's Gallery, London, 1987/Saatchi Collection, London/photo: Anthony Oliver.